SOME THING
ECLECTIC

P.O. BOX 476, LOS GATOS, CA 95031-0476

PARIS: CITY OF LIGHT
1919–1939

VINCENT CRONIN

PARIS

CITY OF LIGHT

1919 – 1939

HarperCollins*Publishers*

HarperCollins*Publishers*
77–85 Fulham Palace Road,
Hammersmith, London W6 8JB

Published by HarperCollins*Publishers* 1994
1 3 5 7 9 8 6 4 2

Copyright © Vincent Cronin 1994

Vincent Cronin asserts the moral right to
be identified as the author of this work

A catalogue record for this book is
available from the British Library

ISBN 0 00215191X

Set in Janson
at The Spartan Press Ltd,
Lymington, Hants

Printed in Great Britain by
HarperCollinsManufacturing Glasgow

For Chantal

CONTENTS

ILLUSTRATIONS

Surrealists in fun-fair aeroplane. *Courtesy Bibliothèque Littéraire Jacques Doucet. Photograph © Jean-Loup Charmet.*

André Gide and Maria Van Rysselberghe. *Photograph © Gisèle Freund.*

Man Ray *Portrait of Jean Cocteau with Empty Picture Frame*, 1922. Vintage gelatin silver print. *Collection High Museum of Art, Atlanta, Georgia. Purchase with funds from Georgia-Pacific Corporation, 1984.224.*

Man Ray *Kiki de Montparnasse*, 1924. *Photograph © Musée National d'Art Moderne, Paris.*

Fernand Léger in his studio, 1931. Photograph by A. E. Gallatin. *Courtesy The Condé Nast Publications Corporation. Photograph © March 1994 The Museum of Modern Art, New York.*

Jacques-Emile Blanche *Le Groupe des Six. Musée des Beaux Arts, Rouen. © DACS 1995. Photograph © Collection Viollet.*

René Magritte *Le Temps Menaçant. Private Collection. © ADAGP, Paris and DACS, London 1995. Photograph © The Bridgeman Art Library.*

Yves Tanguy *The Storm (Black Landscape)*, 1926. *Philadelphia Museum of Art: Louise and Walter Arensberg Collection. © DACS 1995.*

Joan Miró *The Tilled Field/La Terre Labourée*, 1923–1924. *Solomon R. Guggenheim Museum, New York. © ADAGP, Paris and DACS, London 1995. Photograph: David Heald & Myles Aronowitz © The Solomon R. Guggenheim Foundation, New York.*

Constantin Brancusi *Bird in Space*, 1926. Polished bronze with a black marble base. *Philadelphia Museum of Art: Louise and Walter Arensberg Collection.*

Alberto Giacometti *Caress*, 1932, sculpture in marble. *© ADAGP, Paris and DACS, London 1995. Photograph © Musée National d'Art Moderne, Paris.*

The Eiffel Tower illuminated, 1925. *Photograph © Roger-Viollet.*

André Citroën. *Photograph © Harlingue-Viollet.*

Jean Renoir filming 'La Marseillaise', 1938. *Photograph © Roger-Viollet.*

Picasso and Olga Koklova in Rome. *Musée Picasso, Paris. Photograph © R.M.N.*

Josephine Baker poster by Paul Colin. *Photograph © Kharbine-Tapabor.*

Cover of issue of *Vu* dated 1 March, 1933. *Photograph © Kharbine-Tapabor.*

Louise Weiss. *Photograph © René Dazy.*

Roland Dorgelès. *Photograph © Hulton Deutsch Collection Ltd.*

Paul Valéry. *Photograph © Roger-Viollet.*

Alexis Léger. *Photograph © Harlingue-Viollet.*

Comte Jean de Pange. *Photograph collection of the author.*

Portrait of Léon Blum carried by young socialists. *Photograph Collection Viollet.*

Parisians leaving for first paid summer holiday. *Photograph © René Dazy.*

Daladier and Bonnet. *Photograph © Hulton Deutsch / Keystone Collection.*

Monkey house. *Photograph © René Dazy.*

AUTHOR'S THANKS

Madame Marie Plaut, née d'Yvoire, shared with me memories of her life as a student, then as a young wife in Paris. Docteur Gilles Buisson recalled his years as a medical student in the 'thirties, Austin Coates his experiences of musical Paris. Among those no longer alive Jean Renoir talked to me about cinema, Eileen Agar about Surrealist painting and her friendships with Eluard and Picasso, Comte Guy de Rolland about the worlds of industry and finance. General Lucien Robineau and Wing Commander 'Laddie' Lucas gave me the benefit of their expertise in air force matters. André Rousseau, past president of the Fondation Saint-Jean Perse, provided useful clues to the character of Alexis Léger. Other French friends have shared with me memories of life in the army and in politics but have asked not to be named, since events of the 'thirties are, in France, still so controversial. My daughter Sylvelie found for me inter-war newspapers, Parisian and provincial; my daughter Dauphine typed the book from manuscript; Marine Saffar helped me with general research. My friend Basil Rooke-Ley unearthed out-of-the-way facts and gave constant encouragement. The staffs of the French Army Archives, of the Bibliothèque Nationale, of the British Library and of the London Library provided willing and expert help. Once again I am deeply indebted to Elizabeth Walter of HarperCollins for drawing on her insights as a writer and her experience as an editor to make many valuable suggestions.

PREFACE

At 8.40 in the morning of 25 August 1919 a twin-engined Handley Page aeroplane left Hounslow with eleven passengers. Flying at seventy miles an hour, it arrived in Paris three hours later, thus inaugurating a regular passenger service between the two capitals for a one-way fare of fifteen guineas. According to *The Times*, 'the journey cannot be guaranteed every day, owing to the bad climate, and at present engine failure cannot be entirely eliminated, and forced landings and delay may occur.' Nevertheless, soon those who could afford it thought nothing of calling at Keith Prowse in Bond Street, booking theatre seats and a hotel room, then flying across the Channel, returning next day, a colourful hotel sticker on their suitcase, the theatre programme to show friends, and perhaps in a hat box an irresistible little number from a shop in the rue du Faubourg Saint Honoré.

Improved transport brought visitors from other countries, too. Starved of travel by the war, Scandinavians came south by train in their thousands; fast mail boats brought the French-speaking rich from Argentina and Brazil; between June and September 1926 no less than 109 passenger ships, offering 260,000 berths, left New York for Le Havre and Cherbourg.

Some came to see the capital of a country whose fate had for four years mattered so much to the civilized world. Some, admirers of the pre-war work of Matisse, Braque and Picasso, came for the dozens of avant-garde art galleries. Some came to the city of Proust and Apollinaire to discover the latest literary fashions and to savour the 'little magazines', of which Paris published more than the rest of the world combined. Some came to concerts by the *groupe des Six*, some for shapely and poetic films. In other cities you could hear jazz; here you could also listen to animated café-table discussion about the metaphysic of the blues. Wine was plentiful, an additional attraction for Americans during Prohibition. The shadowy quais, the cafés with music on tree-lined pavements, appealed to young people in love, and not a few as before and since came here for their honeymoon.

On their return many of these visitors or temporary residents shared with family and friends their pleasurable memories. Paris's songs, sentimental or saucy, began to be heard round the world, its paintings bought by the discerning, its composers invited to conduct their works abroad, and Paris began to acquire a reputation as, in every sense, the City of Light. In popular imagination it joined early Renaissance Florence and eighteenth-century Vienna as one of those charmed cities that create beauty in an atmosphere of euphoria. Such was the image with which, in the late 1930s, I like many schoolboys grew up.

In 1949 I married into a French family and came to know well my father-in-law. At eighteen, from his native Gascony, he had joined those thousands who, with songs on their lips and flowers in their rifles, had marched off to war in 1914. As an artillery lieutenant for four years at the front he commanded a battery of 75's.

He came out of the war proud to have been able to endure its horrors, including being gassed, and grateful for a camaraderie that he hoped would continue into peace. He went to Paris to study engineering, married and set up home on the slopes of Montmartre. His hobby was collecting lithographs and on weekends he would search the quais for inexpensive items by Daumier and Gavarni. Strong and tolerant, he was not one to dwell on difficulties, but as he reminisced about his life in the capital I began to glimpse tensions and, behind the glitter and jazz, moments of great anguish. The camaraderie had not endured. Paris had indeed been richly creative but also it had been deeply troubled, then divided, not least by the question, 'How do we preserve *la patrie* while also preserving peace?'

My father-in-law described a city still compact, socially very permeable, welcoming new ideas, where artists, writers, thinkers mixed easily with senior civil servants, diplomats, industrialists and politicians, influencing them at a personal level while by their works they helped to re-shape public opinion as Voltaire, Lamartine, Hugo and Zola had done before them. By contrast London at this period was a much more conservative place, unshaken by invasion, defeat or a comparatively recent revolution, and where original thinkers were considered mad until the passage of time might prove them sane.

How did Paris compare with the rest of France? No clear-cut line

can be drawn, but certain contrasts emerge. Two-thirds of French families lived on and by the land, with an income lower than that of a Paris factory worker. Most provincial towns being dependent ultimately on agriculture, dairy farming and the production of wine, all then at a low ebb, at the end of the month few could find the money to buy a subscription to a literary magazine or a concert seat, let alone a couturier's dress or an illustrated edition of Mallarmé's poems.

If a small market for culture limited supply, strong regional patriotism restricted horizons. As in Paris, the discerning appreciated psychological insight and finesse, but liked to find these in books about their region, such as the novels of La Varende set in the Cotentin; they liked paintings of familiar mountains or lakes or rocky seascapes in a style not more modern than Impressionism. The one ubiquitous flourishing cultural centre was the local history society, bastion of traditional values.

It is true that many who contributed to metropolitan culture received their schooling in the provinces, but once they settled in the capital a remarkable osmosis took place. Marcel Pagnol arrived from Marseilles determined to get his historical play about Catullus performed; in this he failed, but before long he achieved success with a sophisticated contemporary drama of civic *moeurs*.

Parisians were believed by provincials to have a looser moral code. When twenty-year-old Mademoiselle Marie d'Yvoire, of a strict Savoie family, proposed to enrol at the Institut Catholique for its three-year course on how to be a good mother, her local curé protested on the grounds that Paris was 'a city of sin'. He was probably thinking of licensed brothels, cocottes and bohemian artists and artists' models. Marie, however, was allowed to enrol in her course and came to no harm, for many Parisian families were as protective of their young as were their country counterparts.

In the provinces political thinking and action were also predominantly local. A leading deputy in southern Normandy was elected, and re-elected, on the promise – which he kept – to protect itinerant distillers' time-honoured right to make untaxed apple brandy. Apart from occasional jibes at England – he happened to be a Bonapartist – he did not speak to his constituents about foreign policy, by common consent and long tradition left to Paris.

If it is true that the French are first to seek new truths and last to leave old truths behind, to a large extent the former activity took place in Paris, the latter in the provinces.

Those first confidences from my father-in-law excited my interest and made me wish to learn more. Whenever I came to know well those with personal experience of the place and period, I questioned them. I say 'know well' because chance acquaintances were understandably reluctant to recall, especially to someone not French, the years preceding defeat and occupation.

I came to see that there are two sides to inter-war Paris. It was indeed a centre of exceptional innovation, ranging from painting and photography, cinema and theatre, to motor-cars and discoveries in physics and chemistry, a city where men and women shaped a style of civilized living that claimed to keep in balance the mental, the physical and the spiritual. Behind the epithet 'City of Light', first applied by painters and fast becoming a cliché, lay a more important boast: Paris was the city of enlightenment. That boast alone would make it worth investigating.

At the same time Paris was struggling to adjust to the aftermath of a war costly in lives and money, to the grave problems posed by industrialization as well as to the radical cult political theories of the day, one Russian, one German. And these two sides of Paris are aspects of a single whole. Creativeness is inextricably linked to a prevailing, often covert anxiety. Maurice Ravel put it like this: 'Our epoch pleases me: this wonderful unease and sincere research in all directions – aren't these signs of a fertile period?'

The subject of the present book is Paris under this dual aspect. I approach it largely through the lives of influential men and women going about their daily tasks, producing, making decisions, acting wisely, acting foolishly. I focus on their values, presuppositions and moral choices. I am aware that I am going over well-trodden ground and readers will encounter some of those, such as Berthelot and Gide, whose earlier development was chronicled in a previous book, *Paris on the Eve: 1900–1914*, but in attempting a revaluation of a society it is also necessary to revalue certain artists in relation to that society.

I have drawn wherever possible on their own words at the time, especially those unguarded, unrevised words in journals, letters and

eyewitness reportages, as well as on the articles and books they published before 1940.

Amid an array of talent I have had to be severely selective, preferring those who have been innovative and influenced the values of their contemporaries. Some well-known and well-loved writers, for instance, are absent, either because like the novelist Roger Martin du Gard they chose to describe the period before 1914, with its fixed standards, or because like Saint-Exupéry they found Paris spiritually claustrophobic and chose to work elsewhere.

Like a watermark on every page of this period is the Great War. It changed the lives of both combatants and non-combatants irrevocably and afterwards remained an ineffaceable memory. To understand feelings and behaviour in the years of peace we should first look briefly, through the eyes of a young Parisian soldier, at the war.

1

FROM WAR TO PEACE

In the early days of Cubism, when writers and painters led bohemian lives in Montmartre, a familiar figure in the studios and cafés was a young journalist named Roland Dorgelès. With high brow, long straight nose, lean face and steady blue eyes, smartly turned out, often in a long black coat with astrakhan collar, he was well liked for his cheerful manner, vein of poetry and adventurousness.

Dorgelès came of petit bourgeois parents. The father, a travelling textile salesman, was often absent and did not get along with his wife, who transferred her affection to her only son without however becoming possessive. She gave him a Catholic upbringing and encouraged him to read good authors, his favourites being Molière and Courteline. After an unsuccessful spell at the Ecole des Arts décoratifs he decided on a literary career. He became a journalist of the Paris scene, had two short plays put on and indulged in light-hearted practical jokes: calling the fire brigade to extinguish a non-existent fire in the flat of a rival in love and, on another occasion, to protest against the thick glass on certain paintings in the Louvre, installing himself in front of one such painting, producing razor, cream and brush, soaping his face and calmly shaving as though in front of a mirror.

In his late twenties, Dorgelès fell in love with Madeleine Borgeau, separated from a stage designer husband, and set up home with her. He pressed Madeleine to marry him, but she had been hurt by her first marriage and for the moment did not wish to repeat the experience.

In summer 1914 France firmly backed her ally Russia in the crisis over Serbia. When this led to German troops invading Belgium,

1

Roland Dorgelès, at the age of twenty-nine, and by temperament adventurous, at once volunteered for active service. The war was expected to be short.

Madeleine promised to wait for him and Dorgelès set off to join the machine-gun company of the 39th Infantry Regiment. His ensuing experiences were to be typical of many, and because he was to publish them, lightly disguised as fiction, in an esteemed, widely-read book, *The Wooden Crosses*, they were to become a frieze of the Great War, both a memorial and a warning.

The book opens with Platoon 5 of Company 3 assembling in the stables of a notary's empty house just behind the Front Line: a variegated lot from Paris and Normandy, each trying to assert his individuality: Fouillard, the thin cook, wears a greasy white scarf knotted at his neck; huge shiny-faced Bouffioux has pinned his identity tag on his képi; meticulous little Belin wears a dragoon's forage cap down over his ears. Most have seen action, but one, Demachy, comes straight from law school, buttons gleaming and with a white haversack. Red-bearded Sulphart, loud, assertive and critical, remarks: 'If you're afraid the Boche won't notice you, you can always carry a little flag and blow a trumpet.' He adds gruffly that he'll put things right for the newcomer with burned cork and a pinch of soot.

In darkness the platoon moves up. Demachy lurches under his heavy haversack, cross-straps cutting into his back; at each pause he sheds medicines, a water filter, a tin of powdered meat; the others scramble for these, useful or not. Demachy sees a scattering of wooden crosses, then a whole field of them, a tiny flag, like a toy flag, on each, and red and green flares zooming into the darkness make him think not of a battlefield but of the Fourteenth of July. Demachy wants to feel deep emotion, but finds nothing tragic yet, just a strange contrast between the festive lights and silent fields. Then there is a sharp, rapid blast; the men throw themselves to the ground, as a shell explodes. Demachy finds himself enjoying the acrid smell.

They settle like badgers into the earth. Fastidious Demachy finds himself quartered next to Fouillard, the cook, whose feet stink, but when he sprinkles eau de cologne on his handkerchief, Fouillard complains they'll all be asphyxiated. Each of the men takes shape. Thin, gloomy Bréval writes a letter a day to his wife and gets a reply

2

if he's lucky once a fortnight. Maroux, a peacetime poacher, sees spies everywhere and swears the peasants are signalling with their lamps to German HQ. Sulphart, seated apart, smokes a pipe, pondering ways of outsmarting his personal enemy, the adjutant, and getting his squad the best cuts of meat.

German guns put down a barrage and as the men watch, Sulphart, like a fairground barker, calls for bets as to where the next shell will fall, while tiny Belin, holding his canteen to his ear like a telephone, plays the gunner commander: '4800 metres . . . Explosive . . . Barrel three . . . Fire both guns . . .'

Oafish Vairon, thinking he sees a German, fires his rifle. This brings him a dressing-down from the adjutant. '*Alors*, it's forbidden to kill the Boches? . . . That's the first round I've fired in three months.' He ambles off in a huff to his dug-out, rolls a cigarette.

Fouillard is temporarily recalled and the corpulent Bouffioux, in civilian life a horse-dealer and now a professional shirker who has fought at Charleroi and vowed never to fight again, persuades the captain to give him the cook's job, though he has no qualifications for it. As he kneels on all fours, coaxing flame from his cooking fire, and preparing his first soup, the others pretend to help. They persuade him to add first milk, then rice, then wine, holding in their laughter. Vairon even persuades him to put two bars of grated chocolate in his horrid-looking brew. After which they disperse gleefully to sup elsewhere.

An adjoining company mounts an attack, supported by heavy artillery fire. But someone blunders and their own shells land among the advancing French. One prostrate soldier tears off his red flannel cummerbund and waves it: a signal to up the range. But the gunners don't see it and continue to shell their own men. The soldier again waves his makeshift pennant, but with no success, then in desperation gets to his feet, only to fall under German machine-gun fire.

It becomes necessary to crawl out to identify the dead and bring back wounded. Demachy volunteers. Now for the first time he knows what war is about, as he touches the cold cheeks of dead comrades, gently eases off their identity tags and removes their papers. On his return Fouillard sneers, 'Did it to get promotion.'

Six days in the trenches, shivering, standing guard, bleary-eyed with lack of sleep, an occasional patrol – these are followed by three

days' rest. Safe in a farm, they delouse one another, Sulphart betting on the numbers found, while someone says lice are healthy, suck out infection. They can now put on civilian clothes, and agree not to talk of the war or to use soldiers' slang at meals – penalty two sous. They recall good times, vaunt their girlfriends or wives. Someone says, 'We needed the war to teach us we were happy,' while another adds, 'Before, we were ungrateful.' On a violin improvised from a cigar box one of the men plays last year's Paris hits, while the rest sing. One evening a wounded man is carried in and given wine, while the farm dog licks the blood that has dripped to the floor. But with the confidence of youth each thinks that though others may die, he will come through.

While holding a much disputed ridge, Mont Calvaire, one evening they hear an ominous tapping directly underneath. The captain is called, listens, and identifies the sound of picks. The Germans are tunnelling, evidently in order to lay, and explode, a mine. The tapping continues, more and more pronounced. In two and a half days the platoon will be relieved; but will the mine explode first? With nerves near breaking-point they try unsuccessfully to forget the tapping with card games and banter. At last they're drawn back, passing on the way fourteen men going up to the danger spot. As they reach the nearby village, they hear in the distance the mine exploding.

After having marched all day a soldier refuses to go on night patrol. Court-martialled, he faces a firing squad, blindfolded, wrists tied behind his back to a stake, while the regiment are made to watch. As eight rifles point at his heart, he shrieks, 'Ask pardon for me, ask the colonel's pardon.' He slumps forward, receives the coup de grâce. Then, heavy-hearted, the regiment are made to march past his slumped body, while the band's pipes and drums play *'Mourir pour la Patrie'*. The dead man leaves two children, 'just the height of the stake at which he died'. For some it is the worst moment of their war so far.

An anomalous Sunday: crowded into a side chapel of the village church, most of which has become a dressing-station, Company 3 hears Mass, taking pleasure in eyeing the pretty local girls, asking Our Lady to pray for them 'now and at the hour of our death'.

A big offensive is launched. The platoon captures a village in

ruins, has to shelter from heavy German fire by piling up dead bodies. Bréval is badly hit. He begs Demachy to go to his home and tell his wife she's a bitch for carrying on with another man; then, with almost his last breath: 'No, just tell her to behave, for the sake of our small daughter.'

Sulphart is wounded in the chest and hand, drags himself from overcrowded dressing stations to a field ambulance. Told by the doctor that he must lose two fingers: '*Tant pis!* I'm not a pianist.' He is hospitalized. As he recovers, he describes his experiences, but compared to exaggerated newspaper stories – a zouave bayoneting fifty Boches in one day – Sulphart's stories sound flat. So he begins inventing incidents: climbing a tree, for instance, to get a sprig of mistletoe and meeting a Boche with the same idea; whereupon they help each other and part friends. With these stories of war as they would like to picture it he has nurses crowding round his bed. Then one day Sulphart receives a letter informing him that his wife has gone off with a Belgian, taking all his furniture. He stops his stories.

His comrades of Platoon 5, meanwhile, continue to fight and to suffer losses – Demachy is killed, Vairon too – as Marshal Foch prepares his all-out and eventually victorious offensive of late summer 1918, backed by tanks and aeroplanes.

The Wooden Crosses is a book that imposed itself then, and still does, by its ring of truth and by the author's generous touch. Dorgelès shows no rancour that four years have been docked from his prime, no hatred of the Germans, who were only doing their job, no anger at governments, capitalists, arms dealers or profiteers for allowing war to happen, no condemnation of those whose spirit broke. For Dorgelès the essential lies in his envoi, when he pictures the wooden crosses he planted on comrades' graves, since flattened or shattered by shelling:

'My poor friends, it's now that you're going to suffer, with no cross to protect you, with no loving heart to welcome you. I think I see you roaming an endless night, arms outstretched, groping for the living who, in their ingratitude, have already forgotten you . . . You were so young, so confident, so strong . . . no, you shouldn't have died. Your joy in living overcame the worst ordeals. Standing guard in the mud, straining under the

heaviest loads, even when fatally wounded, I heard you laugh, never cry. The laughter that made you so strong, can it have been your soul?'

For long the destiny of France had lain in the trenches of north-eastern France; with Armistice Night Paris resumed its role as centre of national life. Though Dorgelès was not there to join in, almost the whole depleted population took to the streets, laughing, embracing, shouting, dancing. Forgetting the shelling of the city by the great German gun Big Bertha, and Spanish influenza daily claiming 300 lives, crowds in the Place de la Madeleine sang their soldiers' favourite *Madelon*, in praise of a pretty, obliging canteen-girl, and *Tipperary*, while American soldiers on leave asserted their presence by shinning up lamp posts and waving to their girls. Peace at last! The relief and joy!

The crowds converged on the Place de l'Opéra. Here a favourite singer of the day, blue, white and red sash draped over her gown, led a hundred thousand voices in the *Marseillaise*, Paris's salvo to victory.

Then they called for Georges Clemenceau, staying in a suite overlooking the square. As the young mayor of Montmartre he had seen the Prussians shell a defeated city in 1871; now, in old age, Prime Minister since 1917, he had, by his tenacity, contributed much to victory. Soon he appeared on the balcony, a small figure with glittering brown eyes and white walrus moustache. He was greeted with cheers, then persuaded to come down; lifted on stout shoulders, he was carried among the crowd, his short legs dangling, tears trickling down his wrinkled cheeks.

For Clemenceau it was a moment of respite, but only a moment. Next morning he resumed work on the complicated preparations for a Peace Conference due to meet in Versailles. He knew very well what the jubilant throng had been thinking: that victory must be followed by a lasting peace. The soldiers had played their part; now it was for the statesmen to do theirs.

Paris in that winter of victory became, in the words of an eyewitness, 'a vast cosmopolitan caravanserai, teeming with un-wonted aspects of life and turmoil, filled with curious samples of the races, tribes and tongues of four continents who came to watch and

wait for the mysterious tomorrow.' Although the United States had joined late in the fighting, it emerged from the war economically the world's strongest nation, and Woodrow Wilson sat on equal terms with Clemenceau and Lloyd George. He had suggested Lausanne for the conference, believing it would cool heads, but Clemenceau had insisted on the château of Versailles: 'In the Hall of Mirrors the German Empire had been proclaimed in 1871. The cradle of the Empire should be its grave.'

'The Tiger', as Frenchmen proudly called him, attended the Conference wearing a black suit and grey suede gloves to conceal an eczema on his hands, giving him a formal air at variance with his downright manner. He had lived for a time in the United States and been briefly married to an American, so he could speak to his two allies in their own language. His principal aims at Versailles were to annexe the Saar and the Left Bank of the Rhine as the only way to safeguard France's eastern frontier. He regarded the Germans as a beaten enemy who should be rendered militarily impotent.

Lloyd George spoke more often and more floridly than Clemenceau, with rotund and jovial gestures of his hands. He held that the German nation was not responsible for the war and now that the Junkers had been ejected by a socialist revolution, Germany should no longer be regarded with suspicion.

The American President, wearing a pince-nez and black button boots, toyed with a pencil with which he always seemed to be about to take notes but rarely used. As befitted a former Princeton professor, he spoke in generalities, expressing a wish that the conference should mark the beginning of a new order for Europe, where differences would be solved by a League of Nations, which Germany must one day join. His attitude to Germany was therefore closer to that of the British than that of the French.

In trying to decide how to treat Germany, the three leaders had to be careful how to check the spread of Bolshevism. From Russia it had radiated out to Poland and the Baltic states, to Budapest with Béla Kun, to Munich with Kurt Eisner, to Berlin with Rosa Luxemburg and the Spartakists. On 8 March 1919 a senior representative at the Peace Conference, Lord Riddell, noted in his diary:

A cable arrived, setting forth the parlous condition of the Germans in the occupied territory. This was taken in to Lloyd George, who read it to the Supreme War Council, upon whom apparently it made a great impression. The Council decided to victual the Germans, provided they hand over their ships and pay for the food in bills of exchange on other countries, goods or gold. The French strongly opposed this. Lloyd George said to them afterwards that the French are acting very foolishly, and will, if they are not careful, drive the Germans into Bolshevism. He told me that he had made a violent attack on Klotz, the French Minister of Finance, in which he said that if a Bolshevist state is formed in Germany, three statues will be erected – one to Lenin, one to Trotsky and the third to Klotz... The Americans are pleased with Lloyd George's speech.

Even those in the French Government opposed to Bolshevism knew that many of their countrymen sympathized with the movement, seeing Petrograd 1917 as a continuation of Paris 1789, and that there were limits to what the Government could do to check it. They had sent a naval force to help the White Russian forces but in April a naval mechanic, André Marty, who sympathized with Bolshevism, fomented mutiny first in one ship, then in a second, and all three had to be recalled.

The threat of Bolshevism was one pressure among many. From all sides came clamours for speed: the starving millions of Central Europe, the prisoners behind their barbed wire, the exhausted soldiers still far from home. 'Get the Boys back' screamed the newspapers.

Week after week in a tense atmosphere the rulers discussed, argued and bartered. The German delegation was stoned by the people of Versailles; Clemenceau narrowly escaped death when three bullets from a young anarchist's revolver struck his shoulder-blade. Finally, under pressure from Lloyd George and Wilson, Clemenceau withdrew his demand that France annexe the Saar and the Left Bank. Terms were then agreed.

Germany was to lose all her colonies overseas. The Rhineland was to be demilitarized and occupied for fifteen years. Germany's army would be limited to 100,000 men and she would not be allowed an air

force. She would suffer one major territorial loss, returning to newly independent Poland the lands (including the Danzig corridor) seized at the end of the eighteenth century. She was to pay France in reparations up to a quarter of her manufacturing output.

Punitive ultra-nationalists such as Léon Daudet called the terms a sell-out: 'With a friend like Wilson France needs no enemies; the best answer to his pro-German machinations is the answer Villain gave Jaurès – two bullets in the chest.' The erstwhile Sorbonne professor of music and crusader for peace, Romain Rolland, called the terms unduly rigorous – as did Keynes and the Bloomsbury set in England. In fact, however, when compared with the terms Germany had imposed on Russia the year before, taking her Ukrainian wheat fields, her oil deposits in the south and almost all her coal and iron industry, the Treaty of Versailles was not unduly rigorous, and the effect of reparations has often been exaggerated. The Kaiser had financed the war out of huge foreign loans; it was repayment of these that was to cause the penury and wild inflation of 1923 in Germany, after which new loans from the United States were to fuel a period of prosperity.

Of much greater lasting importance than the treaty's statistics was Clemenceau's insistence that the document should brand Germany with the mark of Cain. Though there is now little doubt that the French President, Raymond Poincaré, on a visit to St. Petersburg in late July 1914, played a key role in Russia's decision to mobilize in support of Serbia, thus precipitating mobilization by Germany, Clemenceau insisted that Germany alone was to blame for the war.

To this the German Foreign Minister made the following protest: 'Such an admission from me would be a lie. During the past fifty years the imperialism of all European States has chronically poisoned the international atmosphere . . . and contributed to the disease of Europe which reached its crisis in the World War.'

The Foreign Minister refusing to sign, on 28 June 1919, in the Hall of Mirrors, two minor German officials appended their signatures to the Treaty of Versailles. And to make their point unmistakably plain, the French Government presently ordered a commemorative stele to be erected in the Forest of Compiègne, where the Armistice had been signed. A vast granite pavement is inscribed:

9

Here on the eleventh of November 1918 succumbed the criminal pride of the German empire – vanquished by the free people it tried to enslave.

The half-truth in those lines was to cast a shadow on the years ahead.

Besides signing peace, France and her allies had the more difficult task of redrawing the map of Europe. For this Clemenceau called on a trusted top Foreign Office official, Philippe Berthelot. Now and also throughout the post-war years until his retirement in 1933 Berthelot was to be extremely important in shaping France's foreign policy.

Berthelot had been born with exceptional gifts. Physically strong and athletic, handsome, with a long face, blue eyes and curly hair, he possessed charm and a keen intelligence that delighted in complexity. He also possessed a highly developed æsthetic sense. His first and lasting love was poetry. He had wanted to be a poet but encyclopædic knowledge and a prodigious memory were not the best qualifications (though he did produce an ingenious sonnet with rhymes for '*triomphe*', which Herédia had claimed was impossible). In his twenties he wrote lead articles for *La Grande Encyclopédie* and ironically amusing sketches for *La Vie Parisienne*, signed 'Lubin', the shady heretical priest created by Clément Marot, for Berthelot was an atheist who considered religion an insult to the intelligence.

At twenty-nine he joined the Foreign Office. As a son of France's most famous scientist, Marcelin, and brother of a leading banker, Berthelot had valuable connections. With these, his natural gifts and driving energy – he slept on average four hours a night and always arrived first at the Ministry – he rose rapidly. With his wife Hélène, formerly an artist's model, he entertained often, writers and artists for choice, in his large Left Bank apartment. His home, graced with precious porcelain and lacquer collected during a mission to China, with angora and Persian cats and an aquarium of exotic fish, reflected his refined tastes. By October 1919 the British ambassador could inform Curzon that 'the only two men who count in Foreign Affairs are Clemenceau and Berthelot'.

Seigneur Chat – Lord Cat, as Colette called him – operated from a double total assurance: that only one country in the world really

mattered – France – and that he, Berthelot, knew exactly how to forward her intimately interconnected interests, political, cultural and commercial. This he would achieve through personal discussion with his peers abroad – for Berthelot, an unashamed elitist, described democracy in the literal sense as 'the right for lice to eat lions'. 'Philippe is convinced that the world should be run by intelligent men,' observed a close friend, a view based on the premise 'that what is true for the intelligence is true for the facts, since he assumes that facts are dependent on the law of intelligence'.

As early as December 1916 Berthelot had drafted for President Wilson a statement of Allied war aims, in which he proposed the establishment of new states on the principle of national self-determination. This held that in a given geographical area a new nation could be created, united enough in its political convictions to overcome ethnic, religious, linguistic and historic fissures. An example was Switzerland.

This principle won approval. It had to be applied first to the dismantling and restructuring of the moribund Austro-Hungarian Empire. Some well-informed Frenchmen, like Berthelot's friend and protégé Paul Claudel, wished to create, as a counterweight to Germany, an enlarged Catholic Austria allied to Catholic Italy and to France, but Berthelot as an anti-Vatican republican opposed this scheme. He had close friends among Czech exiles and thought highly of their leader Masaryk, who was working for Czech independence, as did the British and Americans. Berthelot therefore proposed the creation of a new state, large enough to be viable, comprising Czechs, Slovaks, Germans, Hungarians and even some Poles, to be called Czechoslovakia.

Berthelot also wished to recognize as a second new state a grouping of diverse peoples formed in Zagreb in November 1918 under Serb leadership, to be known as the kingdom of the South Slavs or Yugoslavia. He tried to ensure that the small kingdom of Montenegro would retain its centuries-old independence, but Serbian troops forced Montenegro to become part of the new grouping, and this Berthelot had no choice but to accept.

Bordering incipient Yugoslavia lay Romania. A rich group of Romanians resident in Paris included Proust's friends, the Bibescos, and the Soutzos, one of whom was to marry Berthelot's protégé,

Paul Morand. Strongly pro-French, lovers of the arts and generous patrons, they were much appreciated by Berthelot and his set. Berthelot intended to favour Romania, with her ruling class speaking French as a first language and with rich reserves of oil, by adding to her territory Bessarabia, taken from Russia – in the throes of civil war and powerless to protest – and Transylvania from Hungary.

Clemenceau was seventy-eight and suspicious of change: Berthelot's plans at first seemed much too innovative. 'Clemenceau finds Berthelot's hotchpotch absurd,' noted a senior diplomat. But Berthelot was a master at winning over opponents. He happened to know that Clemenceau, under his fierce exterior, had a soft spot for poetry, especially the poetry of Victor Hugo. When the Tiger evinced doubts about the viability of these new states, Berthelot would recite to him from memory long stirring passages from *La Légende des siècles*, Victor Hugo's epic about Humanity's painful but sure progress from the devilish to the angelic. Clemenceau was tough but not small-minded. 'France,' he once said, 'formerly a soldier of God and now of Humanity, will always be a soldier of the Ideal.' Slowly he warmed to Berthelot's elaboration of Hugo's vision, withdrew his objections and appointed Berthelot to be France's delegate to the Commission on the Status of New Nations.

On that Commission disputes arose between Berthelot and the British, notably over whether Upper Silesia should be taken from Germany to give to Poland. 'It is very difficult to discuss with Monsieur Berthelot,' complained Lloyd George, 'he loves France as we love England' – indeed, to compensate for Britain's protectorate over Iraq, at the 1920 conference of San Remo Berthelot was to demand, and obtain, French protectorates over Syria and over Lebanon – yet another artificial new state.

The new frontiers of Europe were agreed by the Great Powers, largely along the lines proposed by Berthelot. But now a challenge presented itself. Poland, Czechoslovakia and other states with new frontiers, economically weak and militarily vulnerable, would have to be helped and protected. Who would do this? Britain already had enough world-wide commitments. Wilson had proposed that a League of Nations should shoulder the task and even when Congress refused to let America join the League that plan remained an option.

Berthelot, however, distrusted the whole idea of the League and open-forum discussion where – as he saw it – stupid countries would thwart the intelligent. He proposed instead that the safety of the new states should be guaranteed by France.

In view of the fact that France had emerged from the war much weakened, with many of her départements shattered, this was a grandiose plan. But Berthelot, promoted to be head of the Foreign Office in 1920, argued his case with vigour and subtlety. He invoked France's civilizing mission, her duty to promote republican values in the new nation-states, protecting and guiding, while extending her commercial and financial interests. He intended to sign military treaties with Poland, with Czechoslovakia, with Yugoslavia and with Romania. France's influence would radiate through the Balkans, new allies to replace her fallen ally, Russia.

Theoretically Berthelot's plan was not unworkable. It would call from France's leaders, and indeed from the French people, the energy and dedication Berthelot himself possessed. It would call for altruism and sensitive understanding of young nations' gaucherie.

This then was Europe reborn, fruit of the peace that followed from victory. Devised in Paris with the aim of preserving France from any future war, the agreements embodying it and amplifying it won general approval in that city, though few gave thought to the grave new responsibilities being assumed.

For this was a time of homecoming. Among those returning was Roland Dorgelès, twice cited for exceptional valour, promoted corporal, wounded, then transferred to the air force, where he trained as a pilot. Now that he had laid aside his uniform he intended to resume life as a professional journalist and to write more plays. He would track down the promising new painters, visit his mother on Sundays and look for a wife more faithful than Madeleine who, like Madame Sulphart in his book, had left him for a Belgian. He would spend less time than before in *cafés chantants*, for he had drawn up plans to hold regular meetings of men of the 39th, and to devote part of the royalties from *The Wooden Crosses*, which won the Prix Femina in 1919, to a fund for unfortunates of the 39th who were *grands mutilés*.

Thousands of others were returning too, hanging up their steel helmets – the one item of kit they were allowed to keep – and

13

rejoining the non-combatants, who, having been less involved in the horrors, could be expected to react somewhat differently to peace. Both groups would resume their chosen pursuits: shopkeeping, running cafés and bistros, making and selling quality goods, designing furniture and dresses, staging plays, as well as putting into stories and poetry, into paint and statuary and music, some of the emotions elicited by war and by the longed-for return of peace.

2

A NEW HEDONISM

In June 1919, the month the Treaty of Versailles was signed, Léonce Rosenberg held an exhibition of contemporary painting in his Paris gallery as a tribute to the poet of genius, Guillaume Apollinaire, who two days before the armistice had succumbed to war wounds and Spanish influenza. As he lay dying the poet had heard crowds in the streets shouting, '*A bas Guillaume*', meaning the Kaiser, and thought the words were intended for him.

Among Apollinaire's friends in the gallery that day was a pale young man with a big angular nose and tremulous black frizzy hair; his long quick conjuror's hands emphasized the inflections of a mimic's droll, constantly changing voice. This was Jean Cocteau. At the age of eight he had lost his father, a rich lawyer who in alarm at a sharp fall in the Bourse had put a bullet through his head. Jean, the youngest child, then formed an extremely close relationship with his mother, an intelligent woman who encouraged his artistic tastes; he was now living with her in the rue d'Anjou and was to be supported by her until the age of fifty.

Cocteau possessed a strong vein of narcissism. He loved dressing up and sitting for his portrait. He had sat to Picasso, to Modigliani and to Jacques-Emile Blanche: of the latter's production he wrote to his mother: 'I adore my portrait in profile.' But he had good reason to be vain: he possessed a marked talent for quick line portraiture and for writing poetry, as well as a sense of theatre. Before the war he had helped Serge Diaghilev produce some of the best Ballets russes.

In 1914 Cocteau had joined his friend Comte Etienne de Beaumont's motor ambulance team and helped to evacuate wounded

soldiers in and around Amiens. After further ambulance service abroad he used his influence in high places to be freed from military service in order to stage *Parade*, a ballet in which painting, dance and music are integrated to an exceptional degree, for which he persuaded Picasso to do the scenery and costumes.

Cocteau was someone who needed to love. He was attractive to women – at sixteen and again at twenty-one he had serious love-affairs with actresses, and both times it was he who broke it off, for his temperament was such that he preferred young men to women. In 1917, the year of *Parade*, he met a young poet, Jean Le Roy, and fell desperately in love with him. Shortly afterwards Le Roy left for the Front and was killed.

There were several attitudes young men who had survived the war could take to the suffering and deaths it had caused. They could say that the slaughter of 1.3 million Frenchmen showed that there could not be a good God. They could say that France had won because she was a Catholic country, helped by God. They could say that jingoist politicians had plunged France into an unnecessary conflict, and therefore politics were tainted. They could say that only the stamina of Clemenceau and the courage of such as Foch and Pétain had saved France from defeat. Cocteau for his part, having encountered spiritualism and table-tapping in the home of poet Anna de Noailles, held the unusual belief that the dead and the living are not two separate realms, but part of the same realm, and that those like Le Roy who had given their lives on the battlefield were not really dead but lived on as angels. That is why he declared of Le Roy, 'From the moment I heard of his death dates our never-ending friendship.'

On that June day in Rosenberg's gallery Cocteau was a centre of attention from avant-garde designers such as Jean Hugo and his talented wife Valentine, and from musicians such as Darius Milhaud and Georges Auric. But Cocteau was more interested in a good-looking stranger with a slight limp. Though only sixteen, Raymond Radiguet held rebellious and unconventional views and he confided to Cocteau that he intended to write novels.

Cocteau began a correspondence with Radiguet and by November the two were close friends. They became interested in Dada, a Central European movement introduced that year to Paris which vaunted irrationality. With Radiguet to help, Cocteau began publishing

16

a fun broadsheet, *Le Coq*, printed on pink paper, the text fragmented, the typography variegated – a device used by Apollinaire in publishing his poems. *Le Coq* crowed for only four issues, but it helped to popularize some of the aspects of Dada, though not its nihilism, which made no appeal to life-loving Cocteau.

Le Coq led to a more important collaboration, the libretto for a ballet to be scored by Erik Satie, entitled *Paul et Virginie*.

Adapting a familiar story of innocent lovers in a sub-tropical paradise island, Cocteau centres attention on events after a tragic shipwreck. Believing Virginie is dead, Paul sits mourning her. Then Virginie appears, tells him not to be afraid, and to kiss her. Paul, astonished, wants to run and tell family and friends that Virginie is still alive, but she says they cannot yet see her. She is visible only to the dead. 'But I can see you,' says Paul, to which Virginie replies, 'That's because you are dead.' She then explains in a song:

> Life is the obverse, death the reverse,
> Both in the same universe.
> No one alive in the world knows
> This pretty game of hide and seek . . .
> Those who do know how to play
> Watch the living, who as yet don't know
> To die young is a great advantage
> For then one never leaves one's youth.

> *La vie est à l'endroit, la mort est à l'envers*
> *Toujours sur le même univers*
> *Il n'est pas un vivant au monde qui le sache*
> *Ce joli jeu de cache-cache . . .*
> *Ceux qui savent jouer regardent les vivants*
> *Qui ne le savent pas avant*
> *Mourir jeune est un grand avantage*
> *Car on ne quitte plus son âge . . .*

Cocteau was expressing a desire always to stay young, free of adult responsibilities, and the continuance of his passionate friendship for Jean Le Roy. But as he became more involved with Radiguet and clearly perceived the young man's literary talent, Cocteau found himself beginning to fall in love with his new friend. This would not

do. So with characteristic sleight of hand he decided that Jean Le Roy lived on in the person of Raymond.

In March 1921 Cocteau went to the country to join him. No less vain than his older friend, Radiguet suffered from not having been old enough to achieve the glory accorded to soldiers returning from the war, and was taking his revenge by writing a cynical little novel about the wife of a soldier fighting in the trenches who has a torrid affair with an adolescent. Under false pretences Raymond obtained the intimate diary of his current girlfriend and, unknown to her, used passages from it to add authenticity to his portrait of the soldier's wife.

Madame Cocteau had taken the measure of Radiguet and urged her son to see no more of him. Cocteau replied snappishly: 'Haven't you yet understood that my life is spent letting my instincts run wild, assessing them, sifting them once they've appeared and bringing them to heel when it best suits me?' He then designed two rings and, using money his mother continued to supply, got Cartier to make them in platinum and gold, one for Raymond, one for himself. He also used his influence to get Raymond exempted from military service.

But Radiguet was not to be tied by gratitude. He had finished his novel, *Le Diable au corps*, and been assured it would have a *succès de scandale*. He no longer needed possessive Cocteau. Besides, he had become attracted to a Polish girl of seventeen, Bronia Perlmutter, a popular Montparnasse artist's model. In autumn 1923 he left Cocteau and joined Bronia. Shortly afterwards he contracted typhoid. His body weakened by fast living, he died on 12 December in hospital, at the age of twenty.

Cocteau took to his bed with grief and was too unwell to attend the funeral. The dead we love were not after all living and present; no game of hide-and-seek would reveal them. Declaring that he would never be able to write again, he shut himself in his room in his mother's apartment, where he was visited by a family friend, the abbé Mugnier, who in describing the room evokes Cocteau's wide range of interests:

A big table on which the papers look windswept. Objects of every shape and provenance: a Tanagra statuette next to an aerial

photo of Vienna taken by Gabriele d'Annunzio in 1918; an Egyptian head next to a portrait of Rimbaud; a Greek shepherd's crook with a goat-horn handle found at Herculaneum, a photograph of Delphi, where *Antigone* was first performed, taken by Gide and sent by him to Cocteau ... A photograph of Verlaine in a top hat, a scarf round his neck – a present from Robert de Montesquiou. A photograph of the famous pilot Garros ... A Saint-Sulpice painted statue of a shepherd much admired by Jean Hugo. Photographs also of Picasso and Radiguet.

On the advice of a friend Cocteau began smoking opium and found temporary relief. He collaborated with Diaghilev on a light-hearted ballet, set on the Côte d'Azur and entitled *Le Train Bleu*, for although no train appears, luxury expresses were all the rage. The music was by Darius Milhaud. It opened on 20 June 1924 and was well received. Despite this, Cocteau remained on the edge of despair, intensified by increasing dependence on opium.

Among his friends was the gentle twenty-four-year-old composer Georges Auric, round-faced, protruding ears, mesh of hair dangling over his brow. Auric happened to be a practising Catholic and, believing that Cocteau could find peace only by returning to the Church, took his friend to see Jacques Maritain, a Catholic philosopher who also loved the arts. Maritain and his German-born wife Raïssa, both converts, one from Protestantism, the other from Judaism, had made their spotless little house in Meudon a centre of liberal Catholic intellectuals.

Cocteau warmed to the philosopher, and it was probably the older man, realizing the importance of the visual for Cocteau, who suggested he read the *Life of Jesus* by a German visionary nun, Catherine Emmerich. That autumn, in the south of France, with Auric keeping an eye on him, Cocteau read Emmerich's book and was impressed. He revisited Maritain, who urged him to go to confession and receive Holy Communion.

Cocteau had learned his catechism and made his First Communion – that to date was the extent of his religious life. But Catholicism was never far away. The person he was most attached to – his mother – was a practising Catholic as was his friend, the poet Max Jacob.

Well known to artistic Paris was Max's unusual experience just before the War. On his return from a day's work in the Bibliothèque Nationale, against one of the walls of his small flat the figure of Christ had appeared to the poet – unmistakably, he claimed. The vision, short-lived but intense, changed Jacob's life, causing him joy and humility, followed by repentance and a desire for some more satisfying life than bohemianism. Now he lived simply in an annexe of the monastery of Saint Benoît-sur-Loire, a lay father confessor to those among his many avant-garde friends whose spiritual lives happened to be in turmoil.

As an imaginative artist Cocteau was already inclined to see worlds within or behind the actual world, sometimes peopled by friends such as Le Roy and Radiguet. To this now was added his reading of Catherine Emmerich's visions and probably also his recollection of Max's vision. One day during the winter of 1924–5 he paid a visit to his friend Picasso, now well-off and living in a spacious apartment block with an Otis-Pifre lift. While going up in the lift Cocteau imagined he was growing larger alongside something terrible that was going to last forever, and a voice called to him: 'My name is on the plate.' As the lift jolted to a halt he looked at the plate and read Otis-Pifre as Heurtebise, meaning Confronter of the Wind.

After forgetting the episode, that night Cocteau woke, horribly disturbed. He became certain that an angel was dwelling within him, and to make him aware of its presence uttered its name, Heurtebise. But this was no gentle Saint-Sulpice angel. At first welcomed for his smooth hermaphroditic beauty, Heurtebise turns out to be diamond-hard, swooping like an aeroplane in order to quell evil desire. With friends' help, the poet fights him off. 'You mustn't die . . . Too late. Take aim, fire! He falls, shot down by the soldiers of God.' But the angel is now more than ever present. 'Heurtebise, my swan, show me your precarious hiding-place, Never leave my soul.'

Cocteau believed the angel had been sent to encourage him in his spiritual journey and with reason considered the poem describing its visitation, *L'Ange Heurtebise*, the best he ever wrote. He also made many drawings of the angel.

Maritain decided to start a literary-philosophical review, to be called *Roseau d'Or* and invited Cocteau to join the editorial committee.

Cocteau agreed and on 15 June went to Meudon for an editorial meeting. Also on the committee was Henri Ghéon. As a young doctor Ghéon had led a debauched life in company with André Gide. The death of an admired young naval officer during the war had led to his conversion and to a new career as the author of plays with a religious theme, though not of the highest calibre and sneered at by Gide. Ghéon and Cocteau were too dissimilar as artists to become close, but Cocteau could not help but notice that Ghéon had successfully abandoned pederasty and found fulfilment both as man and writer.

The day after that meeting a friend of the Maritains arrived. Père Charles Henrion belonged to the Little Brothers of the Poor, founded by the saintly ex-army officer, Charles de Foucauld, who worked as a missionary among the desert-dwelling Muslims of Algeria. He wore a white burnous on which were sewn a red heart surmounted by a cross, emblem of the Little Brothers.

Cocteau warmed to Père Charles and to his striking dress. Since he sometimes signed his letters with a heart, Cocteau took the emblem on the burnous as an intended sign. He decided to continue signing with a heart, but in future it would signify the heart of Jesus.

On the 17th Maritain visited Cocteau, this time accompanied by Pierre Reverdy, who with Apollinaire and Max Jacob had founded the avant-garde literary review *Nord-Sud*. Reverdy wrote highly-praised poems about frail human beings in a hostile world; he was a Catholic, who alternated between the excitement of bohemian Paris and the serenity of Solesmes. Reverdy urged Cocteau to return to the sacraments: 'How can you understand anything without them? Pick up the earphones! Pick up the earphones!'

Cocteau did so. Next day he went to confession, and on the 19th heard Mass and received Communion, accompanied by the Maritains and Ghéon. Everything fell into place, for 19 June was the Feast of the Sacred Heart.

That summer Cocteau summed up his life during and since the War in a modern staging of the myth of Orpheus and his attempt to rescue Eurydice from the realm of the dead. Death comes on stage, played by a woman wearing surgical rubber gloves, for Cocteau saw woman as dangerous, even fatal, unless in a sisterly role. In the finale the poet-hero, who has been taking inspiration from the devil, is

converted, addressing God in a prayer that delighted Maritain: 'We thank You for having saved me, because I adore poetry and poetry is You.'

Behind these signs, encouraging to his friends, Cocteau the creator was shaping his own version of Catholicism. God, Cocteau decided, subsumes evil as well as good, and is not to be thought of as a judge. 'God,' he wrote to Maritain, 'is the prototype of audacity. He has suffered the worst insults. He does not ask for religious art or for Catholic art' but for any art that expresses the human condition, and this, for Cocteau, meant a barely separable amalgam of sacred and profane. The task of a Christian artist, Cocteau concluded, was to 'help God to hide in order to do good as the devil hides to do evil.'

Cocteau still suffered from Radiguet's untimely death. At times he identified the lost youth with the angel who had visited him. Wintering in Villefranche, he acquired a small boat and named it *Heurtebise*, hoping as he sailed the morning sea 'that copies out a hundred times the verb "To Love"', for some spiritual encounter with his friend. But nothing could ease the pain, and he turned from opium to drugs.

One day in 1926 a young man of Protestant bourgeois parentage living in the Vosges and about to do his military service in the navy happened to come upon a book of Cocteau's poems and liked it so much he dashed off a fan letter, ending 'My life is yours!'

Cocteau realized of course that the young man, who signed himself Jean Desbordes, had literary ambitions, and was interested enough to reply encouragingly. When in due course Desbordes arrived in Paris, good-looking and wearing a smart new sailor's uniform, Cocteau said to himself, 'He's been sent to me by Radiguet' and immediately used his influence to get Desbordes stationed in Paris, where his duties included standing sentry outside the Navy Ministry. They began to meet and Desbordes showed Cocteau some of his literary work.

To this new flesh and blood angel, sent by that other angel now in heaven – how was Cocteau to respond? The obligations imposed on him by the Sacred Heart, these he understood, but what of those other obligations of the heart, which could be honoured, as Cocteau saw it, only in physical love?

Cocteau's exceptionally keen awareness of the reality of the

spiritual world, including the dead, might well have enabled him to sublimate the physical attraction he now felt for Jean Desbordes, had it not been for another pronounced trait in his character: an insatiable hunger for praise and for love. It had appeared early, on a boyhood visit with his mother to Venice when, unable to sleep, he listened from his window to an orchestra and singer in St Mark's Square, 'and I began to cry because I wasn't the favoured soloist, the composer of the music and all the couples in all the gondolas.'

Cocteau made his choice at Christmas 1926. Instead of going, as in the previous year, to Midnight Mass with the Maritains, Cocteau invited Desbordes to stay with him in the Hôtel de la Madeleine, choosing the very same room he had formerly shared with Radiguet.

Quickly infatuated, Cocteau helped 'Jeanjean' to prepare an effusive book of poetic prose in which the young sailor portrays himself in a new garden of Eden, tasting the delights of solitary love yet remains 'innocent as the animals'. The title of the book, *J'adore*, was repeated in the section headings: 'I adore the handsomest boys', 'I adore love in a lonely garden', 'I adore the Bible', 'I adore Jean Cocteau'. Having written a laudatory preface, Cocteau arranged for its publication and then went round the literary editors urging them to have this 'masterpiece' reviewed on their front pages.

The editors saw at a glance that the book was excruciatingly pretentious piffle, that drugs had blurred Cocteau's usually sharp literary judgment. They murmured excuses, whereupon their visitor hurried off to have an enlarged photograph of Jeanjean displayed in Flammarion's bookshop and to launch the book by signing copies jointly with the author.

Cocteau discussed *J'adore* with the abbé Mugnier who, while expressing disapproval, spoke some characteristically tolerant words. Cocteau then wrote an article claiming that Mugnier had likened the teaching of St Francis to Desbordes' praise of homosexuality. By now close to a breakdown, he sought refuge in the apartment of a sisterly friend, Coco Chanel. Here the good abbé visited him to complain of the article, at which Cocteau 'poured out a torrent of opinions on Maritain, art, theology, etc. which I couldn't grasp. His brain is certainly disturbed.'

What worried his Catholic friends was less Cocteau's lapse than his refusal to admit he was wrong. With Jeanjean he claimed to find

'something of the innocence of animals', and he declared Protestantism to be the true form of Christianity, since it allowed the individual to make his own sexual decisions. He declined altogether to be judged, indeed he who had grown up in a fatherless home could not accept the notion of God as judge.

If Cocteau's dilemma was particular to him, the attitude he adopted to it both illustrated and reinforced that adopted to similar dilemmas by many in avant-garde Paris. True north lay not where the Church or the wisdom of the past said, but in the intensity of one's own feelings.

Subjectivism of this order went hand in hand with disdain of civic duty. Questioned in 1925 about his politics, Cocteau replied: 'The concept of *patrie*? My fellow citizens are in heaven. I travel without identity papers, I do not vote and I never open a newspaper.' His almost total rejection of civic responsibilities he declined to see as a failing. If he refused 'to take part in the world's drift to depersonalization', he explained, it was because 'only by remaining singular, huddling as far as possible into oneself, that one can reach, in Goethe's words, a great number of fraternal souls, connect with those solitudes that form a desert island scattered across the globe.'

In summer 1926, as a form of escape, Cocteau proposed to Desbordes a motoring holiday. Cocteau had taken driving lessons but a persistent – and characteristic – tendency to mistake accelerator for brake and vice versa had obliged him to desist, so it was Desbordes who took the wheel. Beginning to be spoiled by his famous friend, the young man drove with reckless speed and had also taken to gambling.

Cocteau, for all his protests to the contrary, was not at peace and continued to abuse opium and drugs. There came a point where Coco Chanel, shrewd, watchful and masterful, saw the need for drastic action. She persuaded him to undergo treatment in a Saint-Cloud clinic, and since he had insufficient funds she would pay the bill.

Cocteau astonished his doctors by using his four months in the clinic to produce two fine books: *Opium*, a vivid account of his addiction, and a novel, *Les Enfants terribles*, about rich adolescents – brother and sister – living together in a hot-house near-incestuous atmosphere. When the brother tries to break out and join the girl whom he loves, his sister poisons him, then shoots herself. Since

Cocteau drew on a comparable real-life drama involving two of his friends, the novel is an authentic picture of a certain section of Parisian society in the 1920s, and at the same time, if we read 'mother' for 'sister', it objectifies, and so helped to ease, the deep-fixed pain of its author.

Cocteau emerged from the clinic cured of addiction to drugs but not of his passion for Jeanjean or for anyone else who might reincarnate Le Roy and Radiguet. The pattern of his inner life had now established itself, that of his artistic life was, however, to change, as he moved into the world of cinema where in another chapter we shall follow him.

Very different in appearance and character from Cocteau was his contemporary and friend, Paul Morand. Morand had narrow, almost Central Asian eyes, fleshy nose, full lips, short neck and the deep-chested muscular body of a sportsman at ease in the saddle or in the swimming pool. Born into a Parisian literary family, he had come top in the Foreign Office examination and been posted to London in 1913 as second secretary, where he became a favourite of the society hostess, Catherine d'Erlanger. When war came he could have volunteered but chose to remain in London, where he found 'a complete absence of resentment towards the enemy . . . an attitude less tense, less averse to pleasure than ours.'

With peace, back in Paris, Morand took the line that the war had been barbarism rife and marked a breakdown of civilization, so it was best to enjoy yourself while you could. The truth was that he had chosen the easy way and, except by the like-minded, it was held against him.

Morand began to write travel impressions and short stories. These caught the eye of Philippe Berthelot, who saw himself as a literary patron and had already helped Paul Claudel's career. Berthelot created a new branch of the Foreign Office to promote French civilization abroad, with jobs in the rue François I office for Morand and another literary diplomat, Jean Giraudoux, that would give them leisure to write.

Morand frequented the fashionable bar-restaurant near the Madeleine, *Le Bœuf sur le toit*, always after dark, for by temperament he was a night bird. Seated on a stool, sipping a cocktail and

listening to Francis Poulenc – 'Poupoul' – nose in the air and mouth open, play jazz on the piano, he would assess the physical qualities of women as they entered as though they were fillies in the paddock at Longchamp. Already at twenty-six he had a name as an urbane and accomplished connoisseur of the fair sex. But while Cocteau chased one illusion after another, Morand was without illusions. Words like 'love' and 'angel' did not belong in his vocabulary, and he took care to keep his affairs passionate and short.

Morand lived quickly. He could absorb and describe a new scene or acquaintance in five minutes. Then he needed to move on, to be taken out of himself and also to satisfy a tremendous curiosity. 'A pessimist who expects everything to succeed' is how Cocteau described him.

Thanks to his job in the cultural department, Morand was able to travel first-class at the taxpayer's expense. Spain, the Balearics, Portugal, Ireland, Finland, Germany, Italy, Sicily, Dalmatia, Greece and Morocco were some of his destinations. He seldom stayed long: 'To savour a town or a new country you need only 48 hours – or a lifetime.'

Morand particularly enjoyed luxury trains and during the War had contrived to take the diplomatic bag to Constantinople in the Orient Express. When these trains had a sleeping-car, speed and love-making could be combined.

Morand came to be fascinated by the different national temperaments of the women he made love to, and his first important book, *Ouvert la nuit*, published at twenty-seven, is a collection of short stories, each centred on an affair or friendship with a foreigner. Señora Remedios is a wealthy Spaniard fired by revolutionary ideals, intelligent, materialistic, but also a prey to superstition. A Russian lady living in exile alternates between spleen and frenzy; a Scottish girl, silly and affected, tries to play the *femme fatale*, then retreats. Morand excels at sharp observation of people torn by incompatible elements of character, and his stories are literary equivalents of the then fashionable dry martini: quickly absorbed, with quite a kick, but leaving no poetic aftertaste.

Morand was unusual in actually travelling widely abroad; fashionable Parisians mostly preferred exotica on their home ground and achieved this through fancy-dress. For example, to coincide with a

1925 Colonial Exhibition Comte Etienne de Beaumont gave a ball at which guests dressed in the styles of Morocco, Martinique, Tahiti and Indo-China.

One of the most brilliant fancy dress balls was given by Prince Faucigny-Lucinge and his English-born wife, daughter of Morand's London friend Catherine d'Erlanger, on the theme of Proust's novel. Host and hostess impersonated the Marquis and Marquise de Saint-Loup, their friends Charles and Marie-Laure de Noailles, Robert de Saint-Loup and Gilberte. Paul Morand, padded out and leering, became for the evening Baron de Charlus, while Valentine Hugo, stage designer for Cocteau and others, appeared as Sodom and Gomorrah: Valentine's face made up like that of a young man sporting a boater, while a mask on the back of her head showed a lady's smiling face. Gipsy music alternated with jazz, supper was served at three, and at six in the morning Georges Auric and Poupoul, disguised as young soldiers from Jupien's brothel, led guests in a dance round one of the Tour Eiffel pillars.

In contrast to their spontaneous English and American equivalents, Paris balls were carefully rehearsed beforehand. The party-giver wanted to be sure that every gesture and item of dress would be just right. Nothing must be left to chance. The participants' movements were as much set-pieces as the aspics and elaborately iced pâtisseries on the buffet table.

Morand's party-going came to an abrupt end when it became known that he and Giraudoux were furthering French civilization abroad by distributing, at taxpayers' expense, unsold copies of boring books with the imprint of Gallimard, their own publisher. Berthelot's cultural department was closed down and Morand dispatched as Minister to Siam. He chose the long route there, via the United States, Canada, Japan and China, thus gathering material for a travel book, *Rien que la terre*.

Seven weeks after taking up his post in Bangkok Morand contracted amœbic dysentery, and in a panic telegraphed Paris, urgently requesting permission to return at once at his own expense. Berthelot agreed, and Morand sailed for home with the nine superb antique heads of Buddha he had already found time to acquire.

This somewhat ignominious episode sapped Morand's self-confidence and precipitated a crisis. For ten years through amatory

conquests he had been trying to escape from a latent pessimism and to bolster a self he could not really esteem. Christianity he could not accept yet felt the need for some belief bigger than himself. To the abbé Mugnier he confided that he intended to write a novel exploring Western links with the East. 'This journey,' Mugnier noted in his diary, 'has totally changed him. He left as a satisfied materialist and came back with spiritual values. It was the tropics that marked him most. He felt that nothing was real save the soul and the gods, that life is a struggle of spirit against matter. He now believes in the immortality of the soul.'

Mugnier's prognosis was too rosy by far. Morand did write his novel, *Living Buddha*, but his conclusion was this: 'Buddhism consists in not desiring, not being active. But if the West ceases to be active it dies.'

So in the choice between spirit and matter Morand chose matter, which in his case meant the money he needed to satisfy by now expensive tastes. Among the rich fashionable ladies who pleased him was Hélène Soutzo, petite, with brown eyes and beautiful arms. She was intelligent, could speak nine languages including Latin, and was known to her friends as Minerva. Her marriage to a titled Romanian diplomat had broken down and she was now divorced, with one daughter, living in a palatial detached house near the Champ de Mars.

Hélène had gone to a fancy-dress ball as a Christmas tree and found Morand as a St Bernard; thereafter she called him '*mon gros toutou*', a warm foil for her rather chilly intelligence. When he proposed marriage, she recognized that he would continue to have affairs – she was nine years his senior – but felt sure her money would always bring him to heel.

At the marriage in January 1927 one of the witnesses was Berthelot, pleased at the Romanian link, and one of the guests Cocteau.

> He rushes up to Hélène: 'Ah! dear princess!' – the day she had ceased to be one. Then he goes from lady to lady, all in cloche hats, mistakes one for another, notably Madame Berthelot and Suzanne Giraudoux, and ends by saying to them: 'You can't blame me. You all wear the same dress and the same pearls.'

Now one had her clothes made by Chanel and wore real pearls, while the other's pearls were imitation and her dress came off the peg. A third gaffe: Paul embraces Jean: 'Nothing to drink?' 'Yes, a cup of tea,' says Jean, pouring himself chocolate.

Hélène's money allowed Morand to take indefinite leave from the Foreign Office and instead of children, regarded by Morand as a burden and tie, the marriage produced numerous fast sports cars: several Bugattis, a 20-horsepower Panhard, a 16-cylinder Marmont, an Aston Martin, a Porsche. Morand would exchange motoring lore with the novelist Blaise Cendrars, who owned an Alfa Romeo with coachwork designed by Braque; having lost his right arm in the war, Cendrars would drive it one-handed very fast indeed, though less fast than Morand, who would sometimes race against the painter André Derain, who owned a Bugatti, or pick up a friend emerging at dawn from a party and roar full speed to Chartres for a breakfast of coffee and milk and croissants. 'I have the fastest car in France: useless, dangerous and very expensive, but it's stronger than me.' On another occasion he wrote: 'I love speed because then one can stop thinking.'

This sometimes frenzied search for movement and change was to lead Morand, like Cocteau, to an art form centred on movement, cinema, and there, in the 1930s, we shall meet him again.

Older by twenty years than Cocteau and Morand, André Gide had already made his mark in pre-war Paris. An only son, he had been raised in strict Protestantism by a domineering mother. He discovered early that he had homosexual tastes but married a childhood friend, Madeleine Rondeaux, also a Protestant. At intervals Gide indulged his pædophilia, taking care that Madeleine should not discover. He loved his wife, admired her goodness and deep spiritual life and made her the self-sacrificing heroine of two masterly novels, *Strait is the Gate* and *The Immoralist*.

Gide could not convince himself that active homosexuality was wrong or even contrary to the New Testament. He moved away from the ideal of self-sacrifice to the position that each person has a duty to discover his true inclination, whatever it may be, and to follow it bravely, however much society may disapprove. This doctrine,

conveyed subtly and often poetically, had made Gide a hero with rebels among the young before 1914.

The outbreak of war brought a change in Gide's fortunes. Dispensed from military service because of poor eyesight, he started a centre in Paris for Belgian refugees, finding them accommodation and jobs. He ran the centre for sixteen months; then, tiring of what had become routine, he handed it over to others and did no further war work. He hated violence and found that war had dried him up as a writer, and anyway the young now reserved their admiration for military heroes. He felt useless and depressed.

In 1917 a mutual affection ripened between Gide and a gifted eighteen-year-old youth, Marc Allégret, whose father, a pastor, had long been a friend of the Gides. Previously Gide had confined his homosexual activities to boys picked up at the public baths, out of consideration for Madeleine. Now, however, hoping in part for literary inspiration, he put finer feelings aside and crossed the Channel to join Marc in Cambridge, where the young man was studying English. Gide's stay there proved for both an idyllic holiday.

Madeleine had probably guessed at Gide's secret pleasures but had overlooked them. The affair with Marc was quite different, being open, known to all their circle and therefore an affront to her. In her shock and distress she burned all the letters Gide had written to her. Gide was more shaken by the destruction of his beautiful letters than by the pain he had caused and the shadow it was henceforth to cast over their marriage: his otherwise rich nature had one blind spot: an incapacity to feel deeply suffering or grief.

Gide was not prepared to give up Marc, nor could he live beside disapproving Madeleine. So while continuing to visit his wife in the country, in Paris he found a new female companion: Maria Van Rysselberghe, a cultivated Flemish lady living apart from her painter husband Théo. A few years older than Gide, she was *petite* – just five feet tall – but had a beautiful profile and a welcome lack of censoriousness.

One day Maria confided to Gide that her daughter Elisabeth, who had been the mistress of Rupert Brooke, always regretted not having had a child by her lover. 'What would your reaction have been?' asked Gide, to which Maria replied, 'I should have been overjoyed

and helped to bring up the child.' Maria, who kept a Journal of her conversations with Gide, noted: 'I am sure my words left more than a passing impression.'

She was right. Gide had suffered from a dragonish mother and in an early book had written the already famous phrase: 'Families, I hate you!' But he liked children and felt in himself a strong paternal instinct. He was fond of Elisabeth whom he had known since she was nine: she was now an emancipated, independent young woman with gipsy features who earned her keep by working on a farm and did not want to marry. He knew also that she liked him.

At this period, even in Gide's circle, the notion of fathering a child with no intention of marrying the mother was considered very daring, but it grew on Gide. He had made it a principle to explore his soul to the limit and to give expression to all urges not harmful to others. So after long pondering he sent a brief note to Elisabeth, saying in his characteristically oblique way: 'I find it difficult to resign myself to seeing you without a child and to not having one myself.'

Elisabeth readily agreed to the implied invitation and one morning in July 1922, beside the sea at Porquerolles, their child was conceived. Catherine was born the following April. With her long nose and face she looked so like Gide that Théo, seeing his grandchild for the first time at six months, knew immediately who the father was. Gide savoured to the full this new pleasure of parenthood, helping to bath his daughter and trying to read her expressions.

In 1927 Gide set up a strange *ménage à trois*. He bought a sixth-floor flat at 1 bis rue Vaneau, with a communicating door to Maria's flat adjoining, and with a room in the attic, reached by a separate staircase, for Marc, now becoming known as a film director and still the great love in Gide's life. Gide and Maria took tea together and usually dinner, while Elisabeth often visited bringing little Catherine.

Gide's flat was above all a place of work. From there he ran the *Nouvelle Revue Française*, the leading literary monthly he had founded before the War, publishing early work by Malraux and Saint-Exupéry, as well as *Vergers* by the Austrian Rilke, perhaps the profoundest poems in French of the 1920s. Dozens of young writers

of promise received a helping hand from Gide when it was most needed, for he possessed an exceptional gift for detecting in a novice's outpourings the line that could become truly original. This work involved much reading not only in French but also in English and German. Judging from a purely literary standpoint, Gide believed that France and Germany were made to understand each other, and pointed to Thomas Mann's *The Magic Mountain*, where the hero ends by accepting Mediterranean values.

Above all 1 bis rue Vaneau was where Gide did his writing. His books in the 1920s range from an autobiography of boyhood, one of the rare French books in which birds, butterflies and wild flowers are correctly named – young Gide's Scottish governess was a trained naturalist – to a controversial study of Dostoievsky. To these must be added numerous articles, reviews and lectures, entries in his Journal, and letters to a dozen close friends.

In a lesser man this might have led to diffusion. But on almost every page Gide was conveying a message: Dare to be yourself, explore and fulfil your secret desires, for the fruit that society tells you not to eat is the one that will teach you the truth about yourself.

Both Cocteau and Morand accepted that young men of their day faced a choice between Christianity (or in Morand's case Buddhism) and humanism, which allows complete sexual freedom. Gide, before the war, had written a great novel precisely about such a choice, but since then he had revised his views. At a 1926 summer seminar of Paris intellectuals on the subject 'Humanism and Christianity', after admitting that this problem had dominated his life, Gide declared: 'I have never been able to renounce either Christianity or humanism, and I see clearly that they can't be reconciled. I have been so tormented that I have decided to keep both. I now understand that to wish for a resolution of my dilemma is to wish for a state of death that would yield no further vibrations, and I have stopped rebelling against what is insoluble.'

Gide's close friend, Charles Du Bos, chairing the seminar, commented that it was the mark of French genius, down the ages, to have rejected insolubility. This seems to me to be true and Gide therefore, in claiming that the Christian ethic could co-exist in the soul with humanism, and that this co-existence was fruitful both at a personal and artistic level, was making a radically new claim. When the

32

companion of his youthful orgies in Algeria, Henri Ghéon, returned to the Church, Gide blamed him not for his change of heart but for reviling now what at the time he had considered sublimely joyful experiences. In Gide's view *every* experience had abiding value, and he could point to his own complicated but fruitful personal life as proof that his system worked – at least for him.

Though he was criticized by the most acute of the Catholic intellectuals, Henri Massis, for turning on its head the classical definition of man as one who chooses and adheres to his choice, and of legitimizing sin by integrating it into a 'private morality', Gide's new ethic was to exert a powerful influence in inter-war Paris. In telling the young, 'Never remain the same,' Gide was codifying and amplifying the kind of life Cocteau, Morand and others of that set were groping for.

This had importance for individuals and for society as a whole. In rejecting consistency, and any absolute set of values, Gide rejected also the nationalism that was based on them. Instead of social duties, he taught *disponibilité*, the state of being dispensed from social duties in order to cultivate personal fulfilment. Later we shall see how this personal philosophy was to help reshape the idea of citizenship.

3

MEN OF REASON

On the Left Bank, in and around the Sorbonne and Collège de France, men more socially responsible than the literary hedonists across the river went to work after the War in an attempt to rethink the nature of society and to propose for it a new morality. Parisians expected this of their eminent thinkers. Voltaire, Condorcet, Comte and Renan had all proposed such moralities in the past.

The seed-bed of much of this new thinking was a small building in the rue d'Ulm housing the Ecole Normale Supérieure. Founded in 1794 by the Convention in the full flood of the egalitarian optimism deriving from the Enlightenment, it trained an intellectual élite to become teachers in higher education. The school's reputation was as high as the best Oxford and Cambridge colleges; it stamped its graduates with immense self-assurance and most recently had been pointing them in the direction of socialism. Its alumni included Jean Jaurès, the brave and brilliant socialist orator who had opposed Poincaré's unswerving nationalism in 1914, and Romain Rolland, the gentle professor of music who had gone to Switzerland in 1914 and there published a pacifist manifesto, *Au-dessus de la mêlée*, denouncing a war that would ruin European civilization and calling for an immediate cease-fire.

It was the Ecole Normale Supérieure that produced two of the eminent philosophers of our period. The first, Léon Brunschvicg, was born in 1869 into a respected bourgeois Jewish family. He had a secure and happy childhood. He attended the Lycée Condorcet with Proust, where the philosophy teacher, Alphonse Darlu – the Bergotte of Proust's novel – encouraged pupils to think about first

principles, such as the nature of being, knowing and remembering – a lesson both Proust and Brunschvicg were to follow.

Brunschvicg went on to the Ecole Normale where he took a brilliant degree in Greek philosophy. Unusually for the time, he also took a degree in science. Here exciting discoveries were being made: substances such as uranium and radium, and the realization that matter is not something 'hard' and persistent but a concentration of energy composed of continually moving electrically charged particles.

During his student days Brunschvicg read widely in Western philosophy and retained what he read in an exceptional memory. He possessed a mind that readily synthesized and sought to build facts into a whole. When devoid of specific religious belief, this type of intelligence is often drawn to pantheism, and after reading Spinoza Brunschvicg did in fact adopt it. With an unrivalled grasp of the history of philosophy Brunschvicg went on to trace a continuous tradition of pantheism from the time of Plato, and with his knowledge of science to argue that since all reality is composed of the same underlying charged particles, modern physics also confirms the truth of pantheism.

After graduating Brunschvicg chose a teaching career that was to lead to academic posts in the Sorbonne and the Ecole Normale. Good-looking, affable, enjoying excellent health and an assured income, he was to prove a popular teacher, generous with his time, never forcing his views on students.

Brunschvicg married Cécile Kahn, daughter of a rich industrialist, a lady as gifted as himself, who bore him four children and fought effectively for women's rights. Setting up home in fashionable Passy, they kept open house for Léon's colleagues and Cécile's social workers.

In 1920 Brunschvicg met Einstein and saw in him a kindred spirit. 'Einstein,' he told one of his students, 'has finally proved Pythagoras right! From now on, everything is reduced to measurement. *To understand is to measure.* But Einstein goes further. He demonstrates that the thing measured and the measurer, that is to say, being and thought, are one and the same.' It is doubtful whether Einstein held the last view, but Brunschvicg believed he did, and saw in it further confirmation of pantheism.

The pantheist readily views man's benevolent impulses as a working of God-in-Nature. Brunschvicg came to hold that view. He declared that 'from Socrates to Marcus Aurelius, from Descartes to Condorcet, a surge of generosity appears as the distinctive characteristic of reason.' He then went further than any previous pantheist in opining that down the ages man's intelligence and moral sense have evolved, and are still evolving, therefore the surge of generosity is stronger now than ever before. The growth and internationalism of scientific discovery, Brunschvicg predicted, will be repeated at the social and moral level. From narrow nationalism men are moving, through peace organizations and the like, towards internationalism and will eventually attain world federation – a social equivalent of pantheism.

This blithe creed Brunschvicg propounded in numerous books and public lectures. One of them Maria van Rysselberghe went to hear, with André Gide, in 1926.

> He looks like a senior civil servant and speaks in abstract terms [she wrote in her Journal] . . . His lecture and physiognomy are alike good-natured, even a little hesitant, and this is encouraging for the layman . . . He seems to hover above the intellectual scene with a kind of smiling beatitude that I find slightly disquieting.

Gide for his part found the projection of science into ethics 'fragile and vague', but this was a minority view and if Brunschvicg did sometimes 'hover' he could also be active in public life. One of the first in Paris to come out firmly in favour of the emerging League of Nations, in 1922 he became a delegate to the League's International Commission for Intellectual Cooperation. There, with men like Gilbert Murray, he worked to reduce nationalist barriers in education and the diffusion of information.

In later life the affable, still optimistic professor was not above an occasional stab at those who did not share his creed. 'You've studied Pascal and Spinoza,' he said one day to a Catholic newcomer, Jean Guitton. 'Tell me which is the Jew, which the Christian?' While Guitton, sensing a trap, hesitated, Brunschvicg continued, 'Pascal was really the Jew, because he had the sacrifice of the Mass offered for his intention and he sewed a paper into his pocket to remind him

that he'd been granted a vision of God. Spinoza on the other hand achieved union with the immanent God who is not a person, the God of St John, which exists "in spirit and in truth".'

In the 'twenties and early 'thirties Professor Brunschvicg of the Sorbonne stood at the apex of academic life, highly respected, quoted on all sides, a man who lived out his philosophy by his activities for the League. Most important of all, through his position as a teacher at the Ecole Normale, his philosophy of optimistic humanism, as endorsed by modern science, was passed on to future philosophy masters at the lycées, and by them to their seventeen-year-old pupils.

Henri Bergson was a more introspective man than Brunschvicg, a watcher of the self. From his father, a composer of piano music, he inherited an artistic sensibility and from his mother, who came from Yorkshire, an English reserve. In appearance he was slight and slim; with brown bright eyes under prominent eyebrows and a beak nose, he was compared by friends to Pallas Athene's owl. He spoke slowly, pausing quite often to find the exact word, and exact it invariably was.

After brilliant studies at the Ecole Normale, Bergson adopted a teaching career that was to culminate in a professorship at the Collège de France. He made a close marriage but his life was clouded by the birth of a mentally handicapped daughter, Jeanne – who, however, under her father's solicitous care, found a measure of stability as a sculptor.

Bergson taught that a creative force, *élan vital*, is at work in the universe, lifting it from matter in the direction of spirit, and that it is also at work in mankind. When we act, Bergson declared, we do so either as social animals, drawing on collective wisdom, or as individuals, in which case we draw on intuition, which Bergson defines as a current of sympathy with externals and an ability to attune to them. In contrast therefore to Descartes, who said man thinks before he acts, Bergson taught that man acts first and thinks later. At the outbreak of war Bergson's reputation as a philosopher stood so high that in 1917, at the prompting of Berthelot, he was sent by his government to the United States, to urge President Wilson to enter the conflict.

With the coming of peace Bergson turned his attention to ethics.

The naturally altruistic impulses Brunschvicg places in the individual Bergson places in the community. In *The Two Sources of Morality and Religion* (1932) he argues that man, left to himself and his own intelligence, would always act in his own interests, against the common good. Beneficent creative evolution however has protected him from this by making him a social animal, so ringing him round with habits and customs to the community's advantage. This constitutes the first source of morality.

The second source arises in the individual's sensibility. Bergson, a believer in the Jewish God, admits that God cannot be proved, but if he exists, presumably he can be perceived. Certain mystics such as the Jewish prophets, Socrates perhaps, the Buddha and Christ, have claimed to perceive him.

> The mystics are unanimous in witnessing that God needs us, as we need God. Why would he need us, if not to love us? Such will be the conclusion of the philosopher who accepts mystical experience. Creation will appear to him as an undertaking by God to create creators, in order to attach to himself beings worthy of his love.

If the mystics are seen to be trustworthy, we have a duty to believe them, says Bergson, just as we believe a Stanley or a Livingstone when they describe the sources of a river on the other side of the equator.

Here Bergson was attempting something new and important in twentieth-century France: bringing religious experience within the purview of philosophy. But he did not specify which model or models we should believe, and critics asked, did he not open the way for adhesion to gurus, charlatans, even to demagogues – any with power to sway our sensibility?

Though differing about religion and about the role of intuition, Bergson and Brunschvicg shared one important belief: that an all-powerful beneficent force is at work among the intelligent, propelling mankind in the direction of fraternity.

Like Brunschvicg, Bergson actively supported the League of Nations and in 1922 joined him on the International Commission for Intellectual Cooperation. His books influenced the young, notably Teilhard de Chardin, while he drew to his lectures at the Collège de

France the cream of Paris society, including many ladies, attracted by the role he accorded intuition and sensibility.

Paul Valéry also came of mixed ancestry, but from southern latitudes, having been born in the Mediterranean seaport of Sète, son of a Corsican customs official and an Italian mother. He wanted to join the Navy but failed the maths exam. At twenty-three he moved to Paris, a small, neat, fast-talking young man with twinkling eyes and literary ambitions. He took a part-time job in the Havas advertising agency, writing poetry in his spare time and seeing much of Mallarmé, who encouraged him, as did his close friend André Gide. In 1900 he married Jeannie Gobillard, niece of the painter Berthe Morisot and a friend of Mallarmé's daughter, Gide being a witness.

In 1917 Valéry published an esoteric, incantatory poem in the style of Mallarmé. *La jeune Parque* describes how the youngest of the three Fates is bitten by a poisonous snake. She suffers, she is two-thirds in love with easeful death, but being immortal cannot die. The poem ends with the young Fate addressing the sun: 'In spite of myself I must adore my heart, where you come to make yourself known.' In so far as it can be understood the poem exudes pantheism and narcissism. In Valéry's words, 'its obscurity put me in the limelight.'

In 1922 Valéry published *Le cimetière marin*, a brooding poem set in the graveyard of Sète, where again death beckons, but this work contains in its last stanza a line of limited hope: '*Le vent se lève: il faut tenter de vivre* – The wind is rising: we must attempt to live.'

Valéry was unusual in combining with a poet's sensibility an intellectual's urge to withdraw from ephemera: 'Instinctive horror and detachment from the particularity of human life . . . Loves, joys, agonies, all feelings terrify or bore me.' From 1922 he even turned against his poetry-writing self: 'In literature there is always something *sly*: awareness of a public.' An admirer of Leonardo da Vinci's method, Valéry now gave much of his time to sifting and questioning his own thoughts, each year filling hundreds of pages of notebooks. From these emerge a conviction that man's highest activity is the exercise of intelligence for its own sake: in analysis of thoughts as they occur and in the creation of those arts based, as Valéry believed, on mathematics – architecture, statuary and dance.

Taking the *cogito* a stage further than Descartes, Valéry was saying in effect, '"I think" is my reason for being.'

> Valéry is not a Christian [the abbé Mugnier noted in his diary after a lunch in May 1922], does not like the Gospel, finds it wicked. He does not understand the mixture of God and suffering, and he considers miracles as unworthy of God. For example, changing water into wine is a lowly conjuring trick ... He defines faith as 'the power to create what is true.' He says he possesses great intellectual will-power, and his first duty is to doubt.

The following month Mugnier asked Valéry for a definition of morality. After some embarrassment the other replied that one day man would 'break a window on to the universe', and that would allow him to orient himself more clearly ... 'Christianity,' he added, 'has played two tricks on man: by suppressing polygamy [Valéry had three intense Platonic extra-marital love-affairs] and by asking us to forgive wrongdoing. It would be better to repay one wrong with another. That would frighten people more.'

Once he left his study this rigorously intellectual Narcissus became, paradoxically, the most sociable of Parisians, with a huge range of acquaintances, a fast, dazzling conversationalist, the darling of the leading literary salons. He also took an active part in civic affairs. In 1919 he published, first in *The Athenæum*, then in the *Nouvelle Revue Française*, an essay entitled *La crise de l'esprit*. Its opening sentence, 'We now know that civilizations, including our own, are mortal,' repeats what Spengler had already said in Germany, but coming in the year of Paris's victory parade it caused surprise. With his mixed parentage Valéry found it easier than most Frenchmen to think of civilization in terms of Europe as a whole, not just France, and he went on to ask how the civilization of Europe could stave off mortality and, despite its small territorial area, continue to play a prominent world role.

Valèry sees in Europeans a strong will, acquisitiveness, curiosity, a blend of imagination and logical thinking, a certain scepticism, and mysticism without resignation. At present they are divided, pursuing heterogeneous aims, but underpinning the diversity are three strong defining traditions: those of Greece, Rome and

Christianity, from which, however, he excludes Christian religious teaching.

Valéry's definition of Europe in terms of Greece, Rome and ethical Christianity did not satisfy everyone. What about Tristan and Isolde? asked the essayist Emmanuel Berl and might well have added, What about Siegfried? But it did contain enough truth to be used as a starting-point in discussions at Geneva by the International Commission for Intellectual Cooperation, where Valéry sat with Brunschvicg and Bergson as a delegate.

Il faut tenter de faire vivre l'Europe: Valéry worked tirelessly for that, and for the triumph of intelligence everywhere. In accordance with his distaste for the particular, he did not specify how and under what authority Europe was to transfer its strong will from hetero-geneous to homogeneous aims but by his verve and style he kept alive an ideal of Europe, united intellectually and culturally, both in Paris and in the capital cities of France's new allies in central Europe, where the Government often sent him to reassure audiences that France was indeed their loyal friend.

One aspect common to this trio of thinkers strikes an observer. All of them are silent about evil. They appear to live in a city from which evil is absent – surprising in view of the recent war. They inhabit a city where men are reasonable and good. The fact that men may be fallen, flawed, aggressive – however one chooses to word it – does not intrude on their horizons.

And what, one may ask, had become of the Christian strand? Was not France still the Church's eldest daughter? The answer is, in practice no. The Third Republic's policy of secularizing education by dismantling Church schools and exiling teacher priests meant that the generation coming of age during and immediately after the War was the first in French history to be educated, by and large, as pagans. Hence the supply of, and demand for, Christian thinkers was much reduced.

The Church in many ways had itself to blame. Pope Pius IX had advised French Catholics to have nothing to do with an anti-clerical Republic and to abstain from voting. Though this advice was withdrawn by his successor, it left a legacy of distrust on both sides. The position after the War was that the hierarchy nagged the

Government about education, demanding their schools back, while the bourgeoisie kept their distance from a proletariat alienated from the Church. As though this were not bad enough, Charles Maurras, a tiny half-deaf recluse of exceptional virulence and tenacity, an agnostic posing as a Catholic, led the Action française movement in an unscrupulous campaign against the Republic ('the Whore'), against parliamentary democracy and against the Jews. The members of Action française were largely small shopkeepers and clerical workers, 'have-nots' and failures who believed that the monarchy advocated by Maurras would solve their problems. They were noisy rather than effective, but even after Maurras was condemned by Rome in 1926 they found support among some of the clergy, and had the effect of making all Catholic thinking suspect to moderates and genuine reformers.

In these circumstances some of the small number of Catholic thinkers, despairing of influencing mainstream philosophy, directed their efforts elsewhere: Jean Guitton, an admirer of Newman, worked for ecumenicism with the Belgian Cardinal Mercier and the English Anglo-Catholic, Lord Halifax, while the polymath Jesuit, Henri de Lubac, by demonstrating that Christianity and Judaism share a common heritage, won back some of the Jews alienated by Maurras.

One outstanding intellectual directly challenged the assumptions of contemporary pundits and offered an alternative. Jacques Maritain – whom we glimpsed in company of Cocteau – came of a Protestant family. As a high-minded young philosophy student in Germany he met a Russian Jewish fellow-student, Raïssa, who shared his ideals. They married and under the influence of the books of Léon Bloy, who claimed that one of the conditions of saintliness is poverty, both joined the Catholic Church. During the War Maritain befriended a young soldier, Pierre Villard, and helped him overcome his religious doubts. Villard was killed in action; he happened to be very well-off and left half his fortune to Maritain, who used it to buy a house in the Paris suburb of Meudon, where he lived with Raïssa and her invalid sister if not in poverty at least in Cistercian simplicity.

'I was shown into a well-kept home,' wrote a bitter-sweet visitor, 'polished parquet, gleaming copper pans, books neatly shelved,

flowers straight in their vases, not a speck of dust. I still see the mantel portraits of Léon Bloy, St Thomas and Ernest Psichari [a brilliant friend, killed in action], on the walls paintings by Rouault and Severini; I can still see the polished chest of drawers and sniff a comfortable smell, like new-baked bread . . . The Maritains attracted a diversity of people, as a magnet draws rusty pins, thumb-tacks and marvellously sharp needles . . . priests from all over the world, students of every nationality, men and women of every age. On a Sunday I've seen Maritain at a blackboard explaining the dogma of the Trinity while Raïssa later passed tea to quietly-voiced guests huddled in good intentions.'

The order here, in such contrast to Cocteau's pell-mell study, is typical of both Maritain the man and Maritain the thinker. As a thinker, he considered the humanism of Brunschvicg and Valéry to be based on a fundamental error. You cannot, he said, look at the history of philosophy, at science or into your own creative thinking and from what you discover there deduce imperatives that will be binding on all. Bergson's mystical morality Maritain also found inadequate, because based on private experiences.

Maritain decided that the only way out of this impasse was to go behind Descartes' 'I' to Aristotle and St Thomas Aquinas, who took as their starting-point not the 'I' but the external world. Once the external world is accepted as being objectively, undeniably real, each individual view of it is cut down to size, seen to be partial but, in the light of other views of a common external reality, capable of sharing in a consensus. Truth is now no longer a cocoon spun from the individual's experience, but a verifiable correspondence between statements and a real world.

From here Maritain follows St Thomas. Reason can conclude that the order we discover in the world owes its existence to an Orderer. Under the action of grace we can then go on reasonably to believe that the Orderer became incarnate, living out as a model a moral code that really can claim to have a binding authority on all.

Unlike many of his Catholic friends, Maritain had no wish to revive the medieval state. He accepted unswervingly equality, pluralism and tolerance, and held that Christianity must make its impact through family life and small groups of friends.

43

Maritain presented St Thomas's philosophy in terms his contemporaries could understand and showed it to be a genuine alternative to the prevailing humanism. He held no teaching post in the Sorbonne; because of his Jewish wife he was vilified by Action française, and his influence in the early 1920s was almost nil. Cocteau's set found tea and St Thomas more than a little drab. But through his books and study groups he did influence a small circle of intellectuals, Christian or agnostic; he was to be a moderating influence on his wilder friends, notably the novelist Georges Bernanos, and in the 1930s, as we shall see, was to work actively in healing the rift in the Church between bourgeois and proletariat.

4

THE FEMININE TOUCH

While professional thinkers were offering intellectual guidance to their contemporaries, women were playing a less direct but no less influential role in the life of the city. Since the ratio of women to men was now seven to five, many did not marry. During the war women had taken men's jobs and performed them on the whole well, and this continued into the peace. Quite a few unmarried Parisiennes were to enter the professions or public life and some to start businesses.

Those who married, if they had enjoyed a good education and disposed of a modicum of leisure, took pains to furnish their apartments in accordance with the latest styles, to provide a good table and to entertain with chic: in short, to add, within a limited circle, to the beauty and harmony of their city. They also tried to bring up their children according to values more traditional than those of the vogue thinkers.

A convenient vantage-point for looking at their way of life in the 1920s is a well-to-do home in one of the many late nineteenth-century seven-storey apartment blocks. It would be served by a spiral staircase and an often rickety two-passenger lift. High windows down almost to the floor let in plenty of light to a big stucco-ceilinged salon with a dining-room adjoining. Bedrooms were rather small and usually one bathroom served them all. Central heating was provided from a boiler in the basement, where each occupant had his individual wine-cellar. Bathroom and kitchen would have the prized new floor-covering – linoleum. Cooking was by gas; in one of the cupboards there would be a noisy electric vacuum-cleaner. On a hall table would stand a telephone – in the 'twenties still dial-less – more a status symbol than part of daily life, being used only for urgent

messages, invitations for instance always being in writing, sent by post or *pneumatique*.

Furniture which in the first decade of the century had moved from the massive and imposing to the flowery tendrils of art nouveau, took a new turn after the war. As the motor-car definitively superseded the horse, straight lines and circles came into vogue, as did metalwork, glass and leather. Small pieces in light woods were in favour, decorated with circles and spirals; occasional tables and accessories were in chromium plate or steel, and there would be looking-glasses in angular and geometric forms with exaggerated symmetries. A warm note was provided by very large lacquer screens, often with thick bold diagonal gilt and black stripes. On the bookshelves, beside the unbound novels, one might find a few favourite works expensively bound in leather, gold tooling and palladium by Paul Bonet or by a colleague who specialized in inlays of leather, Charles Lanoë. There might well be a small silvered bronze figure of a female archer or javelin-thrower by Marcel Bouraine, a sign of women's growing participation in sport. Three new items were the cocktail cabinet, the gramophone and the wood-veneer wireless set, the last two of great importance since they brought the outside world into the family apartment.

The *maîtresse de maison* – a term which, unlike its Anglo-Saxon counterpart, housewife, connotes respect – had the help of a maid, who with other maids for the block had her bedroom on the seventh floor, a cook who did not live in, and a *promeneuse*, to perambulate any baby there might be for its daily airing. Since her husband would lunch in a restaurant near his office, the *maîtresse de maison* could count on a good deal of free time.

Much of this was given to the all-important matter of dress. With the coming of peace Parisiennes continued to buy Paul Poiret's richly coloured dresses in sumptuous materials with high waists and skirts just above the ankle, but these proved too restrictive for women now leading much more active lives and the early 1920s saw a revolutionary change. Dresses fell in a straight line past a waistline that had dropped to the hips and hair was cut short, exposing the nape of the neck. This was crowned, for street wear, by the severe cloche hat. The profile silhouette of a lady so dressed, a long thin cigarette holder at her lips, resembled the fashionable new dynamic

lettering – strong verticals, slim horizontals – beginning to appear on shop fronts and the new cinemas.

The two fashionable colours for party wear were tango – orange – and *tête-de-nègre* – dark brown. Silk stockings that supposedly would not ladder were now an essential item, beige at first, then, around 1929, in colours such as pink. Necklaces hung low, as did handbags. A new essential for a quick-paced city was the wrist-watch; set with jewels for evening wear, this had become a favourite present from a husband to his wife – or to his mistress.

With the change in dress went a change in facial appearance, made possible by advances in cosmetics. Before the War a lady going out to dinner might lightly powder her nose and cheeks, even pat on a hint of rouge, but now she could draw on a whole range of preparations, the most important being lipstick. This was applied even during the day, and in 1927 a chemist, Paul Baudecroux, introduced *rouge à lèvres baiser*, with which women could kiss without leaving a mark. Coloured nail varnish made pretty hands even more attractive; hair was given a rippling look with the 'Marcel wave', created by Marcel Grateau. Mascara was worn, eyebrows were often plucked and the daring might put on false eyelashes. *Salons de beauté* opened, where experts could help a lady to create her own facial beauty, not unlike a painter or sculptor creating a work of art. Dieting ensured an attractive figure. Colette was not the only Parisienne to try to slim by rowing on the Seine, though she was one of the very few in 1921 to *se faire remonter le visage* – to have a face-lift.

Becoming clothes and an attractive appearance were prerequisites for one of the *maîtresse de maison*'s main roles: entertaining. Before 1914, with well-trained staff, the lady of the house had merely given orders for a dinner party; now, however, she would go out herself, when gurgling water canalized by sandbags was washing streets clean for a new day, to choose fresh fruit, vegetables and cream as they arrived locally from the Halles, and to buy flowers. She would be expected to provide visual pleasure equal to the pleasures of the palate through 'the art of the table', which involved blending table linen, china, glass, silver, flowers, candles and accessories into a welcoming harmony conducive to lively conversation.

According to the Duc de Brissac, a guest at a Paris dinner had

roughly twelve seconds' grace before providing witty answers to questions on the international monetary situation, abstract painting, twelve-tone music or astronomy. After dinner host and hostess might take their guests to the theatre, which would also include dancing, for most theatre foyers in the 1920s had a parquet floor and orchestra, where the audience could fox-trot and shimmy for an hour before the curtain rose and during the intervals. Dancing in night clubs had also become very popular, and couturiers answered the call for formal evening wear by designing close-fitting, clinging evening dresses in satin or crêpe, some with halter neck, accentuating the curves lost in morning or afternoon wear. These are among the finest creations of the period, equivalents of the streamlining of motor-cars and of Brancusi's polished bronze birds.

The other side of a Parisienne's life naturally centred on her husband and children. Here her aim was to impart *douceur*, a gentle warm atmosphere. But this was not a period when husbands were noticeably faithful. Accepted moral standards had been in some degree eroded by the War, and never before had there been so many women available. Most of the husbands in these pages had one or more extra-marital liaisons. Paul Morand indulged in a love-affair with an eighteen-year-old actress, Josette Day, known for her curves rather than for her brain, whom Morand, Pygmalion-like, taught to appreciate good books, as well as to ride and to drive his fast car; Paul Valéry conducted a long-running, much noticed love-affair with a lady mathematician-poet, Catherine Pozzi. Neither Madame Morand nor Madame Valéry rushed to a divorce lawyer. They waited for the storms of passion to blow themselves out, as usually happened. But the situation could lead to self-doubt, for which the psychologist Emile Coué offered a cure much practised by distressed ladies: to repeat regularly the phrase, 'Day by day, in every way, I am getting better and better and better.'

Frenchwomen were exhorted to raise large families in order to replace losses in the war, but few responded. Most Parisian wives bore only one or two children, to whose upbringing they devoted much time and care. In school homework they fostered neatness, clarity and that attention to detail they practised themselves in the art of the table. They checked unusual dress or conduct that might be judged ridiculous – a much feared term of opprobrium. They

inculcated respect for family elders which included writing at New Year long, well-turned, faultless letters to grandmothers and to aunts. Emphasis was placed on politeness, 'Do not give offence' being almost an eleventh commandment, and care was taken 'to educate the heart', that is, to teach children not only to think of others, but to feel for them.

In fine weather after school a mother would take her young children to one of the parks: to the Luxembourg, with its nooks and, in spring, jets of white blossom on espaliered pear trees, to the spacious Champ de Mars, or to the Bois de Boulogne, with its rose garden and many chestnut trees. As they grew older, children roller-skated, bicycled and played tennis, but had few opportunities for team games and for acquiring team spirit.

Catholic mothers sent their children to the local curé's catechism class, gave presents on the feast of the saint rather than on the birthday, and took them to Sunday Mass. Often the father remained away, being *non pratiquant*. When a boy entered the lycée philosophy class he was faced with humanist or agnostic texts to which neither his catechism nor his mother could give satisfactory replies. At this age a son would readily adopt the typical adult male attitude, that religion was only for women.

If, as quite often happened, the husband was absent, errant or dead, the influence of an attractive, *douce* mother could become restrictive on an only son: he might then find it difficult to leave home and, like Cocteau, would live on his mother's money.

Some of these Parisian ladies won high respect because they practised or encouraged the arts. Russian-born Misia Sert carried into middle age that gift for discovering and encouraging talent which before the War had launched Diaghilev. Herself a talented pianist, she commissioned work from young composers and held recitals in the drawing-room of her apartment overlooking the Tuileries, 'rich in objects of mother of pearl, crystal and gold . . . Nothing was showy, but everything caught the eye.' One of Misia's proudest moments came when she invited the discriminating to hear a then unknown trio she had brought from Russia: their names were Milstein, Piatigorsky and Horowitz.

Misia had the reputation of being the perfect friend, affectionate,

discreet, loyal. Among the many who valued her were Jean Cocteau and Hélène and Philippe Berthelot, to whom she gave his aquarium of exotic fish. She was less fortunate in her husbands, all of them rich. The third, flamboyant José Maria Sert, painted enormous loud murals of which the unkind said that mercifully they seemed to shrink with the years. He left Misia for a younger woman who soon contracted tuberculosis, whereupon Misia, desperately unhappy but still in love with José, moved in and nursed the unfortunate rival during her few remaining months.

Younger than Misia, Marie-Laure de Noailles, who commissioned Cocteau's film, was by birth a Bischoffsheim, of the Jewish banking firm, and a descendant of the Marquis de Sade. Described by her Russian lover, Igor Markevich, as a 'Judith painted by Goya', she was very thin, with a pale complexion and brooding dark eyes. She dressed unconventionally, in a skirt and blouse, painted in the Surrealist style, and with her husband commissioned the Spanish film director, Buñuel, to make *L'Age d'or*, considered sadistic and blasphemous, so much so that it led to the expulsion of her husband from the Jockey Club.

It was in Marie-Laure's palatial home on the place des Etats Unis, where President Wilson had lodged during the Versailles Peace Conference, that one heard the interesting *mots* of the period: Fernand Léger's, 'Man is a bicycle,' Le Corbusier's 'A house is a machine for living,' Bergson's 'The universe is a machine for making gods,' and Cocteau's 'France's symbol is the cock, a farmyard animal [as on the postage stamps]; she cannot compete with industrial nations.'

The leading political salon was that of Marie-Louise Bousquet. The wife of a witty vaudeville writer, she lived conveniently close to the Quai d'Orsay, the Chambre and the Institut, and it was here that her close friend Philippe Berthelot came to talk about poetry and the new Europe with Paul Valéry. Another of Marie-Louise's faithful was the Academician Henri de Régnier, with whom she had once been in love; now in his sixties but still very handsome, he was the author of many forgettable poems and one memorable line that Ravel loved to speak aloud: '*Dieu pluvial riant de l'eau qui le chatouille.*'[1]

1. River god laughing at the water as it tickles him.

Madame Bousquet was something of a roguish child, addressing newcomers by the familiar 'tu' and not above using racy language. She dispensed lemonade – the only refreshment – with such style and *à propos* remarks, and despite a slight limp moved so gracefully among her distinguished guests that an English expatriate, Violet Trefusis, said of her: 'Do you know any other city where week after week people throng to the house of a woman who is neither young, beautiful nor rich, simply because she is intelligent?'

Anna de Noailles was Romanian in origin and a relation by marriage to Marie-Laure. She was petite, had large dark eyes set very wide, a Greek nose and a rounded chin, very long black hair and a fringe down to her eyebrows. Before the War she had published poetry about flowers, gardens, the pleasures of existence, large and small, with the emphasis on taste, touch and smell. The best of her poems both Proust and the politician Blum judged to be touched with genius.

In 1923 Anna lost within weeks her mother and Maurice Barrès, the novelist patriot who was her hero and the great love of her life; thereafter the main theme of her poetry was to be the severing of lovers by death. Once a spiritualist, she now believed death to be the end.

Anna's salon was unusual in that the hostess did most of the talking. But what this chatterbox said was freshly observed and deeply felt, so people listened. Anna occasionally listened too – in her fashion: 'I can only pay attention when I'm talking.'

Though delicate health necessitated sleep in the afternoon, Anna led a full life and tried to be at the centre of events. Her circle in-cluded Paul Painlevé, aerodynamics expert and government minister, who gratified her wish to go up in an open-cockpit aeroplane. At Painlevé's suggestion Anna joined his Rationalist Club and would repeat a favourite saying of his: 'I've never had a reply from God,' at which one of her friends remarked, 'Perhaps because you never let him get a word in edgeways.'

Also of Anna's circle was the abbé Mugnier, who respected her paganism but sensed a soul longing for God; intending it as praise, he described her as 'the tail of the romantic comet', but another friend, Bergson, was nearer the mark when he said she revealed infinity through elemental sensation.

51

Anna was fond of another sensuous writer, Colette, finding her maternal and protective. One day she visited Colette's Auteuil garden. She cupped in her small hands the various flowers and plants, then came upon one she did not know. Colette said it was lemon-scented balm, at which Anna exclaimed: 'So this is the balm I've been writing about for years.'

Anna fell easily in love, even for a time, hopelessly, with Maurice Chevalier, for his dancing, 'light as snowflakes', and his blue eyes, 'hard as pebbles'. Marital fidelity meant little to an unbeliever, and Anna continued to seek a successor to Barrès among the young men of her salon. 'They say nice things about my feet,' she complained, 'but never go higher,' to which Colette replied, 'You're not cordial enough with them.'

Partly from vanity, partly as her only hope of survival, Anna sat to many painters: three times to Proust's friend, Jacques-Emile Blanche, once to Forain, once to Romaine Brooks, twice to Laszlo, once to the Basque artist Ignacio Zuloaga, reclining on her bed in a Poiret tunic – her preferred portrait – once to Hélène Dufau, to Vuillard, to Van Dongen, and to Foujita. She sat to Rodin for a bust and her small hands were photographed by Kertesz, a fountain pen in the right, the left poised on the paper after having traced in the air the rhythm of a verse.

Japanese-born Foujita recalled his sessions with Anna. During a break in one of them she said to him: 'Go on to the balcony. There is a white rabbit that will eat only violets. Isn't that terribly Japanese?' 'Yes,' answered the painter, who had never in his life seen a white rabbit eating violets.

When the portrait was nearing completion, Anna insisted on seeing it. 'But you haven't made my eyes big enough! My eyes have been compared to broad flowing rivers. And what have you done to my forehead? Make it broader and higher, I'm a poet – what do you suppose I do my thinking with?'

Vanity however and other foibles were overlooked by Anna's many friends because she had a great deal of heart, helping in particular young writers, and because some of her melancholy pagan poetry is among the best ever written by a woman.

War jobs had taken many wives out of their homes and pointed the

way for unmarried women to take a job or start a business to earn their own living. One of those to do so was Adrienne Monnier. As a schoolgirl she loved reading and everything to do with books, the look of a typeface, the feel and smell of paper. At twenty-three she started a bookshop in the Latin Quarter at 7 rue de l'Odéon, calling it *Les Amis des Livres*. She divided the shop into three. The front part was a lending-library, the middle part a well-stocked bookshop proper, and the rear a meeting-place for those admitted to her friendship. Adrienne, who wore her hair bobbed and dressed plainly, was to be seen every day in the front part at her nun-like task of wrapping books in brown paper and string. She was amiable, independent-minded and had a sense of humour, and soon became a friend to young writers and musicians, organizing readings and recitals at the back of her shop. There Francis Poulenc heard Erik Satie play his *Socrate*, with Suzanne Balguerie singing all the parts. *Les Amis des Livres* was to become the recognized meeting-place and gossip-mart for literary intellectuals. Presently a young American, Sylvia Beach, was to open an English bookshop, Shakespeare and Company, on the other side of the street, and to become Adrienne's close friend.

Many women less intellectually inclined than Adrienne took up sports such as swimming, skiing and tennis. One who made her mark there was Suzanne Lenglen. Her father, Charles Lenglen, was a pharmacist by profession who in his youth had been a keen racing cyclist. He was well off, having inherited one of Paris's horse-bus companies, and the family wintered in Nice, in a house opposite the Lawn Tennis Club.

Suzanne as a girl showed a natural aptitude for sport and excelled at the then fashionable game of diabolo. At eleven she began to play tennis and that summer took second prize in the Chantilly handicap tournament. Realizing his daughter's exceptional ability, Charles Lenglen retired in order to manage her training. In 1913, at the age of fourteen, she won the Picardie championship and in the Monte Carlo tournament reached the final of the doubles. During the War, which she spent in Nice, she kept up her game, playing in tournaments and exhibition matches in aid of the Red Cross.

In 1919 Suzanne entered for the ladies' singles at Wimbledon and

won. In the following year she won again, causing the usually phlegmatic *Times* correspondent to write: 'So hypnotic is her dainty strength that one is apt to brush aside any errors of hers as if they were grammatical slips in a poem.' She was not pretty but she moved beautifully; in 1920 she appeared with hair bobbed, in a loose one-piece frock by Jean Patou and a distinctive *bandeau*, several yards of georgette, varying in colour from heliotrope to lemon, swathed around her hair. She had a habit of gently blowing on her racket hand to cool or dry it, and occasionally wiped the perspiration from her hand with the bottom of her skirt.

Suzanne won Wimbledon five times in six years. She became the idol of France. In 1926 she turned professional and toured the United States as one of a troupe of six, playing against men and often beating them. There she met a rich young American, Baldwin M. Baldwin, with whom she was to spend the next five years. They never married as Baldwin already had a wife and son, but with Baldwin as her manager Suzanne made a successful exhibition tour of Britain; in 1932 she retired and set up home in Paris.

Another woman to achieve success in what had hitherto been a man's world was Hélène Boucher. Daughter of a rich architect, she won prizes for golf and tennis, then qualified as a pilot. Buying a Gypsy Moth, she set off solo, accompanied by her pet dog, for Saigon. She got as far as Iraq where engine failure obliged her to turn back. She then became a test pilot, competed in the top endurance tests and broke the altitude record for women by flying at 5,900 metres.

Quite as much determination was needed for a woman to succeed in the tough world of big business. Gabrielle Chanel, daughter of a shiftless father and asthmatic mother, spent her girlhood in an orphanage run by nuns. There she learned to sew neatly. For a short time she became a singer in a provincial music hall, acquiring the name 'Coco' from the title of one of her songs. She became the mistress of a rich Englishman, 'Boy' Capell, with whose money she started a milliner's shop in Deauville. During the War, with the help and tasteful advice of Misia Sert, she opened shops in Paris and Biarritz, and began to attract attention.

'She was small and very slim [wrote one who knew her then]. Her thick black hair was set low on the brow, her eyebrows met in the middle, she had a smiling mouth and bright hard eyes. She was

always dressed simply, usually in black. She would put her hands in her pockets and begin talking extremely fast and always to the point.'

Coco had a flat chest and thick ankles, was quite without wit but possessed of an inner strength that attracted certain types of men. In 1921, aged thirty-eight, she had an affair with the poet Pierre Reverdy, whom we glimpsed in Maritain's house, a dark-complexioned gloomy little man who could write his sad verses only when very hungry and very cold. For long torn between his love for Coco and his Catholicism, in 1924 Reverdy settled in Solesmes with his pretty seamstress wife Henriette, while Coco went off on a cruise with the Duke of Westminster, the start of a long, close friendship. Shrewd enough to realize that she would never be accepted in English society as the Duke's wife, she broke off the affair and briefly revived her liaison with Reverdy. She was never to marry but had many friends, including Cocteau whom, as we saw, she helped to rescue from opium.

With her background of adversity Coco realized that post-war women wanted less expensive and more functional clothes than Poiret was providing. She launched a simple well-cut black dress in crêpe-de-chine, easy to wear and versatile enough to serve both in the street and at a cocktail party. She followed this by launching jersey wool, hitherto used for men's underwear, as a smart fabric. Then either she or Jean Patou – authorship is disputed – created separates: floppy jumpers and easy pleated skirts. She introduced British tweeds for country wear and, in the form of plus fours, for the golf course.

With the 1930s a reaction set in, as women again sought to emphasize their femininity. The waistline moved up from the hips, the hemline dropped until in 1934 it was below the calf. Coco continued to contribute brilliant additions to this new trend, but in the mid-1930s was eclipsed by a new arrival from Italy, Elsa Schiaparelli, who gave Paris a new vogue colour, shocking pink, and in collaboration with Cocteau and Dali designed amusing box-jackets with surrealist buttons or daringly embroidered with big flowers in raised gold.

Before the War scent had been made from essences of flowers and costly animal oils such as ambergris and musk, so that few could afford it. Coco Chanel encouraged a leading Grasse parfumeur,

Ernest Beaux, to make her eight to ten varieties of chemically synthesized aldehydes, these being cheaper than flower oils. Coco sampled them and decided she liked the fifth one best: it went into production, then into the shops, as Chanel No. 5.

With these and many other achievements to their credit, it is surprising that Frenchwomen still did not have the vote. On this matter there were two schools of thought. Just as the State preferred indirect to direct taxation, knowing it to be more effective and less resented, some women preferred indirect influence on civic affairs. Anna de Noailles was one. In 1923 she told the abbé Mugnier that she opposed the idea of women Academicians, because 'woman is in tow to man, she possesses a fortuitous, grafted-on element, she is accidental.' However, this did not deter Anna the poet from accepting an invitation to become an *académicienne* of the Belgian Academy.

The other school argued that it was a great injustice that women should be denied the vote, especially as half a million war widows were now *chefs de famille*. Léon Brunschvicg's wife, Cécile, presided over the most active group in favour of the vote, *L'Union française pour le suffrage des femmes*. Independently of Cécile, Duchesse Edmée de La Rochefoucauld furthered women's rights, founding in 1931 *L'union nationale pour le vote des femmes*. She discovered that the average Frenchman reacted more favourably to her arguments once she spoke up, not against his control over his wife's money, but against his son-in-law's squandering of his daughter's dowry. Among her most active supporters was Paul Valéry: he had discovered in Madame Bousquet a lady who talked politics more intelligently than many a deputy.

Another who worked for women's rights was Marthe Bray-Smeets. She argued that if women got the vote, that would prevent war. She travelled round provincial fairs with a tent where she showed photographs and films in support of her campaign. In 1930 she began to try to boycott toy soldiers, supported by songs she wrote herself on the evil of war games in the nursery.

The Senate consistently refused to grant women the vote, believing that they would vote as their curés told them, and with many more women than men on the electoral lists, that would be goodbye to a lay Republic. Frenchwomen did not protest against this in the way

English suffragettes had done. Partly they were more law-abiding than their counterparts across the Channel, partly they believed in the power of *douceur*.

In conclusion, we may say that women now had more opportunities than the previous generation for taking up a career or for leading a life of their choice. Those who did so added a rich and dynamic element to Paris. Those who married and had children by contrast saw themselves as guardians of tradition, protectors of home and family. Innovators in visual and æsthetic matters, in face of the new ideas and values beginning to circulate, they showed themselves conservative, sometimes narrowly so, and this could cause frustration or worse in the young. Implicit rejection of the values learned at their mother's knee often lies beneath the welcome accorded protest movements of the day, to one of which, Surrealism, we now turn.

5

ENEMIES OF REASON

There was one group of gifted young men who emerged from their wartime experiences so profoundly disillusioned with the society which had launched the war and emerged intact from it that they rejected en bloc the orderly civic values of that society as formulated by Brunschvicg and his kind, and sought to evolve an alternative creed.

Their movement originated in the Val-de-Grâce hospital in south Paris, where severely shell-shocked soldiers were treated. Here in September 1917 two medical orderlies met and discovered a shared taste in literature. André Breton, aged twenty-one, son of a small-town gendarme, had begun his medical studies when war broke out. Louis Aragon, a year younger, also came from a petit bourgeois family; his mother, separated from his father, ran a modest Paris boarding-house. In looks the two young men were somewhat alike: roundish faces, narrow slanting eyes, hair set in a nearly straight line. Breton had a serious, preoccupied expression, Aragon was more relaxed, an admirer of the Romantic poets. Breton preferred the rebel iconoclasts: Rimbaud, who had left home and an authoritative mother to run guns in Ethiopia, and the prose-poet Lautréamont, who in the persona of Maldoror claimed to be something more than the son of a man and a woman, and rebelled against his mortality.

Breton and Aragon quickly became friends. They moved into the same dormitory and over their beds, much to the derision of their neighbours, pinned up photographs of paintings by Picasso, Braque and Matisse. They went to poetry readings together, browsed in Adrienne Monnier's avant-garde bookshop, showed each other their poetry.

They were sensitive young men and they found their work nursing the shell-shocked an ordeal. The wards echoed to cries of pain, to hysteria, hallucinations and nightmares. The worst cases had to be put in strait-jackets and locked up at night. Breton and Aragon were not doctors, just male nurses, relatively powerless, and whereas soldiers at the front could find some fulfilment in holding back the invader, they were by and large passive figures. Fighting soldiers won citations, but not hospital orderlies. So Breton and Aragon emerged from the war without the sense of achievement experienced by Dorgelès and his kind. For Breton and Aragon war was the product of a selfish bourgeois society, based on a narrow conception of man's personality, and they decided that it was by protesting against society's values that they could win laurels more imperishable than those accorded soldiers in the trenches.

In the Val-de-Grâce some of the unfortunate shell-shocked patients would utter disjointed phrases, and others would repeat verbal images that seemed to obsess them. Doctors, applying the methods of Janet and sometimes using hypnosis, made use of these utterances like an Ariadne's thread to draw the patient safely away from his minotaur. Breton, watching, realized that sanity could sometimes express itself in startling, irrational language.

It so happened that one of the poems Breton most admired, Rimbaud's *Illuminations*, juxtaposed incongruous images in order to express a youthful rebellion against family authority. Putting this and his hospital observations together, Breton groped for a new kind of writing that would give primacy to disjointed images before the conscious mind has time to tidy or censor them.

Breton found that quite often an incongruous phrase would impinge on his mind and become obsessive. One day, while he was crossing the busy place de l'Etoile, the phrase '*Pneus patte de velours*' came to mind – 'Velvet-pawed tyres', and because it would not leave him alone, he decided it might have some occult value.

Breton drew on such phrases in the prose poetry he had begun to write, and in 1919 joined with a hypersensitive young budding poet, Philippe Soupault, to take literary experimentation a stage further.

For ten days in May, without a given subject, Breton and Soupault uttered aloud disjointed phrases and haunting images as they flitted through their unconscious, then jotted down these babblings on loose

sheets of schoolroom paper. After a session of several hours each read to the other what he had written. Breton thought he could detect underlying patterns and set about arranging the papers into chapters by theme, adding favourite obsessive phrases such as '*Pneus patte de velours*'.

These chapters, to which he gave the title *Champs magnétiques*, Breton published in the last months of 1919 in a 16-page monthly review he had founded with the tongue-in-cheek title *Littérature*. Their underlying thrust is to probe beneath accepted surfaces and to expose images from which we usually recoil, as in these examples:

> The window sunk in our flesh opens on to our heart. There one sees an immense lake on which lustrous bronze peony-scented dragonflies alight at noon.

> Beauty dressed in fire, you have wounded me with your thin equatorial riding-crop.

> Alas! A friend of the family had given me a jellyfish and so that this respectable animal should not go hungry, a green liqueur containing copper water.

Champs magnétiques is literary experiment, not literature, but it was quite a bold effort for its day by men in their early twenties.

Breton accepted for publication in *Littérature* innovative work of a rebellious nature, much of it uneven. Aragon contributed free verse in which he asked himself 'Are you going to drag out your whole life in a world half dead, half asleep – Haven't you had enough of platitudes?' Pierre Drieu La Rochelle, who in the trenches had discovered himself to be a coward, was now looking for a strong leader to follow:

> Mankind has seized their totem from the Titans,
> The stern alliance with Iron will be celebrated,
> Our brother Iron will be praised and all the exultant household
> of Steam, Electricity, and the sister forces of him whom we await.

A lighter contribution to *Littérature* came from Marcel Duchamp. Nine years older than Breton, painter, sculptor and chess champion, Duchamp had shocked New York by exhibiting in an art show a

urinal entitled 'Fountain'. Duchamp invented a female character called Rrose Sélavy (an inversion of *C'est la vie en rose*), symbolizing free verse and presiding from New York, where Duchamp was then living, over verbal games and issuing pronouncements in 'Confucius-say' form. Responding to Breton's request for a contribution, Duchamp sent *Littérature* half a dozen such pronouncements, of which this is one:

> *Rrose Sélavy trouve qu'un incesticide doit coucher avec sa mère avant de la tuer: les punaises sont de rigueur.*

> 'Rrose Sélavy finds that an incesticide should sleep with his mother before killing her: drawing-pins obligatory.' *Punaises* can also mean 'mischief-makers'.

Duchamp's rich vein of subversive humour based on punning was later to be successfully developed, as we shall see, by a younger friend of Breton's, Robert Desnos.

While Breton and Aragon were pursuing their vocation of protest through literature, a young Romanian entered their lives. Small, quietly spoken, neatly dressed in a black suit, a mesh of black hair falling over his brow, a monocle in his right eye, Tristan Tzara did not attract notice but neither does a hand grenade. In 1916 he had gone to Zürich as a refugee pacifist and joined with Hans Arp, an artist from Alsace, to found a militant radical movement under the purposely meaningless name of Dada, dedicated to ending war by cleaning up society:

> There is a great destructive negative work to be done [Tzara declared]. To sweep away, to clean . . . Freedom: dada, dada, dada, bellowing of contorted pain, intertwining of contraries and all contradictions, grotesques and non-sequiturs: *Life*.

Tzara's Dada had spread to Berlin, where it took a political form. Dadaists staged street plays and organized a major exhibition under the banner: 'Dada fights side by side with the revolutionary proletariat,' with an image of a pig-headed Reichswehr officer suspended from the ceiling, and parodies of the Old Masters interspersed with Otto Dix's 'War Cripples'.

Arriving in Paris, Tzara expounded to Breton his total metaphysical anarchism, revolt against everything, including Dada itself: 'true Dadas are against Dada,' and found a sympathetic listener.

Now a trio – Breton, Aragon and Tzara – began to stage public meetings, enlivened by jazz, considered subversive, and with walls decorated by Breton's friend, Francis Picabia, who painted pointless machines that do not work. They read Dada manifestos at the People's University in working-class Paris, calling for 'artistic free thought'; they published a tract entitled 'Demon in the Home', urging women to escape 'the conjugal cellar'.

Newspaper reports of these wild doings reached distant Lorient, from where Breton's worthy parents were paying their son an allowance they could barely afford in the belief that he was studying to be a doctor. In alarm they made the expensive train journey to Paris and told André that unless he resumed his medical course or took a steady job in Lorient his allowance would cease.

Breton hesitated. He consulted Paul Valéry, who had encouraged him to found *Littérature*, and through the older poet's influence was offered a proof-reading job by Gallimard. Breton accepted it and found that one of his first assignments was to visit Marcel Proust's cork-lined apartment where he was asked to read aloud proofs of *Sodome et Gomorrhe*, inserting any corrections Proust desired. A dreamy poet opposed to such bourgeois virtues as logic and accuracy was hardly the man for the job, and Proust's book was to appear with 200 errors.

Breton found a new job providing Jacques Doucet, a rich patron of literature, with summaries of avant-garde work. Now self-supporting, he was in a position to pursue literary subversion *à la dada*. In adolescence he had much admired Maurice Barrès, author of quasi-mystical novels idolizing his native Lorraine. But during the war Barrès had become a leading jingoist, pouring out emotional articles about the gaiety of French troops in the trenches and their eagerness to shed their blood, and now, as President of the League of Patriots, he declared that what mattered most to young Frenchmen was the problem of the Rhine frontier. This later Barrès sickened Breton, and he resolved to attack everything his former hero now stood for by putting him on mock trial.

On 13 May 1921 in a hired hall arranged as a courtroom,

proceedings opened. Breton, wearing a square red cap, presided; Aragon and Soupault, in square black caps, appeared for the defence. A tailor's dummy represented Barrès, who had an engagement elsewhere; opposite sat the jury.

The prosecutor, a friend of Breton named Ribemont-Dessaignes, stated the charge: *'crime contre la sûreté de l'esprit'* – crime, not against State security but against the security of the mind – a curious charge considering the Dadaists' disapproval of rationality – then went on to cite alleged misdeeds: Barrès had failed to live up to what was unique in himself ('self-kleptomania'), he had dispersed himself in a flurry of worldly activity and thereby alienated a younger generation from the good in his early work.

Witnesses were called both for and against, some addressing serious topics such as the relation between thought and action. There were funny moments when Tzara sang the Dada anthem, and there was scandal too when the Unknown Soldier entered, wearing a blue French uniform but speaking in guttural German. In due course the jury found Barrès guilty of the charge, but there was no bitterness, and no punishment proposed. The purpose had been mainly to publicize Breton's version of Dada.

During the next two years Breton's enthusiasm for Tzara cooled. The Romanian, he saw, was negative, almost a nihilist, who believed it necessary to destroy society before 'purified man' could emerge. Breton, on reflection, could not subscribe to that. But it was through at first embracing, then rejecting Dada that the Frenchman succeeded in formulating his own position – initially in clumsy and tentative terms.

To describe the merging of costume, decor, music and dance in the Cocteau/Picasso ballet *Parade* Guillaume Apollinaire had used a word of his own coining, *Surréalisme*, adding that such a technique had a great future. In 1924 Breton borrowed Apollinaire's word to describe his creed, when he published a *Manifesto of Surrealism*.

But Breton gave it new meaning, as follows:

SURREALISM. Pure psychic automatism whereby we offer to express, verbally, in writing or in any other way, the real functioning of thought. Dictation by thought, without any control by reason, without any æsthetic or moral preoccupation.

63

SURREALISM as a philosophy. Surrealism is based on a belief in the superior reality of certain kinds of association hitherto neglected, in the overriding power of dream, in disinterested thought-play. It tends to ruin definitively all other psychic mechanisms and to supersede them in solving the main problems of life.

Breton in effect was hoping to replace Descartes' *cogito* with 'I feel, I fantasize, I dream, therefore I am.'

Continuing his *Manifesto*, Breton imparted 'secrets of magic Surrealist art'; 'Put yourself,' he said, 'in the most passive or receptive state possible. Leave aside your genius, your talents and those of everyone else . . . Write fast [Breton in fact tended to be a very slow writer] with no preconceived subject . . . Trust in the inexhaustibility of the murmur. If you make a slip or things go silent . . . alter the word that seems to you suspect, write any letter, *l* for example, always *l*, and restore arbitrariness by making the next word begin with that letter.'

This manifesto created a stir among Paris's avant-garde. Here at last was something solid, that people could get their teeth into. Vaguely rebellious budding young writers flocked to Breton, seeking further information, pledging support.

Breton now felt confident enough to rent a room at 15 rue de Grenelle, to furnish it, and to hang from the ceiling the plaster cast of a woman, for he attributed considerable importance to women's intuitive gifts. He then opened it as a Centre for Surrealist Research, inviting the public to bring material of a Surrealist nature. Whereupon Jean Painlevé, the Prime Minister's son, brought the blotters from a Cabinet meeting. Breton reproduced them in his new periodical, a successor to *Littérature*, *La révolution surréaliste*, as evidence that Surrealism had penetrated the Government.

As well as encouraging research, such as automatic writing and the recording of unusual dreams, Breton tried to impart to his group certain principles of a moral nature – though he would have rejected that description. Holidaying in Brittany, Breton happened one day to see a pig rooting on the beach: 'There goes God,' he announced. On several later occasions Breton repeated that God is a pig, but never explained whether this was a revelation granted to him alone,

a boutade or a deliberately outrageous statement designed to make people think. It is certain however that Breton's code of behaviour owes little to theology and much to a residual petit-bourgeois decency.

Breton held that drug-taking, homosexuality and fast living were incompatible with Surrealism, so he disapproved of Cocteau and Morand. On the other hand he believed that one should never resist the call of passionate love, and that for a man an extra-marital affair was quite in order provided he told his wife about it. Sincerity, in short, had high value. Journalism, however, was disapproved of, as a form of compromise with bourgeois society, as were expensive luxuries, such as fast cars. In all these matters Breton, who had much of his gendarme father, took a firm stand that sometimes irritated his group.

Breton by temperament was tense and inclined to brood. Aragon, still Breton's alter ego, was more relaxed and gregarious: he read newspapers, liked cafés and dancing. It was Aragon who discovered that a good remedy for spleen was to browse in unfamiliar quarters of Paris. In 1926 he published a still readable book about his browsings, *Le Paysan de Paris*. The eponymous *paysan* is the small shopkeeper and resident of Passage de l'Opéra, a dim glass-covered arcade housing small shops, cafés, offices and furnished lodgings. It is under threat of demolition to make way for higher buildings and larger shops – 'a glass coffin'. The book is partly a plea for Paris's 'little men'.

Aragon describes his fascination with the glaucous passage, where he senses a 'new divinity' about to be born. One shop sells curiously carved pipes, another quaintly headed walking sticks. There is a bookshop where browsers read periodicals without buying them, squinting up uncut pages, while an accordionist makes music on an instrument which, as it unfolds, displays the word PESSIMISM.

Aragon watches women in the passageway trawling for lovers and applauds them for possessing a soul noble enough not to rest content with a hollow marriage. On the strength of his status as a medical student, 'wishing to study feminine habits', he is allowed by a friendly café owner to watch, unobserved, lady customers powdering their noses and arranging their hair in the ladies' room of the café.

65

Aragon describes delightedly ladies' hairstyles, their powder and rouge, earrings, necklaces, hats, blouses, skirts and petticoats.

Aragon's tour of the passageway culminates in a brothel, where he is pleased that the woman he chooses accedes 'docilely' to his desires. He now feels 'freed from a convention: in full anarchy as one might say in full sunshine'. The 'new divinity', we note, has turned out to be a lady of the oldest profession.

Aragon's book made exploring quaint Paris *de rigueur* for good Surrealists. For those who preferred something more sedentary Breton recommended a familiar nursery game. One person writes the subject of a sentence, hides it by folding the paper and passes it to a second, who writes a verb, again folds the paper, while a third writes the object or complement. This continues until a short text has emerged, supposedly 'magnetic' or Sibylline.

A more dramatic activity centred on a young member of the group. The son of a Les Halles wholesale poulterer, Robert Desnos was small, with full cheeks, sensual lips, black hair brushed straight back and memorable protruding oyster-coloured eyes under heavy dark lids. Too young to have taken part in the war, he earned his living in a publishing firm. After reading *Champs magnétiques* he joined the Surrealists and began to write free verse drawn from the states of reverie to which he was prone.

Breton discovered that Desnos could fall asleep almost at will and while asleep describe the scenes passing before his closed eyes. Here, as it seemed, was Surrealist art bubbling up from the depths of the mind! So Breton would invite Desnos to a café where under bright lights, surrounded by the faithful, amid beer glasses and cups of coffee, he would close those heavy-lidded eyes and very soon begin to pour forth vibrant colourful phrases, disconnected but vaguely prophetic, with certain underlying themes, notably an alternation between anguish and joy, and sexual encounters in which he was both executioner and victim.

Occasionally he became aggressive. On one evening he claimed to be Robespierre – whose name resembled his own Christian names, Robert Pierre – and declaimed revolutionary slogans, while on another evening he grabbed a knife and began attacking the company. Breton had to call a doctor who eventually disarmed him.

Some thought Desnos was shamming and in later life he was to

admit to occasional dupery. But Breton was probably correct in considering Desnos genuinely capable of trance states, and his public performances certainly did much to substantiate Breton's theorizing.

The Surrealists had not forgotten their commitment to protest and tumult. In 1924, when Anatole France died, they demonstrated scoffingly against nationwide mourning for one they considered 'smugly ensconced in irony'. In the same year they crowded the Vaudeville loudly to applaud a self-indulgent plotless play by a rich amateur, Raymond Roussel, which ended in a free-for-all between them and the rest of a disapproving audience. They carried on a running battle with Maurice Martin du Gard's mainstream literary weekly, *Les Nouvelles littéraires*, and on one occasion raided its offices, throwing typewriters out of the window.

At the centre of Breton's character was a sensibility open to the new or strange together with a dour, plodding steadiness: these qualities magnetized – a favourite word – an inner circle of friends. One was Paul Eluard, yet another wartime medical orderly: good-looking, warm, easy to get on with. Like Brunschvicg, Eluard was a pantheist but his pantheism took the form of believing that God manifests himself most fully in beautiful women, to whom, beset by chronic tuberculosis, he felt an extreme and persistent attraction. Much of his early writing, in free verse, rhapsodizes his Russian-born wife Gala Diakonava, something of a *femme fatale*, and rhapsodizes her yet more passionately when she left him for Salvador Dali.

Another of Breton's friends, though more tormented, was Antonin Artaud. An actor by profession, he was to turn in a haunting performance as the virulent revolutionary Marat in Abel Gance's silent film, *Napoléon*. Shortly before this, he joined Breton, inform-ing the Magus – as Breton was often termed – that he had been a Surrealist all the twenty-nine years of his life. He meant that he frequently became aware in daily life of what he called an anguished shuttling between existence and non-existence. For such a man Eastern thought proved attractive and, invited by Breton to compile the third issue of *La révolution surréaliste*, Artaud addressed the spiritual head of Tibetan Buddhism: 'We are your very faithful servants, O Great Lama, convey to us your insights in a language our

contaminated European minds can understand'; then he calls on the schools of Buddha: 'Come, save us from these larvæ in which we subsist. Invent for us new mansions.' Artaud ends by declaring that Siva has taken a new avatar in the latest 'oriental' creed – Bolshevism!

Among those close to Breton it was Aragon who valued Bolshevism most highly, seeing it as the total emancipation of man from moral and social traditions. It was largely through his influence that Breton joined the Communist Party in 1927, along with Aragon and Eluard. Whereupon Artaud, characteristically volatile, broke with the group: 'What separates me from the Surrealists is that they love life as much as I despise it.'

The two years he spent in the Communist Party taught Breton that it was a mistake to place experiments relating to the inner life under external control, but they also helped him to develop further his own thinking. Breaking with the Party in 1929, he published the *Second Manifesto of Surrealism*.

In it Breton calls for a more complete and furious break with society in order to discover that point in the mind 'where life and death, the real and the imaginary, past and future, what is communicable and what is incommunicable, high and low cease to be perceived as contradictory.'

The manifesto, insofar as it is intelligible, seems to be a plea for a wholeness and completeness such as mystics strive to attain by self-control. Breton, however, wished it to be attained by losing control, by free association and by acting on the prompting of dreams and 'intended coincidences'.

What Breton says about life and death not being contradictory is close to Cocteau's belief that life and death are parts of the same whole. Despite contrasting temperaments and ways of life, both men were searching for a less one-sided creed than the rationalist-humanism taught at school. Traditionally Christianity had supplied the need, with religious belief underpinned by reason but going beyond reason to express man's longing for wholeness and perfection, but Breton, like Cocteau, was unable or unwilling to accept it.

In France any group, school or party is almost by definition doomed to quarrel, then splinter. Breton devoted part of his manifesto to criticizing Artaud, and also Desnos for earning his living as

a journalist. Whereupon Desnos and his sympathizers, including Ribemont-Dessaignes, published a virulent pamphlet, *The Corpse*, denouncing Breton as a police inspector. Aragon, remaining in the Communist Party, formed a third splinter group. Tzara left Dadaism to join Breton. Yet in their different modes all continued to wage war on restrictive rationalism.

Let us look at how some of the Surrealists put to work in their private lives a central aspect of their creed: namely that falling in love is a sure means to becoming 'whole', particularly if the woman is of exotic origin, like Gala, or possesses unusual gifts of intuition.

Nancy Cunard was the daughter of an American lady who had become one of London's leading hostesses, and of a wealthy shipping magnate. Her parents lived apart. Nancy did not get on with her mother and, encouraged by the author George Moore, who had spent happy youthful years in France, came to Paris. Already a rebel, Nancy warmed to the Surrealists, particularly to Aragon, who had published poetry, for she had ambitions to be a poet. She became a familiar figure in the Surrealists' favourite Café Cyrano, on Place Blanche. Aged thirty, 'Nancy's allure was striking,' one of the Surrealists wrote. 'One noticed first her eyes, which were very blue and quite strange, her fine bony face, her lion-like mane of fine blonde hair; then one was amazed to see how her thin arms were covered, from wrists to shoulder, with African ivory bracelets.'

Aragon fell in love with Nancy, conducted her round Paris, instructed her about the city's poor, whose plight was to be alleviated somewhat by the 1928 Loi Loucheur, providing inexpensive State housing. For two years they were inseparable, in Left Bank cafés, in country holidays, in Madrid where Aragon went to lecture, in Venice. Breton disapproved, for Nancy represented the rich fashionable world that he despised.

Aragon wanted the liaison to be exclusive and lasting. Nancy, more frivolous, wished to have several admirers dancing attendance. Physically also she was less robust than he, with a tendency to anorexia, and she began to find Aragon's sexual demands exhausting. In Venice she left him for a black jazz pianist. After a carefully unsuccessful suicide attempt expected of a Surrealist, Aragon

returned to Paris, where presently he was to find, and to marry, another woman with blue eyes, the Russian Communist Elsa Triolet.

Breton's attitude to women was more complicated than Aragon's. As a boy of seventeen he had been stirred by Gustave Moreau's decadent paintings of destructive women, some in armour, notably *Salomé*, holding the decapitated head of John the Baptist, and he considered these influenced his attitude to the other sex.

Breton's most deeply felt love-affair began on the afternoon of 4 October 1926. Leaving his flat at 42 rue Fontaine, he made for the Opéra, stopping at *L'Humanité* bookshop to buy Trotsky's latest publication. He walked on, noticing tired workers returning home after a full day and he thought: It is not with such people that the Revolution will be made.

He crossed in front of the church of St Vincent de Paul and noticed among the crowd a young woman with fair hair and strongly mascaraed eyes, poorly dressed but walking with style, like a dancer, head high. Wondering whether she was an actress or prostitute, he stopped and spoke to her. She said she was on the way to the hairdresser. He persuaded her to join him at a nearby café and there she told him her story.

She was twenty-four, born near Lille of a Belgian mother and French father. Her name was Léona but she called herself Nadja because, she explained, 'in Russian that's the beginning of the word meaning hope – only the beginning.' Her parents didn't get on, money was short, and at eighteen Nadja had had an affair with a student. A baby girl was born. Three years later, leaving the girl with her parents, she came to Paris, where she worked as a food shop salesgirl.

Breton was stirred first by the name Nadja at a time when he was deeply attracted to Russia; then by the girl's plight, and most particularly by her words as they parted, to the effect that she had always known they were fated to meet.

Next day they met again. Nadja was now smartly dressed, with a hat, silk stockings and high-heeled shoes. Selecting a poem from a book Breton was carrying, she read it aloud, and to Breton's astonishment her reading was unusually sensitive to the sound and meaning of every word. He discovered also that she could draw well, among her favourite subjects being the snake-woman enchantress,

Melusine. In the taxi going back they played the game of closing their eyes, thinking of a word and building a story round it.

At their next meeting Nadja chose to have dinner outside in the Place Dauphine. There, telescoping past and present, she claimed to see the Templars being burned at the stake. Later, passing the Conciergerie, she seized the window bars, claiming she was a friend of Marie Antoinette. As they crossed the Seine Breton tried to calm her by reciting a Baudelaire poem, but this increased her anguish and she claimed to see a terrifying flaming hand rise from the river.

In the rue Saint-Honoré, Nadja noticed an illuminated bar sign, *Le Dauphin*, and recalled that they had come from Place Dauphine. Breton was much struck by this, for friends called him the dolphin – an animal said to have guarded the Delphic oracle – and Nadja could not know this.

Soon the predictable happened. Nadja could not pay her rent and told Breton she would have to pick up a rich 'protector' outside one of Paris's smart hotels. Breton promised her 500 francs next day, whereupon she allowed him to kiss her front teeth: to Breton they seemed like a Communion host. His mail next morning included a postcard from Aragon depicting part of Uccello's *Profanation of the Host*. More and more he felt himself being guided by some 'magnetic field'.

A week after their first meeting Breton and Nadja went for a walk in the forest of Saint-Germain and spent the night in a nearby hotel. Afterwards Breton confided to a friend, 'With Nadja it's like making love to Joan of Arc.' A woman in armour.

Breton tried to integrate Nadja into his circle. His wife Simone helped, knowing how much her divinatory powers mattered to André. But Nadja became increasingly possessive, writing him passionate letters comparing him to the sun, and urging him to write a novel in which she would be the heroine.

Breton decided that he didn't love Nadja and that she was dangerous but could not bring himself to leave her. He received pathetic notes:

> It is still raining
> My room is dark
> My heart is in an abyss
> My reason is dying.

Two months later the unfortunate young woman became a prey to violent hallucinations and was removed to a psychiatric hospital, first in Paris, then in Lille, where she was to remain until her death in 1941. Breton meanwhile wrote a Memoir of their affair and a poem about her, speaking of her fair hair, 'full of little splinters of glass', and confessing that he should never have involved himself with her. One reminder of Nadja persisted. He felt convinced that the Seine at Paris concealed the body of a mythical woman, her pubes the Place Dauphine.

Robert Desnos was better integrated into society than Breton – he won a reputation as a journalist, then as a writer for radio – but his relations with women were even more singular. At thirteen he had been sent for a term to a school in Kent to learn English. For some misdemeanour he received a caning from the schoolmistress, and derived from her blows acute pleasure. Thereafter he felt drawn to women who would be sure to hurt him.

First there was Yvonne George, a prominent Montparnasse singer, whom he named 'the starfish'. When Yvonne died of drugs in 1930 Desnos fell in love with Youki, an artist's model married to the Japanese painter Foujita. He called her 'the siren' and, Cocteau-like, believed her to be Yvonne in a new body. Neither granted him the passionate embraces he secretly feared and over the years he suffered pangs of rejection. In these pangs lay his pleasure and the inspiration of some of his writing.

Deuil sur deuil is a collection of stories in which the narrator pursues an elusive blonde virgin, abounding in coded allusions to castration and avoidance of sexual encounter:

L'étoile du Nord à l'étoile du Sud envoie ce télégramme: 'Décapite à l'instant ta comète rouge et ta comète violette qui te trahissent.'

The North Star sends the Southern Star this telegram: 'Behead instantly, for treachery, your red comet and your violet comet.'

Tiré de son sommeil, l'aviateur enterré au kilomètre 178 détourne les rails trente secondes avant l'arrivée du rapide et l'aiguille sur la lune. Le train passe avec un bruit d'enfer. Il fait ombre sur notre satellite et disparaît . . .

72

Woken from his sleep, the pilot buried at kilometre-marker 178 switches the rails thirty seconds before the express arrives and sends it towards the moon. The train passes with a hellish noise. It casts a shadow on our satellite and disappears . . .

Linked to this sexual predicament was a gift for humour of the nonsense variety. Using as a starting-point Marcel Duchamp's contribution to *Littérature*, Desnos published under the title *Rrose Sélavy* 150 unconnected phrases in which Spoonerisms, puns and anagrams are used to light up seemingly dim statements.

Le gras légat sorti du cloître a vraiment l'éclat d'un goitre.

The fat legate who has left the cloister really possesses a dazzling goitre.

Rrose Sélavy a découvert que la particule des nobles n'est pas la partie noble du cul.

Rrose Sélavy has discovered that the particule prized by noble families is not the noble part of their posterior.

Dans un temple en stuc de pomme le pasteur distillait le suc des psaumes.

In an apple-stucco temple the pastor distilled the pith of the psalms.

In his next-but-one collection, prose poems entitled *Langage cuit* (as opposed to *Langage cru*, crude language) Desnos carries verbal subversion further by distorting or jettisoning the rules of syntax. We find '*je neigerai*', '*je fais tard*', '*je mauve*', '*je cristal*'. Conventional similes are turned on their head: '*dents comme des perles*' becomes '*les perles de son collier étaient belles comme des dents*'; '*le baiser du feu*' becomes '*feu de baisers*'. By subverting the expected order, Desnos is suggesting that meaning is a convention imposed on a nonsensical world.

When he went to work for radio in the 'thirties, Desnos used his love of puns to publicize a brand of tea called *Thé des Familles*. His slogan ran: '*Pas de santé, Sans Thé des Familles.*' And, as a specialist in the dream world, he composed many charming poems claiming to interpret listeners' dreams, nearly always in a playful way, for

despite his unhappy love-life Desnos was the most cheerful of all the Surrealists.

Desnos's experiments were to make possible the work of two fellow Surrealists: Raymond Queneau, who in *Le chiendent* (1933) discovered the humour in cliché-strewn petit-bourgeois conversation, and the poet Jacques Prévert, who saw vocabulary as a group of children, and his role to bring them out of the classroom into the playground. Though the Surrealists' literary techniques have today been abandoned or superseded, at the time they had a sharp cutting edge.

As an approach to life Surrealism was to have a widespread effect throughout our period. Breton the young medical orderly had become a trusted doctor of the psyche, castigating superficiality and lazy thinking. He taught the young to cast their nets deeper than their parents had done. He urged them to be sincere with themselves and with one another. All this could be helpful. But also he taught civic subversion, rebellion against established authority. He attached undue value to imagination in the void. So the Surrealists' creed of extreme individualism threatened society more than the Hedonists' did, since their rejection of any generally binding absolute values made reasonable argument with them difficult and a consensus almost impossible.

In the specific field of the arts other than literature Surrealism also left its mark, notably through its use of incongruous images and free association, but it was only one of a great many new influences. After the War's four-year virtual silence creative Parisians were bursting into song. In painting, on film, in the theatre and in music they had new things to impart and new ways of imparting them. To the first of these we now turn.

74

6

THE SEARCH FOR MAN'S CENTRE

Already before the war a few innovative painters had been moving away from representing on paper or canvas the object before their eyes. The Fauves had done this emotionally, Matisse with green shadow in a portrait of his wife, Derain with an orange Seine, the Cubists intellectually, adding to the object present before them data from their memories of it.

The war intensified and speeded up this process. After the savagery of the trenches many sensitive people recoiled from the past and from traditional ways of looking at the world. Their trust in society shaken, they turned their creative gifts towards making art that reduced the importance of the object and increased the importance of their own feelings and interpretation of it. Against a background of changed frontiers and suddenly valueless currencies such art gave its creator a reassuring sense of identity, even a certain feeling of power.

So great had the reputation of Paris become under Matisse, Picasso and Braque that it was there that young artists chose to go to create their private worlds. Tiny Montmartre having become too expensive, they crossed the river to idyllically named Montparnasse.

They came from countries near and far. Marc Chagall arrived from Russia with his sky enlivened by angels and flying brides, Chaïm Soutine from Lithuania with his pinched boy faces and gory carcases of beef. They and others who had formed their style before arriving stood outside the main currents of innovation.

Among the immigrants a small group chose to address anew a favourite Parisian subject, the female nude. Three artists in particular excelled here: Jules Pascin, a Bulgarian who, like Charlie

75

Chaplin, wore a bowler hat even indoors; Moïse Kisling, a jolly Pole who could make funny animal noises and mix the latest cocktail, and Tsuguharu Foujita, a Japanese with round horn-rimmed spectacles and a thick black fringe, a natural comic whose monkey antics made him popular with women and with the Press.

The women they painted were no less colourful. Alice Prin came from Burgundy to start work in Paris at fourteen; three years later she was performing as a singer and dancer. She had big wide-set eyes, dark hair worn in a low fringe, a turned-up pert nose and a strong body. Known to everyone as Kiki, she was full of fun, a good storyteller and a general favourite. In the evening at the Dôme café she could be seen at her usual table, stroking a pet white mouse chained to her wrist, her olive pallor heightened by a heavy coat of powder and set off by black-cherry lipstick. She drew and painted competently and in 1927 held an exhibition, its catalogue prefaced by Desnos, who wrote: 'You have, my dear Kiki, such beautiful eyes that the world you see through them must be beautiful.' As well as posing for scores of artists Kiki played the game of musical beds more ardently than most, and at twenty-eight had lived fully enough to write her Memoirs, prefaced by Ernest Hemingway, who compared her to Moll Flanders.

Another favourite in the studios and cafés-dansants, Lucie Badoul, was a prosperous farmer's daughter with a well-proportioned figure and a taste for adventure. One day she read Apollinaire's description of the Rotonde café and its bohemian clientèle; so intrigued was she that she put on her make-up, picked up her cat and took the *métro* to Montparnasse, a district she did not know. There she saw Foujita, fell in love with him, secured an introduction, posed for him and within a week had become his mistress.

Foujita usually worked with a low easel sitting on the floor. He prepared his canvas to obtain an even milky ground, on which he drew with a fine brush. In his first large painting of Lucie, shown at the 1924 Salon d'Automne, he depicts her lying arched backwards on snow-covered ground, beside her a black dog. With arms and long black hair falling down behind her head she has become an object of total submission, and the icy hair holds a hint of sadism. Foujita entitled the painting *Youki, Goddess of Snow*, and thereafter Lucie was known as Youki.

Foujita publicized his work with innumerable stunts such as riding a tiny bicycle along the front of Deauville and having Youki do a handstand for photographers in the studio of their new home. He became rich and lavished gifts on Youki. Then in 1931, having earned and squandered a fortune, he returned alone and penniless to Japan, entrusting Youki to her adoring swain, Robert Desnos: 'You will celebrate her in words as I have done in paint.'

A few streets away from the Rotonde's champagne parties a Catalonian worked in a ramshackle garden shed, quite unknown and with barely enough to eat. Joan Miró was the son of a goldsmith. At art school in Barcelona he was taught to observe closely animals and insects and to recognize objects, blindfolded, by touch. From an early age he felt drawn to the small things of nature. If he was shown a landscape of mighty eucalyptuses, what he noticed was the texture of the trees' bark.

At twenty-seven Miró went for a winter to Paris. 'As soon as I arrived, my hands became paralysed. I couldn't hold a pencil. It was intellectual paralysis. The shock had been too much, and for a long time I remained unable to work. In the mornings I went to the Louvre, in the afternoon to galleries.'

Presently Miró began to paint, in a spare naïf style, imaginary landscapes, often with animals, enlivened by filigrees of small detail. The most important of these early works, *La Ferme*, depicts a Spanish farm by moonlight, with tools and animals in an outhouse like so many toys in a shop window, the whole dominated by a thorn the size of a tree, its spindly branches like electric bulb filaments. The picture was so big he had to take it by taxi to a dealer, Léonce Rosenberg. Rosenberg said it was much too big for a Paris flat and advised him to cut it into four. Miró resisted the advice and later sold it to an American.

Miró led an orderly life and kept his tiny shed spick and span. He had a strong sense of fun and was good company. Soon he drifted into Breton's group, not yet called Surrealists, and watched their experiments in automatic writing and in the composite drawings on folded paper already mentioned, in which three artists in turn contribute on a given subject.

Miró saw in some of the Surrealist work an approach similar to that of the Romanesque fresco painters of legendary and heraldic

animals he had much loved as a boy. Under the influence of the Surrealists and of the Swiss Paul Klee, whose small-scale work he first saw in 1923, Miró discovered his own centre, that is to say a distinctive way of representing the small-scale natural world he felt so closely in touch with in a spirit of fantasy and joyful humour.

The first important work to emerge from this is *Le Carnaval d'Arlequin*, painted between 1924 and 1925. Miró then quite literally did not have enough to eat and refused to call on his parents for financial help. He found that his diet of two or three dried figs a day induced hallucinations, some of which found their way into this strange picture of eels and tadpoles wriggling among small balloons and notes of music.

At midnight on 12 June 1925 at the Galerie Pierre in rue Bonaparte, Miró presided at the vernissage of his newest works. In black jacket, striped trousers, white gaiters and in one eye a monocle – Surrealist taste for the unusual – Miró received his guests, who included Kiki and Youki. At one point there was such a crowd the police called, suspecting sedition. But there was no sedition, and no sales either. Never mind, they adjourned to the Jockey night club, where Miró danced with Kiki. Though good-looking, Miró was short, while Kiki was tall, so their partnership added to the oddity.

The following year, in order to keep alive Miró composed designs for Diaghilev's production of Prokofiev's *Romeo and Juliet*. The ballet was subsidized by rich patrons. Breton and his group broke in to the theatre and from the stage threw tracts into the stalls, declaring: 'It is inadmissible that thought should take orders from money.' Again the police had to be called, and Miró was put in Breton's bad books, though the Catalonian lost no sleep over that.

Miró's neighbour in the run-down garden of 45 rue Blomet was André Masson, who had emerged from the War shattered and incoherent and undergone long treatment in Val-de-Grâce. With his wife and small daughter he lived in an extremely decrepit lodging where mouseholes in the wainscoting were covered with biscuit-tin tops. Masson worked by night as proof corrector for the *Journal Officiel*, and by day at his easel, subject to sudden fits of rage, struggling to establish in paint an order that continually eluded him.

Masson was saved from the hell of incoherence and insomnia by his dealer. Daniel Kahnweiler was a short stocky man in his early

forties, with a round face, big eyes, dark hair, prominent determined lips and an incipient double chin. German by birth, he had long made his home in Paris and before the War as Picasso's friend and dealer had done more than anyone to establish the Cubists. He held an exalted view of the dealer, whom he compared to an explorer working for posterity, and he considered a painting not an end in itself but an incitement to intellectual effort.

Masson's work was very much to the taste of Kahnweiler. After an early Surrealist period he entered the dangerous no-man's-land between figurative and non-figurative, striving to convey sometimes the anguish of his shell-shocked self, sometimes the lyrical joy of having survived, of being alive at all. Then he moved on to figurative painting of violent subjects: young girls wringing the necks of chickens and plucking them, bullfights, slaughterhouses.

Kahnweiler signed an agreement with Masson whereby he became his exclusive dealer in return for a regular monthly income. He photographed each of Masson's paintings as he finished it to form a record of his development, and sought buyers who valued his style and would continue to purchase. Perhaps most important of all, he welcomed him into the group that he and his Loire-born wife Lucie entertained in their house at 12 rue de la Mairie in the suburb of Boulogne-Billancourt every Sunday. The group included the sweet-natured sculptor Henri Laurens, who had lost a leg to tuberculosis of the bone and accompanied Kahnweiler to every performance of an opera by their beloved Gluck; Antonin Artaud, whose poems *Tric-trac du ciel* Kahnweiler published in a limited edition, and Kahnweiler's brother-in-law Elie Lascaux, a painter in the naïve style who illustrated Artaud's book.

The conversation would turn inevitably to art: the Salons, the state of the market, depressed since the War, the theatre, Diaghilev's Ballets russes, much disliked by Kahnweiler because they drew so many painters to costume design and decor. And Paris being Paris, because he insisted on living in the south of France, Matisse got short shrift: 'He sells Moroccan carpets to chic millionaires.'

Also of the company was Juan Gris, Kahnweiler's most important 'name'. With big dark eyes, black hair and olive complexion, this Spaniard was temperamentally at the opposite pole from Masson: contented and stable, he produced calm Cubist paintings notable for

pale blues, pale browns and greys – from which he took his assumed name. Gris was popular with everyone except Picasso, who considered he had reaped the fruits of Cubism without having done the hard pioneering. He was loyal to Kahnweiler, constantly refusing tempting offers from other dealers, and so friendly were the two that Gris had taken a house in the same street. After Lucie Kahnweiler had provided her guests with a supper of pork chops, salad and a cake, Gris, who loved dancing, would lead the company in a tango.

Masson repaid Kahnweiler's kindnesses by introducing him to a fellow-Surrealist who, like himself, owed much to André Breton's incitement to create art from fragmented images as they well up from memory, dream or other states unmonitored by mind. Yves Tanguy, the son of a Breton sea captain, began life as a trainee officer in the merchant navy. He left the sea for Paris and the Surrealists, where, without any formal training, he began to paint. A pugnacious character, with thick black eyebrows and unruly hair that stood up as though he had just seen a ghost, after a night's drinking Tanguy would lower his head and for no good reason charge at letter-boxes. In contrast to Miró's vivid palette, Tanguy used subdued, pale colours, to depict a sea world, estuaries and sands and stormy seas inhabited by fragments of sea-weed, micro-organisms and small fish. It is interesting that both Miró and Tanguy, such dissimilar characters, found the centre of the self in kinship with very small creatures.

Kahnweiler admired Tanguy's work and tried to become his dealer. But Tanguy already had a dealer and remained faithful to him. In 1933 his *Wanderlust* proved stronger than attachment to Paris, and he emigrated to the United States.

Side by side with the artists so far described are those who used every device of their keen intelligence cunningly to subvert society's traditional values. Some of them, but not all, were then to construct a fantastic alternative world that would symbolize the paradox, incongruity or impotence that they discovered at the centre of themselves.

Max Ernst was born in 1891 in the German town of Brühl. Reacting against his fervently Catholic parents, as an art student he became a prominent Dadaist. In *Œdipus Rex* (1922) he painted a

great haunting enigmatic scene in which fingers and a thumb protruding through an opening in a wall are trying to split a walnut – emblem of the female's sex and also of the eye; one finger is transfixed by a rivet, suggesting some powerful restraint, while the heads of two captive birds convey a locked-in, stifling atmosphere.

Persuaded by Eluard to come to Paris, Ernst became a close friend of Breton. The German's lean angular face, cold blue eyes and thin unsmiling lips betokened a haunting fear of nothingness, of the void. In the convivial atmosphere of Paris he slowly shook off the fear and an obsession with impotence, and turned to subversive parody. As Breton's *bête noire* was Barrès, Ernst's was Raphael, because the Italian's harmonious compositions were so esteemed in art schools and because he painted religious subjects. In *Au Rendez-vous des amis* (1922) he parodied Raphael's Parnassus and formal poses with a group portrait of fourteen prominent Surrealists against the background of a huge iceberg, Ernst himself seated on the knees of Dostoievsky, whose shaggy beard he is stroking.

Ernst tried to shed his residual Catholicism by parodying Raphael's painting of the Madonna and Child, *La belle jardinière*; under the same title he depicted a girl standing, asleep, clothed with petals, a dove on her right leg, behind her a shadowy dancing figure from a sketchbook, garlanded with fruit. In another work, *La Vierge corrigeant l'enfant Jésus devant trois témoins*, a vigorous Our Lady is shown spanking the boy Jesus, whose halo has fallen to the floor, watched by Paul Eluard, André Breton and Ernst himself.

In 1923 Ernst received a welcome commission from his best friend, Eluard, to decorate Eluard's villa near the forest of Montmorency. Ernst repaid this kindness by seducing Eluard's wife Gala.

The heartbroken poet took ship for Tahiti, continuing later to Indochina. Here Ernst and Gala joined him. The trio returned together to Paris, for Eluard, as a sound Surrealist, had come to recognize that Ernst and Gala were driven by a true shared love which must not be thwarted by so petty and outworn an attitude as possessiveness.

Ernst is the most subversive of the Surrealist painters. He pulls down, rather than builds up. A much more positive, distinctively

Surrealist metaphysic was to emerge in the person of René Magritte. Born into a middle-class home in Lessines, Belgium, as a boy Magritte enjoyed adventure stories such as *Treasure Island* and films featuring Fantômas, a crook who eludes the police by assuming many identities and brilliant disguises. He studied painting at the Brussels Academy of Beaux Arts, his ambition at this time being to transport the viewer as Stevenson does in *Treasure Island*. He took a job in a wallpaper factory and later did design work for commercial advertising. He made a happy marriage, led an orderly life, dressed soberly – outwardly a model of bourgeois conformity, but inwardly an explorer.

When he was twenty-five Magritte saw a reproduction of a painting by Giorgio de Chirico, who had begun to adopt a Surrealist idiom. It depicts a surgeon's rubber glove hanging beside the head of an antique statue, and this odd juxtaposition is made odder by the picture's title: *The Song of Love*. This work, Magritte declared, taught him 'the ascendancy of poetry over painting'.

Two years later Magritte painted his first major canvas. *The Lost Jockey* shows a racehorse galloping amid towering giant balusters from which sprout branches of foliage. But the horse is completely hemmed in by the balusters and is therefore galloping to no purpose. It is the sort of situation that occurs only in a bad dream, but Magritte renders it under the strong light with such precision of detail that the scene imposes itself as something actually taking place. It has a teasing mystery and grips the viewer tenaciously.

In 1927, now a full-time painter, Magritte moved to a suburb of Paris with his wife Georgette. Contact with the work of Ernst and Miró, and the conversation of Breton and Eluard helped him to develop further his distinctive vision. In 1928 he painted a seascape with rocks surmounted by a blue sky where, painted in whitish grey, hover a woman's torso, a tuba and a straw-bottomed chair. As often in a work by Magritte, the title – *Le Temps menaçant* – puzzles rather than explains, the weather in the picture looks set fair, and we are left with an uneasy feeling that what threatens our calm are memories or fantasies hovering at the back of our minds.

Magritte showed this work at the 1928 Surrealist exhibition in a gallery owned by a fellow-Belgian, Goemans. Paul Eluard had wanted to preface the catalogue but was prevented by illness. Eluard

based many of his poems on the strange scenes depicted by Surrealist painters; he particularly admired Magritte and bought *Le Temps menaçant* for his own collection.

Magritte painted no less than sixty works in his first year in Paris. He became increasingly interested in the question, 'What relationship does a work of art have to the object it represents?' In *L'Usage de la parole I* (1928–9), he famously depicts diagonally a smoker's curved pipe, its bowl to the front; underneath, in neat cursive script, are the words *Ceci n'est pas une pipe*. The pipe Magritte has painted looks exactly like a real pipe, yet it is not something a smoker can make use of. Since we know this, why should anyone value the painted pipe? Magritte seems to be saying that art which merely copies the visible has nothing to give us; only when it makes an imaginative combination of objects – visible metaphor – does it convey the wonder and mystery lying behind the immediately visible and banal.

In theory Magritte should have delighted Breton; in fact the Belgian got on the Frenchman's nerves. How could so revolutionary a painter lead a calm orderly existence, happily married, putting on his bowler to walk his dog of a morning, within a tainted society? One day, while having a meal with the Magrittes, Breton noticed that Georgette was wearing round her neck a small cross. To the Magus the only admissible Christians were the visionaries and heresiarchs, and some in his group thought fit to hang crucifixes on lavatory chains. Breton objected to the cross and wanted Georgette to remove it. A minor scene ensued. Magritte naturally was pained and after a number of other contretemps he came to the conclusion that the Surrealism of Paris was no longer for him. He returned to Brussels where he was to continue, poker-faced, to use humorous incongruity in order to startle us out of conventional attitudes.

In the summer of 1929 the Magrittes spent a working seaside holiday with Paul Eluard and Gala, who after her liaison with Ernst had returned to Paul. Also of the company was a strange-looking febrile Catalan. Very thin, with protuberant dark eyes, straight hair combed sleekly back, a shadowy moustache on his upper lip, Salvador Dali was twenty-five and pulsating with new ideas. In the course of the holiday Dali fell in love with Gala and after a period of

grotesque courting persuaded her first that he was a genius and secondly to link her life with his. He suggested she return ahead of him to Paris, where earlier in the year he had taken a studio, and urge André Breton to write an introduction to the catalogue for his first exhibition in the French capital.

Gala, a forceful woman, succeeded in this task and in November the exhibition of Dali's work opened in Goemans' gallery. The painting that attracted most comment, *The Enigma of Desire*, depicts a rock structure, honeycombed by erosion and inscribed many times with the words '*ma mère*', which is also the skeleton of a huge bird, its beaked head lolling on the desert sand. Dali's world was more accessible than Ernst's, spaciously more open, and each work, however improbable, possessed inner consistency. A few wealthy amateurs were already buying Surrealist canvases, so the ground had been prepared for Dali, and most of his work found buyers.

Breton was one of the buyers and he recruited the young Spaniard to write up his scatological sexual fantasies for *La révolution surréaliste*. Picasso gave Dali useful introductions, including one to Gertrude Stein, while Etienne de Beaumont, a generous encourager of talent, commissioned weird costumes for his period balls. Goemans meanwhile went bankrupt and Dali was still short of money. Moved by pleas from Gala, Prince Faucigny-Lucinge formed a syndicate of twelve backers, each of whom agreed to pay Dali a monthly salary; in return each received one drawing or painting a year. Dali, more than any other artist in the city, owed his early livelihood to discriminating Parisians.

Over the next few years Dali was to divide his time between working on the Mediterranean coast and in Paris. Strengthened by Gala's faith in him, he produced a succession of important works, most notably in 1932 *The Persistence of Memory*, with time remembered in the shape of limp watches hanging from trees.

Whereas Ernst and Miró jumble familiar building-blocks, Dali produces wholly new building blocks and with them creates imaginary landscapes under a relentlessly blazing light: dead trees, arid desert, hollowed-out skeletons and skulls, limbs supported on crutches. It is known that Dali was impotent. His most authentic work – for he produced much that was meretricious – does seem to

express the pain of sexual impotence for one with a strong need to love and be loved, pain that issues into visions of great beauty flawed by sterility and deadness.

The year 1934 saw three bizarre marriages in the Surrealists' world. André Breton had met a Peruvian-born aquatic dancer, Jacqueline Lamba, who happened to be living in the same hotel room in rue du Faubourg Saint-Jacques that Breton had once occupied as a young man. This and other coincidences convinced Breton that he and Jacqueline were predestined. The witnesses at the civil ceremony were Paul Eluard and the sculptor Giacometti. Afterwards Breton organized a picnic reception in the country. Jacqueline was invited to remove her clothes and recline on the grass between the clothed males, as in Manet's *Déjeuner sur l'herbe*, and the scene was photographed.

Next day Paul Eluard – who had divorced Gala in 1932 – married Nusch, a slim petite streetwalker from the Alsace region with a timidly appealing smile. Eluard continued to be in love with Gala and whenever circumstances permitted to sleep with her.

The third marriage, between Gala and Dali, was as improbable as a Surrealist painting, since Dali was incapable of intercourse. Yet this oddly matched pair were to lead the closest of lives for fifty-three years. Dali was to paint Gala hundreds of times and signed some of his best works with her name entwined around his. Gala had already been the subject of adoring poems by Eluard, so, even more than Youki, she could claim to have been celebrated repeatedly both in paint and in words.

It was Gala, with her strong commercial streak, who launched Dali into self-publicity. He proclaimed himself a genius, letting it be known that he discovered his subjects in dreams, hence a sign on his bedroom door: 'Poet at work', and that his favourite exercise was going up in a lift. Surrealism could not have had a more effective exponent.

While the Surrealists continued to startle Paris right through the late 1930s, other great artists more quietly and in a less arcane manner were also devoting their gifts to the task of expressing what they believed to be man's centre.

Fernand Léger, son of a Norman cattle-dealer, was a burly red-

head who might have been Sulphart in *The Wooden Crosses* come to life, for he was truculent, pushing, suspicious of authority yet with a deep concern about society. After studying architecture in Caen, he came to Paris to paint. At the Salon de l'aviation he was deeply impressed by the beauty of some of the machinery, 'hard, permanent and useful . . . dominated by the power of geometry', representing, as he believed, 'the life of tomorrow, when Prejudice will be destroyed'. He exhibited Cubist-style paintings of machinery which the critics laughed at: 'Léger replaces the cube by the tube. He's a tubist. He's in the cast iron and sheet metal trade. This isn't painting, it's plumbing.'

Undeterred, Léger continued to paint, living from hand to mouth until 1913, when Kahnweiler came to the rescue, giving him a three-year contract.

Léger had a hard war as a sapper and was gassed. Once out of uniform, he became a close friend of the Swiss architect, Le Corbusier, and adopted his creed that a building's form should express its function, and that painting instead of being a decorative addition should be an integral part of the building.

In 1924 Léger could write: 'Let's go into the factories, the banks, the hospitals . . . Let's bring in colour; it is as necessary as water and fire. Let's apportion it wisely, so that it may be a more pleasant value, a psychological value; its moral influence can be considerable. A beautiful and calm environment. Life through colour. The poly-chromed hospital, the colourist-doctor . . . It is a religion like any other. I think it is useful and beautiful.'

Léger also believed that the working man was at heart an æsthete who wanted colour and strong – therefore geometric – beauty brought into his environment, as in the best of posters. All these beliefs Léger sought to satisfy in big primary-coloured paintings with a geometric structure, many of them depicting machinery. In *The Mechanic* a moustached worker in singlet is depicted in profile: he has bulging muscles and his strong capable hands obviously have total control of the machine behind him. He is intended to signal a new and happier industrial age.

Léger painted a mural celebrating machine workers for the Renault factory canteen. When it was unveiled the employees objected that the workers Léger had painted had hands like iron-ribbed gauntlets: they wanted hands to look like hands.

Though he did not get much encouragement from the proletariat or from the sophisticated, who judged his work raw and crude, Léger worked extremely hard both as painter and teacher to express his view that contemporary man had entered an era of machinery, that he must welcome this, live with it and see in its usefulness a new kind of beauty.

Another who trod a lonely path was Constantin Brancusi. Born on a sheep farm in the Carpathians, he studied sculpture in Bucharest, from there walked to Paris, sleeping rough, singing on the way, to enrol in the Ecole des Beaux Arts. He was a strongly built man, with a craggy handsome face, joyful eyes, a moustache and full beard. In 1916 he rented a cheap small well-lighted studio with white walls at 8 impasse Ronsin, in Montparnasse. Here he was to live for the rest of his life in considerable austerity, with rough-hewn furniture made by himself. There were no stairs to the tiny attic bedroom, which he reached by climbing a rope.

Brancusi worked long hours; as he worked he sang and talked to his chisels and hammer. He had a few close friends, whom he would entertain from time to time in the studio, serving Romanian plum brandy and cooking dinner of cold beans purée, followed by steak or by chicken – his neighbour kept hens and Brancusi would entice one down from its perch with a long stick to become the main course. Afterwards he would play violin duos with one of his guests. But mainly he lived like a hermit and was never to marry.

The fast Montparnasse set saw Brancusi as an impoverished dim-witted peasant, unable to master French spelling, hacking logs of wood – the only material he could at first afford – into weird totem-like forms. In fact the Romanian was well educated and had a thorough knowledge of his favourite Plato. He also had strong mystical feelings, and believed that the greatest happiness lies in what he called the contact of our inner being with the Eternal Being. He thought that the so-called death of God was the reason why the world was adrift.

Brancusi's early work consisted of Rodinesque portrait busts, but he soon rejected totally this craggy style. In 1909, aged thirty-three, he made *La Muse endormie*, a beautiful smooth ovoid head in white marble in which the features are reduced to a whisper. Simplifying

further, he made a number of smooth marble or bronze ovoids, variously entitled *Le nouveau-né* or *Le commencement du monde*; Cocteau called them brontosaurus eggs. In 1912 came *Le baiser*, an upright squared work in stone, very strong indeed but also marked by simplicity: the two lovers carved in one block may express Aristophanes's view in *The Symposium* that a man and a woman were originally created one, then became separated, to be joined again when they fall in love.

In the same year Brancusi accompanied Fernand Léger and Marcel Duchamp to the Salon de l'aviation. Duchamp marvelled at the sleek lines of aircraft and engines; turning to Brancusi he said in his dry way, 'This puts an end to painting. Who could do better than that propeller? Tell me, could you?'

Brancusi already believed, with Plato, that each object in the world embodies to a greater or lesser degree an eternal form, which our soul glimpses before being placed in our body. The form is more perfect than any material embodiment of it; it is to be found by peeling away inessentials, and this is the artist's task, drawing also if he can on those pre-natal glimpses.

The helix shape of the pre-war propeller, being a form seen in nature and spare in its use of material, interested Brancusi. He found it helped him in his search to depict the essential form of the bird Maiastra, which in Romanian mythology is an embodiment of good and participates in the creation of the world.

From this encounter of the very new and very old flowed much great work: *L'oiseau d'or* (1919), several versions of *L'oiseau dans l'espace*, the first in 1923, and several versions of *Le coq*. The final versions of these works Brancusi usually made in bronze brought to a high polish. As in a piece of engineering, streamlining adds power to these sculptures, while the high polish suggests an inner light. In making them Brancusi succeeds in creating an original lyrical form of beauty, based firmly on respect for the object.

Brancusi's influence marked many, among them another lonely pilgrim of the absolute. Alberto Giacometti came from Italian-speaking Switzerland, eldest son of a gifted post-impressionist painter. During a happy childhood he did brilliantly at school and tirelessly copied any work of art he happened to like. At twenty-one

he came to Paris to enrol in Bourdelle's sculpture classes. He looked like an Iroquois, with black fuzzy hair, almond-shaped eyes and full lips; his very expressive face mirrored his feelings in a remarkable way that people found endearing.

These feelings, very intense, proved an artistic stumbling-block. He wanted to reproduce the person before him, but like a mist or a cloud emotion came between him and the face. And next time he saw it, his emotion had changed and the head looked different. Who could teach him to turn an elusive vision into the permanence of stone or metal? He worked his way through the Louvre and the Musée de l'Homme, tirelessly copying Egyptian, archaic Greek and Cycladean sculptures.

Giacometti rented a tiny Montparnasse studio, sharing it with his brother Diego, who gave him the support and encouragement Théo Van Gogh had given Vincent. In order to earn a living they began making conventional decorative objects for the luxury market and jewellery for Elsa Schiaparelli.

In 1925, through photographs and an exhibition, Giacometti came to know Brancusi's chunky pre-war work and from it formed the beginnings of a style. *The Couple* (1926) is an unsuccessful bastard of *Le baiser*, but *Peering Head* (1927–8) is a considerable work: an almost rectilinear bronze, set slightly aslant, with two shallow grooves, one horizontal suggesting the eyes, the other vertical, suggesting the nose and mouth.

In 1930 Giacometti met Aragon, then Breton, joined the Surrealists and stopped working from the model. *Trapped Hand* (1932) derives from Ernst's *Oedipus Rex*; it is orthodox Surrealism, hailed at the time but now seen to be contrived. In 1935 he began working again with a model and did a fine drawing of his own head. 'A head!' fumed Breton. 'Everyone knows what a head is,' and excluded him from the Surrealists.

Even during his Surrealist period, Giacometti did work influenced by Brancusi; *Caress*, a marble sculpted in 1932, is perhaps the finest. A smooth rounded piece of white marble has two shaped perpendicular indentations on the right side, suggesting eyes and mouth of some primeval creature; on the left, lightly traced, the outline of an outspread hand seems to be trying to calm or to tame the creature. Here one sees embodied two layers of Giacometti the man:

his always tentative, hesitant attempt to humanize an often frightening reality; his predilection for austerely plain forms, stripped of inessentials. The latter was to issue in the 1940s in those elongated wire-thin sculptures of people, with which his name is most often associated.

In the first years of the century Picasso had dazzled Paris with his blue period, his rose period and Cubism. In 1914 he did not feel any call to take French citizenship, like Apollinaire, and to join the co-creator of Cubism, Georges Braque, at the front. Picasso ignored the war as he ignored virtually everything outside his work and love-life. As a young man he had gone hungry and shivered in a run-down studio and he hardly noticed when heating fuel became so scarce that a Paris jeweller placed in his shop window, beside the diamonds, a lump of coal. He continued to paint, with undiminished brio, subjects unrelated to the war.

Picasso accepted an offer from Cocteau to design costumes and sets for *Parade* and in 1917 accompanied the poet-producer to Rome to work with the Ballets russes company. Here he met and fell in love with a young ballerina who was to change the course of his life and art.

Olga Koklova had a well-proportioned body, a roundish face, high cheekbones, strong dark eyes, a strong chin and a will to match. Russian ballerinas led disciplined and closely chaperoned lives; Olga was almost certainly a virgin who would agree to sleep with Picasso only on a marriage bed. This was a new situation for the painter who during the war had had in turn three adoring mistresses. But after the Paris première he followed the ballet company to Barcelona and there he introduced Olga to his mother. He brought her back to Paris, where a year later they were married in the cathedral of St Alexander Nevsky.

Picasso was then aged thirty-six, co-discoverer with Braque of Cubism, painting with mastery in half a dozen styles, changing back and forth from one day to the next, thereby proving – perhaps for the first time in history – that a single powerful painter can surmount limitations of place and period. For Picasso no joy on earth could equal that of artistic discovery and creation, and he did not intend marriage to interrupt his work.

At first, because Olga was still dancing and they both liked the world of Russian dance, he gave some of his time to designing decor and costumes for ballets, five in all including *Parade*. Olga wanted a social position, so they bought a fashionable apartment in rue La Boétie, and the apartment above as a studio. They engaged two servants. Picasso's close Russian-born friend, Misia Sert, arranged for them to be invited by *le tout-Paris*. Picasso enjoyed it all – staying at the Savoy when he visited London, wearing suits tailored in Savile Row, meeting the rich and famous, and he could be counted on to add to the fun. At the reception after the ballet *The Three-Cornered Hat* he delighted guests by painting laurel leaves on the composer Manuel de Falla's bald pate. They spent holidays by the sea, and because Picasso never learned to drive, engaged a chauffeur to take the wheel of their Hispano-Suiza.

Nineteen twenty-one provided Picasso with a new subject. Olga gave birth to a son, Paulo, and the proud father was to paint mother and child many times, using a new style that owed something to the classical statues he had seen recently in Italy, something to the chunky Romanesque sculptures that had excited him in 1906. In one of the most successful of these renderings a little battle is taking place: the very sturdy child is trying hard to take hold of his mother's chin; she too is sturdy, with a Grecian nose; head tilted back, with one hand she holds him off, while with the other she parries the small prying hands.

Paulo grew into a handsome little boy and, inevitably, a subject for his father's brush. Picasso painted him in Pierrot costume, dressed up as a bullfighter, or simply as a child playing. The most sophisticated painter alive threw sophistication to the winds and allowed the sweet, open trusting little face to speak for itself.

Picasso now possessed everything the most demanding man could wish for. But the price for delectable Paulo was marriage, and marriage must entail some form of limitation, a modicum of un-selfishness and forbearance. Picasso's life as a painter had been one of unremitting toil and dedication, but as a person he had never for a moment allowed others to stand in the way of what he wanted. If he tired of a mistress he managed to get rid of her with a minimum of fuss, for if there was one thing he hated it was a scene.

Olga was living in a country not her own, speaking a strange

language. Naturally she needed security in the form of attention from her husband, the presence of friends, entertaining them and being entertained. Picasso, however, had begun to see the hollowness of rich party-going, and to find Olga's conversation on the conventional side.

In 1927, outside a *métro* station, the face of a young girl with a rounded chin and rather wide mouth attracted Picasso. He stopped the girl, chatted with her and arranged a meeting. Marie-Thérèse Walter, seventeen years old, had a mother of Swedish origin and no known father. She was keen on sport, enjoyed cycling, swimming and mountaineering. She was not intelligent and by temperament submissive. Six months later, with her mother's approval, she became Picasso's mistress: compliant, undemanding and worshipful.

With the arrival in his life of Marie-Thérèse a new sensuality enters Picasso's work, expressed most notably in a series of etchings to illustrate Ovid's *Metamorphoses*. With a masterly economy of line Picasso creates an Arcadian world of nude athletic figures, all beautiful and most directing their energies to the pursuit of love.

Marie-Thérèse also became the subject for a group of portraits where we find Picasso at his most daringly innovative. *The Mirror* (1932) depicts the head and shoulders of a nude girl asleep; behind her an oval hinged mirror reflects her smooth white back and suggests also the peacefulness of her sleep. Serenity is also the mood of *The Dream*, painted in the same year. Marie-Thérèse is asleep in a chair, head tilted back, and the profile of her face is combined with a frontal view, thereby suggesting the dream that is occupying her attention.

At first their meetings had to be secret. In the summer of 1928, while on holiday in Dinard, Picasso would join Marie-Thérèse in one of the bathing huts lining the beach. But in 1930 he installed her in an apartment close to his own in rue La Boétie. Olga began to make scenes, on occasion became hysterical, and when Picasso asked for his freedom, she said no: she would not hear of divorce. And she was strong enough to stand by her words.

A trap had sprung. Woman in her lovable aspects, the source of much of his best work, now showed that she could also be, so it seemed to Picasso, a cruel predator. As a result, his creativeness bifurcated

in a much more fundamental way than when he alternated between the Cubist and naturalist styles. Even while he was painting the adoring, supremely peaceful child playmate, perhaps recalling sprawling sun-bathers on a summer beach half hidden by sand, he depicted the female body as an ugly heap of disjointed limbs. Sometimes these limbs resemble tusks, flippers or the legs of a crustacean, and the most prominent feature of the head is a yawning mouth from which pro-trudes a dagger-sharp tongue. In *Seated Bather* (1930) the female is bony or cartilaginous, even the rounded breasts and curved thighs are of this hard substance, and instead of a head two jagged pincers are about to lock together, like the jaws of a mechanical shovel. This is woman the trapper, this is Olga, who will not release him. Adoration of Marie-Thérèse's body and its counterpart: execration of Olga's possessiveness.

For eight years the struggle with Olga divided Picasso's life and his work. Then, one day in July 1935 after yet another dreaded scene, his wife left the flat for good, taking Paulo. Lawyers arranged a separation and the following year Picasso was to find a new com-panion and in the Spanish Civil War a new subject.

Picasso then, during most of the inter-war period, shows us two sides of sexual love. In one woman is bone-hard, literally two-faced, a daemon who fragments man's centre; in the other she is sensuous and beautiful, inspiring and embodying his aspirations: the same now as in Ovid's day, she is literally his other self.

From this brief survey of Paris's most innovative artists we see that subject-matter had been extended in a most remarkable way, to include not only machinery but riddles, chimeras and dreams. Artists were not afraid to create private worlds: indeed this was often their aim, and this was what the public had now come to expect. The public no longer wanted further illumination of a person or object, there for all to see; they were looking for singular sensations, moods and insights, and these the artists provided. As forcefully as Luther, both denied 'real presence'.

This was at times a purposely subversive move. But even when not purposely so, it naturally had the effect of dividing. Each world was self-contained, with its own assumptions and inner logic, and since there was no longer much common ground from which to criticize it,

and certainly no accepted authority for so doing, each could be said to be valid. This strengthened a prevalent subjectivism, the view that in the decisions of daily life too the individual should follow his own inclinations, regardless of society's approval or disapproval.

Though to the question, What constitutes man's self? each of the artists offered a different answer, their work has certain qualities in common: immense vitality, great boldness, most often a spirit of joy, sometimes infused with humour. They contributed to a mood of optimism we shall meet elsewhere in the city.

One further point is noticeable. Of the artists here considered only Masson, Tanguy and Léger were French. The others came from abroad and were Parisian by adoption. Flags meant little to them. Brancusi once said, 'In art there are no foreigners' and asked his nationality in 1925 replied: 'Terrestrial, human, white.' The ten thousand or so artists working in Paris formed a true international community. Despite their small numbers, they were to be a force for peace.

7

FILM

The fabric of Paris naturally influenced those who lived and worked there, none more than practitioners of 'the seventh art', photographers and film-makers, for whom the city would become a favourite subject. That fabric was predominantly classical: clearly stated, sober, harmonious. Long wide avenues led as ineluctably as Racine's alexandrines to proud monuments evoking classical antiquity: arch, dome and colonnade. Extremely strict building regulations had ensured that the many seven-storey balconied apartment blocks of the prosperous nineteenth century should harmonize with earlier structures, even to the mansard roof, and that the newish Gare d'Orsay for example should resemble a great Second Empire mansion more than a railway station.

Auguste Perret's Théâtre des Champs Elysées in 1913 was the most notable early twentieth-century addition. Instead of customary whitish grey local stone, Perret used reinforced concrete, which allowed him to enliven the façade with three bays of high windows framed by flat pilasters surmounted by large bas-relief friezes. Material and treatment were new, yet the building remained acceptably classical.

Most post-war additions took the form of apartment blocks on the outskirts for low-income families. Here Roux-Spitz took the lead. In a typical apartment house he used a concrete frame and a cladding of rectangular polished stone panels; an undecorated façade he enlivened with a vertical bay projecting upward from the first storey. Shutters and balconies he dispensed with, and traditional tall windows were replaced by very wide ones, each containing only two panes. The building shows a net gain in smoothness and luminosity.

Expressionist architecture, popular in Holland and Germany, made only a furtive appearance, as in the jagged 116 *bis* avenue des Champs-Elysées and in the Rex cinema, topped by a gratuitous tiered tower and REX in huge letters, but by and large expressionism, like United States modernism, was rejected by Parisians as unharmonious and 'inhuman'. The dominant trend was toward a gently streamlined classicism, to be consecrated in the 1937 Palais de Chaillot, of which Perret's theatre was one of the inspirations and Roux-Spitz a co-architect.

As yet no heavy traffic roared along the quais, so the Seine retained its quiet central importance, in winter liable to flood, occasionally with fatal results, but for much of the year a peaceful, clear and sparkling presence. On both banks the look of the buildings was to remain surprisingly conservative and 'unmodern' during the inter-war years, and it was against such a reassuring background that the most modern of the arts – film – would develop its innovations.

It is logical to begin with the still photograph. This came first in time and the aims of its practitioners were to influence the silent cinema, then the talkies. Nearly always they worked in black and white, and like the nineteenth-century lithographers and etchers found this tonality particularly appropriate for depicting the poorer parts of Paris, dark cobblestoned alleyways, the sooty precincts of railway stations, and also the distress of the poor who lived there. If Raoul Dufy, with his flag-festooned regattas and racecourses, is taken as representing life enjoyed by the well-off, the best of the still photographers sought to show the other face of the city, the hard lot of the manual labourer, the street as the only playground for poor children, not in an aggressive or subversive way, but with tender compassion.

Nineteen twenty-seven is a key date, for then still photography came of age, with the opening of the first Salon Indépendant de la Photographie. The most original of the exhibitors was thirty-three-year-old Hungarian-born André Kertesz. He had been living in Paris only a couple of years but, roaming back streets like a newspaper reporter, he showed great talent for seizing a decisive moment or poignant juxtaposition.

On the landing of a poor apartment block, for instance, between a rickety staircase and a sloping stained wall, Kertesz shows us a

middle-aged washerwoman patiently scrubbing linen on a ribbed board over the communal sink fed by a cold water tap. The sloping wall prevents her standing upright, thus heightening the mood of servitude.

A thin horse, ribs visible, has collapsed on a cobblestoned street in front of the dray it has been hauling; its traces are cut, and its driver is trying to get the poor animal to its feet; this was photographed from the second floor of a nearby house from such an angle that the prostrate horse appears at the top of the picture.

A well-dressed man in a boater is dozing at a café table, where piled saucers tell us that he had eight drinks. On the wall behind is a poster of a gleaming sprinter, captioned 'Ovaltine gives strength.'

Kertesz had two slightly younger disciples. Gyula Brassaï, like Paul Morand in literature, made Paris by night his chosen world; his portraits of those who frequent cafés, dance halls and bars won him the admiration of Picasso, whose close friend he became. The other disciple, Henri Cartier-Bresson, awakens us to the tones and textures of our everyday world; near the end of our period he was to bring home to the French the agony of Spanish civilians during the civil war. Again, his work is shot through with compassion. Of Kertesz, with undue modesty, he was to say, 'Everything we do, he did better.'

Still photography was to play a different role in Surrealist hands. Here the key inventor was American-born Man Ray, whose real name was Emmanuel Rudnitsky. Brought from New York to Montparnasse in 1921 by that gifted diviner of talent Marcel Duchamp, Man Ray set up as a photographer. He was not exactly a lady's ideal: short, stocky, with round dark eyes, a big nose and tight, harassed mouth, but Kiki liked his accent and a little air of mystery about him. She agreed to model for him and soon became his mistress.

'He photographs people in the hotel room where we live,' wrote Kiki, 'and at night I lie stretched out in the bed while he works in the dark. I can see his face over the little red light, and he looks like the Devil himself.' Though she found him phlegmatic and 'had to beg for a caress', they were to remain in love for eight years.

Quite by accident Man Ray stumbled on new processes. With these he created what he called 'rayograms' – direct exposure of objects to

sensitized paper – and 'solarizations' – partial exposures to light during development. It so happened that these were curiously suggestive of the charged currents underlying visible reality being probed by Madame Curie and her daughter Irène but, more important for the Surrealists, they provided a medium for depicting the para-rational. In 1922 Man Ray made a rayograph of himself and Kiki kissing: it has an eerie ghost-like quality; and in 1924 he made a collage photograph of Kiki, *Le Violon d'Ingres*, in which he superimposed an *f* and an inverted *f* on a photograph of Kiki's back in a pose favoured by Ingres, so metamorphosing her into a violin. Since *violon d'Ingres* means 'hobby', the collage can be said to lower woman to the status of an object; nevertheless it became one of Surrealism's most admired images.

In February 1928 Man Ray listened to Robert Desnos read a short love poem inspired by Yvonne George. Recognizing its visual possibilities, he decided to make a silent film of the poem, *l'Etoile de mer*. He persuaded Desnos to act the part of the narrator, while Kiki played the woman he loves, and a sculptor friend of Desnos took the role of 'the other man'. To escape censorship Man Ray processed the nude scenes in such a way as to give them a blurred, mottled effect, and he succeeded in getting his film shown as a short in May that year in the cinema featuring Marlene Dietrich in *The Blue Angel*.

Meanwhile, influenced by Surrealism but with a different aim, some were envisaging a film with no scenario in which a sequence of images would speak for itself as a painting does. The painter Fernand Léger joined an American cameraman, Dudley Murphy, who had worked with Man Ray, and an American composer, George Antheil, to make a 15-minute film centred on Kiki but with no storyline, just 'the interaction of rhythmic images'. Entitled *Ballet mécanique*, and using a prism device, it presented fragmented images of Kiki's face, and close-ups of her eyes and mouth, spliced with diverse shots such as a mechanical marionette of Charlie Chaplin, pulsating metallic discs, household appliances, wine bottles, geometric shapes and the like. The film was shown privately, boring some but stimulating others, among them Jean Cocteau.

We left Cocteau in hospital undergoing treatment for opium intoxication. He came out cured in spring 1929 and spent that Christmas with Charles and Marie-Laure de Noailles, who had a

keen interest in experimental cinema. Mickey Mouse had just arrived and Marie-Laure, who was a little in love with Cocteau, suggested he make an animated cartoon. Cocteau, enemy of the obvious and with plenty of wit but little humour in his temperament, declined, but he did persuade the Noailles to finance a real-life film, which would be an allegory of a poem's origin.

Filming began in April in a Montmartre studio. The Noailles and close friends were convened, placed in theatre boxes overlooking a courtyard deep in snow and, while Cocteau's cameras turned, told to applaud. Then they were regrouped and again told to applaud. After that they were free to leave, still unclear as to what they had applauded.

Cocteau shot until September, trying by means of mirrors, reverse action and blurring of boundaries between the outer and inner world to recreate a state of inner consciousness. A young man passes through a mirror into a world where he sees a Mexican revolutionary executed and restored to life – death is reversible, a theme of many of Cocteau's poems – opium smoking, a hermaphrodite, living statues and much else.

When the film was shown to them privately, the Noailles discovered that what they had been applauding was the killing of a schoolboy in a snow fight and the suicide of a poet. They demanded that Cocteau cut them out of the film. Cocteau insisted that the sequence was vital, a sign of society's mockery and indifference to suffering innocence. However, he was forced to yield and re-shoot the scene with professionals.

A cabal by the Comte de Beaumont, jealous of the Noailles, delayed a public showing. Cocteau fretted, raged and fell seriously ill of typhoid, scarcely comforted by a well-meant letter from Thomas Mann: 'You belong to the race that dies in hospital.' Finally the film was shown in January 1932 and was well received by the discerning. Though he was not to make another film for eighteen years, it proved the truth of Cocteau's claim: 'Now I know how to write on celluloid as well as on paper.' In calling it a 'poor imitation' of Surrealism, Breton was profoundly mistaken: *Le Sang d'un poète* is through and through Surrealist work at its best, with all the insights and limitations that term implies.

*

A different way of making poetry on film was pioneered by Cocteau's younger contemporary, René Clair. Born René Chomette, second son of a prosperous soap wholesaler in Les Halles, he had enjoyed a secure childhood. Tall and thin, he wrote poems and a play for his puppet theatre but, like Dorgelès whom he resembles, he could also be a formidable opponent with boxing gloves. At eighteen he volunteered as an ambulanceman and served in the front lines. He wrote poems about his fear of being killed and never again seeing the pretty girls of Paris. 'This violent experience of reality immediately matured me . . . Until then I had thought only of myself.' After the war he spent some time in a monastery, trying to make sense of his experiences.

Clair wanted to write plays but in fact became a journalist for the best evening newspaper, *L'Intransigeant*, while living with his parents off the Champs-Elysées. One day he received a phone call from an actress acquaintance, Maryse Damia, with whom he was a little in love. 'Come at once,' she said, 'to the Gaumont Studio, rue de la Villette.' There he was introduced to an elderly American lady, bespectacled, wrapped in shawls, gauze pad over her mouth to protect her from germs. This was no other than Loïe Fuller, the dancer who had triumphed at the 1900 Exhibition, whirling light as thistledown in coloured flowered gauze veils. Having trained a group of English girl dancers, she was now directing them in a film entitled *Le lys de vie*.

'What am I doing in all this?' asked Clair, whereupon Maryse explained that someone was needed for the role of the young prince. René loved everything to do with theatre and he had clean-cut handsome features. True, he was quite without experience, true, he had his job, but shooting would last only three days, he could get time off.

With Maryse and the pretty English girls eyeing him, Clair acquiesced, whereupon Maryse covered his face in make-up, the wardrobe lady wrapped a turban round his head and draped a leopard-skin over his shoulders, he was hoisted on to a horse and, almost blinded by floodlights, ordered to bestow passionate kisses on an English girl with whom he had hardly exchanged a word, while Miss Fuller shouted through her gauze pad: '*Baisez, monsieur, baisez encore!*' Such was film-making in the early 'twenties: makeshift, amateur, but above all, fun.

After further acting experience, this time in a film directed by Feuillade, who made *Fantômas*, Clair became so interested in cinema that he decided to shift his creative ambitions to that medium.

In 1923, after an unhappy love-affair, Clair consoled himself by occasionally smoking opium, though never more than a pipe or two. One night under its influence a strange hazy idea came to him in sequence form. He quickly wrote it down. Paris has suddenly come to a complete halt. People as well as traffic are motionless under the influence of mysterious rays released by a scientist. The only persons able to move are a young man who has slept on the top platform of the Eiffel Tower and five people who arrive by aeroplane. Eventually the scientist checks the rays and Paris begins once more to move.

Cinema is primarily movement and by imagining, in familiar surroundings, this contrast between movement and immobility Clair had hit on a subject ideal for the medium and also with poetic and metaphysical overtones. He decided to treat it as gently ironic comedy, found a producer and shot the whole film in twenty days, much of it atop the Eiffel Tower where it was less the height that bothered Clair and his team than the cold air which made them very hungry at a time when they were too poor to buy big meals. Edited by Clair, *Paris qui dort* was shown in 1924, receiving a warm reception from critics and public.

Clair meanwhile had taken the part-time job of editing a supplement on cinema for *Le Théâtre* magazine. This entitled him to a small office in the vast Théâtre des Champs-Elysées, where the Swedish ballet company – in the wake of the Ballets russes – was rehearsing a new ballet, *Relâche (No Performance)* by the Surrealist painter of purposeless machines, Francis Picabia. One day Clair was approached by Picabia, a tiny man who wore built-up shoes, and invited to make a fifteen-minute film to project during the interval of his two-act ballet. He showed Clair ideas jotted down on writing paper headed *Maxim's*:

Marcel Duchamp and Man Ray playing chess: Enter Picabia with a water hose to send the pieces flying.

Hunter squirting an ostrich egg with a hose; a dove emerges

and perches on his head. A second hunter shoots at the dove and kills the first hunter, who falls, while the bird flies off.

A funeral: the hearse drawn by a camel.

Clair saw possibilities, particularly in the last idea, which he thought could be amplified into a breakneck chase, and agreed to make the film. In Picabia's words: 'From the flimsiest of scripts he made a masterpiece.' Erik Satie provided one of his more original scores, conscientiously matching each phrase to the relevant frame.

Hoping for a *succès de scandale*, Picabia wrote in the programme: 'I prefer to hear shouting than clapping,' while Satie in his dry way announced that he had composed 'pornographic' music, adding however that it would not make a lobster or an egg blush. Picabia got his shouting, as an audience composed of *le tout-Paris* divided into protesters and enthusiasts, among the latter Aragon, Robert Desnos and a weighty critic, Paul Souday. Though the ballet is now forgotten the charm of Clair's dizzy romp has survived.

For New Year's Eve 1925 Clair helped Picabia produce a stage spectacular, *Ciné Sketch*, in the course of which Cranach's painting *Adam and Eve* is enacted. Adam was played by Marcel Duchamp, Eve by Bronia Perlmutter, the blonde blue-eyed artist's model for whom the young novelist Radiguet had left Cocteau before being struck down by typhoid. René Clair fell in love with Bronia and married her. Rare among show business unions, this one was to last.

In 1928 the first talkie arrived from America and Clair saw that he would have to re-think completely his artistic principles. He believed that sound would increase the demand for an imitation of real life, whereas he, with his poetic temperament, wished to convey a world where the outwardly dull is made wonderful by imagination. He decided that he would minimize dialogue, using it as the equivalent of sub-titles.

One evening, leaving the studio, Clair saw a street singer surrounded by passers-by who in drab surroundings had stopped to enjoy a few moments of magic. This set Clair planning a film that would be highly innovative in several ways: it would take place in a poor district in Paris, its characters would be *le petit peuple* and it would have no one famous in the cast, in fact it would be acted by non-professionals.

Sous les toits de Paris tells of a love-story between a street singer and a young Romanian against a background of petty thieving, mistaken arrest, escape and a chase, ending in the street singer losing the girl to his best friend. Theme music is more important than the scant dialogue, but it is Clair's tender but never sentimental compassion for his subject – the mood of André Kertesz – that makes the film memorable. Curiously, Parisians did not immediately warm to it, because in 1930, when the film was shown, they had come to expect '*cent pour cent parlant*' and only when Berlin had hailed it did Clair's masterpiece make its mark in France.

After a light-hearted film about a lost winning lottery ticket, *Le Million*, Clair again turned to a serious subject and again the idea grew from a visual 'moment of truth'. As he walked to the Epinay studio he passed flat waste ground overgrown with grass and a few wild flowers, beyond which stood a line of factories covered with a cloud of smoke. He imagined a tramp sleeping there in the open, master of his fate, while beyond men toiled in a prison called factory.

From this grew the simple plot of *A nous la liberté* (1931). Two prisoners sharing a cell try to escape. One succeeds, the other fails. The first, clever and ambitious, rises to become a rich industrialist. The second, after his release, becomes a worker in a modern American-style factory, where his lack of training disrupts the production line. And who controls this factory where life is regulated as in a prison? His old friend. But in the cut-throat world of industry power and money soon disappear, whereupon the two friends take happily to the open road.

Among Clair's notes: 'Work force tramping in line through long echoing corridors making a noise like a machine; in the refectory they all eat together, their spoons and metal goblets jangling mechanically.' Clair intended *A nous la liberté* as a fable, devoid of any political message, so he made extensive use of music and male choirs: the factory is producing gramophones.

Another light-hearted film, *The Ghost Goes West*, directed in England for Alexander Korda, was so successful it brought tempting offers from Hollywood, all of which Clair resisted. Then one day he happened to go to the Gare de Lyon to meet his twelve-year-old son, returning from a Christmas skiing holiday in Switzerland. Clair was struck by a group of street boys outside the station gazing

enviously at the fortunate youngsters, tanned and fit, skis on their shoulders. He decided to make a film about the holiday homes recently established where children of poor Parisian families could get away from their shut-in smoky world to breathe clean air. Choosing seventeen youngsters and an unknown actress as their *monitrice*, he began filming in mid-July 1939. Final scenes were to be shot in a Nice studio, but in September quite a different scenario unrolled. *Air pur* was to be the film industry's first war casualty.

Through such films as these Clair emerges as a man who loves the *petit peuple* but does not sentimentalize them. He sees that many live in run-down housing and work long hours, but is not so naïve as to believe that merely by improving conditions you ensure happiness which, in Clair's view, comes from matching adversity with good humour, from imagination, song and a touch of idealism, even though his characters know that idealism will often backfire.

Younger than René Clair, but sharing his tenderness for the *petit peuple*, was Jean Vigo. Born in Paris in 1905, he was the illegitimate son of parents both of whom were militant anarchists. His father was imprisoned for allegedly selling information to the Germans and a week later was found hanged in his cell: officially he was described as a suicide, but twelve-year-old Jean believed he had been murdered.

Jean was cared for by his grandfather, a photographer, in Montpellier. He contracted tuberculosis and was sent to a sanatorium in the Pyrenees, where he met Elizabeth Lozinska (Lydu), twenty-year-old daughter of a Polish industrialist undergoing treatment for a tubercular infection of the spine. The two fell deeply in love, became engaged and in 1929 were married, Lydu's father providing the young couple with enough money for Jean to buy a ciné-camera and begin his chosen career of film-maker.

Vigo was thin and bony, with full sensuous lips, prominent teeth and low-set unruly hair; he was also sensitive, silent with strangers, full of good humour and jokes with friends, but downright, on occasion violent, and with a horror of pretence. With a Russian-born friend, Boris Kaufman, as cameraman he made a documentary, *A propos de Nice*, the city where he was then living, which he showed in Paris to favourable critical opinion, but without finding a commercial outlet.

For the next three years he moved between Nice and Paris, trying to find backers, making one or two documentaries, caring for Lydu, afflicted now with a kidney condition, and finding friends who were later to be useful. Among the most gifted was Jean Painlevé, son of the government minister Paul, who had made a pioneer natural history film: *The Stickleback Ovum: from fertilization to hatching*, and was to make other poetically evocative studies of aquatic fauna and flora, notably *The Sea Horse*, with a musical score by Darius Milhaud.

In 1932 Vigo at last got a break, when a businessman, Jacques Louis-Nounez, put up money for a forty-five-minute film about a group of boys in a boarding school who lead a rebellion against the masters. It wavers between realism, fantasy and Buñuel-style caricature and it is not a good film, but throughout it shows an eye for telling detail and imaginative camera work. It was refused a certificate by the censors and never recouped its cost.

Despite this, Nounez believed in Vigo and persuaded him to try again, with a less controversial scenario, while Gaumont put up half of a total budget of 216,000 francs[1] for a full-length film.

Vigo shot *L'Atalante* between December 1933 and January 1934. The opening scenes show a village wedding: family and guests escorting the bride to the nearby canal, where the bridegroom's working barge is moored. Misgivings are expressed about Juliette's ability to adapt to a bargee's life.

The mate of the barge, père Jules, is a huge, jovial fellow, often lazy, sometimes leering, even darkly threatening, but indispensable. As the barge chugs through the canals of ugly industrial France, he keeps intruding on the privacy of Jean and Juliette; is it from curiosity, loneliness or jealousy? Also, he keeps numerous cats, feeding them cuts from a raw beef lung; they foil Juliette's attempts at tidiness. Père Jules has travelled the East and keeps in his cabin fascinating exotica. One day he shows them to Juliette, recounts his adventures, so much more thrilling than canal routine. He has a gramophone too; one day he puts on a record and, painting on his bare torso the face of a girl with his navel as her lips, places a cigarette there and performs a belly dance that is very funny and also perhaps an invitation to lechery.

1. 216,000 francs in 1932 = 648,000 of today's francs. The exchange rate was 89 francs to the pound sterling, 25 francs to the US dollar.

One night the barge ties up near a fairground. A slick, fast-talking pedlar chats up Juliette and asks her to dance. Again she feels drawn to a world more glamorous than that of her barge cabin. Jean begins to feel jealous.

The barge arrives in industrial Paris. Juliette longs to see the shops. She goes ashore alone; her handbag is snatched, she loses her way hopelessly and fails to rejoin the barge. Jean has a schedule and is obliged to continue without her. We cut from his loneliness and anxiety to her helplessness, lodging in a cheap hotel and seeking work. Finally Jean leaves the barge and goes off to Paris to look for her, finding her at last through hearing her play, on a 'thirties equivalent of the jukebox, a tune they both like.

Vigo's film is an epithalamium drawn from his own close marriage. It is also a celebration of the power of love to survive straitened living conditions, a joyless industrial background and the snares of infidelity. Vigo treats his characters with strong, never sentimental, tenderness. He uses little dialogue, for these are not eloquent people, but an accumulation of small visual touches, and the metaphor of ship and water tells us as much as Racine's alexandrines about the quality of young love.

Vigo had never completely recovered from tuberculosis. Working under enormous pressure in a cold winter he suffered a relapse. He became too ill to do the cutting or to attend the showing, where those who controlled the commercial circuit insisted on inserting as a musical theme a popular song of the day, and giving the song title, '*L'Atalante*', to the film.

In summer 1934 Vigo's condition worsened and in October he died, aged only twenty-nine. Four years later Lydu was to succumb to her kidney disease.

René Clair and Jean Vigo have been singled out because in one or more great films they created a mood of tender fellow-feeling for *le petit peuple* and, given the already large cinema audiences, this mood influenced values. But of course there were other directors in the front rank, and enormous interest from literary people in film. André Gide accompanied Marc Allégret to West Africa where Allégret made a pioneer documentary about village life on the Congo. Paul Morand thought his clipped rapid style and strident

contrasts would translate well to the screen, but he had six scenarios rejected by Paramount before one of the short stories in *Ouvert la nuit* was filmed with Adolphe Menjou miscast as the hero. The film failed to please and Morand blamed the system: 'A film may chance to become a work of art; before anything else it is a business contract.' This was unfair. In France young directors, if they had talent, were far more likely to find backers than in other countries, and in a moment we shall look at two of them.

In the 'thirties French studios produced good films in almost every genre known today except Westerns: musical comedies, Foreign Legion melodramas, Fernandel farces, military vaudevilles. According to René Clair, it would take fifty years to winnow the chaff from the grain, and now that fifty years have elapsed certain films do impose themselves as classics, among them Julien Duvivier's nostalgic romance, *Un Carnet de bal* (1937), with its haunting waltz theme; Marcel Pagnol's Marseille trilogy, the third of which, *César* (1936) was directed by Pagnol himself; Pagnol's *La femme du boulanger* (1938); and Marcel Carné's *Le jour se lève* (1939), with Jean Gabin as a working-class hero.

These and other good films were admired in Hollywood, and their directors and stars offered large sums to work in California. Whereas many Germans accepted similar offers, the French by and large declined. In answering the question why, one might point to two moments near the end of *La femme du boulanger*. When the unfaithful wife comes back to her husband (played by Raimu) he acts as if nothing had happened and hands his wife a piece of bread baked in the shape of a heart. He even pretends that the shape was accidental. She is very moved and does not say anything but one can tell that she feels guilty. Nevertheless, this is followed by a scene in which Raimu insults the female cat that has just returned from a pleasurable outing and sympathizes with the male cat that has been waiting for her. In creating and acting such scenes directors and stars knew that they were participating in a work of art with poetic overtones and found a fulfilment that would be missing across the Atlantic.

Elation at victory in the years after the War went hand in hand with concern to avoid another conflict, and these two attitudes are found

in the work of Abel Gance. Born in 1889, only son of a Montmartre doctor, at school young Gance started, edited and wrote most of a four-page broadsheet illustrated with colour cartoons. He wanted to become an actor but, failing to get into the Conservatoire, went to Brussels and wrote film scenarios, notably a 'Paganini', which reveals Gance's love of music – he played both piano and violin – and of tempestuous Romantic figures. Gance possessed a robust, extremely energetic physique, but at this period suffered from tuberculosis and was exempted from war service.

Returning to France, Gance made a film about the world of railways, with sets designed by Léger, ever machinery's best friend. An engine-driver after a disastrous crash adopts an orphan girl, falls in love with her and eventually becomes blind. This melodramatic story Gance treats brilliantly. He sees the long-distance railway journey as an epic performed by heroes, and by using new techniques of montage allows us to share his vision. But the trouble with an epic is that it goes on and on: *La Roue* lasts seven and a half hours.

Gance next decided to make a film that would stand as a visual monument to France's recent four years of heroism. As his objective correlative he chose the aftermath of the French Revolution, when Napoleon assumed power as First Consul and led his troops to their first victory in North Italy. It is safe to say that such a film could never have been made at any other date. Pride in victory was still strong enough for Napoleon, normally a figure of controversy, to be considered a national hero; costs were low; and it so happened that because of a wave of strikes in 1926 Gance could find the extras he needed.

Gance in fact so thought himself into the role of his main character that when he signed on hundreds of Renault strikers as Napoleon's poorly clad, ill-shod soldiers, he addressed them in Napoleonic language coloured by the poetry of Auguste Barbier:

'From actors, technicians . . . and you, the extras who are about to shoulder the heavy burden of reenacting the spirit of your forebears and by your unity of heart to express the formidable face of France from 1792 to 1815, from you all I ask, indeed I demand, abandonment of petty personal considerations and absolute dedication. Only so will you serve loyally the already illustrious cause of the most beautiful art of the future expressing the most marvellous lesson of history.'

Gance spent three years making *Napoléon*. One of the best scenes is when Bonaparte, a subaltern, goes home on leave. The future of the Revolution, in which he believes, is in doubt. To calm his anxiety, he puts to sea in a small boat (the real Napoleon was never at ease with the sea or boats, but no matter); a storm blows up, he uses his cloak as a sail and steers a course between high waves, while the film cuts to stormy scenes in the Convention between Danton and Robespierre, declamatory speeches, angry crowds in the public gallery. Back and forth the camera moves between Napoleon's storm-tossed small boat and the threatened ship of State.

Napoléon lasts almost six hours and the final scenes, shot with three cameras, are shown from three projectors on to a wide screen, conveying powerfully for that period the immensity of the French army's task in the Alps. At the end Napoleon is only twenty-seven, but Gance's funds were exhausted and he decided to end the film at that point.

Napoléon is a film about national morale being regalvanized by a gifted, dedicated patriot. It is one of the great epics of cinema, and perhaps the best silent film ever made. It was shown at the Opéra in April 1927 but failed to make an impact. Sadly for Gance, the Locarno Pact had now been signed, France and Germany seemed set for *rapprochement*, and it was no longer *bon ton* to glorify victory.

Two films about the Great War were made in the years immediately following. Léon Poirier's *Verdun, souvenirs d'histoire* (1928), a reconstruction of the 1916 battle, carried the message that France and Germany must settle future differences peaceably, while Raymond Bernard's *Les Croix de bois* (1932) betrayed the spirit of Dorgelès's novel, for it emphasized the futility of war and also catered to a new Leftist political current by depicting officers as needlessly sacrificing their men.

With the rise to power of Hitler, newsreels brought into French cinemas goose-stepping Brownshirts and Jews being beaten up, while a growing infringement of liberties in Germany was to be seen in the banning, for instance, of Clair's *A nous la liberté* on the grounds that it was subversive. At first sight it may seem surprising that no one in the world of French cinema, where some of the most talented were Jewish, thought fit to make a film which, without being unduly provocative of Germany, would castigate totalitarianism.

The explanation will emerge when we come to examine more closely the mid-'thirties.

One masterly film about war did come from Paris studios in 1937. Jean Renoir, second son of the Impressionist painter, was just old enough to serve in the war as a *chasseur alpin*. Invalided out after a sniper's bullet damaged his leg, he turned first to pottery – his grandfather's craft – then followed his brother Pierre into acting. In the 'twenties he began making silent films, including one sponsored by the Government celebrating the centenary of French Algeria. Becoming increasingly critical of capitalism and business ethics, he turned his gifts, which included a sense of humour, to defending 'the little man' and the underprivileged. In *Toni* (1935), using amateur actors, he depicted the distress of poor Italian immigrant workers in southern France. By then he had become a committed Socialist.

Renoir chose to set *La Grande Illusion* in a German camp for French prisoners of war. One is working class, one a nobleman, one a Jew, yet they share a sense of belonging to a national group. The German commandant comes from a Prussian military background; played by Erich von Stroheim, he is the embodiment of stiffness and national pride. Slowly the French nobleman discovers that he and the German share many of the same values, while the German's hauteur slowly crumbles as he finds in the Frenchman a chivalry similar to his. Through this and other interactions of character Renoir lets us see that the values of any one group or profession are more deeply rooted than nationality. There is a hint that these might become the basis of a new *rapprochement* between peoples.

Whatever one may think of the film's message – and it was widely held by Socialists of the period – Renoir's point of view is a far cry from the unalloyed patriotism of Gance's *Napoléon*. Yet the two films have this in common: deep compassion for the underdog, a compassion conveyed also in the films of Clair and Vigo. It is the hallmark of much of the best work in inter-war French cinema.

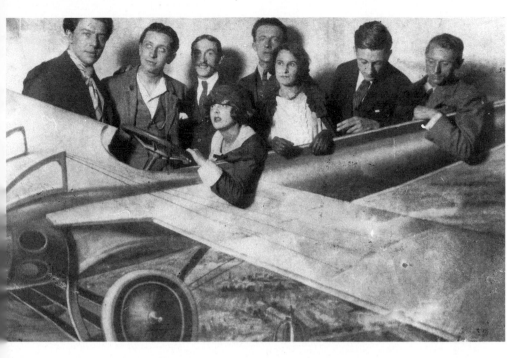

Surrealists in a fun-fair aeroplane: from left, André Breton, Robert Desnos, unidentified man, Simone Breton, Paul Eluard, Mick Soupault, Philippe Soupault, Max Ernst.

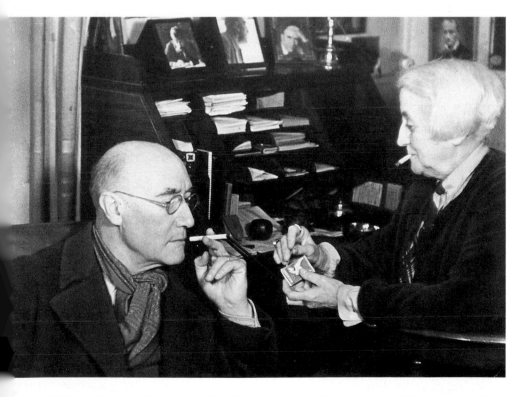

André Gide and his close friend Maria Van Rysselberghe, assiduous diarists of the literary world.

Jean Cocteau parodies the traditional posed portrait in a photograph by Man Ray.

Kiki of Montparnasse: a fragmented image of the dancer from Fernand Léger's experimental film, *Ballet mécanique*.

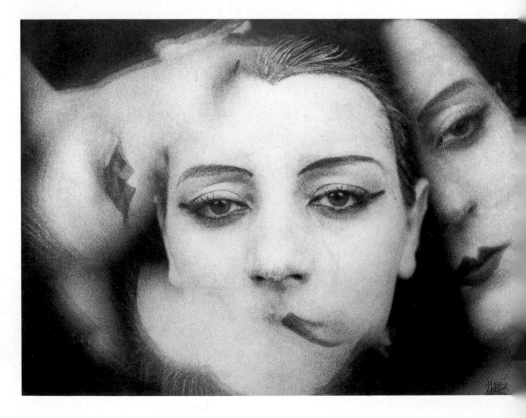

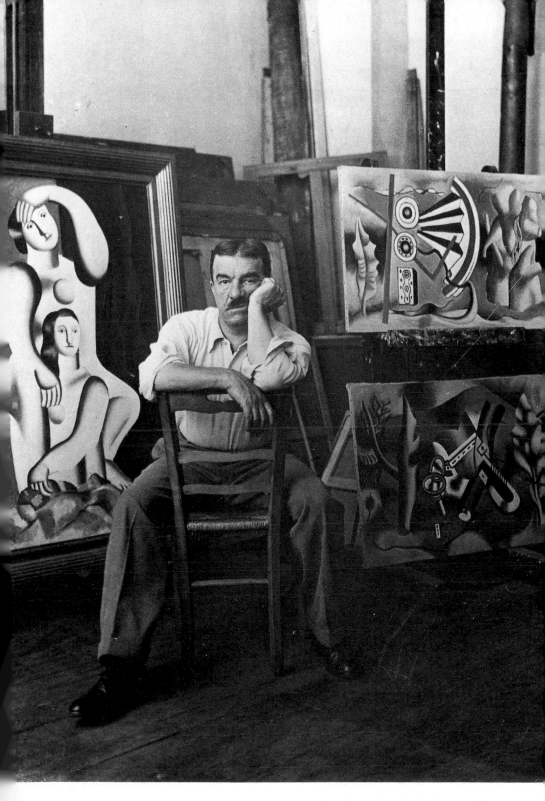

Fernand Léger, truculent painter of machine-age Paris, in his studio.

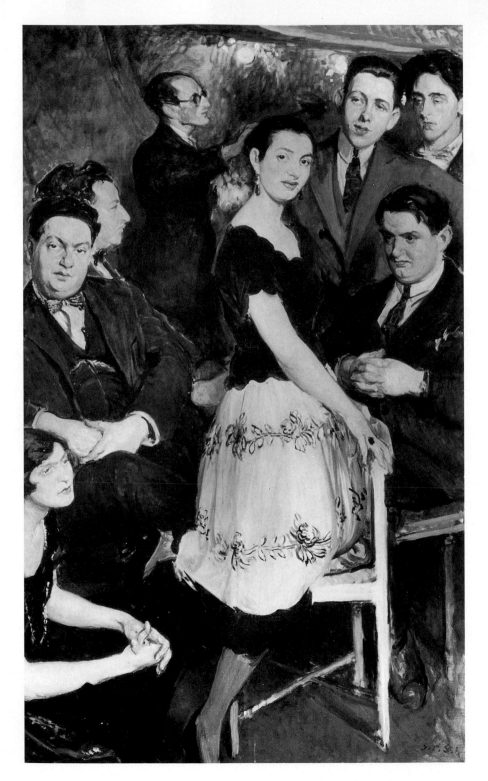

Le Groupe des Six by Jacques-Emile Blanche: gathered round a
favourite pianist, Marcelle Meyer, are on the left Germaine Tailleferre,
Milhaud, Honegger, and on the right Poulenc and Auric. Louis Durey is
missing. Jean Cocteau looks on from a corner.

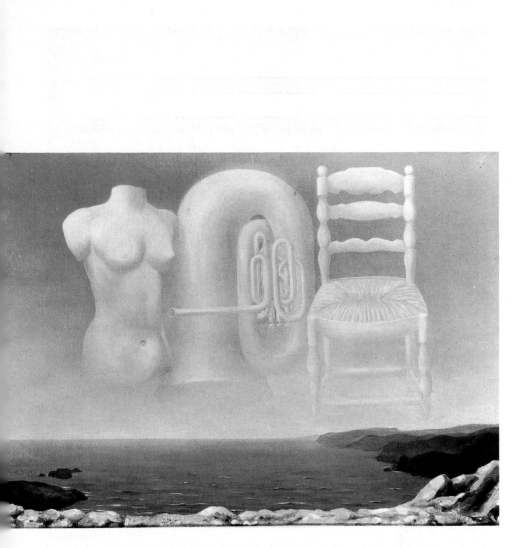

Le Temps menaçant by Magritte. By lifting familiar objects from their usual context Magritte seeks to startle viewers out of their preconceptions.

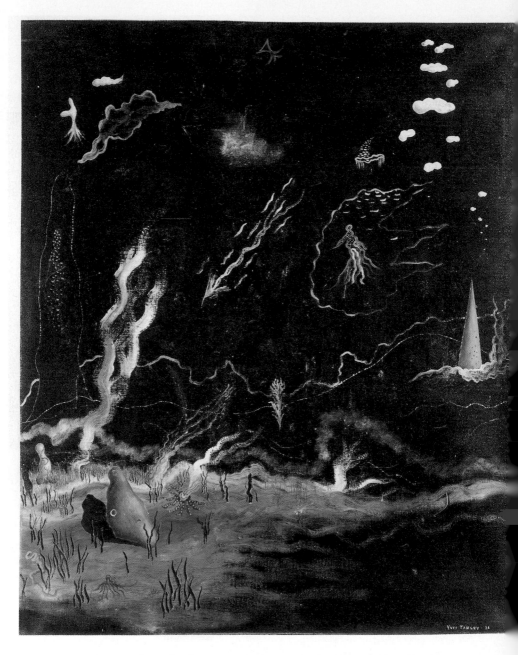

In an early work, *The Storm*, which was to influence Dali, Yves Tanguy
draws on his Brittany childhood to depict a Surrealist subaqua world, occupied
by algae, strange scurrying and floating creatures and a puzzling conical shell,
alarmed by flashes of lightning.

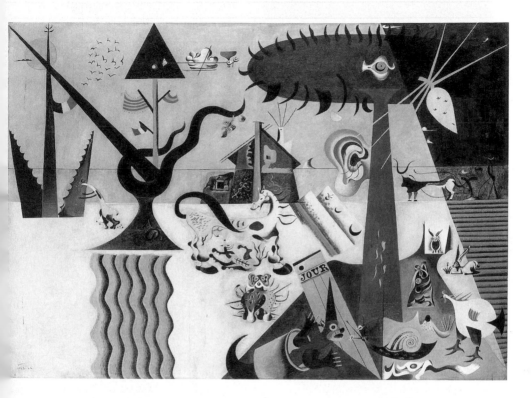

Joan Miró's early landscape, *La Terre labourée*, a growing fascination with pattern and imaginary small creatures.

Bird in Space made by Brancusi in 1926. It was refused entry to the United States by customs officials, who could not believe it was sculpture, and accused Brancusi of clandestinely shipping an industrial part.

Giacometti's *Caress*, 1932. To a slablike abstract shape influenced by Brancusi's early work Giacometti adds a tentatively tender touch.

8

THE STAGE

One September morning in 1922 a young man arrived at the Gare de Lyon by the overnight train from Marseille. He had glossy black hair, soft dark eyes and a natural distinction, but he was so thin and narrow-chested he had been judged unfit for army service. A schoolmaster's son, he had come to take up the post of English teacher at the Lycée Condorcet. With him was his shy wife Simonne, in his suitcase a verse play about Catullus's love for Clodia, and in his heart a driving ambition to become, before the age of thirty, a playwright as successful as Edmond Rostand had been with *Cyrano*.

Too poor to afford a flat, Marcel and Simonne Pagnol rented a boarding-house room and took 3.50 franc meals[1] at the Bouillons Chartiers, a chain of cheap restaurants. Marcel taught until 4.30; from then until 7.0, while supervising his pupils as they did their written work, he sketched out ideas for plays. Almost every evening he went to a theatre, usually getting a free seat in exchange for reviewing the production for a literary magazine he had founded in Marseille. In this way he came to be familiar with Paris's diverse companies.

In his tiny unheated Atelier theatre Charles Dullin, a gaunt, stooped, long-nosed, grousing, cavilling figure bundled in shawls and scarves, staged fast-paced productions of Aristophanes, Shakespeare, Pirandello, as well as serious contemporary work, such as Cocteau's *Antigone*, while training young actors like Jean-Louis Barrault. The Russian-born couple Georges and Ludmilla Pitoëff, at their Théâtre des Arts, staged poetic productions of plays such as Claudel's *L'Echange* and Gide's *Œdipe*. Jacques Copeau directed

1. The franc's purchasing power in 1922 was four and a half times more than in 1993.

until 1924 the Vieux Colombier, where he favoured stylized acting on a minimal set; among his productions were Obey's *Le viol de Lucrèce* and a play about St Alexis, *Le pauvre sur l'escalier*, by Gide's former friend, Henri Ghéon, who himself founded a company to put on religious plays. In sharp contrast to Copeau, André Antoine at the little Théâtre libre favoured a photographic realism. 'Speak like anyone else,' he commanded his actors. 'Turn your back to the audience, spit, burp if you like. If you want to serve the cause of drama, forget you're in a theatre.' Antoine had staged more than a hundred plays by authors as different as Zola, Barrès and Loti, and at sixty-four his anger could still make grown men quail. Delighted by such vitality and variety, Pagnol dashed off a letter to a friend in Marseille: 'I have a very distinct impression that it is easy to win literary success in Paris, infinitely easier than we thought! . . . The only thing needed is talent.'

Contacts, however, could speed the process. Pagnol saw much of Paul Nivoix, a journalist friend from Marseille who had become drama critic for the influential *Comœdia*. Nivoix knew men who from a modest provincial background had risen to the top and might be willing to help a gifted beginner from out of town.

One such was Henri Béraud, a baker's son from the suburbs of Lyon who had left school without a *bac*, travelled the world as a hard-hitting journalist, and had just published a witty novel about a fat man – Béraud himself was large and fat – *Le Martyre de l'obèse* – which won the Goncourt prize. Béraud was an Épicurean who enjoyed pretty women, good food and fine wines. He had recently attacked Paul Claudel, André Suarès and André Gide – prominent upholders of Christian values, though Gide's interpretation of Christian love was to say the least unusual – claiming that they were in no way representative of fun-loving France. Béraud called them 'writers for export', pushed by the Quai d'Orsay and Gide's *Nouvelle Revue Française*. 'Do these latter-day saints believe that it is enough to parade their long faces, Bibles, sermons and sobriety across our land for the grapes to dry up on the vine, for laughter to disappear and for literature to go to bed at ten o'clock?' Punning on the axiom, '*La Nature a horreur du vide*', Béraud declared, 'Nature has a horror of Gide.'

Pagnol, himself a fun-loving man, took to Béraud and, brought up

as an anti-clerical republican, sided with Béraud in his attack on the so-called moralist school, which was then dividing Paris. Béraud, as drama critic of *Mercure de France*, helped circulate Pagnol's play about Catullus.

One late afternoon a car drew up at the Lycée Condorcet. From it emerged an elderly imposing figure, to enquire the whereabouts of Monsieur Pagnol. Informed by the concierge that Monsieur Pagnol had gone home, the caller left his name, which the concierge took to be his Christian name.

Informed next day that someone called Antoine had called, Pagnol took it to be a joke. But no. A copy of his Catullus play had found its way into the great producer's hands; he liked it, thought it showed great talent. He encouraged Pagnol to submit it to the Comédie Française and invited its author to his Sunday afternoon receptions.

At first in collaboration with Nivoix, then alone, Pagnol began to work on several promising dramatic ideas. As writing took more and more of his time, his headmaster taxed him with unpunctuality, to which Pagnol replied with a disarming smile, 'At least I am punctually unpunctual.'

Though the Comédie Française did not put on his Roman play, in his fourth year teaching English Pagnol scored the success that Antoine had foreseen. The eponymous hero of *Topaze* is a hard-working schoolmaster, content with little. At examination time he is told to give the idle son of influential parents good marks; he refuses and is dismissed. Suzy, a rich woman, works with businessmen, arranging crooked deals with town councils. She takes on Topaze, treating him first as a goose. But the young man learns fast, discards his principles and becomes highly successful at shady business. In the last scene he tells an old teacher friend that it's power that governs the world, and power today takes the form of 'these little pieces of crinkly paper'.

Both the public and the critics loved the play. Paris could talk about nothing but *Topaze*. One newspaper recalled Lindbergh's unheralded arrival and his words on stepping from his aircraft: 'I am Lindbergh'; 'This new arrival can say, "I am Pagnol."'

Over the All Saints holiday in 1928 Pagnol's father took the train to Paris to see *Topaze*, dining afterwards with his son at a brasserie. There he enquired about Marcel's schoolmastering, and the other

had to confess he'd taken indefinite unpaid leave. 'Unpaid? Then how do you live?' This brought a smile. Pagnol's second success, *Marius* – later to be filmed – was about to be staged, while every day a fifty-yard queue stretched outside the Variétés, where *Topaze* was being performed. Pagnol did not add that he had also taken indefinite leave from Simonne who had been unable to make the transition from Provençal village life and a Protestant background to the world of theatre. She did not want a divorce and Pagnol was living with an actress, Orane Demazis, the first in a string of liaisons that was to include Josette Day, after her brief idyll with Paul Morand.

So Pagnol achieved his ambition of equalling the success of *Cyrano* in 1897, but *Cyrano* celebrates courage, *finesse de sentiments* and unselfish love, *Topaze* dishonesty. At a more general level, whereas French comedy traditionally resolves a conflict within the moral code of the day, *Topaze* resolves it by contravening the code.

That this was more than Pagnol's private view becomes clear if we look at another play with an educational setting. In Jean Sarment's *Le Discours des prix* (1934) a schoolmaster, finding he has mislaid the final pages of his prize-giving speech, throws discretion to the winds and, speaking from the heart, advises pupils to 'live for themselves', to play a part in the life of the family, of society, of the nation, but to play it *knowingly*, like good actors, while safeguarding their own private inner world, and, most important of all, to beware of the word 'discipline', because what is required of us in that name is servility.

Sarment's message is close to that of Alain, pen name of Emile Chartier, an Ecole Normale graduate who taught in a Paris lycée and in a series of influential essays argued that there is only one reasonable attitude to authority: '*Contre*'. It was part of a widespread reaction by those who blamed governments for the world war.

Successful plays such as these left their mark on the intelligentsia, for whom theatre-going was a social and intellectual pleasure, and also on politicians, who were often seen in the audience because not a few chose an actress as their *petite amie*. Aristide Briand was for long the lover of Berthe Cerny; André Tardieu, prime minister in 1929, of Mary Marquet, tall and imposing, an unforgettable Athalie; Yvon Delbos, Foreign Minister in 1936, shared part of his

life with Germaine Rouer; Georges Mandel, said to be the most intelligent deputy in the Chamber, with Béatrice Bretty; and the list is by no means exhaustive.

In drawing-room comedy the favourite writer was Sacha Guitry. Son of the famous actor Lucien Guitry, Sacha made his stage debut at seventeen and his dream, he once said, would be 'to live in a theatre. Then I could walk from the stage to my bedroom without even noticing.' He wrote about a hundred plays, and took the lead in many of them. His first wife was an actress, his second Yvonne Printemps, Paris's favourite singing star. In all Sacha Guitry had five wives. He was a big spender and besides his Paris house kept up a château and a villa on the Côte d'Azur.

The paradox of Guitry is that in real life he was a notoriously errant husband while his best plays turn on a wife's inconstancy. After six years, according to Guitry, marriage becomes so unbearably dull that a wife needs to find amusement in a clandestine love-affair. It is feminine infidelity that sets in motion male jealousy, quarrels, foolish behaviour and, in the last scene, reconciliation, all this in a moral vacuum. The plots do not bear summarizing but their common denominator is a happy ending.

In a city with an excess of women it is not the wife who is likely to be inconstant; Guitry's plays undoubtedly misrepresent her and they probably had an effect on liberated women as described earlier. In a larger sense Guitry's plays, like *Topaze* and *Le Discours*, show selfishness successfully passing for righteousness, and their popularity suggests that this is what the public wanted to believe.

As always in Paris there were playwrights eager to attack particular injustices. In *Vient de paraître* (1927) Edouard Bourdet showed up malpractices in the world of publishing, and in *Le sexe faible* (1929) the methods by which gigolos prey on unsuspecting women, while Jules Romains in *Knock* (1923) showed man's credulity in matters of health and illness. But by and large the structure of society was left in peace.

One actor-producer did, however, bring a genuinely radical approach to theatre. Antonin Artaud came to Paris in 1920 and became an actor in Charles Dullin's Atelier company and joined the Surrealist set, where we have already met him. The son of first

cousins, he exhibited the brilliance and instability that sometimes mark the children of such marriages. During the 1920s he conducted a tormented seven-year love-affair with a Romanian actress in the Atelier company, while giving increasingly bizarre performances on stage: in one play, as the Emperor Charlemagne, he entered on all fours and crawled towards his throne like an animal. Dullin was not amused.

In 1927 Artaud founded his own theatre with the Surrealist Roger Vitrac. He wrote and produced a short piece, *Le Jet de sang*, a gruesome spectacle that includes a whore eating a young man's eyes and biting God's wrist. Artaud was groping for something bigger than Surrealist subversion. He saw theatre as ritual, necessarily violent in order to induce a degree of frenzy that will radically modify the audience's lives. He compared theatre to an epidemic of plague, since both force men to drop their masks and see themselves as they are: fearful and aggressive. This goes beyond Aristotle's catharsis, for Artaud rejects the unfolding of character through dialogue, demanding instead that reason be subjected to the revelations of magic. He directed plays tragic and macabre, his most considerable production, in 1935, being *The Cenci*, based on versions by Shelley and Stendhal, after which he left for Mexico to study pre-Columbian culture: one wonders what truth he managed to draw from the Aztecs' annual sacrifice of thousands just to keep the sun alive in the sky. In 1937 he was to enter a mental hospital and never fully to recover. Like Picasso with his bone-hard women, Artaud insisted on revealing man's aggressive and nihilistic urges, a brave voice in a theatre world that believed men act according to enlightened self-interest.

In the first years of peace audiences wanted to forget the war and there were no plays dealing directly with battle experiences. Some writers, however, dealt with its aftermath. In *Le Retour* (1920) Flers and Croisset envisage a fraternal union of Frenchmen developing out of the fellowship that emerged among soldiers at the front, while in *Le Feu qui reprend mal* (1921) Jean-Jacques Bernard takes a pessimistic view. André, in civilian life a university teacher, has fought briefly in the trenches, then been made prisoner. After four years of misery he returns home to his wife Blanche. They were in

116

love when he left but now he has difficulty in settling down to home life. He learns that Blanche has billeted an American captain in the house. He probes into her motives, which she protests were innocent, but he is unconvinced. When the American writes Blanche a letter asking her to join him, André's jealousy erupts in bitter accusations, while Blanche, hitherto passive, retorts with angry charges of cruelty. Encouraged by his peaceable father, André pleads for a reconciliation on the grounds that he is not responsible for his behaviour: 'Don't blame me, blame the war.' At the end they remain together, held no longer by love but by a hurtful bond they do not understand.

The character of André rings true. It was the Frenchman in uniform who for one reason or another had been unable to prove himself in action who returned embittered. Bernard was to go on to write many good plays and to found the 'school of the unspoken', characterized by silences that suggest unexpressed, perhaps inexpressible, feelings.

The years 1928 to 1933 saw impressive plays by Berton, Obey and Bernanos depicting war as a great drama which reveals man's virtues and weaknesses. They do not pass judgement, but they recapture the heroism and brutality of conflict.

The same period witnessed a number of anti-war plays. In *L'Homme que j'ai tué* (1928), which has echoes of Wilfred Owen's poem 'Strange Meeting', Maurice Rostand – son of Edmond – portrays a soldier who having killed a man in battle perceives that he is morally responsible for his deed, and the fact that he is not legally responsible will offer him no solace. He travels to Germany, finds the family of the dead young man and makes himself known. Suffering helps them to transcend nationalism and in the last scene he assumes the role of the dead son.

By and large the plays dealing with war and peace are fair-minded and show all sides of the question. The largest number express anti-war sentiments and others a naïve faith in some miraculous happening – such as discovery of a weapon so terrible it will deter men from aggression – or else a fearful scepticism about man's capacity to attain a diplomatic solution. Yet none was sufficiently a work of art to make a lasting impact on a sophisticated audience. That achievement was to be realized by Jean Giraudoux.

'Scintillating' is the adjective friends applied to Giraudoux, and from the start he did show himself quite out of the ordinary. A civil servant's son from the Limousin region, at school he came top in every subject and won medals for running and swimming, before passing out first from the Ecole Normale Supérieure. Well-built, tall and supple, he had reddish hair cut short, keen eyes behind thin-framed spectacles, a self-possessed quick-talking yet friendly air: very much an intellectual. 'The Ecole Normale,' he was to write, 'is a school of the spirit . . . All who pass through it are servants of the spirit, in other words, enemies of matter. They accept neither the weight of the world, nor its material trammels.'

Giraudoux won a travelling scholarship to Germany, where he met Paul Morand, who was to become a close friend, and coached him in German. After a year teaching at Harvard he published a number of light-hearted, stylish short stories and joined the consular service. In 1914 he served as an infantry sergeant, was wounded in the groin and leg. He returned to active service as a second lieutenant in the Dardanelles campaign, when he was again wounded. In 1918 he married and resumed his duties in the consular service.

It was Philippe Berthelot who had recruited Giraudoux. One Sunday Berthelot had noticed Paul Claudel laugh while perusing the latest *Mercure de France*. Berthelot asked him why. Claudel read him a sentence from a short story by Giraudoux about farmyard hens falling into line behind a passing horse, hopeful that it is going to feed them. 'That perhaps was the beginning of my success,' Giraudoux later recalled, 'Berthelot concluding that insouciance is useful to a diplomat.' Giraudoux might have added that Berthelot had spent large poker winnings on making a tennis court at the Foreign Ministry, where he liked to play a set before work, and Giraudoux, an excellent player, made an agreeable opponent.

Promoted by Berthelot to be head of the Cultural Relations section, Giraudoux replaced his spectacles with a monocle and spent the afternoons in this easy job writing stories, essays, and later plays. 'He had decided,' a friend noted, 'to meet life with a smile, and he stood by that decision.'

But the smile came from a distinctly odd way of seeing himself. In 1923, in a piece of writing entitled '*Prière sur la Tour Eiffel*'

Giraudoux proclaimed himself the spiritual heir of the Adam of the days before the Fall. 'I still live, as Adam did, in the interval between creation and original sin. I have been exempted from the curse laid upon all mankind. No thought of mine is charged with guilt, with responsibility, with liberty.'

In this spirit Giraudoux offered Paris *Siegfried*, a drama about the troubling problem of Franco-German relations. The hero is a French writer, Jacques Forestier, who had been picked up by Germans on a battlefield in the Great War suffering from amnesia. Restored to health by a German nurse, Eva, and re-educated as a German in German hospitals, he becomes under the name of Siegfried a prominent political reformer.

To discredit him, Siegfried's opponent, Zeltin, has sent for Geneviève Prat, the Frenchwoman Siegfried had loved before the war, and who still hopes to discover again the man she had loved as Forestier. A struggle ensues for Siegfried's true identity between Eva and Geneviève, each citing scraps from his past that will weigh with him. Siegfried-Jacques eventually discovers his real identity and decides to return with Geneviève to France. But in recovering him Geneviève accepts his German accretions, for at the frontier station she calls him for the first time 'Siegfried': '*Siegfried, je t'aime.*'

This very clever play, brilliantly staged with appropriate realism by Louis Jouvet in 1928, proved an immense success. Giraudoux's theme, that human nature is fundamentally good and fundamentally the same, whatever our place of birth, and that nationality only marginally modifies it, might have been judged several notches too glib but for the fact that Giraudoux was a respected member of the Foreign Service, played bridge and tennis with the almighty Berthelot, knew Germany well and spoke the language fluently. This gave his play weight and despite adverse reviews in *Revue des Deux Mondes* and *Mercure de France* it was hailed as a hymn to peace.

By 1935 the international scene was to have worsened, but Giraudoux, still a believer in Franco-German friendship, would offer another of his pre-Adamite interpretations of human affairs in a Jouvet production. As the hero of the cleverly titled *The Trojan war will not take place*, Hector is a young patriot whose battle experience has made him a convinced pacifist. Opposite him the older Ulysses is prepared also to try conciliation. Despite the bellicose slogans of

poets on both sides, between them they arrange a settlement whereby Helen is to be handed back to Ulysses, and the Greeks will sail home.

As the Greeks head for their ships and the play nears its end, Hector finds a drunken Greek, Ajax, pawing his wife, but manages to curb his urge to reprisal. As Ajax withdraws, Hector is challenged by the jingoist Trojan poet Demokos, loudly contesting the handing back of Helen. To silence this dangerous threat Hector strikes down the poet, who, dying, accuses Ajax of having killed him. On the basis of this lie, flung from mouth to mouth, the Trojans rush on the Greeks; war has begun.

In saying that reasonable men of good will can resolve their differences by discussion provided men of words – be they poets or journalists – do not tell lies, Giraudoux is re-asserting the triumph of spirit over matter proclaimed in his youth. Again, the solution might well have seemed too glib but for the weight of Giraudoux's name, paired with that of Jouvet, by now Paris's most esteemed actor-director, and the fact that it chimed in with Professor Brunschvicg's optimistic philosophy. Together with *Siegfried*, which had been successfully revived in 1935, it encouraged Parisians to believe that a reasonable solution would be found to Franco-German differences.

9

SONG AND DANCE

Itinerant singers, cafés with a pianist or accordionist where customers join in the singing, operettas and music hall had long been a feature of Paris life. After the War, as wireless and the gramophone brought songs into the home, popular tunes became part of the texture of living. Later this swell of song was added to by theme tunes of films sung by glamorous stars. If Plato is correct in saying that the music favoured in a republic reflects and contributes to its values, then the songs of Paris have something useful to tell us.

One popular singer overarches the interwar years. Maurice Chevalier was born in 1888 in the suburb of Ménilmontant, youngest of a wastrel house-painter's seven children. He had a rough-and-tumble childhood, left school at ten, picked up the elements of music and dancing and at eighteen began to appear in music hall. As well as a good voice he possessed two welcome attributes: an unfailingly cheery manner and a beaming smile. With these he succeeded in charming the ladies without antagonizing the men.

In pre-war Paris Mistinguett was a favourite music hall star, praised by her friend Cocteau as 'belonging to the class of animals that murmur, "I don't think, therefore I am."' She and Chevalier sometimes shared billing and before long were sharing a bed. War came and Chevalier went off to the front. In his first engagement shrapnel pierced his right lung and he was taken prisoner. In 1916 Mistinguett used her influence to obtain his release on health grounds, although he was by now perfectly fit.

In 1917 Maurice Chevalier and Mistinguett were joined in the Deauville villa they shared by a young song writer, Jacques Charles. Charles had been reading a novel by Carco, *Mon Homme*, about

pre-Picasso working-class Montmartre, and quickly composed a song inspired by Carco's characters, with the same title as the book:

> *Il me prend tous mes sous*
> *Il me flanque des coups*
> *Mais je l'aime.*
> *Ce n'est pas qu'il soit beau*
> *Il n'est ni grand ni costaud*
> *Mais je l'aime,*
> *Je l'ai dans la peau.*

> He takes all my money,
> He knocks me about,
> But I love him.
> It's not that he's handsome,
> He's neither tall nor strong,
> But I love him,
> He's got under my skin.

Mistinguett launched this song, made it a hit and sang it hundreds or times, alone or with Maurice Chevalier. Its vignette of a rough, none too easy man and an indulgent woman suited the last years of hostilities and of a sometimes difficult homecoming.

Maurice Chevalier, fifteen years younger than Mistinguett, found his co-star more and more possessive and tried to free himself, at first unsuccessfully. In 1924 he suffered a severe breakdown. He found himself incapable of remembering his lines and on one unfortunate occasion dried up on stage. Retiring to the country and helped by Yvonne Vallée, a chorus girl whom he was later to marry, he recovered the following year and made a successful comeback at the Empire. For the next fifteen years his love songs, dashingly tilted straw hat and warm smile were to epitomize for many a romantic, rosy Paris.

Among Chevalier's songs one of the most popular, in the mid-'twenties, was *Valentine*:

> *Elle avait de tout petits petons*
> *Valentine, Valentine,*
> *Elle avait de tout petits têtons,*
> *Que je tatais à tâtons,*
> *Ton ton tontaine!*

122

She had dear little tootsies
Valentine, Valentine,
She had dear little titties,
That I tried to fondle,
Ton ton tontaine!

Another song of the 'twenties in the same mood is Jean Lenoir's *Parlez-moi d'amour*:

Parlez-moi d'amour,
Redites-moi des choses tendres . . .
Vous savez bien
Que, dans le fond, je n'en crois rien,
Mais cependant je veux encore,
Ecouter ce mot que j'adore.

Speak to me of love,
Say tender words again . . .
You know quite well
That at heart I don't believe you,
But still I want to hear
The word that I adore.

Falling in love is closely linked, musically, with the sights and sounds of Paris. Often it is these that create the atmosphere in which love blossoms. So quite a few of the songs are in praise of Paris, the city of lights and the accordion, of burgeoning chestnut trees in spring, of pavement cafés where chance encounters can easily lead to romance.

A Paris, dans chaque faubourg
Le soleil de chaque journée
Fait en quelques destinées
Eclore un rêve d'amour.

In every district of Paris
The sun, as it rises,
Brings to certain lives
A dream of love.

So sang Annabella, a flower-seller in love with a taxi-driver, in

Clair's 1933 film, *Quatorze Juillet*. The music by Maurice Jaubert on a waltz theme by Jean Crémillon was to become a favourite tune of the 1930s.

What distinguishes many of the songs of this period is that the love described is set among the *petit peuple*; it is unsophisticated, exclusive and by its tenderness compensates for harsh working conditions. Such songs are the musical equivalent of Vigo's *L'Atalante* and Carné's Jean Gabin films.

No one loved Paris more than Marseille-born Vincent Scotto, and many of his more than one thousand songs are hymns to the city. *Sous les ponts de Paris* tells of poor lovers:

> *Sous les ponts de Paris,*
> *Lorsque descend la nuit,*
> *Comme il n'a pas d'quoi s'payer une chambrette,*
> *Un couple heureux vient s'aimer en cachette.*

> Under the bridges of Paris,
> When darkness falls,
> With no money to pay for a room,
> A happy couple can secretly make love.

Scotto rhapsodized his adopted city in a song that was to echo round the world:

> *J'ai deux amours –*
> *Mon pays et Paris,*
> *Paris toujours,*
> *C'est mon rêve joli.*

> I have two loves –
> My own country and Paris –
> Paris forever,
> That's my pretty dream.

When sung by the American Josephine Baker, whom we shall meet presently, the lyrics were to assume deeper overtones. Paris was not just one capital among many: it claimed and tried to be a city where tenderness and romance united people, whatever their origin.

When Maurice Chevalier went to Hollywood, one of the rare entertainers to succeed there, Jean Sablon, dark, with a velvety

warm voice, and the Corsican Tino Rossi continued his role of purveying to Parisian audiences a steady flow of romance.

With the vogue for songs went a vogue for dancing. The graceful One-Step evolved to become the Fox-Trot which, with the waltz and tango were the great favourites of the period. In the smart clubs and dance halls importations from the United States were preferred: the Charleston, a fast, kicking dance; the Shimmy, a ragtime dance which called for shaking the hips and shoulders; the Black Bottom, which required sinuous rotation of the hips.

American dances received a powerful impetus when a troupe arrived from New York in autumn 1925. As they began rehearsing their revue, one of the lead dancers, nineteen-year-old Josephine Baker, finding she could not see eye to eye with the star, Maud de Forest, persuaded Douglas the choreographer and Sidney Bechet, the band leader, to reshape the show round a new title, *La Revue nègre*, in which Josephine would dance solo, apparently nude, but in fact wearing a tight, partially transparent cinnamon leotard, with satin briefs and feathered skirt.

La Revue nègre opened at the Théâtre des Champs-Elysées: a sentimental vision of black America, with Mississippi steamboats, water-melons, peanut vendors, a jazz club in Harlem. With her long arms, slender india-rubber body and panther-like ease of movement Josephine Baker astonished *le tout-Paris*. As the Ballets russes, sixteen years earlier, had brought to Paris primary colours and dancers who leaped, so this show introduced black vitality and the powerful sensuality of Afro-American dancing.

Josephine Baker had been born in St Louis, but the show's publicity men hinted that she came from French-speaking Haiti or Louisiana. When Paul Derval signed her for the Folies Bergère she scored an even greater success and became a cult figure. Intellectuals somewhat foolishly hailed her as a Baudelairean enigma, as Cubism in motion, or as an animated version of African carvings. To American tourists who filled many of the seats she was just 'a fireball of sex', which occasioned Josephine's trenchant comment: 'The white imagination sure is something when it comes to black.'

During her first year in Paris Josephine Baker tried to look like a white girl, washing and combing flat her hair, rubbing her body with lemon juice. Then, realizing that Parisians had little if any colour

prejudice, she accepted her cinnamon pigment and found a lover-impresario. A hard-headed business woman, she opened a cabaret with a dozen oysters selling at 45 francs, the most expensive in town. After a spell in New York she was to return for the 1937 Exhibition. She has come to be regarded as the prototype of a woman who was tough enough to establish herself in a man's world, indeed who was able to get men to do her bidding.

The nearly nude girls of the Folies Bergère had initially come on stage to entertain American soldiers on leave. The nudity came from American strip shows, the performers mainly from England: girls with a gift for dancing but too tall to be ballerinas, who lodged in an Anglican clergyman's house and received an annual visit from the ambassador and his wife. Each revue took ten months to prepare and rehearse, and the glitter-mad Russian émigré, Erté, provided many of the settings.

'Eroticism has found a style,' said Cocteau of Josephine. Her performances and those of other scantily clothed Folies stars were certainly a form of eroticism, more obvious but perhaps no more powerful than the can-can of Toulouse-Lautrec's days. Eroticism has for centuries been a feature of Paris: in Josephine Baker's day it lay at the violet end of the spectrum, near the blue of love songs and the pink of film romance.

Jazz, which had been an important feature of *La Revue nègre*, made an impact on fashionable Parisians. It is to be found throughout Morand's novels and stories. Aragon, Cocteau and Pascin pounded out jazz on the piano, clever intellectuals wrote essays with such titles as 'Syncopation as an anti-logic.' It was all rather fun – and amateurish, according to Austin Coates, then a private student in Paris:

After you'd heard Jack Hylton and his band, or Carroll Gibbons and the Savoy Orpheans, French dance-bands were pathetically bad. The players couldn't get the idiom, and you saw they were marooned. A French fox-trot sounded like a little march of tin soldiers. Not till the late 'thirties did they make a contribution; this was the use of the violin as a jazz instrument – real jazz, improvising on a set tune. This was a unique contribution, and very French; but it took about seventeen years to get there. In

fairness I should add that Italian dance-bands were even worse. The American syncopated idiom goes with slurred speech, and in French and Italian you don't slur.

Jazz gave a great deal of pleasure to avant-garde Parisians but proved less influential than the café songs. It was those that imparted the unique light-hearted, carefree mood that smoothed out any unease about a fluctuating franc or constantly changing ministries.

A light-hearted tone also stamps much of the classical music between the wars. Debussy's death in 1918 had left Erik Satie as Paris's senior innovative composer. A bachelor then in his early fifties, small, narrow-shouldered, with a pince-nez and a pointed blond beard at a time when beards were no longer much worn, he dressed faultlessly in morning coat, stiff collar, black tie and bowler hat low on his bald head. Even in sunshine he carried an umbrella. He lived in the poor suburb of Arcueil, in one cheap room containing a piano and instead of a bed a hammock, under which in winter he would place a row of bottles filled with hot water, like some strange marimba. His toilet accessories were a scrubbing brush and a lump of pumice stone. He kept everything, even pieces of string, and notably piles of old hats and walking sticks.

Satie had a child-like, sometimes childish sense of humour. This was the period when Parisian mothers put their small boys into sailor suits, and one day Satie approached the sailor on sentry duty outside the Ministry of Marine: 'Why at your age,' he demanded, 'do you let them dress you like that?'

Hating the grandiloquence of the Romantics and Debussy's lush impressionism, Satie was writing a new kind of music, small-scale, restrained, apparently naïve though in fact ingeniously contrived, shot through with fun and sly humour. Ignoring or distorting traditional processes of chord progression and phrase structure, he relied for many of his effects on the repetition of very simple material.

In his score for the ballet *Parade* Satie amuses and intrigues by juxtaposing contrasted types of music, including a slow waltz and ragtime, and introducing novel sounds: a typewriter, steamship

127

whistle and a pistol shot. His music for *Relâche*, in 1924, carries improbable juxtaposing still further, almost to the point of Surrealism, with jazz as a witty digression. These two works won the approval of the young, who hailed Satie as the David who had slain the Goliath of musical impressionism and invited him to their parties, where however he ate lightly, having a weak liver which he treated with Pink pills, and sometimes showed himself very prickly. One wet evening Georges Auric, a gifted young composer, inadvertently put his umbrella in the stand in such a way that the point made a big hole in Satie's. When he discovered this, the older man went into a fury, refused to say goodbye and slammed the door behind him. He gave Auric's music unfavourable notices and in one review remarked: 'My umbrella is going to be very upset at having lost me.' His anger lasted several months.

Behind his quirkiness and jesting Satie had a serious side. In this period of his life it appears in short, deliberately understated yet moving pieces, such as his *Cinq Nocturnes* and *Ludions*, settings of verse by Léon-Paul Fargue, melancholic poet-in-residence at *Le Boeuf sur le toit*. It was revealed also during visits to the studio of his close friend, Constantin Brancusi, where the two bearded bachelors would discuss Socrates. While the Romanian carved Socrates' portrait sculpture in wood, Satie envisaged setting to music Plato's description of the philosopher's death. For this work he obtained a commission from that indefatigable and discerning patron, Princesse Edmond de Polignac.

La Mort de Socrate is a thirty-five-minute symphonic triptych on French translations of Plato for solo sopranos and small orchestra. Having written it, Satie, as so often, felt he had not gone to the heart of his subject and spent a year rewriting the score. The piece was performed in 1919. At first hearing some found its regular rhythms monotonous, but time has shown that beneath the even, chant-like vocal lines there is a cunning ingenuity, and that words imparted in the measured tones of confidentiality can be as moving as the heroic heights of grand opera.

Paris's musical set could sometimes be cliquey backbiters but Satie's last months show them at their best. Suffering from cirrhosis of the liver, Satie resumed practising his religion: one morning, coming out of church he met Stravinsky and with characteristic droll

self-deprecation murmured: *'Alors, j'ai un peu communiqué ce matin.'*
The Comte de Beaumont found him a private room in the Hôpital
Saint-Joseph, where he had endowed a ward; Braque helped
him into the ambulance, Maritain brought a priest to his bedside.
Brancusi came regularly to sit with him; Lerolle came to discuss
publication of his last work, the music for *Relâche*, whereupon
Satie insisted on being paid at once in cash, remarking wisely:
'You never need money so much as when you're in hospital.' Hardly
had the money been paid over than he hid the banknotes between the
sheets of old newspapers piled up on his suitcase, together with all
sorts of papers and bits of string. Darius Milhaud and his future
wife Madeleine visited him every day for six months; after his death
they and other friends bought in at the public sale of his effects
everything personal that had belonged to the composer. Of his
musical legacy to the young particularly important were his prefer-
ence for small-scale, precise, highly intelligent works, and his sense
of humour.

Maurice Ravel, was, like Satie, short of stature, but well-propor-
tioned and muscular. He had been exempted from military service
because of a hernia but on the outbreak of war, aged thirty-nine, he
volunteered and for two years drove an artillery lorry close to the
fighting. Nervous and sensitive, he suffered great mental anguish, as
is evident in the delicate piano suite, *Le Tombeau de Couperin*,
completed in 1917. Each piece is dedicated to a fallen comrade in
arms, one of them Captain de Marliave, husband of Marguerite
Long, who was to give the first performance. It is perhaps the most
moving music to come out of the war.

Ravel adored his mother, lived with her in Paris until enlisting
and stayed with her on leave. In 1917 she died. Even almost three
years later he was to write: 'My despair increases daily. Since I have
begun composing again, I am thinking about it more – I no longer
have this dear silent presence enveloping me with her infinite
tenderness, which was, I see more than ever, my only reason for
living.' He was never to marry – though he did propose unsuccess-
fully to the violinist Hélène Jourdan-Morhange – and as with Anna
de Noailles after the death of Barrès, some of his work was to bear
the imprint of loss.

'He is a child and an old man,' wrote a friend in 1922. 'He will laugh at a trifle but his drawn face can easily take on a severe, closed expression. He moves instantly from gentle light-heartedness to gloomy gravity.'

This volatility marks the score Ravel composed in 1919 for a ballet planned by Diaghilev as a musical homage to Johann Strauss. In *La Valse* violent excitement alternates macabrely with breakdowns of the waltz beat. Anything further from the Viennese composer would be hard to imagine. Ravel wrote it under the shadow of his mother's death but some feel that the dissolution of the waltz rhythms also represents the breakdown of the old order by the war. This tremendously engaging work was rejected by Diaghilev, who described it as 'not a ballet but a painting of a ballet'; it was performed in the concert hall in 1920 to mixed opinions.

The child in Ravel – his wonder, love of small creatures, of surprises and jokes – comes to the fore in *L'Enfant et les sortilèges*. With a libretto by Colette, the music conveys the world of childhood with charm but without sentimentality. It was well received at its first Paris performance in 1926 at the Opéra-Comique, the flight of the dragonflies and bats, and the miaowing duet between the two cats, attracting special praise.

In 1928 Ravel was asked by the Russian-born dancer Ida Rubinstein to compose a ballet for her. During a brief holiday in St Jean de Luz, before going for a morning swim, he tapped out a melody on the piano with one finger. 'Don't you think this theme has an insistent quality?' he asked his host. 'I'm going to try and repeat it a number of times without any development, gradually increasing the orchestra as best I can.'

That theme and a second, both derived from Arab-Hispanic folk tunes, became the basis of the ballet *Bolero*, a piece lasting seventeen minutes, consisting of one long, very gradual crescendo. From his stage directions we know what Ravel intended to convey: a woman dancing in the open air, inflaming with desire a watching crowd of men, a jealous lover, a *torero* who secretly meets the dancer by night only to be stabbed by her lover.

This richly orchestrated circular dance moves from repetition into frustration and ends in bloodshed. In mood it belongs with the work of another creative artist locked into the image of his mother,

Jean Cocteau's *Le Sang d'un poète*, and one can see affinities too with Artaud's theatre of cruelty and Picasso's disjointed women. *Bolero*'s immediate popularity in Paris of the smiling 1920s suggests that audiences recognized their own suppressed memories of violence and bloodshed and welcomed their exposure in music that was exciting – and brief.

Ravel esteemed popular music and drew on it in some of his scores. He went often to cafés and cabarets with friends like Ricardo Viñes and Léon-Paul Fargue, with whom he would discuss the music while chain-smoking *caporals bleus*. He loved the *chansons de Paris*, which he considered a distinct genre, such as those of Naples or his mother's Basque country. He told Viñes that they were 'a product of virtuosity and savoir-faire,' to which Viñes added that they were also an instinctive expression of hope. The songs' words pleased Ravel less than the music, 'yet I'm forced to admit they couldn't have been different. Without them all these tunes would be lost, perhaps they wouldn't even have been invented.'

In both of his last major works Ravel introduces melody as tender as any in the *chansons de Paris* and also jazz rhythms such as he had heard in cabarets. The Concerto for Left Hand, commissioned in 1930 by the Austrian pianist Paul Wittgenstein, who had lost his right arm in action, Ravel decided would be 'light-hearted, not profound', and at one time thought of calling it 'Divertissement'. 'After a first part in traditional style,' the composer explains, 'a sudden change occurs and the jazz music begins. Only later does it become evident that the jazz music is really built on the same theme as the opening part.' The ending is sombre, as the various melodic elements are brusquely interrupted by an almost brutal conclusion.

The following year Ravel completed a Concerto in G Major for piano and orchestra. The opening theme cam to him on a train journey between Oxford and London. The slow second movement, composed 'two measures at a time', introduces and develops a melody of exceptional sweetness, but this is not allowed to run its course. It is overpowered in a dissonant climax, to return briefly on the piano and cor anglais. Here again the contraries in Ravel's character are apparent.

Ravel travelled much, conducting – badly – and often forgetting on the way part of his luggage. Despite fame he remained modest.

'I've written only one masterpiece – *Bolero*,' he told Honegger. 'Unfortunately, there's no music in it.' He wanted a peaceful death, with *Prelude to the Afternoon of a Faun* played at his funeral – 'the only score that is absolutely perfect'. In fact his last years were far from peaceful. In 1933 he began to suffer from aphasia and apraxia; unable to coordinate his movements, he would take over a week to write a simple letter. In 1937 an operation was performed to equalize the level of his cerebral hemispheres, one of which had become depressed; ten days later he died. He left behind music that is intelligent, subtle, allusive and never tedious, in which, with rare exceptions, emotion is kept under restraint. It is music that pleases by its lightness, and in this mirrored its period.

Ravel, Satie and jazz acted as catalysts on those composers under thirty in the first year of peace. Darius Milhaud, aged 27, a big square affable Southerner, had returned from a spell as secretary to Paul Claudel, France's ambassador in Rio, humming Brazilian tunes and sporting strawberry-pink or lemon-yellow ties. On Saturday evenings in his boulevard de Clichy flat Milhaud gathered other young composers and friends, including Jean Cocteau and Paul Morand, who mixed and shook the latest cocktails. After dining in a restaurant, they went to the nearest fairground, savouring the hurdy-gurdy and Scotto's tender songs, or went to the circus to laugh at the clowns, then returned to play their latest compositions on the piano.

Georges Auric, plump, snub-nosed, with his red forelock hanging over a bulging brow, was the best educated member of the group. He had suffered a breakdown during military service and passed through the Val-de-Grâce; perhaps it was that which made 'le gros Georges' so concerned a friend, always ready to do a service; it was he who typed *Le diable au corps* from Radiguet's dictation. Georges was yet another of those brilliant Parisians to marry a Russian girl, Norah, an engineering graduate who was also a talented painter. A pale, serious young Swiss who had studied at the Conservatoire, Arthur Honegger, also joined in the Saturday fun, but more reservedly.

A discerning cellist named Félix Delgrange took Milhaud and his friends under his wing and in a modest-sized artist's studio

organized performances of their work, and of Satie's – now a cult figure. These attracted the attention of *Comoedia*'s music critic, Henri Collet, who singled out as particularly gifted Milhaud, Auric, Honegger and three others: Germaine Tailleferre, Louis Durey and Francis Poulenc. In the nineteenth century a famous group of like-minded Russian composers had been known as 'The Five'; Collet decided to call his chosen few 'The Six'. The label stuck, though it is one of the least appropriate ever devised, since the six shared little beyond companionship and places on the same programme.

Jean Cocteau, who saw himself as an expert and impresario in all the arts, took up The Six and issued a manifesto in which what he called the fuzzy imitators of Debussy – such as Ravel – were attacked, while jazz, the catchy tunes of music hall and circus, the primitivism of Stravinsky's *Sacre*, and Erik Satie were praised. He liked to think his views were shared by The Six. And in 1921 by his drive and charm he did indeed persuade the *Groupe des Six* (now reduced to five, Durey having seceded) to write the score for his half-play, half-revue, *Les Mariés de la Tour Eiffel*, a spoof on bourgeois values. All the musical pieces were parodies or jokes, each composer writing in his or her own style, and the show enjoyed quite a success. But The Six wanted to do more than jump through Cocteau's limited hoops and after this joint effort each was to follow his own bent.

Darius Milhaud worked in the line of Ravel and was most open to jazz. In 1923 he composed a black jazz ballet, *La Création du monde*, performed by Rolf de Maré's Swedish company, with outstandingly good sets and costumes by Fernand Léger. In the following year he wrote the music for *Le Train bleu*.

It is noticeable how many of the young worked for ballet or film. Georges Auric, also one who drew on jazz rhythms, wrote a brilliant score for the ballet *Les Fâcheux*, with decor and costumes by Braque, and incidental music for René Clair's *A nous la liberté*, while Arthur Honegger who, in contrast to Auric, found Satie quite uninteresting, wrote the music for Abel Gance's railway fiction *La Roue* in the same year as his important symphonic piece *Pacific 231*, and music for Gance's epic *Napoléon*.

This tendency to latch music on to visual images suggests a lack of robustness in the composers concerned, explicable perhaps by the number of possible musical paths opened up not only by Satie and

jazz but, abroad, by Bartok and Schönberg. Great dedication, power and singleness of mind would be required to produce major works in a new style, and these converged in the youngest member of The Six.

Francis Poulenc was born in 1899 to parents who both loved music. Emile Poulenc was co-director of a successful family pharmaceutical firm, very well-off; his favourite composers were Beethoven and César Franck. Jenny Poulenc, who came of a family of furnishings craftsmen, was a gifted amateur pianist. As a child Francis received piano lessons from César Franck's niece. Jenny Poulenc would have liked him to enter the Conservatoire, but her husband insisted on all-round education, so Francis attended the Lycée Condorcet and practised in the evenings. Holidays he spent at Nogent on the Marne, where he loved listening to popular tunes in the riverside *bals musette*. He began to study under Ricardo Viñes, perhaps the best pianist of his day for modern works, a mustachioed hidalgo who arrived wearing a brown sombrero and used to kick Francis in the shins whenever he was clumsy at the pedals.

When he was sixteen, Francis's mother died. This perhaps was a mercy for him since it spared him Ravel's fate. He transferred his affection to his married elder sister, Jeanne, and cultivated numerous friends, male and female, Auric in particular becoming a 'spiritual brother'.

Mobilized in the last months of the War in an anti-aircraft unit, Poulenc served a further three years as a typist, using his leisure to compose, notably three short pieces, *Mouvements perpétuels*, which Viñes performed in 1919, and which already show a gift for joyful melody, chastened by dissonances derived from Satie. This was the period when Poulenc attended Milhaud's parties.

In appearance young 'Poupoule' was tall and heavy, with hanging arms, and he walked with feet turned outwards. His face was not handsome but people remembered it: dominated, as Ravel's was, by a strong jutting nose, ears very big and alert as a gun dog's. The brown eyes were rather small, slanting and very mobile, with the whites much in evidence. His hands were big and plump, and he used them when speaking, holding them stiffly, bent at the wrists. To the baritone Pierre Bernac, Poulenc was a surprising mixture of gaiety and melancholy, of profundity and triviality. 'There was something of the spoilt child about him, but this could readily be forgiven for he

possessed great and genuine kindliness. He was the most natural and simple of men, the most direct and the least vain imaginable.'

Poulenc's compositions until 1935 fall into three main categories: settings of poems, pieces for piano, symphonic works. In choosing poems Poulenc found it necessary to have heard the poet's voice: 'I think this is essential if a musician does not want to betray a poet.' Apollinaire's voice Poulenc remembered as both melancholy and joyous, with a hint of irony. He set to music numerous poems by him, and even two by Apollinaire's mistress, Marie Laurencin, as well as poems by Max Jacob and a great many by Paul Eluard. Since all save Apollinaire were close friends Poulenc was able to enter into their intentions and match his accompaniment to the mood of their lines. Similarly, the interpreters of his songs were close friends. A charmed circle came into being, with not a little mutual admiration, and self-protective. The resulting music is knowing, witty, sometimes childishly playful, music for a highly civilized, fast-moving society impatient with lengthy pieces or profundity.

In 1932 Poulenc wrote to a lady-friend: 'I am well aware that one has to keep working for love of art but there are nevertheless moments when one has to think of the next bit of coal and the next pork chop. On the brink of a winter without any commissions, I find myself forced to "write for piano" which is what all these "Publisher-Gentlemen" want.' Hence over the next two years Poulenc composed many works for piano, ranging from the brilliant *Improvisations* and *Deux intermezzi* to children's pieces (*Villageoises*), a *Humoresque* and a *Badinage*. Here he showed himself in a variety of styles to be a master of joy, fun, surprise, irony and occasional tears that quickly dried.

Thirdly, there are Poulenc's orchestral works. A suite of nine gay dances makes up the ballet *Les Biches*, for which Marie Laurencin designed appropriate costumes and decor in melting pink, dove-grey and pale blue. Poulenc's attraction to the piano shows itself in two concertos and there is an invigorating concerto for organ. His *Concert champêtre* evokes Watteau and is remarkable for its use of the harpsichord – rescued from near-oblivion by his friend, the gifted teacher Wanda Landowska. These compositions are invariably very intelligent and often wittily allusive, with borrowings from composers such as Mozart, Tchaikovsky and Stravinsky.

This on the whole joyful music was composed by a man who in company laughed easily and took your arm but who constantly bit his fingernails, resented any interruption of his closely ordered daily life, was terrified of the sea and feared for his liver. 'There are no eggs or cream in this cake?' 'Oh no, Monsieur.' The cake would be full of eggs and cream and he would eat a great deal of it and suffer no harm at all. When not working he could not bear to be alone. He would sink into unaccountable attacks of depression and self-hate. Then he would hurry back from his Touraine house to his flat near the Parc Monceau: 'Paris is the only place where I can bear great sorrow, anguish, melancholy. I have only to take a walk in the *quartiers* that I love and life seems suddenly lighter.'

To such a man friends were as indispensable as Paris. One among them was Pierre-Octave Ferroud, a year Poulenc's junior, composer and promoter of musical events. In 1935 his motor-car crashed and Ferroud was instantly decapitated.

Poulenc heard the news while on a working holiday in the Aveyron, where his father had grown up. Emile Poulenc, a deeply religious man, had brought up Francis in the Catholic faith and spoke to him often of the sanctuary of Rocamadour, perhaps the oldest in France, but from the time he was eighteen and his father died, Poulenc had worn his religion lightly. Now, under the shock of Pierre's death, finding himself near Rocamadour, he arranged to be driven there. A simple chapel, half scooped from the rock, shelters a figure of the Virgin in black wood, said to have been carved by St Amadour, the little Zacchæus of the Gospel who had to climb a tree to see Christ.

Shaken by his loss and deeply moved by the shrine his father had loved, Poulenc found his religious faith welling back – 'the faith of a country curé' – and that evening began to compose the *Litanies à la Vierge Noire*, for women's or children's voices and organ, on a text of one of the pilgrims' rustic prayers.

It was the beginning of a new category of work. Side by side with secular compositions Poulenc was to write choral sacred music, notably the *Sept Chansons*, a modern counterpart of Renaissance polyphonic works, his Mass in G Major – both of 1937 – and *Four Motets for a season of penance*, composed in 1938, which he considered his most personal religious work. Not since Fauré's *Requiem* and

Debussy's *Le Martyre de Saint Sébastien* had French sacred music of this quality been heard.

Poulenc's religious music is important in his own career and also as a symptom of a wider change of direction. When the sky of Europe darkened in the mid-1930s the prevailing tone of light-heartedness and playfulness no longer satisfied a number of composers.

The great figure in the revival of sacred music, Olivier Messiaen, was born in Avignon in 1908. His father was a schoolmaster who taught English and translated all Shakespeare's plays; during his four-year absence at the Front Olivier was brought up, in Grenoble, by a mother who published poetry about the joys of motherhood without being any the less a satisfactory mother. She read him fairy tales, developed his imagination, encouraged his passionate interest in birdsong and his love of the piano.

At the age of eleven Messiaen entered the Conservatoire, where he won four first prizes, and in 1930 he was appointed organist of Paris's La Trinité, not a pretty church but endowed with a magnificent organ built by Aristide Cavaillé-Col. Here, for forty years, Messiaen gave weekly organ recitals that often included brilliant improvisations. Kindly and easily approachable, he would sit for an hour afterwards talking to whoever wanted to talk to him.

Poulenc had declared that in returning to Catholicism he rediscovered freedom. Similarly Messiaen was fond of quoting a passage from St John: 'If you remain in my word, you will be truly my disciples, you will then know the truth, and the truth will set you free.' Messiaen, who from childhood possessed an unwavering belief in the truth of Christianity, early recognized that his freedom as an artist was intimately linked to that belief, and that it must be his privilege to expound in his music the truths of Christianity, in particular God's redemption of man, the glory of God in the splendour of creation, and the transfigured life that awaits man after the Resurrection.

Messiaen sets out not just to evoke a religious mood, or to write liturgical music, but to create sonorous images that will be exact equivalents of those truths. Already, in *Le banquet céleste* for organ, a meditation on the Eucharist composed at the age of nineteen, simple and spectacularly beautiful chord-sequences, the passage from stillness to moments of powerful intensity, convey the dissolving of

137

linear time into eternity. Rhythm is an important element in Messiaen's compositions, and he reflected much on the relation of time and number, which divide, to eternity and infinity, which unite. Time, he was to say, 'is one of the strangest of God's creatures, because totally opposed to Him who is in essence eternal, to Him who is without beginning, without end, without succession.'

In 1934 Messiaen heard a string quartet by a young composer, André Jolivet, and made known his admiration. The two met and became friends. Jolivet believed that musical composition had its roots in ritual and incantation – a view akin to Artaud's conception of theatre – and that its primary aim was religious in the widest sense: that is, to *religare*, to reconnect God to men and men to one another. With Yves Baudrier and Daniel-Lesur, Messiaen and Jolivet formed a new group called *Jeune France*. Opposing what they held to be the frivolities of Ravel and the cerebral works of Stravinsky, they inscribed on their banner, 'Sincerity, generosity, conscience.'

Music has often been considered the most spiritual of the arts because it is totally non-representational, but it is perhaps surprising that *Jeune France* should give prominence to conscience in the religious sense.

During the inter-war years the religious strain in French civilization could not find satisfactory expression in literature, on the stage or on film, all dominated by humanist values, but thanks particularly to Poulenc and Messiaen it did emerge in music.

The group *Jeune France* gave their first concert in June 1936, under the patronage of François Mauriac and Paul Valéry, with Roger Désormière conducting and Ricardo Viñes at the piano; on the programme were two works by Messiaen: *Offrandes oubliées* and *Hymne au Saint-Sacrement*. It was an event of more than passing interest. Paris already had its share of tender catchy tunes, of jazz, of witty ballet music and of exquisitely wrought intimate songs for a small circle of sophisticated friends, their mood on the whole joyful; now it could add to the list joy in the supernatural, as religious music, for too long identified with saccharine hymns or austere plainchant, now firmly re-established itself as a necessary element in any complete culture.

10

THE ENGLISH-SPEAKING ENCLAVE

Paris contained two large communities of foreigners: the Russians, who began to arrive as refugees in 1917, and the Americans, the first of whom arrived as ambulancemen in the same year. Whereas the former were poor and counted themselves lucky to get work as waiters or taxi-drivers, the latter, because their dollar was strong, could live well on what was to them very little. Englishmen and Irishmen were soon to join the Americans, the whole forming a highly articulate English-speaking enclave, whose work was to influence their native cultures. How that community viewed the City of Light, what they drew from Paris and what if anything they contributed to it, is the subject of this chapter.

A number of budding young writers, curious to see what war was like, chose to join the American ambulance corps. One was e. e. cummings, son of a New England Unitarian minister, and a student of English at Harvard. After crossing the Atlantic and spending an idyllic month in Paris he was sent to the Front. Here his Yankee nonconformism showed in remarks that his American superior judged unduly sympathetic to the Germans. Cummings was handed over to a French tribunal and spent three months in a French prison before being sent home. His father, indignant, wanted to sue the French Government for one million dollars; the son agreed to write down his experiences, which became *The Enormous Room*, but dissuaded his father from suing. He then returned to settle in Paris, finding in the work of Apollinaire a satiric-sentimental temperament close to his own. He began writing poems in the style of *Calligrammes*, to the extent of making his typography choreographic and suppressing

139

capitals, even in his own name. He was to continue living in Paris off and on until 1928.

John Dos Passos, another ambulanceman and a Harvard friend of cummings, also chose Paris after the war as a place for learning his craft as a writer. Dos Passos's model – and later his friend – was Blaise Cendrars, who wrote the black jazz ballet, *Creation of the World*, and was doing for prose what Apollinaire had done for poetry: blending narrative with techniques learned from cinema, incorporating newspaper items, advertisement slogans, the technical language of motor-car engineering and much else into montage. Dos Passos was to transfer this 'Total Art' technique to American subjects with considerable success.

A third young Harvard writer, Malcolm Cowley, frequented the Dadaists, discovered Radiguet, whose *Diable au corps* he translated, and developed a fine eye for talent that he was later to bring to the editorial chair of *The New Republic*.

Each of the three young Americans made endearingly fumbling attempts to convey what Paris meant to him. 'I participated,' wrote cummings, 'in an actual marriage of material with immaterial things . . . celebrated an immediate reconciling of spirit and flesh.' Cowley particularized: 'Paintings and music, street noises, shops, flower markets, modes, fabrics, poems, ideas, everything seemed to lead toward a half-sensual, half-intellectual swoon.' While still in uniform Dos Passos wrote of 'Loafing around in little old bars full of the teasing fragrance of history . . . talking bad French with taxi-drivers, riverbank loafers, workmen, petites femmes, keepers of bistros, poilus on leave, we young hopefuls eagerly collected intimations of the urge towards the common good.' All three were perhaps celebrating a warmth they sensed was missing at home.

They did their celebrating with a good deal of youthful rowdiness. Cummings was arrested for pissing in rue Gît le Cœur at 3 a.m. and released through the intervention of Paul Morand. Malcolm Cowley, tall and strong, punched the jaw of the owner of the Rotonde Café, believing him to be a stool-pigeon. Cowley spent a night in prison and on his release was surprised to find that his French friends put a high value on his action for two reasons: 'French writers rarely came to blows . . . and bearing no private grudge against my victim, I had been *disinterested* . . . I had uttered a *manifesto* . . . For

the first time in my life I became a public character . . . I was interviewed for the newspapers, asked to contribute to reviews published by the Dadaists . . . My stories were translated into Hungarian and German.' In short, he had acted in the cause of *esprit*, not of *matière*.

Another ambulanceman, Ernest Hemingway, though not averse to punching, declined to swoon before the beauty of Paris or to recognize any urge towards the common good. For Hemingway had been closer to the shooting and bloodshed than the others; he had been wounded on the Italian front and now he had to earn his living as cub reporter on the Toronto *Star*.

Hemingway was twenty-three and his wife Hadley eight years older when they signed a lease for a small apartment in Montparnasse's rue du Cardinal Lemoine, an apartment so cold they had to go to a café to get warm. Hadley, who had learned French at school, could manage simple conversations. Hemingway started to pick up the rudiments, mainly from reading the racing press, but his French was never to be more than faltering.

From the first Hemingway saw Paris in the anti-Romantic terms of a would-be hard-boiled reporter: 'A first look into the smoky, high-ceilinged, table-crammed interior of the Rotonde gives the same feeling that hits you as you step into the bird house at the zoo.' And the Americans drinking there? A character in Hemingway's first novel puts it like this: 'You're an expatriate. You've lost touch with the soil. You get precious. Fake European standards have ruined you. You drink yourself to death. You become obsessed by sex. You spend all your time talking, not working. You are an expatriate, see? You hang around cafés.'

Hemingway himself hung around plenty of cafés, most often the Dingo bar, where the owner and customers were American and the barman, Jimmie Charters from Liverpool, provided droll stories about them. He kept fit by boxing, which briefly came into vogue when Georges Charpentier won the light heavyweight championship in 1920. Among those he sparred with was Miró, one of whose paintings he purchased. The rest of his spare time he spent at the race-tracks, studying form and betting when he could afford it. He once said that what he liked most about France were the trees in spring, the women and the horses.

Hemingway at first liked Paris because it provided him with

colourful copy and because it allowed him to live without drawing too heavily on Hadley's money. Then, as he made headway with his story-writing, he liked it because there he met older Americans such as Robert McAlmon and Gertrude Stein and an Englishman, Ford Madox Ford, who gave him encouragement and helped shape his craft and style.

This style owed nothing to the Paris of Frenchmen. One of Hemingway's first errands on arrival had been not to buy Gide's *Symphonie pastorale* or Proust's *Jeunes filles en fleur*, but to head for Shakespeare and Company, the English-language bookshop-cum-lending library owned by Sylvia Beach, an unmarried American with lively brown eyes, wavy brown hair and a determined little chin, who, with her sense of humour, was to become a friend and her shop a congenial place for meeting other American writers. The book Hemingway chose to borrow on that first call tells us something about his tastes: Turgenev's *A Sportsman's Sketches*.

Sport meant very little to creative Parisians, whereas it was always at the centre of Hemingway's life. Already, during his first years in Paris he went three times to Pamplona for the bull-running. His pages on bull-fighting are perhaps the best he ever wrote, and if one compares them with *Les Bestiaires*, the 1926 bull-fighting novel by Henry de Montherlant, a Parisian who like Hemingway chose to be an expatriate, one finds another pointer to the gap between American and Parisian attitudes. Montherlant intellectualizes the bullight; he treats it as a revival of Mithraism, expressing and justifying the hero's paganism. He misses the elemental physical contest, but that is what Hemingway admirably seizes, with its implication that life itself is a contest.

Hemingway moved from Paris in 1927, but in later life was to return there in spirit to write *A Moveable Feast*. This nostalgic account of the 1920s is so vividly written it is often taken as the truth, but where it can be checked against known facts it is found to be large-scale misrepresentation. The friends who had helped Hemingway, such as Gertrude Stein and Ford Madox Ford, are brutally satirized; Scott Fitzgerald – during his brief passage through Paris a welcome drinking companion – is cruelly depicted as a money-minded, ill-mannered, sexually inadequate alcoholic, and other examples could be cited of Hemingway's determination to be seen to win the

contest of life. Particularly relevant to us is that Hemingway who, when he wrote the book, was a rich man, asserts that he and Hadley were happy in Paris because they were poor. Hemingway was never poor in Paris, otherwise he would have been unable to drink, bet and travel as much as he did, or to pay $500 for Miró's *La Ferme*. In making that assertion Hemingway has unconsciously adopted Scott Fitzgerald's equation in *The Great Gatsby*: money = insensitivity, an equation meaningful to Americans but not to Parisians, where in creative circles money values were irrelevant and where the rich consistently used their money with great sensitivity to advance the arts.

'I disagree with what you say but will defend to the death your right to say it.' Voltaire's words had become axiomatic in Paris where, provided you did not impugn someone's honour, you could print whatever you liked – in sharp contrast to New York and London, where residual Puritanism in the form of censorship restricted the outspoken language favoured by the post-war avantgarde. That was one of the attractions of Paris for publishers who wished to make known the work of unknown writers. The other was low costs compared to New York and London. In Paris you could publish a small circulation literary magazine and hope to break even. One of the leading expatriate publishers was Robert McAlmon, a coldly intense Middle Westerner. He put part of his rich wife's money into the Contact Press, which published Hemingway's first book, *Three Stories and Ten Poems*, as well as work by the talented Kay Boyle and his own collection of stories. Another was William Bird, a newspaperman with his own press agency and a passion for printing, who acquired a seventeenth-century hand press on the Ile Saint-Louis and on it printed limited editions of promising work. From 1923 Bird's Three Mountains Press and the Contact Press published some thirty books that in London and New York would never have seen the light of day.

In 1926 Bird sold his press to Nancy Cunard, who renamed it the Hours Press. Helped by Henry Crowder, her jazz pianist friend, Nancy set the type and printed the books herself, among them Aragon's translation of Edward Lear's *The Hunting of the Snark*.

In 1931 the Hours Press published Nancy's pamphlet, *Black Man and White Ladyship*, a public attack on her mother in which she

flaunted her association with Crowder in the worst possible taste. This outburst of hatred shocked her former lover, Louis Aragon, and André Breton too. They questioned the motives behind her concern about racial discrimination and this weakened the impact, three years later, of her big important anthology on black politics and culture, *Negro*.

Either in association with the small presses or independently no less than eight American literary reviews came into being in Paris during the 1920s, the most noteworthy being *Transatlantic*, edited by Ford Madox Ford: it lasted only a year but published significant work, including four poems by e.e. cummings and fiction by Dos Passos and Robert McAlmon. These adventurous little periodicals carried to New York and London, in refracted form, some of the stylistic advances initiated by the French writers of Paris.

The most important book to issue from a private press came from the pen of a forty-year-old Irishman. After a long spell in Trieste James Joyce had taken a flat in the Latin Quarter. With his wife, son and daughter he spoke Italian, with his drinking companions English. He had studied the Dadaists and been influenced by them, but he made no close French friends and read no more than a couple of pages of Proust – 'I cannot see any special talent.' As Canaletto brought the golden light of Venice in his suitcase when he came to paint the Thames, Joyce moved through Paris wrapped in the mists of Dublin.

Parts of *Ulysses* had appeared in the *Little Review*, edited from New York, where the Society for the Prevention of Vice brought an action for obscenity and despite an able defence by John Quinn, a perceptive collector of Brancusi's sculpture, they won their case. Joyce's admirers persuaded Sylvia Beach to issue the book under the imprint of Shakespeare and Company and on 2 February 1922 *Ulysses* appeared in an edition of 1000 copies a dozen years before it could be published legally in any English-speaking country. It quickly became a cult book. Every self-respecting young American or Englishman in Paris felt obliged to taste of the forbidden fruit, to share the unheroic but shockingly funny adventures of Stephen and Bloom.

What did the French make of this very long novel? On the

appearance of a translation in 1925 the *Revue des Deux Mondes* commissioned a review from a large-minded intellectual, a former disciple of Romain Rolland, named Louis Gillet. His twelve-page assessment calls for notice, since it points up the difference between Anglo-Saxon and Parisian literary values.

The book, says Gillet, is really an interminable monologue. 'Bloom thinks, therefore the world exists. We are given the process of thinking instead of the finished thought. Never brackets, because there are no brackets in nature, a minimum of punctuation and, in the last part, none at all. One wonders why M. Joyce didn't suppress the separation of words, and even writing. Does Nature write?'

> M. Joyce, in his passion for analysis, forgets that the most elementary sensation instinctively brings together everything it tries to separate: the eye does not count the blades of grass in a landscape; it assembles, eliminates, synthesizes: do we see the pores in a pretty face?

Gillet then turns to Joyce's method of conveying 'the coral of consciousness.' 'In vain does he bone and dislocate sentences, jumble words, pulverize language, grind down grammar, overturn every accepted method of representing reality. Who can assure me that this molecular style is not, as painters would say, *chiqué* – artificial? These rows of nouns, this message tapped out like Morse in no way resembles what I find in myself, when I lend an ear to my inner voice.'

Gillet gives Joyce full marks for his verbal acrobatics and for the brilliant parodies of every style from the troubadours to the sporting press. But what is the book's central message? 'Perhaps simply that while Stephen and Bloom strive after truths and chimeras, happiness is attained by Molly the *muliercula* and is found under the plump paw of pleasure. Was that conclusion worth shaking heaven and earth, piling up so many pages and more words than were needed to build the tower of Babel?'

> There remain throughout [concludes Gillet] a tone of acridness, something inhuman, a sarcasm and mockery of everything, not seen since Rabelais: the gaiety of the renegade monk . . . There

145

is no pity in the author's heart: he is completely lacking in tenderness.

As for artistic innovation, *allons donc!* The author of *Ulysses* enjoys mystifying, that is his right. But one snook is as good as another. Consciousness, subconsciousness, psychoanalysis, Freudianism, the self, the non-self, opening of 'the gates of the future', what a to-do! The old drunkard said as much in his song: *J'ai la cathédrale dans l'ventre,/Les enfants de chœur,/Les sacristains, les chantres/Et les bonnes sœurs* . . .[1] That at least is clear. And shorter.

Paris as a musical centre proved particularly attractive to young Americans, for in 1921, at the suggestion of General Pershing, an American School of Music had been established in Fontainebleau. The presiding genius was Nadia Boulanger. Daughter of a Russian princess and a violin professor at the Conservatoire, she herself studied composition there under Fauré. After composing some songs and incidental music, she recognized that her gifts lay in teaching and conducting. Tall, thin, with a pennant-like nose, she worked tirelessly to revive Renaissance and Baroque music, and she also said that when Nadia could not get her way by Gallic logic she resorted to Russian tears. Much loved at the school, she was to teach so many gifted Americans that on their return home they became known as the Boulangerie.

Among the most gifted was Aaron Copland. Born into a Brooklyn family of Polish-Lithuanian descent, he became Nadia Boulanger's pupil in 1921, returning to America three years later with the Organ Symphony, which won him notoriety and the patronage of the conductor Serge Koussevitzky. His tough dissonant style derived from Stravinsky and jazz; it was to reach a peak in his 1930 masterpiece, *Piano Variations*.

Virgil Thomson, a native of Kansas City, toured Europe as a member of the Harvard Glee Club and elected to remain as a pupil of Boulanger. From her he learned meticulous craftsmanship and developed a style that owed much to Erik Satie, whose *Socrate* he conducted at Harvard in 1923.

[1] In my belly, there I have the cathedral, The choir boys, The sacristans, the cantors And the good nuns as well.

Small, neat and well-mannered, Thomson made friends easily with Parisians and felt more at home in their city than in America. He composed a series of musical portraits of acquaintances, including Picasso, as well as the music for an opera, *Four Saints in Three Acts*, libretto by Gertrude Stein. Thomson organized a brilliant production of that opera with black singers, first in New York, then Chicago, thus introducing to a country long under the sway of German music the fun-loving finesse and elegance of the Satie tradition. Later, through his reviews in the *Herald Tribune* Thomson was to further the cause of French music, which he characterized as 'quietude, precision, acuteness of auditory observation, gentleness, sincerity and directness of statement' – very much the qualities also of French prose.

Quite a different sort of young American composer paid a two-month visit to Paris in 1928. Having settled into a suite at the Hotel Majestic, chewing his habitual cigar, accompanied by his brother and sister, George Gershwin ascended the Eiffel Tower, dropped in at Shakespeare and Company, and bought, for $6, a large sack of fruit, some bottles of Cointreau and 'a quart bottle of wonderful Spanish port [sic]'. He asked Nadia Boulanger if he could study with her, but she said there was nothing she could teach him. He then put the same request to Stravinsky. The hard-headed Russian looked up and inquired: 'How much money do you make a year, Mr Gershwin?' Off-guard, Gershwin named a sum that ran into six figures. 'In that case,' said Stravinsky, 'I should study with you.'

Gershwin went round Paris gathering impressions for a suite to be called *An American in Paris*. What particularly struck him was the taxi horns. He then visited the motor-car accessory shops, squeezing the various bulb horns until he found a 'honk' suitable for his new score.

Almost every evening Gershwin attended a party, either arranged in his honour or where he played recent work. His *Concerto in F* Diaghilev pronounced 'good jazz and bad Liszt'; Prokofiev, on a visit to Paris, found it a succession of '32-bar choruses ineptly bridged together', but admired Gershwin's gifts as a pianist and predicted he'd go far if he left 'dollars and dinners alone'.

With a flair for showmanship equal to Gershwin's George Antheil also made a name for himself as pianist and composer. This brash

young American of Polish descent composed percussive jazz-style pieces, creating a sensation in 1923 by thumping out three piano sonatas as a curtain-raiser to the Ballets suédois, while a Surrealist claque applauded, others booed and the police had to be called. Having created a second sensation with his score for *Ballet mécanique* – eight pianos, four xylophones and two airplane propellers – Antheil turned to higher things, as Hemingway noted: 'If George Antheil asks you to write a Jazz Opera with him, say "Yes, George" and let it go at that. He asks all his friends. It is his way of paying a delicate compliment.' One Antheil asked was James Joyce, suggesting the Cyclops episode from *Ulysses*. Finally Antheil settled for helping a close friend and warm admirer to write *his* opera.

Ezra Pound had arrived, aged thirty-six, with a Master's degree in Romance Languages and a schoolmaster's belief that he knew better than anyone else what direction music, painting, sculpture and literature should take. He associated with some of the minor Surrealists, he proposed to write a book about Brancusi – the Romanian, sensing an alien sensibility, wisely said no – and instead wrote a book about Antheil, who did not really merit such an honour. As for his view of Paris, Pound had hoped to find the city of Villon and the troubadours, rather as his friend T. S. Eliot had hoped to find the London of Queen Elizabeth. In his disappointment he took a somewhat jaundiced view of French genius. He sat through *Pelléas* – 'mush of hysteria' – and Satie's *Socrate* – 'damn dull'. Pound's one achievement in Paris was to write a two-voice opera, *Villon*, and it was this work that Antheil helped him notate. Of *Villon* Virgil Thomson said, 'The music was not quite a musician's music, though it may well be the finest poet's music since Thomas Campion.'

To a questionnaire put by the little magazine *Transition*, 'Why do Americans live abroad?', answers from expatriates in Paris made two claims: (1) Europe values the arts and confers self-respect on the artist, while America has no use for him; indeed, Malcolm Cowley was to say that writers in New York have only three justifications for their acts: to make money, to get their name in the papers, or because they are drunk; (2) Europe is tolerant, takes a more realistic view of human nature, and leaves a man freer to lead his private life.

Both views of Paris are embodied in the life of a powerful lady who

had been living at 27 rue de Fleurus, in the Latin Quarter, since before the War. Gertrude Stein, helped by her brother Leo, had early on bought paintings by Cézanne, Matisse and Picasso, the last two when they were being jeered at; she had understood the Cubists' principles and applied them in a highly original piece of writing, *Tender Buttons*. She believed Paris to be the world centre of artistic experiment, and that living among French-speaking people was a positive advantage: 'It has left me more intensely alone with my eyes and my English.'

During the War Gertrude Stein had done useful work delivering hospital supplies by van, which had endeared her to the French. With peace, now nearing fifty, her hair cut short and wearing an embroidered robe, Gertrude Stein resembled a Roman emperor and believed she had earned the right to pontificate. She declared that only the present tense is appropriate to the twentieth century, and used it in her own writing. She also used what she called insistence, explaining that it is not repetition but constant slight variation, corresponding to the way our thinking feels its way forward. She rejected plot and conflict and development of character: 'Generally speaking, anybody is more interesting doing nothing than doing something.' She tried to depict character mainly through speech mannerisms.

Stein's libretto for Thomson's music, *Four Saints*, reveals her strengths and failings. There are two saints, not four: Teresa of Avila and Ignatius, each, according to Thomson, 'surrounded by younger saints learning the trade of being a saint at the feet of the living consecrated masters, very much as the young American writers were clustered around Gertrude Stein and James Joyce.' The mood is informal, warm and would-be naïve. A vision of the Holy Ghost becomes the refrain 'Pigeons on the grass, alas.' There are various clever gnomic remarks and unexpected snatches of nursery rhymes, but without Thomson's firm musical structure it has to be said that the text would not cohere. Only in her memoirs of life in Paris, *The Autobiography of Alice B. Toklas* (1933), did Stein achieve a cohesive work, precisely by abandoning her experimental devices.

Of great importance also is Gertrude Stein's experiment in living. In 1907 a slim, quiet Californian lady, Alice Toklas, fell under the

spell of Gertrude's intelligence and self-assurance. Very soon afterwards Alice moved in to 27 rue de Fleurus and took her place on the other side of the fireplace under the Matisses and Picassos. Their lesbian relationship was on the whole happy and as stable as a heterosexual marriage. The two American ladies became the most celebrated exemplars of the truth discovered by other Anglo-Saxon expatriates: that Paris leaves one free to lead one's private life.

Self-effacing, observant, with a sly sense of humour, Alice acted as Gertrude's cook, housemaid, typist and 'chucker-out' of bores or of those deemed insufficiently appreciative of the Baltimore lady's genius. Hilarious stories circulated: Alice batting a cow around a field so that Gertrude could write to the rhythm of the cowbell.

By the late 1920s, according to Hemingway, Stein was becoming 'awfully damned patriotic about sex. The first stage was that nobody was any good that wasn't that way. The second was that anybody that was that way was good. The third was that anybody that was any good must be that way.'

In her neglected but important *How to Write* (1931) Stein went so far as to claim that traditional syntax and literary forms are patriarchal or male-dominated, and should be resisted. The section called 'Arthur A Grammar' has been perceptively analysed by Shari Benstock, whose interpretation I follow here. Stein sees grammar as a serious male, style as a frivolous female. Arthur A Grammar joins noun to verb, subject to object, to produce meaning. He is thereby enforcing his own linguistic law – a declaration of what parts of speech shall be joined to others – a law not unlike the one that enforces marriage and declares the male to be 'substantial' and the female to be 'inessential'. It is the 'inevitability' of the sentence presided over by Arthur A Grammar that Stein wishes to disrupt and redirect, for example by giving a noun adverbial qualities. This is Surrealist subversion in the cause of feminism. To validate such a hypothesis a wide array of languages in matriarchal societies would have to be invoked, but even in the tenuous form sketched by Stein it opens useful pathways into the connection between gender and particularities of style.

As André Gide was the panegyrist of pederasty, so Gertrude Stein was of lesbianism. Each effected a change of attitude among the *literati*, though Stein's influence was mainly confined to Americans.

Natalie Barney, another American who chose the lesbian way, did so with different motives from her more famous contemporary. The child of an unhappy marriage, Natalie Barney resisted her alcoholic father's efforts to marry her to a social equal and entered into an affair with a prominent Paris courtesan, Liane de Pougy. After trying unsuccessfully to save Liane from prostitution, Natalie decided to form a Sapphic circle. In 1909 she took a long lease of a two-storied *pavillon* at 20 rue Jacob that Maréchal de Saxe had built for the actress Adrienne Lecouvreur. In its spacious garden stood a small Doric temple, inscribed '*à l'amitié*'. Here on fine afternoons Natalie convened a small group of lady friends dedicated to the love of beauty and the love of sensuality.

In appearance Natalie was not mannish. She was tall, had beautiful long fair hair and soft eyes but her mouth was hard. She saw lesbianism as a healthy, vital state that allowed women to enjoy sensuality free from the fear of unwanted pregnancies. She also believed that it slowed the ageing process. She wrote a set of theatricals in French to be enacted in her garden, one of them featuring her beloved Sappho. But these, like her poems and maxims, lack the strength of Stein's writings, and it was her personality, sincere, idealistic, good-humoured, that friends valued. She was to gather her nymphs regularly until the outbreak of war, when she returned to America. Her claim that her chosen way slows the ageing process may in her case be valid, for she was to live to be ninety-six.

With financial independence, robust health and an absence of guilt a lesbian could achieve a stable, fulfilled life. Without them the sapphic road could prove more than a little stony. Of the several young, mainly American women who chose it Djuna Barnes is typical. Of Irish descent, a rebel against her family, she arrived in Paris from Greenwich Village at the age of twenty-eight as a journalist for *McCall's*. She had pale skin set off by auburn hair, wore dark red lipstick and painted her nails blood-red. She attracted men, but her caustic wit frightened them.

She began by joining Robert McAlmon's set of literary expatriates. She had a horror of ageing – 'this flesh laid on us like a wrinkled glove' – yet burdened her none too strong body with heavy smoking, alcohol and wearying affairs with men. Then, beginning to feel a

sexual attraction to women, she began to frequent Natalie Barney's garden at 20 rue Jacob.

In 1928 Djuna Barnes published *Ladies Almanack*, a *roman à clef* about the lesbian community. Dame Evangeline Musset, modelled on Natalie Barney, teaches how a woman is to withdraw her body from men, to discover her true sexuality and its pleasures, to reject altogether the image man has given of her. But in shaping her new self, woman finds she cannot escape a man's world. For example, if she asserts her separateness by wearing man's clothes she is accused of being a man 'in drag'. The brave experiment ends in shame and despair.

Djuna Barnes fell in love with an American sculptress, Thelma Wood, and set up home with her in a flat furnished with a decadent mixture of secular and profane. In all her affairs Barnes had been betrayed, probably because her feelings of guilt alienated her partner, and this relationship followed pattern. Thelma Wood was unfaithful and eventually left Djuna, who took her revenge by writing *Nightwood*, an autobiographical novel that corrects the bland idylls of Natalie Barney by describing the agonizing realities of a destructive love between women.

Sexual relations in every form, including perversion, were to dominate much American expatriate writing in the 1930s. Here the chief figure is Henry Miller. Brooklyn born, Miller came of German stock – on his father's side from Hanover, on his mother's from Prussia; he looked like a German, was often mistaken by waiters for a German, and early in life adopted the deep pessimism of the German prophet of doom, Oswald Spengler, whom he considered the greatest contemporary writer. Loathing America, unable to hold a job or write a publishable book, Miller arrived in Paris alone in winter 1930, at his wife's expense. He was then in his fortieth year: that is, his ideas and view of life were fully formed, and Paris was merely the place on which he happened to project them. Hamburg or Vienna or Berlin would have done just as well.

Miller was one of those full-lipped non-stop talkers who tell you more than you care to know about the body scent of the whore he slept with the previous night, about this complicated dream he had, and how it confirmed what an astrologer friend had predicted, about his stomach disorders and piles. For his first year he lived by cadging

meals and lodging, then took a newspaper proof-reading job, so that his leisure time was spent in Paris by night – not the Right Bank nocturnal world described by Morand, but the world of pimps and whores. He made friends with a Russian-born American book salesman, Fraenkel, whose belief that the Great War symbolized the death of modern man confirmed Miller in his sense of doom and love of corruption.

In Paris Miller seized on anything that, however improbable, could bear out his view that the world is squalid, sleazy, cancerous. Paris for young men like cummings and Dos Passos had been a springtime world of hope; Hemingway had loved the trees in blossom; but only a decade later here is Miller describing a favourite haunt, the Square de Furstenberg: 'A deserted spot, bleak, spectral at night, containing in the centre four black trees which have not yet begun to blossom . . . swaying with a rhythm cerebral, the lines punctuated by dots and dashes, by asterisks and exclamation points. Here, if Marie Laurencin ever brought her lesbians out into the open, would be the place for them to commune. It is very very lesbienne here, very sterile, hybrid, full of forbidden language.'

Miller in short possesses what the French call '*un esprit mal tourné*' and his sojourn in Paris would be of scant interest but for the fact that he poured out his fantasies into a novel which is really a long monologue, and while he wrote it, he had this memorandum above his desk: 'Get old manifestos of Dada and Surrealism, Steal Good Books from American Library, Write Automatically.' *Tropic of Cancer* owes much to the Surrealists but goes far beyond them in salaciousness. Here is the nightmare world Miller had already created for himself in Brooklyn, and Paris's contribution takes the form of a bright – but unbelievable – feature: the good, faithful whore with the heart of an angel. At one point in the book Miller exclaims: 'Give me a whore always, all the time!' Miller's novel could not be published in New York or London, but the Obelisk Press in Paris issued it in 1934.

Miller had become a close friend of a young expatriate woman, the wife of a rich banker. Anaïs Nin had a blank doll-like prettiness and a fascination with her own body. She spent a greal deal of time admiring herself in the mirror and confiding her sexual fantasies, including a latent lesbianism, and her dreams to a voluminous diary.

Miller encouraged Anaïs's literary ambitions, became her lover and when he needed it used her money.

The arrival of his wife June in 1932 complicated life for Miller and cramped his style. Presently, however, things improved. Anaïs found June 'the most beautiful woman on earth', and there ensued a *ménage à trois*, punctuated by emotional quarrels. Anaïs became increasingly drawn to psychoanalysis and astrology. In 1936 she vanity-published *House of Incest*, a book as fetid in its own way as *Tropic of Cancer*. Here the subjectivism preached by Breton and company is stretched to the limit as Anaïs, in the form of a dream, explores the nature of lesbian love and perversion generally. Never before had a woman written so frankly about her sexual longings and frustrations. Culminating in anger, cruelty, torture, physical deformities and the destruction of the world by fire, *House of Incest* caused delighted shivers in the Anglo-Saxon enclave.

In 1919 and 1920 young Harvard ambulancemen had hailed Paris as the City of Light. By 1936 it was becoming known abroad as the City of Darkness, a twentieth-century Sodom and Gomorrah. As seen from New York and London the emancipated lifestyle of a few prominent expatriates and half a dozen daring books had obscured the more measured achievements of born Parisians. From the mid-1930s, without deserving it, the capital of France was being described abroad as self-indulgent, decadent, perhaps unsound, and this was no trifling matter. It was to weigh not a little with public opinion and statesmen when it came to the important business of how far France, and Frenchmen, could be trusted.

11

TWO CHEVRONS, A SHIP AND THE ATOM

While twenty thousand or so Americans and English copied at the Louvre, followed their music courses, wrote daring books, operated their hand presses, watched Kiki dance or merely sat and enjoyed the city's fragrance and history, Parisians around them got on with the business of earning a living. For many that meant producing luxury goods in small family businesses: gloves and shoes, dresses and jewellery, furniture, and glassware, in constantly renewed forms, for as Louis XIV's finance minister, Colbert said, 'Fashion is to France what its gold mines are to Peru.'

These craftsmen looked on themselves as artists, and artists they were. They were content with a modest profit because they found fulfilment in producing work of excellence and individuality in the convivial atmosphere of family or friends. They are closer to Cocteau than to Henry Ford. Indeed they abhorred and feared standardized goods and the factories that produced them. The wickedest word in their vocabulary was '*taylorisme*', a system devised by the American F. W. Taylor for the scientific organization of work, to produce the most in the shortest time, and payment of each worker according to the amount he produced. '*Taylorisme*' was considered 'dehumanizing' and stubbornly resisted. We have already seen René Clair attacking such a system in *A nous la liberté*. This fierce grass-roots resistance to factory work, even though people admitted that it would increase the gross national product, was to prove a limiting factor in France's industrial performance.

Another limiting factor stemmed from the nature of teaching in Paris's most prestigious scientific institution: the Polytechnique. Each year only a small number of mathematically brilliant young

men passed the Polytechnique's daunting entrance exam and proudly donned the school's military-style uniform, dating from the Revolution. We have seen how socialist-utopian theory dominated the Ecole Normale and seeped through to lycée philosophy teaching; in the Polytechnique theory itself became an end. Louis Leprince-Ringuet graduated from the Polytechnique, then worked world-wide laying submarine cables before returning to the Polytechnique to become professor of physics at the unusually early age of thirty-eight; a fearless man with a love of mountaineering, he dared to spell out the school's shortcomings:

> One professor for each subject, giving 30 lectures a year without ever speaking to his students. No personal tuition... Practical work limited to a few basic experiments but no time allowed for students to propose original ideas... As a result *polytechniciens* are trained to handle abstract ideas and to reason logically. They have learned physics, optics, thermodynamics, electromagnetism, they can talk sensibly about Maxwell's equations but they have never set their hand to the plough. At the end of their two years they believe they have mastered their subjects, when in fact they have committed to memory a great number of definitions.

These were the young men who went on to highly paid executive jobs in State industries and – since the term *polytechnicien* had immense prestige – were sought after by private industry. They worked long hours, they excelled at precision and analysis, but they were conservative to a fault.

Despite these limitations French industry and science were to perform reasonably well in the 1920s and 30s, and in one field spectacularly well.

André Citroën was the youngest child of Polish immigrants, Levie Citroën, an esteemed diamond merchant, and Masza Kleinmann. When André was six, Levie Citroën, depressed by ill health and needless financial fears, committed suicide. His widow continued the business while looking after her five gifted children. André went to the Lycée Condorcet where, while winning prizes, he read copiously and was lastingly impressed by Jules Verne. Good at maths, he went on to the Ecole Polytechnique. Here he became

interested in gear systems, of which there were then three; one using horizontal teeth, one diagonal, one chevron-shaped.

At Easter 1900 André travelled to Warsaw to stay with his married sister. Already thinking of starting his own business, he investigated the city's small workshops. In one he noticed cast-iron gears with chevron teeth being produced by a new process for pump engines. André promptly borrowed money from his sister's banker husband and bought the patent from its Russian inventor. By 1914 he had built up a business supplying chevron gears to motor cars, aeroplanes and ships.

The War came. Citroën built, largely with his own recent profits, a factory in Javel on the outskirts of Paris to mass-produce 75 mm shrapnel shells. By the end of the war it had sent to the Front 23 million shells, a figure unequalled by any similar supplier.

In 1919 André Citroën was aged forty-one, moustached, prematurely bald, his short sight corrected by pince-nez, energetic, good company, happily married to a rich banker's daughter. In his apartment were shelf upon shelf of books about Napoleon, whom in some respects he took as a model. He too wanted to innovate, to take decisions alone and to win.

In 1919 Citroën entered the motor-car business with a car bearing his own name and the double chevron emblem. This was the A Type 10-horsepower four-seater open tourer: its engine had four cylinders in line, with a capacity of 1,327 cubic centimeters. The water was cooled by thermosiphon; no pump and no fan. Its maximum speed was 65 kilometres per hour, petrol consumption 7.5 litres per 100 kilometres, good figures for that period. It had an electric starter, the first non-luxury French car to have one. The car's price in October 1919 was 15,900 francs.[1]

Citroën had visited Henry Ford's Detroit factory and been converted to mass production. He trained each worker to do one simple, highly skilled job. But he also continued the generous welfare facilities he had pioneered in his shell factory: showers, ample washbasins, trolleys circulating hot drinks, a canteen serving the same meal for workers as for management, an infirmary with a full-time doctor, a dental surgery manned by six dentists, optional gym classes during

[1] £500 or $2,178 at that time.

the lunch break, a nursery for babies of working mothers and a cooperative selling food and basic goods at low prices.

As their numbers grew, the trade unions became critical of Citroën's facilities. They called them 'paternalistic' and 'propaganda for and by management'. Citroën, piqued, disbanded them. But he continued to give priority to good labour relations. He went round his factory almost every day, chatting to workers, listening to complaints and to stories of illness at home or other hardship. Often he gave financial help from his own pocket, and he was the first large employer to give a Christmas bonus equal to one month's pay.

With a willing work force and a good car in the A Type 10 Citroën had a lot going for him. But he knew that to compete with Renault, Panhard and a dozen other established makes he must use innovative sales techniques. It so happened that he possessed a marked gift for showmanship. At the 1919 autumn salon he had a hundred A Type cars waiting for the public to try out free of charge. He arranged guided tours of the factory so that prospective purchasers could see the car being made. He sent publicity caravans across France with attractive photographic displays, music and leaflets describing the car.

In 1922 Citroën put up 100,000 road signs at crossroads, dangerous corners and so on, each displaying the double chevron. He signed an agreement with Migault toys to market model Citroën cars to scale: 860,000 were sold. Then came Citroën lotto, Citroën building blocks, Citroën colouring albums, Citroën yo-yos, followed by a nation-wide competition: depict a motor-car with the letters of the CITROËN.

An inveterate theatre-goer, Citroën made selling cars a kind of theatre. In 1922 he sent up a biplane 12,000 feet above Paris to write his name in smoke, each letter 450 metres high. In 1925 he rented from Monsieur Eiffel's heirs the right to advertise on his famous tower. Two hundred thousand bulbs of six different colours were attached to wooden panels with six hundred kilometres of electric wire, spelling out CITROËN in letters thirty metres high. On the Tower's second floor specially recruited circus acrobats and firemen attached to the iron frame eight double chevrons, each 1,200 cubic metres in size.

The display was inaugurated at dusk on 4 July 1925, for the

opening of an International Exhibition of Decorative Arts. Every evening while the exhibition lasted, and afterwards on every Sunday, the lights flashed on. The display continued into the 1930s, with new features for every Salon de l'Auto, and the name altered to zigzag form. Later an illuminated clock face was incorporated, twenty metres in diameter.

To meet the demand stimulated by so much publicity, between 1919 and 1925 the Javel factory produced close on 200,000 cars: first the type A, then an improved version, the B2, followed by an economy 5 CV, with a 856 cubic centimetre engine capable of 100 kilometres on five litres of petrol. Now that the engine could be started without a crank handle, women were driving and buying. To attract them, Citroën offered the 5 CV in a range of bright colours, and when Coco Chanel launched her beige jersey dress, at his wife's suggestion Citroën brought out a model with beige upholstery.

In 1925 a serious set-back occurred. Citroën decided to use steel instead of wood for the upper part of his bodywork, but he imposed this on a relatively light chassis. Buyers of the new B 10 found that on rough roads the doors swung open and in time the roof began to shake and buckle. The model had to be withdrawn.

In 1926 Citroën, finding himself short of capital, took the then unprecedented step of issuing bonds. Offering high interest of 7½%, they were quickly subscribed. In 1927, wishing to start assembly plants abroad, he entered into an arrangement with Lazard Brothers, bankers. Citroën remained president, but three members of Lazard joined the board. But the commercial Napoleon soon felt frustrated by his bankers' insistence on lower capital investment and in 1930 he ended the agreement.

Citroën now had nine factories in the Paris region. His name was a household word as far afield as North Africa and the Far East, where as a publicity device he had sent Citroën half-track vehicles through desert and snow. But now the Depression struck. Citroën responded not, like his cautious rival Louis Renault, by drawing in his horns and laying off workers but by modernizing – in 1933 he totally rebuilt his Javel factory – and by stepping up innovative publicity. Every Saturday Radio Luxembourg beamed a programme about Citroën cars, *Citrons*, as they were popularly called. Chanson-

niers were encouraged to write lyrics that might stimulate sales, such as the following by André Barde:

> *Les Citrons sont les plus rapides*
> *Et c'est forcé*
> *En vertu du dicton limpide:*
> *Citron pressé!*

> Citrons are fastest.
> Of course,
> in view of the well known drink,
> *Citron pressé* (Citron in a hurry).

In the course of an annual dinner the writer of the best lyric received a new car.

With publicity like that, in the year he rebuilt Javel, Citroën struggled to boost lagging sales of his latest model, the 8 HP Rosalie. Bonds were maturing and had to be repaid. His workers refused to take a wage-cut and Citroën would not lay off men as many employers were doing. He kept telling his colleagues that economic recovery was round the corner: the important thing was to astound the public, rather in the style of Diaghilev, by offering a product so original that all rival cars would appear old-fashioned.

On the recommendation of a new recruit to the firm, André Lefebvre, former aircraft designer with artistic leanings, who before the War had been friendly with Dorgelès, Forain and Picasso, Citroën decided to produce a motor-car suspended on torsion bars instead of on leaf-springs, with front-wheel drive. The advantages were: elimination of the propeller shaft; weight brought forward, hence better road-holding; lower centre of gravity. From drawing-board to finished car usually took sixty months; Citroën gave Lefebvre and his team a mere eighteen months. Impossible, they said. Eighteen months, Citroën insisted.

In the prototype 7 CV, known as the 'Sept', transmission of movement from engine to front wheels by way of a Cardan joint had to be perfectly uniform no matter the angle at which the wheels were turned and the position of the chassis. Prototype joints were made, but under trial were found to leak their lubricant. Months passed before a satisfactory joint was found. Then Citroën decided he

wanted an automatic gearbox. Again much time and effort were spent trying to devise one that could be mass produced, but without success. Meanwhile Citroën was becoming increasingly worried. He began to find difficulty digesting his meals. He said nothing and plied himself with bismuth.

The 'Sept' was ready for launching at the 1934 Salon – with a manual gearbox. The public could see that it was a highly original product but the engineers knew it was a rush job. Beside it on the stand were its more powerful brothers, an 11 HP and a 22 HP eight-cylinder. Citroën had won his race against the clock. If these cars sold well, he could face his creditors.

The moment of triumph turned out to be the moment of disaster. When proud buyers took the *traction avant* as it came to be called on to the road, some found that the engine overheated or the clutch slipped or the gearbox jammed, or, in some cases, that the front wheels fell off. Fifteen years of building up the good name of Citroën were nullified in weeks.

Citroën found himself on the brink of ruin. Unable to meet his creditors, he called on friends at Michelin. They were willing to help, but a cash injection of 180 million francs would be needed. When the banks declined to provide it, Citroën applied to the Prime Minister. Pierre Flandin had already burned his fingers trying unsuccessfully to save the Aéropostale company, and he refused government aid.

As the financial situation deteriorated, so did Citroën's health. He suffered from stomach pains, ate little, his formerly plump cheeks sank in. On 15 December 1934 the Citroën Company officially went bankrupt; one month later its founder was rushed to hospital, where X-rays showed advanced stomach cancer. An operation in May was followed two months later by his death at the age of fifty-seven.

Convinced that the twentieth century was the age of the automobile, Citroën had set out to provide the public with the best motor-cars he could devise, and continually to improve their quality. By treating his workers well he overcame resistance to mass production. By recruiting gifted engineers regardless of their schooling or diplomas he circumvented the cliquishness of much French industry. To the marketing of a tool of communication he brought a remarkable gift for mass communication through what we now term the media.

For fifteen years André Citroën and another showman, Maurice

Chevalier, were considered *the* Parisians par excellence. Both enjoyed the pleasures and parties of Paris, both were strongly imaginative, both were convinced optimists who succeeded in imparting their optimism to others, both were gamblers. In the end it was a gamble that proved Citroën's undoing. But one cheering event was to follow his death: Michelin, having patched up the company, made a success of the *traction avant*, radiator still emblazoned with the double chevron.

The inter-war period saw a second world-famous success by French industry, again combined with Parisian design, artistry and show-manship. Again it started with a man of energy and vision.

John Dal Piaz – wholly French despite his name – had joined the Compagnie générale transatlantique in 1888 as an assistant accountant at 3 francs a day. He rose rapidly and in 1920 became president, in charge of 10,000 employees and a small fleet of ships, hitherto mainly engaged in transporting to the United States many thousands of poor emigrants.

Dal Piaz foresaw a boom in travel in the other direction, by American tourists, many of them rich, some travelling with a maid, and desirous of comfort and speed. The CGT's transatlantic liners, the elderly *France* and the new *Paris*, would be unable to handle the expected numbers. Dal Piaz therefore commissioned in 1924 the 43,000 ton *Ile de France*. Drawing on his knowledge and love of modern art, he personally supervised her decor and furnishing.

The *Ile de France* proved popular but on the slow side, ranking only eighth among transatlantic liners, well behind Britain's *Maure-tania*, which for twenty years had held the Blue Riband, awarded for the fastest crossing.

Dal Piaz decided that the CGT could make profits on a now fiercely competitive route only by constructing a fast ship able to carry a very large number of passengers. He conceived the idea of a liner twice the size of the *Ile de France* and more luxurious than any ship afloat. It would make New York in under four days, thereby clipping ten hours off the *Mauretania*'s time. It would be both a showpiece for France and a showcase for the best in French art and design.

Such a ship, Dal Piaz calculated, would cost around 850 million francs. Normally his company raised capital in the world's money

markets, with a guarantee from the State. But in 1927, following a run on the franc the previous year, State finances were shaky.

Deciding to bide his time before tackling the Treasury, Dal Piaz began to draft plans for the *T6*, a code name for the super-liner. Applying his maxim, *'Vivre, ce n'est pas copier, c'est créer* – Living means creating, not copying' – he envisaged a hull that would incorporate the latest advances in streamlining, the most sophisticated steering, the most powerful steam turbines. Like Abel Gance, he gave of his best when controlling a cast of hundreds: in this case, initially, 250 draughtsmen who drew 7000 plans for possible hulls. Ten scale models then underwent 92 trials – in Hamburg, which possessed more advanced testing machinery than France. Since no existing yard was big enough to construct a hull 400 metres long, Dal Piaz coolly ordered a wholly new yard at St Nazaire.

By 1929 a government of national unity had restored faith in the franc and the CGT deemed the moment ripe to ask for financial help. Even so, their arguments for State guarantees might not have prevailed but for two factors: worrying unemployment in the shipbuilding industry, and the fact that the German company Norddeutscher Lloyd was about to put into service the 51,656 ton *Bremen*, a fast ship likely to win the Blue Riband – as indeed it did later that year. To so persistent a Germanophobe as Prime Minister Raymond Poincaré the prospect of a German liner beating the rest of the world was hateful and he agreed to back Dal Piaz's expensive ship.

In January 1931 the first keel plates were laid down at the Penhoët yard in St Nazaire. Since there was already a *Paris* in service, *Normandie* had been chosen as her name. Shipyard work is less repetitive than a factory assembly line and at the end there is a product of which a man can be proud. So as the Depression worsened and the Left denounced the liner as an inexcusable luxury for the rich and called for construction to halt, work continued with only minor interruptions on building the 28,000 ton hull. Rumours were then circulated that saboteurs had penetrated the yard and that once launched the ship would plunge to the bottom of the Loire.

The launching passed off without mishap, but more worrying to the Company than possible sabotage was fear of fire. In 1934 the Sud Atlantique's new flagship went ablaze while under way without

passengers, and in the same year fire on the *Georges Philippar* cost 52 lives. So the *Normandie* was fitted with low-voltage electricity and sophisticated fire detection, while decorated glass panels, fireproof and effective fire-breaks, were to be fitted in public rooms.

Even at this stage the hull aroused favourable comment with her gracefully curved stem and rounded semi-counter stern. Now it was up to the two teams of Parisian architects in charge of creating the interior to make of the ship, as Dal Piaz intended, a showpiece and showcase of France.

Patout and Pacon designed the first class dining-room and main hall, the chapel and the swimming pool; Bouwens and Expert the theatre, first class drawing-room, smoking-room, grill room and bridge room. In contrast to the German liner's stark gilt and chrome, they used subdued tones and softened necessarily functional lines with figurative murals. In the *pièce de résistance*, the first class drawing-room, twenty-foot curtains decorated with cerise wistaria on a cream ground and Jean Dupas's silvered and gilt *verre églomisé* murals celebrating Navigation through the ages made a dramatic background for hundreds of chairs and canapés upholstered in petit-point specially made by Aubusson, depicting flowers from French colonies in ivory and olive tones on orange-red and grey grounds.

The dining-room, entered through Raymond Subé's bronze door, had a high bronze-coloured coffered ceiling and was lit by thirty-eight Lalique luminous columns. Perhaps the most successful decorative items were six lacquer panels by Jean Dunand in the smoking-room, each six metres square, depicting man's mastery of the horse. For passengers with a taste for history and the money to indulge it there were period suites, such as one inspired by Madame de Pompadour's bedroom at Bellevue. Children had their own dining-room, decorated by Jean de Brunhoff, creator of the Babar books, and a small guignol theatre.

Very clean-cut with her turtle-backed forecastle and three low raked funnels, the completed liner was a gift to the many artists commissioned to design posters and publicity material. Paul Iribe set the ship full-length, in bold colours, against a skyline of pale drawings of Paris's chief monuments, including Notre Dame, the implication being that the new ship was in the direct line of Parisian

artistic achievement. Wilquin, by contrast, painted a famous poster of the *Normandie* full face, her prow towering above the Statue of Liberty – another French work of art – and the skyscrapers of New York.

Sadly, Dal Piaz had died before he could see his completed brainchild and it was the new president, Marcel Olivier, a former governor general of Madagascar, who made a speech before the liner sailed in which he felt obliged to parry Leftist criticism: 'We want those who are not well-off to know that the finest transatlantic liner has been built not just for the very rich. Never has care for comfort and harmony been so fairly distributed, from the largest suites to the least expensive berths.'

On the evening of 29 May 1935 the *Normandie* left Le Havre, 83,000 tons powered by four electro-turbines generating 160,000 horse power. She had berths for 1,970 passengers. Among those on board were the First Lady of France, Madame Lebrun, who had christened her, Maurice Chevalier, the novelist Colette, and Paul Iribe. Amid general praise for the comfort, the fine food, the wine – free in all classes – and the attentive service, Colette's sour husband could not resist a dig at construction delays: 'The decor,' he remarked, 'already looks dated.'

Breaking all existing records with an average speed of 29.98 knots, the liner sailed into New York harbour on 3 June, blue pennant flying from her aft mast, to be greeted by tugs and ferries blaring their hooters, and hundreds of pleasure craft. The scene was recorded by the official photographer, Roger Schall, and promptly set on canvas by specially commissioned artists aboard. Citroën would have approved.

On the return voyage the *Normandie* performed her prime function, carrying Americans to Europe in the atmosphere of Paris. On this crossing she was to average 30.35 knots. In 1937, fitted with improved anti-vibration four-blade propellers, she made Bishop Rock to Ambrose Light in 3 days 20 hours.

For three years the *Normandie* won praise as the best of the transatlantic liners, and the smart way to go to or from New York. The ship made money. Then the international situation darkened, fewer Americans embarked for Europe. As with Citroën cars, an initial success was dimmed by unforeseeable events. Then in 1938

the *Queen Mary* regained the Blue Riband – a blow to French pride, but at least the new record-holder was not German.

Paris before the War had been the leading centre of research into X-rays and radioactive elements; after the War research continued in those and related fields towards discovering the nature of the atom.

One laboratory engaged on this work belonged to Duc Maurice de Broglie. After a distinguished career in the Navy, Broglie had obtained a doctorate with a thesis on the ionization of gases and fitted out part of his house near the Arc de Triomphe as the most up-to-date laboratory in Paris. On the principle of *noblesse oblige* he paid for all the equipment and the attendant staff out of his own pocket. In the other part of the house Madame la duchesse, who was president of the Society for the Protection of Animals, kept thoroughbred poodles and pugs, a flamboyant Brazilian macaw and many homeless cats. Soon her cages and kennels were vying for space with the duke's Geiger counters and voltage amplifiers. A solution was found by acquiring the house next door as an annexe of the laboratory.

Duke Maurice, who had real qualities of leadership, attracted a team of young assistants to help him in his study of how a gas containing metallic particles becomes electrically charged under the action of X-rays. One was Leprince-Ringuet, whose comments on the Polytechnique we have noted. With the jolly-ugly face of a panto-mime dame, Leprince was an affable and indefatigable young physicist who in his leisure played a fast game of tennis, performed on the flute and was a leading light of *Equipes sociales*, a movement that aimed to prolong the camaraderie of the trenches by giving free instruction to manual workers who wanted to rise and taking them on occasional Alpine holidays. It was Leprince who took charge of Broglie's 'cloud chamber' – an apparatus for detecting high energy particles by observing their tracks through a supersaturate vapour. He improved devices for measuring the tracks and was the first in France to use a three-electrode lamp for registering and retaining the electrical charge, which could then be amplified, making possible precise identification of the particle and its energy. Later, as professor at the Polytechnique, Leprince-Ringuet brought students to Broglie's private laboratory, the only one in Paris suitable for advanced experimental work in this field.

Maurice de Broglie had a brother, Louis, seventeen years his junior. This child of ageing parents had a yellowish complexion, narrow eyes and a hang-dog jaw. 'Restless as a worm cut in two', according to his sister, Louis spoke in a shrill voice, dressed haphazardly and voted for the extreme Left. He liked to read medical books on lack of energy and heated his urine in a test tube to measure the extent of his diabetes. He saw himself as a born failure.

One day Louis happened on a work by the mathematician Henri Poincaré relating to electromagnetic theory. He became deeply interested and decided to take a degree in science. Then he put himself under Maurice's wing. Unlike his brother, Louis was a pure theorist. He took no part in experiments but joined the other young men attached to Maurice's lab in their discussions, which then centred on a curious phenomenon: X-rays fired a ceaseless stream of minute bullets of light, but when they encountered large crystals these bullets started to behave like waves.

Louis de Broglie asked himself whether this Janus-like feature of radiation might not also apply to the particles of matter, such as electrons, composing the atom. Though generally held to orbit the nucleus, might not they too display the characteristics of waves? Drawing on recent advances in related fields, notably Einstein's theory of relativity, Broglie calculated that the waves associated with such particles would have a wavelength inversely related to the mass multiplied by the velocity of the particle. The wavelength associated with electrons of moderate speed, he predicted, ought to be in the X-ray region.

In 1923 Broglie presented his theory in the form of a doctoral thesis. At the oral exam two of France's best brains, Paul Langevin and Jean Perrin, put the young mathematician through the hoops; they recognized his intelligence, gave him his doctorate but neither believed so revolutionary a theory could be true.

In 1927 two researchers at the Bell Telephone Laboratories in the United States were bombarding metallic nickel with electrons. As the result of an accident the nickel was in the form of large crystals, ideal for diffraction purposes, and they found that the electrons passing through the crystals behaved not as particles but as waves. From the measurement of the interference bands the wavelength associated

with the electron could be calculated, and it turned out to be 1.65 angstrom units, almost exactly what Broglie had predicted.

This news threw the French scientific establishment into alarm. Louis de Broglie was not One of Them: no teaching post, no official status. Fearing ridicule, they hastily found him a lectureship in mathematics, and just as well, for in 1929 he received the Nobel Prize for physics. Louis being a bachelor, his married sister Pauline de Pange held a reception for him at her house in rue de Varenne, attended by *le tout-Paris*. Time passed with no sign of Louis, and Pauline began to be concerned. Late in the proceedings the guest of honour at last slipped in. No longer a hypochondriac but still extremely shy, he found a hard chair in a dark corner of the room.

Louis de Broglie's discovery and Maurice's cloud chamber experiments proved useful in Paris's other important research laboratory. Across the Seine in the cramped quarters of the Radium Institute Marie Curie and her elder daughter Irène were beginning to break down the atom with bombardment from radioactive substances. Perhaps because her mother had been too busy to give her time and affection as a child, Irène had grown up cold and unemotional, but totally single-minded. Four years close to the trenches helping her mother X-ray seriously wounded soldiers had also marked her. Even after her marriage to a fellow research chemist, the amiable Frédéric Joliot, Irène lived for her work and talked of little else, easing up only on her short annual holiday to Brittany, where she swam long distances.

The fact that atomic research was underfunded added to her tenseness. Even with Irène's salary as a teacher at the Sorbonne, the laboratory was so short of money that Marie Curie, in her sixties, had to undertake long tours in the United States, giving lectures – which her shyness rendered exhausting – and pleading with women's organizations for just a little more money to continue research which, it was believed, would lead to further improvements in the treatment by rays of cancer.

At the beginning of 1934 Irène and Frédéric Joliot-Curie were bombarding aluminium atoms with alpha particles emitted by the radioactive element, polonium, which Marie Curie had discovered. They found that this procedure instantly and explosively produced protons, neutrons and positrons. But when they stopped the bom-

bardment, to their astonishment the aluminium continued to emit positrons. Three minutes later the emission began to decrease. The phenomenon could be explained only by the fact that they had created in what had been aluminium a new radioactive substance.

This substance after analysis the Joliot-Curies showed to be a form of phosphorus, with a mass number of 30 instead of the usual 31. With a brief lifetime that exists only when produced artificially, phosphorus 30 was the first radioactive isotope created by man.

In 1935, the same year James Chadwick from Cambridge's Cavendish Laboratory received the Nobel Prize in physics for his discovery of the neutron, the Joliot-Curies received the Nobel Prize in chemistry. At the Stockholm ceremony, after Irène had described the process of discovery, Frédéric warned that 'research scientists smashing and building atoms at will could cause an explosive chain of nuclear reactions.' Shortly afterwards Hans Spemann, on receiving the prize in medicine, shocked the assembly by giving the Nazi salute.

We have looked at three of the high points in technology and science. All followed from the initiative and drive of exceptional individuals. Elsewhere progress was hampered by the limiting factors mentioned earlier: management by theorists and a deep sentimental attachment to the small business – and the 'little man' – with its corollary: opposition to large-scale mass production.

One of France's most efficient industrialists, Ernest Mercier, led a campaign to fight the prejudice against big business. After exceptionally brave service as a naval officer Mercier modernized Paris's run-down electric power system, then went on to found the first large petroleum firm, Compagnie Française de Pétrole. A Protestant, brought up to think and decide for himself, Mercier did not hesitate to meet head-on prevalent public opinion. In 1926 he founded Redressement, a non-political movement dedicated to pooling knowledge across the board of industry for modernization along American lines, and for shop-floor efficiency, through Marshal Lyautey's principle of overcoming class friction through team spirit. In the course of the next decade Mercier gathered no less than 223 experts to meet in study committees, and published 127 reports in 35 volumes of *Cahiers*. This campaign persuaded some low-profit

companies to merge and so become more efficient, but in the aircraft industry especially Mercier's was a voice in the wilderness.

Small profits of course led to under-investment: even as late as 1939 France's most modern steel plant dated from 1906, and had been built in Lorraine by Germans during the annexation. The public telephone system was one of Europe's least efficient because no one dared reduce staff – Proust's dear 'Danaids of the Invisible' – and so it could not finance research as Bell in America so successfully did.

A *Redressement* handbook sums up Mercier's creed: 'Individualism is very nice, it's very pleasant. But it's obsolete.' Obsolete in some advanced countries, but not in France. In France it could be said still to flourish. Paul Valéry identified industrialization with an increasingly powerful state, and urged men to protect their freedom by returning to craftsmanship, while the poet, Robert Desnos, who was a political moderate, wrote these lines in 1935:

> *La machine enfin au travailleur*
> *N'imposera plus de lourds fardeaux*
> *que moins longue soit la semaine,*
> *Plus de travail à la chaîne*
> *les barons de l'or et de l'acier*
> *seront forcés, amis, de plier . . .*

> The machine will no longer
> impose heavy burdens on the worker,
> his week will be less long;
> No more assembly-line production,
> The gold and steel barons will be forced,
> my friends, to bend . . .

The French for 'assembly-line production', we note, is *travail à la chaîne*, with connotations of slavery.

The scene in France, therefore, is a mixture of strength and weakness, and it needs to be set against that of her neighbour across the Rhine. Keynes's prediction that vindictive reparations would ruin Germany had proved unduly sombre. By the late 1920s France's neighbour had pulled out of the disastrous inflation caused by strikes and labour unrest to become a world leader in chemicals, paints,

fertilizers and electrical goods. Giant companies emerged, managed not by theorists but by men who had started on the shop floor as apprentices, and which could afford to finance their own research. One result was that in the years 1918 to 1933 fourteen Germans won a Nobel Prize in science, compared to four from France. In 1913 France accounted for 7.6% of the value of world trade; by 1929 this had fallen to 6.1%, while Germany's share was 9.2%.

France benefited from Germany's resurgence, since it opened a profitable market. But those who held economic strength to be quite as important as the number of soldiers in uniform viewed Germany's efficient performance with dismay. It gave urgency to the task of putting peace on a firm and lasting basis.

12

TOILERS FOR PEACE

The sufferings of war had left inescapable marks on peacetime France – one went to the Louvre to see in Praxiteles or Poussin the perfection of physical beauty and the museum attendant was without an arm or a leg – and memories of those sufferings directed the efforts of men of good will towards preventing their repetition. Never perhaps in their history were French men and women so active as now in the cause of making peace last.

Each individual drew conclusions from his war experience in the light of character and upbringing, and with those of like mind formed a group. There were many such groups, each with its programme. The legalists, headed by Raymond Poincaré, demanded prompt payment of reparations as the outward sign of victory, and when Germany delayed took a hard line by occupying the Ruhr. Charles Maurras and Léon Daudet, at the head of Action française, opposed talks of any kind with France's 'undying enemy'.

In the centre Brunschvicg and Valéry believed that the League of Nations would bring traditional enemies together, that reason would resolve disputes, and that from the League would be born a United States of Europe. Elsewhere in the centre groups or individuals, some of whom we will follow, put their hopes of peace in collective security.

On the Left the Surrealists identified bourgeois nationalism as the cause of war and worked, in a variety of ways, for its overthrow. The Socialists, led by Léon Blum, believed that lasting peace would follow when the working class got a greater share of national wealth, and pointed to the socialist revolution in Germany in 1918, which had led that country to sue for peace. Even more pacific,

Romain Rolland taught a Tolstoyan non-resistance to aggression and was to find an unexpected exemplar in Mahatma Gandhi. Rolland's disciple, Henri Barbusse, author of the angriest war novel, *Le Feu*, moved from Tolstoyism to Marxism, and taught that only a world revolution would ensure lasting peace.

Very rare were those who took the teaching of the Gospels literally. One was the abbé Mugnier. In 1914 he held that France had been morally wrong to go to war over Serbia and now he saw his country's commitments in Eastern Europe as an assertion of national pride rather than a guarantee of peace and wished her to annul them.

One feature common to these groups and persons, save Mugnier, is that they rejected any absolute authority, religious or metaphysical. As recently as 1815 the signatories of the Holy Alliance had been wholly convinced of the absolute value of legitimate monarchy – in effect kingship by divine right – but now the principles were manmade: democracy, self-determination of peoples, international law as defined in The Hague: sensible humanist concepts but lacking the binding force of a moral or religious imperative. This lack called for even greater effort on the part of their champions.

One of the most active and influential among the toilers of peace, Louise Weiss, belonged to an Alsace family obliged by the Franco-Prussian war to move west. On her mother's side she came of the Jewish haute bourgeoisie; her father was a mining engineer who at the time of the Couvrières disaster became a local hero by leading a team that rescued thirteen trapped miners. With a sister and three younger brothers Louise was brought up in the big Paris house of her mother's parents. Weiss *père* was nominally Protestant, but the children received no formal religious education.

At the Lycée Molière Louise came under the influence of Marie Dugard, a high-principled, strong-minded young woman whose admiration for Emerson, about whom she had written a book, led her to become a Protestant. Monsieur Weiss, who was very fond of Louise, would have preferred her not to continue her studies after the Lycée, knowing that young ladies with degrees frightened off potential husbands. Her mother, however, believed she had the makings of an outstanding teacher, and allowed her to accept Marie Dugard's offer to coach her free for university. Already Louise had learned fluent English and German.

Her studies interrupted by the outbreak of war, Louise, then aged only twenty-one, took over her uncle's house in the Brittany village of Saint-Quay and turned it into a reception centre for refugees. Then came the Battle of the Marne, with thousands of wounded needing care, and Louise turned the house into a cottage hospital. She had no nursing experience but by leadership and good organization she secured voluntary help and the necessary medicines, then in short supply.

When she had her cottage hospital running smoothly, Louise placed it in charge of a trustworthy director and went to Paris. Her father had become seriously concerned about the Government's mismanagement of coal resources and wished to publish his views in *Le Radical*, owned by a senator friend. However, he found himself more adept with machinery than with the pen, so Louise offered to write the articles, which would appear under his name. When her father received his first payment and offered half to his daughter, Louise held out for payment in full – and got it. One result of this father-daughter collaboration was that the government initiated economic collaboration with Britain, sending to London a young cognac manufacturer of whom more was to be heard, Jean Monnet.

In 1916 a stocky dynamic Slovak officer arrived in Paris. Milan Stefanik had fought the Germans in Serbia and had come as the Slovak representative to take part in Beneš's National Council of the Czech Lands, its aim to work for the break-up of Austro-Hungary after the War and the creation of Czechoslovakia. He lived in a poor top-floor flat opposite the Santé and on clear nights observed the sky with a telescope, for he was a keen amateur astronomer. Louise admired Stefanik's courage, sympathized with his maltreated people and in January 1918 co-founded with a financier a weekly entitled *L'Europe Nouvelle*, in order to publish mainly articles on foreign affairs and economic problems, and to press for the independence of the peoples of Austro-Hungary.

Louise fell in love with Stefanik. She was a good-looking young woman, with an energetic head, lively blue eyes, fair hair and strong chin, perhaps a little on the plump side. Stefanik, while grateful for Louise's support, failed to respond, putting it to her in an odd formula: 'You are continually using your brain. Whereas the woman I want to present to my people must be a virgin – mentally as well as

174

physically.' Louise's father had been right. In May 1919 Stefanik died in an air crash. Thereafter Louise was to place her heart exclusively in the service of peace.

Deciding she needed to see Europe, Louise left *L'Europe Nouvelle* in charge of a colleague and set off as foreign correspondent for *Le Petit Parisien*, the city's most esteemed moderate newspaper. She visited London and the countries of Central Europe, interviewing political leaders, and more often than not secured articles for her periodical. She then travelled to Moscow, one of the first women correspondents to do so. There she interviewed Lenin and with a mixture of charm and tough reasoning secured the release of some fifty French governesses, caught by the Revolution and held by the Russian police.

Louise returned to Paris, where Philippe Berthelot had begun to construct a system of alliances as complex as one of those Chinese puzzles he found fascinating. By 1924 Seigneur Chat had master-minded a tri-partite pact between Yugoslavia, Czechoslovakia and Romania against a potentially hostile Hungary; he had negotiated military treaties between France and Belgium, France and Poland, France and Czechoslovakia. Treaties between France and Yugo-slavia and France and Romania were soon to follow. These alliances, maintained Berthelot, would deter Germany from further aggression.

Louise Weiss disagreed. She thought they would alienate Germany still further. Louise wanted France to receive Germany back into the community of nations and start direct talks with the German government about outstanding differences. Still only in her twenties, Louise had enough of a reputation to meet, interview and publicize politicians desirous of leading France in that direction.

One who seemed particularly promising to Louise was Edouard Herriot. A graduate of the Ecole Normale, he had carried the school's liberal optimism into politics, heading the left-of-centre Radical party and opening workshops in his native Lyon for severely wounded ex-servicemen. But Herriot was by no means just a well-meaning politician. Possessing a lively imagination and a gift for words, he had written a number of biographies, including warm, sympathetic lives of Beethoven and Madame Récamier, and was to publish in all twenty-three books.

While recognizing his gifts, Louise also knew Herriot's weaknesses. As a child he had suffered separation from his parents. Insecurity showed itself in an abnormally voracious appetite for food at any time of day or night and an equally huge appetite for sexual activity, which led him indiscriminately to boudoirs and brothels, for, as he put it, 'There are no ugly women.' During the war he had fallen ill with claustrophobia and loss of memory, requiring electric shock treatment. He needed desperately to feel he was liked and to receive regular rounds of applause. A good but not a strong man.

In June 1924 Herriot became Prime Minister of France, in time to lead his country's team to the most important meeting of the League of Nations so far.

In September of that year delegates from 48 nations gathered in the recital hall of Geneva's Hotel Victoria. Among them an eyewitness recognized a Persian prince, the Chinese chargé d'affaires, the Japanese Foreign Minister, a turbaned Maharajah from India and an American observer in a green dress, Ruth Morgan, president of the Union of Women Voters, bearing a letter in favour of disarmament with a million and a half signatures and a plan for children of the world to learn peace by exchanging dolls. There was Emile Dufret, a French teacher from Saint-Gaudens who for twenty years had been dreaming of creating international protection for nightingales, and next to him two Sioux chiefs who hoped that the infant League would return the United States to the Indians. 'It is like Deauville during the season,' remarked the Aga Khan, to which the President of the Swiss Confederation replied, 'No, your Highness, it is Geneva, new capital of the universe.'

The English delegation arrived, headed by Ramsay MacDonald, fresh to office. There was no German delegation. Then the French delegation entered, led by Herriot, a burly figure with plump cheeks and tousled hair wearing a crumpled black morning coat. The delegates took their seats, the proceedings began.

Ramsay MacDonald spoke first, with a vague but ardent pacifism. He urged that Germany be admitted to the League without delay, and that all disputes between member countries be submitted to arbitration, but he did not specify any procedure for this, which somewhat disappointed the French.

Herriot followed. Ignoring the desk and microphones, he walked to the edge of the platform and spoke without notes in a firm voice that could be heard by all.

'Making peace,' Herriot declared, 'demands more virility than making war. For the common good France offers you her share of reason, of *cœur*, of feeling, lucidity and the experience learned from centuries of hardships; she knows what it is to have fragile frontiers. Innocent yesterday – yes, innocent I swear – and today still nursing her wounds, France extends brotherly hands to each and every one of you.' Herriot then went on to stress the need for arbitration, sanctions and disarmament. On German membership he spoke with less fervour than MacDonald, but his language was calm and conciliatory. His speech, stronger on emotion than on practical measures, was well received and Louise received Herriot's permission to publish it in *L'Europe Nouvelle*.

A committee of twelve leading member states chaired by Beneš then got down to four weeks of intensive discussion. Article 16 of the Covenant of the League did not forbid all wars and, in the case of wars that took place despite its prohibition, the help which it promised a victim was uncertain and slow. The committee decided a more water-tight procedure was required, and produced a text entitled 'Protocol for the Pacific Settlement of International Disputes.' Any dispute was to be brought before the Council of the League. If the Council was unanimous its decision was binding. If the Council were divided, the parties were not thereby, as in the Covenant, set free to go to war three months later; on the contrary, the disputing States were to submit their case to arbitrators appointed by the Council and to abide by their decision. Furthermore, if any State failed to abide by that decision, all signatories of the Protocol were bound actively to resist the aggressor and to help the victim – though retaining control of their own forces.

The Protocol is generally considered to be the best text ever devised by the League for preventing war. The French and Ministers for nine other countries immediately signed it. The British delegation, however, while approving the Protocol, was not yet allowed by its government to sign, because it was thought that the Dominions might raise objections.

This was disappointing to the French, and the sequel even

177

more so. In a General Election MacDonald's government was replaced by Baldwin's Conservative government, which formally rejected the Protocol. The reasons, though not those voiced publicly, were four: the opposition of the Empire to last-resort military action, fear of trouble with the United States – not a League member – should the Council act against United States' interests, a reluctance to underpin Berthelot's continuing involvement with Eastern Europe, and the Foreign Office's deep-seated dislike of compulsory arbitration.

After this rejection France had no option but to abandon the Protocol, and initiative was to pass from Herriot to a senior member of France's delegation to the Assembly, Aristide Briand.

Pale-cheeked, sloppily dressed, hair uncombed, and under his drooping moustache a cigarette butt perpetually dangling, at sixty-two Briand looked what he was, a bachelor who cared not a fig whether people liked him or not. Born in Nantes, Briand, like many a Breton, was solitary by temperament, independent and acted often from instinct, so that some called him feminine. In contrast to Herriot, who knew the world's great literature, Briand read only detective stories and thrillers. In private conversation he often seemed confused but directly he got to his feet he became coherent. A lawyer by training, he had a very fine voice with a beautiful timbre: 'It never seems to vary. It never seems too high or too low . . . When he speaks, his mouth, which is hidden under his moustache, seems to work sideways.'

With that voice Briand could, and literally did, charm the birds off the trees. For at Cocherel, the modest country home in Normandy which he loved, 'he leads a sort of Edward Grey life, rising at 4.30 or 5 in the morning' to get golden orioles to answer from the trees when he called to them from his bedroom window.

Louise met Briand in Geneva and fell under his charm. She wanted an article from him but knew he rarely put pen to paper. His enemies attributed this to laziness; he himself to caution. 'Give me two lines by an Evangelist,' he would say mischievously, paraphrasing Voltaire, 'and I'd guarantee to get him hanged.' But Louise, with characteristic dash, asked Briand for an article on Security and received a favourable reply.

Léon Blum, leader of the Socialist party, happened to be present as

an observer. Tall, precise and, as editor of *Le Populaire*, a prolific writer, he bet Louise a twelve-course dinner in Paris that she wouldn't get her article. But Briand saw in Louise a valuable voice for peace and did write for her a short piece which contains a phrase soon to become famous:

> The right to security – this is the first principle of the declaration being prepared by the Fifth Assembly. It is as vital as the right to bread, the right to work, the right to education.

Blum, much surprised, gave Louise her promised dinner at a restaurant near the Bourse, but contrived that one of the other guests, the financier Louis Loucheur, an admirer of hers, should pay the bill.

The Fifth Assembly ended, therefore, with the rejection of the Protocol and Briand's determination to work alone for an understanding with Stresemann, the German Foreign Minister, that would satisfy Germany's wish to rejoin the nations and France's need for security.

Louise undertook to help Briand by devoting an issue of *L'Europe Nouvelle* in March 1925 to interviews with prominent Germans, including Catherine von Oheimb, a member of the Reichstag, Thomas Mann, author of the recent bestselling novel, *The Magic Mountain*, whose hero is drawn to Latin culture, and Stresemann himself.

To publicize German political aspirations at that date was a daring act. It provoked angry comments from Briand's enemies. *L'Action française* called Louise 'a Jewish Boche' and worse, whereupon Louise made her way to the top-floor office of the editor, Maurras, and because he was deaf shouted at the top of her voice close to his ear: 'I forbid you to treat me as a slut. Do you hear me? Do you hear me? Do you hear me?'

Briand, for four months that summer and autumn both Prime Minister and Foreign Minister, carried to success his negotiations with Stresemann. By the Treaty of Locarno Germany, France and Belgium bound themselves to regard their existing frontiers and the demilitarized zone of the Rhineland as inviolable, and, secondly, in no case to attack, invade or resort to war against one another. For all possible disputes between them, they accepted a system of peaceful

settlement on the lines of the Protocol. These obligations were placed under the guarantee of Britain and Italy as well as of the three states directly concerned. The Treaty was to come into effect the following September when Germany formally became a member of the League.

The Treaty of Locarno was an important step towards normal and peaceful relations with Germany and as such warmly welcomed in Paris, where Briand was hailed as 'the pilgrim of peace'. But some observers were concerned that Stresemann had refused to guarantee frontiers in Eastern Europe. This seemed to suggest that he wished Germany to be free to act as she chose in that region: 'What a formidable adversary,' was Louise's comment.

Berthelot worked alongside Briand as he tried to improve relations with Germany through friendship with Stresemann, but he never truly believed that this was the way to ensure France's security. He had no faith either in the League, likening the famous speakers there to tenors in an opera. He continued to base France's security on formal diplomatic treaties, carefully devised at the Quai d'Orsay, duly signed and sealed, the latest, in 1927, being with Yugoslavia.

With Briand's approval, in 1929 France began to withdraw troops from the Rhineland five years earlier than stipulated by the Treaty of Versailles, even though Germany had not yet fully paid reparations, and some thought the pilgrim of peace was sacrificing too much on the altar of friendship. Clemenceau, during his last illness, said to ambassador Barrère: 'In the delegation escorting Briand to the ditch of Vincennes [execution place of traitors], I appoint you to represent me.'

The League of Nations now began strongly to advocate disarmament as the only certain way of ensuring lasting peace, and this won wide support in Paris from left-wing pacifist groups. Twenty-seven different schemes were proposed in Geneva, some very radical: Litvinov, Soviet commissar for foreign affairs, urged that every weapon in the world should be scrapped down to the last rifle, while André Tardieu proposed that all national armies should be placed under international control. Every such scheme foundered on a fundamental incompatibility: while Germany wished to assert her equal rights with other nations by increasing the size of her army,

limited to 100,000 by the Treaty of Versailles, France, still fearful of German militancy, refused to allow this, and was reluctant also to take the first step in disarmament, and so weaken her Rhine defences.

This was a serious set-back. But the toilers for peace continued to toil. While Louise Weiss worked for disarmament through *L'Europe Nouvelle* and her many influential friends, other perceptive Parisians in different ways tried to unblock the incompatibility by working for Franco-German understanding. Jean Schlumberger and Jacques Rivière, two of Gide's colleagues on the *Nouvelle Revue Française*, both with a strong civic sense, formed a Franco-German Committee in order to promote economic cooperation and a more impartial Press coverage of each other's affairs. They found a backer in Emile Mayrisch, president of the huge Luxembourg steel consortium Arbed, himself a huge, full-bearded patriarch. Two meetings a year were held, with seventeen French and seventeen German delegates.

Of the French the most energetic was Pierre Viénot. A war volunteer, he had won a citation for bravery and been badly wounded. After taking a law degree he worked for three years in Morocco under the best of colonial administrators, Lyautey, helping to modernize the country. Returning to France, still in his twenties, he moved between Paris and Berlin on behalf of the Franco-German Committee, organizing visits by leading journalists, ensuring that German correspondents in Paris were no longer treated as a least favoured group, persuading German educationalists and senior civil servants to back schemes for intellectual and economic cooperation. Viénot was to marry Mayrisch's daughter Andrée, whose socialist leanings he shared, and to become chief French delegate in Berlin for four years.

There, in 1929, two events occurred harmful to the new rapprochement: the death of Gustav Stresemann and the effects of the Wall Street crash. The United States was obliged to stop making loans to Germany, where the beginnings of unemployment set in, with an upsurge of nationalism and growth of extremist parties, Communist and National Socialist. In 1930 the Franco-German Committee found itself unable any longer to function usefully and disbanded, but Viénot published a vigorous book about his experi-

ences in Berlin, spelling out certain disturbing facts virtually ignored in Paris.

> Many Germans [wrote Viénot] blame the League for ensuring not so much justice and equality among rival countries as the hegemony of bourgeois democracy . . . But a world organized on democratic principles does not attract Germany fundamentally . . . They prefer the ideas of the 'organic development' and 'spontaneous growth' of national organisms. They put the emphasis on the unconscious elements in national and international life, on the laws of necessity and fatality.

Anxiety and a passion for the future, continued Viénot, were permanent factors of German life, and he did not need to tell his readers that avoidance of anxiety and a passion for the present were the counterparts in French life. Instead of foolishly thinking that the German attitudes could be changed by calling them illegitimate, 'we must learn how to escape from ourselves, understand things that are different from us,' and modify French foreign policy accordingly. He hinted that only if France took the lead in effecting disarmament would the League gain binding moral authority.

Another who worked tirelessly for peace was the Broglies' brother-in-law, Jean de Pange. Like Louise Weiss, Pange came from an Alsace family. As a young man he was deeply influenced by Ruskin: for a time he dreamed of a decentralized France to be run by elected representatives of craftsmen's guilds and professional bodies. After taking a history degree he wrote a brilliant book on kingship, his studies there leading to a lifelong admiration of the British constitution and things English.

Jean and Pauline de Pange set up home in Paris. They were devout Catholics but shunned the flag-waving Catholic nationalists, with their cult of Jeanne d'Arc, canonized in 1922. Jean de Pange had no time for narrow nationalism or indeed for the politicians' periodical announcements that the world had entered a new era. He believed that lasting peace could come only from the acceptance of certain absolutes: if not any longer Christian princples, then the gentlemanly principles of honour and fidelity to one's word – he knew that these principles still survived in many German, as in many

English and French, families, and he worked through his own friendships in Alsace and through the Broglies' international contacts with men of science, to build up trust. His view that class and values cut across frontiers is not unlike Jean Renoir's in *La Grande Illusion*. Parallel with this he wrote regularly for *Le Petit Parisien*, whose editor, Elie-Joseph Bois, was a close friend of Louise Weiss and furthered her work of rapprochement. Pange also organized discussion groups and other functions calling attention to the common heritage of France and Germany.

One of these calls for notice. Pange admired Goethe who as a young man in pre-nationalist days had felt at home anywhere in Europe, and he decided to organize an exhibition in Paris for the forthcoming centenary of the poet's death. He first approached Anna de Noailles's friend and former left-of-centre prime minister, Paul Painlevé, a nervous man who under stress had the odd habit of 'leaping in the air like an india-rubber ball and screaming when he got to the highest point of each jump'. Painlevé promised to ask Briand, then Foreign Minister, for funds. Weeks passed and nothing happened. Pange telephoned. Painlevé admitted that he hadn't even asked Briand: recent expressions in Alsace of alarm at growing German nationalism worried him, and he feared they would be exacerbated if it were known that public money was being spent by a prominent man of Alsace on Goethe. 'When passions are aroused,' Painlevé concluded sanctimoniously, 'reason loses her rights.' Pange realized that no money would be forthcoming. Though not rich, he funded the exhibition alone.

The Goethe exhibition was not a flashy Cocteau-style affair. Pange did not operate like that. His diary, the daily record of an unselfish Parisian, less famous than Gide's but more profound, shows continual activity in his chosen field: lectures and discussion groups at the French Society of Philosophy, at the Dominicans' Intellectual Centre, at the lay Christian Union for Truth, at the Society for Political Economy, at the *Journal des Débats'* dinners. In his own home or at the Broglies' he put his views to Lindemann, a frequent visitor from England, and to a close friend, Sir James Frazer, very active in the cause of peace and whose *Golden Bough* Pauline de Pange translated. He would have liked to do one thing superbly well, like Louis de Broglie, and on some evenings confided to his diary that

he felt he was dispersing his energies in a fruitless cause, since the moral basis of a peaceful Europe – as he saw it – seemed continually elusive. But next day he was as busy as before.

Louise Weiss, meanwhile, was beginning to move in a new direction. In 1929 the foundation stone of the League of Nations building was laid: it had become an awesome institution but in Louise's view had lost its momentum. Jean Monnet, star of the League's early years, had had to resign in order to save the ailing family cognac business. Top jobs, now highly paid, were filled by ambitious faceless civil servants. In the long corridors, with their multiplying committees, even the voice of Briand, beginning now to feel his age, failed to rally enthusiasm. On disarmament the view of France and Britain continually diverged.

Louise came to see that 'behind all the meetings, assemblies, committees, seminars and dinners contemporary man was battling with himself, unable to decide whether he preferred the boringness of peace and its weight of day-to-day difficulties, or war – costly certainly in lives – but which could bring long term profits and a number of immediate pleasures.'

Louise had a house in Passy, furnished exuberantly, with paintings by Van Dongen and Dufy, and pride of place given to Emilie Charmy's portrait of Briand. This house Louise decided to turn into a School for Peace. While continuing to edit *L'Europe Nouvelle*, in the school she would initiate suitably qualified young people into the legal, economic and educational reforms essential if a United Europe were to come into being.

In November 1930 Paul Painlevé inaugurated Louise's new School, officially recognized as such by the local teaching authority. It was to grow in numbers, and soon lectures had to be given in one of the Sorbonne halls. With financial help from Horace Finaly, Proust's boyhood friend and model for Bloch, now head of the Banque de Paris, Louise established 32 scholarships for trainee teachers to reside for a time abroad. She also opened branches in Marseille and in Toulouse.

Louise's doubts about the effectiveness of the League reflected the views of many Parisians at the beginning of the 1930s and proved to be well founded when Japan invaded the Chinese province of Manchuria in autumn 1931 and the League failed even to take

sanctions against the aggressor. Edouard Herriot, who had for ten years sworn by international law, declined to alienate Japan, while Sir John Simon in the Commons said that the Japanese were wrong to take the law into their own hands, but since they were reestablishing order in Manchuria they could be forgiven.

In November 1931 Louise made her most ambitious bid in the cause of peace. In conjunction with private pacifist bodies in other countries she organized an international congress on disarmament, attended by 600 delegates, including Lord Cecil of Chelwood, an esteemed disarmer, and Baron von Rheinbaben, of the German People's Party, friend and biographer of Stresemann. There was much good will, but still from inflexible positions. The German delegates insisted upon the necessity of disarmament being general and immediate, the Belgian representative advised its being applied by stages, while Paul Painlevé insisted once more that disarmament be conditional upon the security of France.

The following evening some 8000 people attended a public meeting at the Trocadéro organized by Louise, who spoke second, after Herriot. In accordance with her doubts about the effectiveness of the League, she declared that she now placed her hopes of disarmament in women getting the vote.

Previous peace meetings had passed off peacefully; to Louise's dismay this one proved far from peaceful. Some in Paris who had applauded Briand in 1925 now, like Clemenceau, seriously doubted the wisdom of France's withdrawal from the Rhineland. Adamant that there should be no further erosion of France's security, they interrupted proponents of disarmament with cat-calls and abuse. 'Obstruction was so determined and consistent,' wrote *The Times* correspondent, 'that it must have been carefully organized . . . Until Lord Cecil rose to speak the only orator to receive any applause had been Herr Joos, and this brief outburst had been provoked by the word "*sécurité*" used in a context which must have been unintelligible to 99% of the audience. Although Lord Cecil was allowed the advantage of a loud-speaker, which had been denied to his predecessors, it was not until M. Herriot had appealed for "*la politesse française*" that he was granted a hearing.'

13

DEFEND AND AGAIN DEFEND

Whether international conferences would lead to disarmament or not, successive Ministries found themselves responsible for the day-to-day safety of their land. Between 1928 and 1934 a forthright public opinion wanted France to be safe from attack but opposed any kind of provocative or offensive action. Remembering the huge losses in bayonet charges on the Somme and at the Chemin des Dames, by and large the French wanted a peace based on defence, and any Ministry that hoped to stay in office had to heed that opinion.

When the Higher War Council debated such matters the veteran marshals Foch and Joffre declared that the best way of repelling a hypothetical attack was to thrust into enemy territory, cut his supply lines and encircle the attackers. Marshal Pétain, however, disagreed. At the battle of Verdun troops under his command used underground concrete forts – some built years before by the Prussians – to beat off waves of assaults; one of these forts, Douaumont, withstood 120,000 shells of every calibre, yet of its thirty casemates only five had to be evacuated through damage. Pétain argued that a system of such forts along the Rhine frontier would wield such massive fire power as to deter any attack. Between 1925 and 1928 the Marshals several times argued the matter but, being wholly dependent on the civil power, they had no authority to make a choice one way or the other.

In 1928 an unlikely War Minister took office: Paul Painlevé. We have already glimpsed him in Anna de Noailles's circle and as an earnest, if nervous, toiler for peace beside Louise Weiss. The clever son of a Paris lithographer, Painlevé had begun his career at the Sorbonne as a teacher of mathematics and aerodynamics, where he

became known for absent-mindedness. One day while returning home by cab he took chalk from his pocket and on the panel behind the driver's seat succeeded in solving a complicated differential equation; only when he found himself back in his apartment did he realize that his answer had disappeared with the cab.

In his spare time Painlevé taught without payment in adult education classes for the poor and presently resigned his university post in order to stand as a republican socialist for the Sorbonne district. Small, with heavy jowls and thick moustache, Painlevé resembled a hamster but he spoke ebulliently, won the seat and went on to become a prominent politician of the moderate Left. During a short wartime spell as Prime Minister he promoted Pétain to command the French army.

On taking office in 1928 Painlevé's first action was to discard the 'provocative' title of Minister of War, saying he wished to be known as Minister of the Armed Forces. Almost his next action was to ask to see plans of the proposed system of discontinuous underground fortifications for the eastern frontier. They were brought to him by Marshal Pétain.

The son of Picardy peasants, Philippe Pétain was commissioned into the infantry, then taught young officers at the School of War in Paris; until 1914 he was in effect a teacher, and a good one, nicknamed 'Dry and Precise'. In 1916 he was placed in command of the Second Army by Joffre and at Verdun showed outstanding qualities of leadership and courage. In 1917 he quelled a serious mutiny with tact and great humaneness, earning praise from the Government and from ordinary soldiers, who looked on him as their friend.

As a Marshal of France, Pétain had a seat on the Higher War Council, of which in 1928 he was vice-president. At seventy-two he was four years over the age limit for active service, but so exceptional were his gifts that this rule had been waived, and he held the posts of Chief of the General Staff and Commander-in-Chief designate in case of war.

It would be a mistake to picture Pétain as a tired old soldier, fossilized in 1916, out of touch with new thinking. In fact he mixed socially with civilians and, like other Parisians, was affected by the ideas around him. He lunched fortnightly with other members of the

Hervieu Dining Club, named after a well-known playwright killed in action; here he talked about books, theatre and current affairs with distinguished writers such as Paul Valéry, who presided over the Club, the historian Jérôme Carcopino and the philosophical essayist Georges Damas. Everyone who met Pétain on these and similar occasions speaks of his composure, his keen, balanced intelligence, his lack of hauteur.

At sixty-eight Pétain had married Eugénie Herain, divorced wife of a sculptor, and at her prompting was preparing a book about Verdun which she hoped would secure his admission to the Académie Française. True to his rural origins, he also made a point each autumn of going to a small estate with a vineyard which he had bought in the south, to supervise the gathering and pressing of grapes.

To a cautious politician of the Left like Painlevé, Pétain, with his humble ancestry and proved humaneness, was a soldier one might trust, while to a mathematician the detailed plans produced by the 'dry and precise' former teacher were pleasingly rich in measurements and statistics. Along almost 200 kilometres a system of underground casemates, each with an anti-tank gun, would be reinforced every three to five miles by a very powerful underground fort, with heavy guns in electrically powered turrets and living quarters for up to 1,200 men. No attempt would be made at a continuous fortified line; rather, gaps would be left at chosen points in order to funnel the enemy into preselected sites where the defence would have every advantage of terrain and fire-power. It was a very ambitious plan, it would cost a lot of money but, as Pétain explained, it would save soldiers' lives.

Painlevé discussed Pétain's plans with his prime minister, Poincaré, and got his approval. Then, presiding over a session of the Higher War Council, he obtained the Council's approval. In January 1929 he put the plans to the House. They called for 12 million cubic metres of earthworks, 1.5 million cubic metres of concrete, 150,000 tons of steel, 450 kilometres of roads and railways, and 100 kilometres of tunnels. The whole work would take four years, and since France had not yet recovered from a run on the franc, no credits would be asked for until the following January. Painlevé assured the House that the fortifications would give France the

security she needed and, given his known character as a cautious peace-lover, deputies voted a bill authorizing the project.

Aware that the scheme still aroused opposition, particularly among senior officers, Pétain now stepped openly into the arena. In 1929 he published his book, *The Defence of Verdun*, describing from personal experience the vital role of underground forts in that costly but decisive victory. With Pétain the soldier backing Painlevé the man of peace, public opinion now swung behind the new defensive line.

There remained, however, the voting of credits, and here a change of Ministry helped Pétain. In November 1929 Briand succeeded Poincaré and replaced Painlevé, now aged sixty-six, by a younger man.

André Maginot was born in Paris into a Lorraine family. Well over six foot and broad in proportion, strong-featured, a good mixer yet at heart reserved, in 1910 he won a seat in the House as a moderate republican representing the Meuse. War came. A deputy could not join the army and retain his seat. Maginot chose to enlist and was posted to the Lorraine front, where in two months he showed such courage and coolness he was four times mentioned in dispatches and promoted sergeant. On 9 November 1914 his section was ambushed and he himself had his kneecap shattered. He dragged himself to where six survivors were sheltering behind a large boulder and for nine hours fought off the enemy. When darkness fell his men dragged him to safety by his hands – he was too heavy to carry. A clever surgeon saved his right leg but the articulations of the knee were severed, causing him to limp badly and to suffer much intermittent pain.

In January 1930 it fell to Maginot as the new War Minister to obtain from the House – notoriously careful about money – the then enormous sum of 3,000 million francs: four years' credits at a stroke instead of the usual one year's. It says much for Maginot's popularity – as Minister of Pensions he had worked tirelessly to cut red tape in order to secure blocked or overdue payments – that he succeeded.

The money had been voted, but in so vast a project could easily trickle away. It so happened that Maginot had been devastated by the death in childbirth of the wife he deeply loved and, instead of remarrying, had chosen a life of public service. Moreover, as a

Lorrainer he had an additional motive for making a success of the projected fortifications, for he saw them as the surest way of preventing German troops from again annexing that cherished region. So Maginot spent seven days a week on site, overseeing the earth-moving machines as they gouged pits twenty metres deep, and the cement-mixers as they churned out concrete to make underground walls, floors and ceilings. Delays, contractors' pleas for more time – these he would not tolerate, saying 'I'm like my knee, I won't bend.'

As the underground forts took shape Maginot was seen limping up and down damp narrow stairways with his stick, squeezing himself into gun chambers. With the same energy he had brought to the payment of small pensions, he ensured that the millions voted by Parliament produced the most effective defences modern technology could devise. He contracted diabetes but refused to slow down. He supervised the installing of the first armament, notably 47 mm anti-tank guns with a range of 1000 metres.

In January 1932 Maginot died of diabetes and exhaustion, aged fifty-five. The line was not yet finished, but on its completion it was to be called by common consent not after Pétain who devised it, nor after Painlevé who had seen it through Parliament, but after Maginot, its unbending implementer.

The year 1932 was to be important for France's defence system. It was the year of the Disarmament Conference in Geneva and of high hopes of agreement on arms reduction. In June Edouard Herriot became prime minister of a Radical government exuding Ecole Normale optimism as purveyed by Brunschvicg, and chose as his War Minister a doctrinaire pacifist and long-time leading socialist, Joseph Paul-Boncour.

With Paul-Boncour in the chair, the Higher War Council held several sessions in order to discuss France's frontier defences. The line of underground fortifications, which ran from Longuyon in Lorraine to the Swiss frontier was now well advanced, and the question now arose, should the line be continued to the Channel, that is, in order to cover France's frontier with Belgium?

Since a defensive line becomes a white elephant if its flank can be turned, the common-sense answer would obviously seem to be yes.

But a number of arguments could be raised in favour of a different reply. First, an extension of the line in the north would be more difficult to construct than the original line because a number of industrial towns lay close to the frontier. Secondly, for that reason it would be expensive, and France in 1932 was suffering from the worldwide Depression, and army credits had been cut in January that year.

Thirdly, the Belgians would object on the grounds that France was putting her own safety before Belgium's.

Fourthly, at a time when public opinion, hopeful of agreement at the Disarmament Conference, was at its most pacifist, an extension of the Line would be tantamount to telling Germany, 'We do not trust you to abide by the Treaty of Locarno,' and would certainly be denounced by the German government as provocative.

These points were raised in the Higher War Council and provided attractive pretexts for not continuing the Line. But the most compelling argument was not put forward during the discussion, yet it was very much in the minds of a majority of the generals present, to emerge only later in the decisions and *obiter dicta* of Marshal Pétain and General Gamelin, a future commander-in-chief designate, from 1936 onward.

Pétain had decided that if another war broke out it must on no account be fought on French soil. He had seen the land of France devastated, many of its finest buildings shattered, towns reduced to rubble, farms burned, and he was determined that such happenings should not recur. Pétain believed that the Line in its present form would deter Germany from attacking France and channel her territorial ambitions eastward. Suppose, however, that Germany still intended to expand in the west. If the defensive Line were not continued to the Channel, Germany would naturally be tempted to strike through Belgium. France and Belgium had a military alliance, and in the event of a worsening situation France would be able to deploy her armies in Belgium. Any war would be fought in Brabant and Flanders, not on French soil. The *patrie* would be saved from a second desecration. This scenario rested of course on the assumption that Belgium would remain France's ally.

Pétain's prestige was now at its height – architect of the defensive Line that would save French lives, received into the Académie

Française by his friend and darling of the intelligentsia, Paul Valéry. Pétain had no difficulty in persuading a majority of the senior officers round him – dependent on him for promotion – that the Line as it stood answered France's needs.

Such was the undisclosed thinking behind the Higher War Council's decision in early summer 1932 to complete the existing defensive line but not to continue it from Longuyon to the Channel. Given the country's pacifist mood, the press took no special interest in the matter, failed to signal an inherent danger, and continued to vaunt France's impregnable girdle of concrete and steel.

As a Marshal of France Pétain still retained his seat in the Higher War Council but he had at last stepped down, at the age of seventy-four, from his post as commander-in-chief designate and had been succeeded by a man in almost every respect his opposite. Maxime Weygand was a cavalry officer, married to the daughter of a general. He was lean and wiry, holding his small head cocked, brown eyes alert, as though he had just heard a bugle call to attack. Early each morning he had a long hard ride in the Bois. Before holding posts in Poland and Syria he had been chief of staff to Foch and had retained Foch's commitment to offensive strategy.

Weygand found himself in a difficult situation. On the one hand successive Ministries had cast the army for a passive role, on the other Berthelot had committed France to four military pacts in central and eastern Europe. According to a shrewd Belgian observer of the Paris scene, 'If one told Berthelot, in his ivory tower, that his cunning combinations had been possible two centuries earlier only because 40,000 men sufficed for Maréchal de Belle-Isle and Colonel Chevert to blockade Prague and wear down the Imperial army, whereas now a million would be needed, he shrugged evasively.' Intelligence would render force unnecessary.

Perhaps. But Weygand had to assume it would not. From the first he outspokenly contested the cliché of the day, that 'France should have a defensive army.' 'From the military standpoint,' Weygand declared, 'that contention is absurd and dangerous . . . Nor is it less ominous from the political standpoint, for it conduces to the slackening of effort, to the exalting of weakness.' Here indeed was a difficult customer for the likes of Herriot, Paul-Boncour and their kind.

No less worrisome, Weygand found himself in command of a shrinking army. Conscripts' service with the colours had been two years in 1922; in 1923 it had been reduced to 18 months, and in 1928, as an economy, to 12 months. Worse lay ahead, for in 1935, as a result of the decline in the birthrate from early 1915, the number of conscripts would drop sharply.

The German army numbered, officially, 100,000 men, with a high proportion of officers. Taking account of paramilitary groups, its actual numbers were probably 650,000. The French army, including reservists and conscripts doing their year's service, hardly amounted to 600,000 and the figure would be more like 500,000 in the second half of the 1930s.

With the support of a majority in the War Council, Weygand therefore urgently pressed the ministries, as they rose and fell, to increase conscripts' service to 18 months. But every plea brought the same answer, suitably wrapped in politeness: 'There is a world Depression and we can't afford it.' Those underground fortifications – the line with a limp – were taking the major share of military expenditure.

In January 1933 Edouard Daladier, leader of the moderately left-wing Radical party, became Prime Minister and also Minister of War. A baker's son from the south, he had fought bravely in the trenches as an infantry sergeant, then taught history at university before entering politics, initially as an associate of Herriot, the leading partisan of disarmament.

On 9 February Weygand wrote to Daladier, alerting him to the dangerous effect on numbers if further cuts were made in spending. Without consulting Weygand, Daladier introduced and carried a bill suppressing 5000 officers out of a total of 30,000 and the following month introduced a bill, sponsored by a left-wing Radical, Paul Bernier, to reduce the intake of conscripts to 200,000 a year.

Weygand considered this to be the height of irresponsibility and put all his energy into fighting Bernier's bill. Daladier and his colleagues took the line, 'If we give this hot-headed general more men, he will be even more likely to press for a strategy of attack.' Weygand went so far as to take his case to the new President of the Republic, Albert Lebrun, but Lebrun replied that it would be unconstitutional for him to intervene.

On 18 December 1933 the War Council met to consider Bernier's bill. All but three of the generals supported Weygand in opposing it unreservedly. But as Paul-Boncour, when Minister of War, had written to Weygand, 'The Council exists only to give advice' – and had no binding authority.

That advice again the Government chose to ignore, for twenty-four hours later the House passed Bernier's bill by 449 votes to 147.

Weygand continued fighting. In 1934 he again urged the Government to increase the length of service. Pétain had now entered politics as Minister of War, and Weygand had reason to hope that the great man would say yes. But Pétain gave his answer when he told the Senate military committee in March: 'We cannot for the moment extend length of service. The people won't let us.'

Those last words come strangely from the victor of Verdun, and one asks, were they just a feeble excuse? An answer emerges in one of many typical manifestos of the period, that issued in August 1933 by the highly influential National Trade Union of Teachers. This body by a very large majority condemned war in any form, even defensive, paid homage to conscientious objectors and expressed satisfaction at seeing an increasing number of trainee teachers refusing to enrol for officers' training. 'The people won't let us' was not an excuse, it was a fact of life.

On 17 May 1934, still not beaten, Weygand wrote a personal letter to Pétain, asking him to convene the War Council so that they could work out a weighty request to Parliament to extend service to two years. By now Germany had quit the Disarmament Conference and the League of Nations and had announced her intention of tripling the size of her army. Though Pétain and Weygand were on good terms, the Marshal did not reply.

In another area Weygand had more success. The Maginot Line had to be accepted as the mainstay of France's defence, and perhaps indeed it could repel infantry and tanks. But what about parachutists? Weygand was one of the first to foresee the Line's vulnerability from the air, and was to write in the *Revue des Deux Mondes* in 1936: 'The enemy's assault will be supported . . . not only by the weight of massed aerial bombardment alone, but by the dropping of detachments from the sky, whose mission it will be to paralyse the vital centres of our resistance.'

To counter such a threat a highly mobile force would be needed, so Weygand urged that part of the cavalry should switch from horses to light tanks. This caused an outcry from fellow officers who had chosen the cavalry because of a passion for horses and riding, and from the horse-raising lobby: 'Why replace a horse fed on home-grown oats by an engine fuelled by imported petrol?' For once Weygand got support from Daladier, and in December 1933 the first Light Armoured Division was authorized. Ten thousand horses and mules were put out to grass and light tanks ordered; by 1935 the division would be fully equipped. At the same time Weygand used his sparse budget to motorize the infantry, so that they could be moved speedily to any breakthrough in the Line.

In May 1934 a protégé of Pétain with a special interest in heavy tanks, Lieutenant-Colonel Charles de Gaulle, published *Vers l'armée de métier – The Future Professional Army*. This lucid book is in two parts: 'Why' and 'How'. 'Why' starts from the fact that France, geographically vulnerable, is no longer Europe's most populous nation and can retain her leading position only by virtue of the *quality* of her weapons, and the use she makes of them. 'How' calls for a professional army of 100,000 men equipped with the most advanced tanks, in six armoured divisions. In any war these tanks would race across the frontier and, backed up by a strong air force, create panic among the enemy.

For the mid-1930s this was a very strong brew indeed. In one and the same book an unknown lieutenant-colonel was calling for three revolutionary changes: a strong, highly trained professional army instead of a conscript force; a tank force no longer moving side by side with infantry but acting on its own; and sudden attack deep into enemy territory as the way to victory.

Because its author was to become famous, the importance of his book has often been overestimated. At the time it caused, by and large, alarm and suspicion, and as regards the adoption of heavy tanks, its impact was negative. For by associating tanks with a strategy of offence – anathema to the civil power – it made all the more difficult the task of other officers who were pressing for that weapon. Weygand, to whom de Gaulle sent a copy of his book, said he found the book 'interesting' but that he did not agree with it. The most important single effect of the book was that a député from

Savoie, Paul Reynaud, who liked it, met the author, thought highly of his character and seven years later was to give him a minor post in his wartime government.

Parallel with the building of the underground fortifications and attempts by Weygand to extend military service and to make his army more mobile went the building of an air force to protect the new fortifications from aerial attack.

From the very first, Frenchmen had warmed to the aeroplane. They claimed Adler as the first to make a powered flight and men like Blériot and Farman had pioneered and piloted new types of aircraft and broken records with them. During the War French planes had performed very well. In the inter-war period the private Aéropostale service pioneered air links between France and South America via North Africa. Men like Mermoz, Guillemet and Saint-Exupéry flew light aircraft through full gales, blizzards and sand-storms on these long distance routes. The mail must get through! Such work was dangerous – in six years 120 crew were lost – but it had an epic quality that attracted men of daring. In a series of books describing admirably the poetry of flying and the team spirit generated by daunting missions, Saint-Exupéry did much to inspire his younger contemporaries with a keen interest in aeroplanes and a desire to fly them.

By the late 1920s aircraft were being built capable of carrying heavy loads for long distances. Public opinion became aware that such planes must inevitably play an important role in any future conflict, and although the Treaty of Versailles denied Germany an air force, it was widely acknowledged that her excellent fleet of commercial planes could be refitted for a military role.

From this followed two conflicting conclusions. For the Socialist Party Congress of 1931 the plane would spell mass destruction of the civilian population: 'What would victory on the battlefield mean if we find ten million, fifteen million, twenty million dead bodies in our cities and countryside?' – and delegates agreed that it constituted the supreme argument against war in any form.

In the same year a different conclusion was drawn at a meeting of the Association Française Aérienne, organized by the industrialist André Michelin, the ex-servicemen's leader, Colonel de La Rocque,

and a deputy, Charles Delesalle. It took the form of the following announcement:

> Ten thousand citizens meeting in the Salle Wagram, convinced of the horrors of aerochemical warfare but persuaded that in the actual state of the world fear of such horrors can prevent them occurring, provided that the fear is reciprocal and general, demand that the State provide France with an air force equal to that of any other power, which will allow her to reply energetically to any aggression with immediate and decisive reprisals.

This view received support from an unexpected quarter. Marshal Pétain, who was Inspector General of Air Defence from 1931 to 1933, saw the importance of bombers and urged the Government to start building them. A senior officer on Pétain's staff, General Armengaud, went so far as to argue in print that only a strong fleet of bombers would permit France to intervene effectively should her allies, Czechoslovakia and Poland, be attacked.

It so happened that the government of the day – the second half of 1932 – was trying to persuade the Disarmament Conference to outlaw bombs in aircraft altogether. This plan won considerable support from the international community. Britain, however, was finding bomber planes necessary to keep order on the North-West Frontier and in Iraq, where Kurds were massacring large numbers of Christians. She declined to support France's proposed ban, and the proposal was passed to committees – what Louise Weiss termed 'paralysis'.

In 1933, as disarmament talks dragged on inconclusively, Daladier's government saw that a decision must be taken regarding France's air force. Existing planes were old-fashioned and mainly suited for reconnaissance, since the air force, although given a nominal autonomy in 1928 with the establishment of a Ministry of Air, was still regarded as an appendage of the army and received its orders from the commander-in-chief, always an army man. New planes must be ordered, but before this could happen the Government had to decide on the role of the air force.

At this period both inside and outside France, the views of an Italian air expert, General Giulio Douhet, carried weight. Douhet

argued that in any future war armies would be locked in virtual stalemate. An air force therefore should be composed of 'all round' planes suited to reconnaissance and the direction of artillery on behalf of ground troops, but capable also of dropping bombs on enemy supply lines. Such aircraft would not need to be fast, and so could be heavily armed. A typical plane would be manned by a pilot, a machine-gunner amidships and a second machine-gunner in a rear turret.

This multi-seater plane, known as the BCR (bombardier-chasseur-reconnaissance) and unofficially as the flying hedgehog, fitted in very well with the Government's over-all defence thinking. It was not a 'provocative' plane, not a 'terror' weapon. Basically it was a defensive tool, and, being heavily armed, presumably would not prove costly in lives. It embodied, in the air, the principles embodied on land by the Maginot Line.

In 1933 the Government ordered several prototypes of the BCR and in the following January voted the money for building 310, the first major order for aircraft since 1918.

On paper this sounded very satisfactory, but in France between the placing of an order and delivery of the completed planes there lay three formidable impediments: a multiplicity of Small Firms, the hydra of Prototypes and the quicksands of a Ministry Inspectorate.

The first resulted from the patriotic spirit of the late war, when many family engineering firms switched to building the aircraft then so urgently needed. With peace, demand for military planes slumped – in fact many veteran planes were bought by Americans for the new national craze of barnstorming – and the little firms could survive only by receiving crumbs from the Ministry of War in the shape of a couple of orders now and then. It would have been in the national interest for most of these 'cottage industries' to merge or go out of business, but they did not want to merge and become 'capitalist' – wicked word – and those who placed orders did not like to see them die. Again, tender-heartedness. There were almost fifty such firms in existence, eight times the number in other advanced countries. They had neither the money nor the equipment for mass production; they built a plane as Brancusi made a sculpture, lovingly, expensively and very slowly.

The second impediment followed from the first. You could best

keep small firms alive by commissioning many prototypes of any given category of plane required by the Ministry: say, one prototype of a reconnaissance plane from a dozen different firms. In that case the State paid all expenses for the plans, the construction and the testing. If the prototype performed according to stated minimum criteria, the builder retained the licence to produce it; otherwise the licence passed to the State. If the performance proved better than the stated criteria, the builder received a bounty.

From 1919 to 1929 no less than 332 different prototypes of military aircraft were ordered and built, and 371 prototypes of engine. Of these only 36 aircraft and 19 engines went into production. The hydra of prototypes was generally recognized to be a voracious monster, and successive governments were to try their best to slay it, without success.

The third impediment arose from the creation in 1928 of a Ministry of Air structured, according to the philosophy of the day, in such a manner as to prevent such a dangerous arm coming under the control of any one body. Decision-making was therefore divided between a Minister – invariably short-lived – the General Staff of the Air Force and a Directorate of Military Air Equipment, all subject to approval by the Higher War Council. The Minister's freedom of action was further curtailed by a large and watchful Technical Inspectorate-General, independent of his authority, and by the need to wrest funds, year by year, from a close-fisted parliament.

The Ministry of Air was made to feel its inferiority by being assigned characterless modern buildings in run-down Boulevard Victor, far from the centre. Here it set up its own version of the Polytechnique, the Ecole Supérieure d'Aéronautique. Known as Sup'Aéro, this produced young men very clever at mathematics and aeronautical theory but with no flying experience. These were fed into top posts – by 1935 there would be 96 such graduates in the Ministry. Many were Inspectors, charged with examining and testing those prototypes being churned out from artisan firms. It was an ideal situation for clever theorists, abreast of the latest thinking on engines and fire power, to fault a prototype commissioned a year or two earlier, and to send it back for improvements or alterations. Moreover, the Inspectors thrived on the prototype system: the more

prototypes, the more occasions they had for asserting their expertise and authority. So the third impediment safeguarded the second.

Under these conditions it is not surprising that production of the BCR was intermittent and extremely slow. Nevertheless, some units were delivered on time and took their place in late 1934 beside the completed underground fortifications.

The Maginot Line was now admitted by qualified observers, French and foreign, to be a work imaginative in conception, endowed with the latest technology and, as regards its limited purpose, probably extremely effective. Each of its casemates was self-contained. On the top floor an anti-tank gun, mortars and machine-guns; below, chairs, lockers, beds, store rooms holding munitions and food for twenty-five men, and a diesel generator to provide lighting and induced ventilation.

The forts were much deeper and varied in size, the largest holding 1,200 men. The entrance would lie some two kilometres behind the gun turrets. Here munitions and supplies were taken down by a powerful lift to the main gallery 30 metres deep, where 'the Métro' – a light electric railway – carried them to the appropriate store rooms and magazines. An engine room equipped with three large diesels produced the fort's electricity, ventilation and, in case of a poison gas attack, a high air pressure that would keep the gas out.

The turrets, weighing sixty tons each, were raised to fire in two or three seconds and lowered immediately by electric motors. In the firing chamber, of chrome-nickel steel seven inches thick, four gunners received shells sent up from the control room, loaded and fired, returning the spent cases down a shaft. Heat built up in the small chamber, only seven feet in diameter, and the men chosen for these duties had to be small and robust.

The ground in front of the fort was swept by twelve sets of double machine-guns. A guide mechanism – steel rollers on an irregular circular track, conforming to the terrain – ensured that their fire passed a foot above the barbed wire defences.

One-third of the men slept while another third were on duty, and the last third eating or standing down. Though blowers circulated fresh air for a total of eight hours a day, the fort was damp. Paper wouldn't take ink, and the men had to use pencil for their letters home.

Outside the fort roads were blocked by upright rail lines ten feet high embedded in concrete festooned with barbed wire, and all trees and buildings that might have hampered the complex interlocking fields of fire had been cut down or levelled.

Overhead, if mobilization should be decreed, the BCRs would be observing enemy movements and reporting on the effectiveness or otherwise of anti-tank fire, while beating off attacks from enemy planes with machine-guns amidships and at the rear.

Though its purpose was so different, the Line might be described as the largest and most ambitious construction since Cheops' Pyramid. It was a huge piece of military technology built in the cause of peace. It was also a cocoon, a steel and concrete cocoon, but still a cocoon, in which thousands of soldiers huddled in order to avoid direct contact with the enemy. Whether it was to continue to be the mainstay of France's defence system or one item in a more resolute and dynamic strategy depended not on the generals in the Invalides but on the civilians in charge of foreign policy down the road on the Quai d'Orsay.

14

THE RUSSIAN CARD

In January 1933 against a background of mass unemployment and widespread hardship there emerged a new Chancellor of Germany. The name of Adolf Hitler meant little in Paris, even to the well-informed; however, the new Chancellor had conveniently put into a book a great deal about his character and his political intentions. It was a long book – over 600 pages – repetitious, ranting, in places showing signs of paranoia, and unlike most such books it did not look at the past in order to devise a programme. Leaving the past altogether out of the picture, it dwelled only on the future, doing so in terms of pronouncements. First, Communism and Jewry are the enemies of Germany: both must be destroyed. Second, Germany must expand in Europe. Third, the mutual, inexorable enemy of the German people is, and remains, France. There must be 'a definitive showdown with France' and 'the complete annihilation of France'.

Mein Kampf enjoyed a special status. Reprinted in 1933, orders went out that a copy was to be presented to every young couple throughout Germany on their wedding day. It thus took its place beside the book traditionally given on that occasion, the Holy Bible. The absolute value already beginning to be attached to *Mein Kampf* was further strengthened by an event that occurred some three and a half months after Hitler became Chancellor. Around midnight on May 10, in rain, a torchlight parade of thousands of students ended at a square opposite the University of Berlin. Torches were put to a huge pile of books that had been gathered there. They included works by Thomas and Heinrich Mann, by Stefan Zweig and Walter Rathenau, by Hugo Preuss, who had drafted the liberal Weimar constitution, and by Albert Einstein. In the words of a student

proclamation, any book was to be burned 'which acts subversively on our future or strikes at the root of German thought, the German home and the driving forces of our people'.

As the flames enveloped them, more books were unloaded from trucks until some twenty thousand had been burned. Dr Goebbels, the new Propaganda Minister, addressed the students: 'The soul of the German people can again express itself. These flames not only illuminate the final end of an old era; they also light up the new.' The new era lay enshrined within the covers of *Mein Kampf*, to the absolute truth of which all future writers must bow.

Similar *autos da fé* occurred in Bonn, Göttingen, Hamburg, Cologne and Nuremberg, and one might have expected them to arouse widespread protest or at least dismay in the French press, for among the works burned was Remarque's *All Quiet on the Western Front*, which had sold 600,000 copies in French and been hailed as a sign of anti-war sentiment, and books by Marcel Proust and André Gide. In fact, however, the book-burning was scantily reported and, with disarmament uppermost in many minds, editors were not disposed to pass adverse comment on a neighbour's internal affairs.

A different situation arose in March 1934, when *Mein Kampf* appeared in French. Now the future as planned by Germany's Führer was available in any bookshop for Frenchmen to buy and read.

Romain Rolland, Ecole Normale socialist, bravest of pacifists and most experienced of Germany-watchers, had this to say of the book in a letter written to his disciple, Jean Guéhenno, also an Ecole Normale socialist and editor of *Europe*, a periodical promoting peace through cultural exchange founded by Rolland:

I suppose you have read *Mein Kampf*, either in the original or in the translation published by Nouvelles Editions Latines. It makes terrible reading for a Frenchman, whether he be an internationalist or a nationalist. It leaves one in no doubt about the iron determination to destroy France completely, and the implacable necessity for her annihilation.

That many French journalists [continues Rolland], like those on *Notre Temps* (and how many others) should be campaigning furiously to prevent the French people from learning those

203

plans, known to every last German, is the most monstrous act of treason ... It is not a matter of stirring up war against Germany – you know my [pacifist] sentiments – but of recognizing that Hitler's Germany is manifestly waging war on France.

Guéhenno, aged forty-four, was a schoolmaster: weak chin, small moustache, spectacles, respected for his deeply felt but distressingly vague pleas that men should draw on their generous impulse in order to build a new, more fraternal and peaceful society. He replied to Rolland that he hadn't read the book. Given his long-standing respect for the older man and the urgency of his remarks, one would have expected him to read the book immediately and review it in *Europe*. However, no review appeared and in subsequent letters Guéhenno does not mention having read the book. It must be assumed that he did not read it.

If that is so, he was by no means alone. Parisians are quick, nervous, impatient. They have a low threshold of boredom, particularly when the subject lies outside the Parisian purview, as one example from many will show. Rainer Maria Rilke, the greatest living poet, visited Paris in 1925. In perfect French he would tell guests of the automatism with which his vision expressed itself in uncontrollable words as soon as he relinquished prose for verse. According to his host, Raymond Schwab, 'Rilke put his listeners to flight. After a few minutes I remained as his only audience ... I have got to say it, they only considered him a bore.'

Mein Kampf in French runs to 685 pages, much of it heavy going. Nor at the time would it have made pleasant reading; rather, it was a book to give one goose-flesh. And so it fell flat, much flatter even than de Gaulle's *The Future Professional Army*. It was ignored by most of the press. Jean de Pange, an alert observer of the German scene, was to open a copy only three years later.

One Parisian who did read *Mein Kampf* was France's ambassador to Berlin. André François-Poncet had acceded to that post in a curious way. A graduate of the Ecole Normale, with values akin to those of Brunschvicg and Giraudoux, he was a career civil servant specializing in economic affairs when in 1931 Pierre Laval, a slippery political fixer, particularly friendly to Germany and at that time Prime Minister, coopted him into the Foreign Office as

ambassador to Germany and gave him instructions to work for economic cooperation and rapprochement. François-Poncet therefore had not undergone the rigorous training in objectivity of career diplomats or received the warnings against duplicity that emerge from close study of Niccolò Machiavelli. He was a friendly man, a good mixer, well liked by high-ranking Germans and during his eight-year term of office a willing recipient of the views they wished the Quai d'Orsay to believe.

François-Poncet wrote long dispatches short on hard facts, coloured by the writer's optimism and the need to come up with the rapprochement for which he had been appointed. Of *Mein Kampf* he provided summaries but took the view that on coming to power its author would be bound to have to modify the programme therein, and he told Paris that Schacht, the Chancellor's financial adviser, had persuaded Hitler to shift his territorial ambitions from Europe to overseas colonies.

These dispatches arrived in a Ministry that took a very superior view of France and itself. Lacornée's solid mid-nineteenth-century building on the Quai d'Orsay enjoyed arguably the best location in the city, commanding views across the river to the Place de la Concorde, and southwards to the Invalides, doubly glorious as the Sun King's foundation and burial place of Napoleon. It stood next to the Chambre des Députés, transitory figures who required regular guidance from their neighbours, the experts. The Ministry had its own fine gardens and the tennis court added by Berthelot. Here worked a large staff of 700, and so prestigious was service in the Ministry that it was called *la carrière*, as though no other calling could touch it.

This exalted status naturally fostered complacency. When François-Poncet's dispatches arrived from Berlin, senior staff noted their reassuring aspects, but no one thought fit to read the German edition of *Mein Kampf*, though 90,000 Germans had bought copies in 1932 alone; and the book came to the attention of the Secretary General only when a press copy of the French translation was picked up by his own private secretary. Having spent part of the night leafing through it, next morning, shaken, he passed the book to his superior urging him to read it at once because 'all France will soon be questioning us about it.' A revealing phrase: the paranoid nature

of the new Chancellor mattered less than a potentially embarrassing situation at home.

In the first year of his Chancellorship, much occupied with such home matters as setting up concentration camps and excluding Jews from office, Hitler gave no signs of troubling France. The Quai d'Orsay and senior politicians, still at their games of musical chairs, could look with some satisfaction on a situation where Germany, by the Locarno Pact, recognized the existing Rhine frontier, her army was still limited in size, and the Maginot Line, almost finished, its hedgehog planes on order, ensured impregnability along its length. True, France would have liked general disarmament, but she had, or appeared to have, a second-best: security.

In April 1934 this calm was unexpectedly shattered. Hitler requested France and Britain to be allowed to triple the size of the German army, to 300,000 men. In return Germany would resume her place in the League of Nations – which she had left the previous November – and would there work actively for peace.

The man who had to face up to this alarming situation was the new Secretary General of the Foreign Office. It must fall to him to provide the particularly shaky government of the day not only with guidance in replying to Hitler's request but with a clear policy towards a neighbour evidently resolved to throw off the restrictions imposed at Versailles.

The man in question, Alexis Léger – no relation to the painter Fernand Léger – is a complex character and since he was to be the shaping spirit behind foreign policy until 1939 he merits detailed attention. He was born in Guadeloupe, where his French parents had a small plantation. He spent a secure childhood and as an only son with three sisters was made a fuss of. From a Hindu nurse, who worshipped Siva, he passed to an abbé, who taught him to identify the island's colourful birds and trees. He had a special fondness for the sea and sailing.

When he was twelve his parents moved to France, settling in Pau, where Alexis attended the lycée and went on to read law at Bordeaux, in the holidays accompanying his father on climbing expeditions in the Pyrenees. He discovered the romantic music of d'Indy and the fascination of rocks and semi-precious stones. But his chief passion was poetry. He liked the esoteric, incantatory verse of Mallarmé and

André Citroën advertised his motor-cars by illuminating the Eiffel Tower and displaying his double chevron trademark.

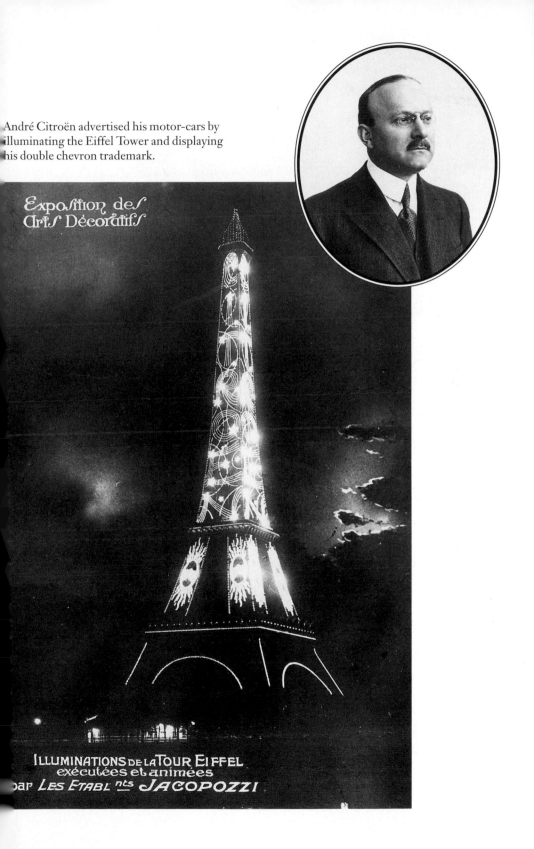

Exposition des
Arts Décoratifs

ILLUMINATIONS DE LA TOUR EIFFEL
exécutées et animées
par LES ETABL nts JACOPOZZI

Jean Renoir filming *La Marseillaise*, a celebration of the little man's role in the French Revolution.

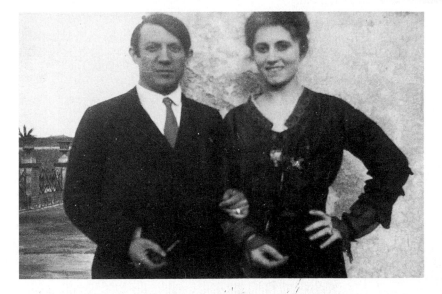

Picasso and the Russian dancer Olga Koklova shortly before their marriage.

Josephine Baker on Paul Colin's poster for the 1930 winter revue, *La Joie de Paris*.

A front cover of *Vu* in 1933 expresses a widely felt hostility to modern machinery.

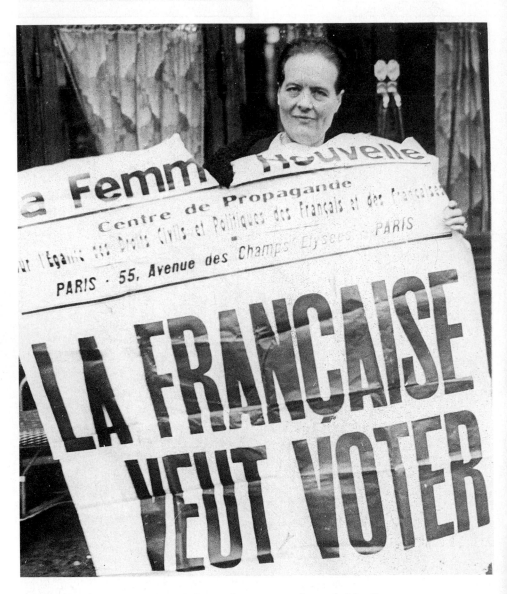

Louise Weiss demanded votes for women and crusaded for disarmament.

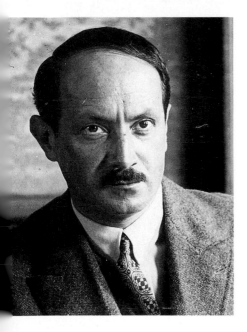
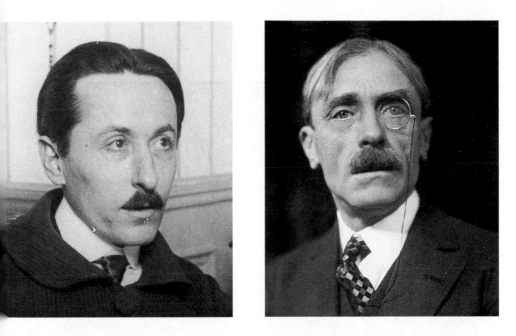

Four influential Parisians: Roland Dorgelès, author of *The Wooden Crosses*; Paul Valéry, poet and essayist; Alexis Léger, Secretary-General of the Foreign Office; Jean de Pange, tireless worker for Franco-German understanding.

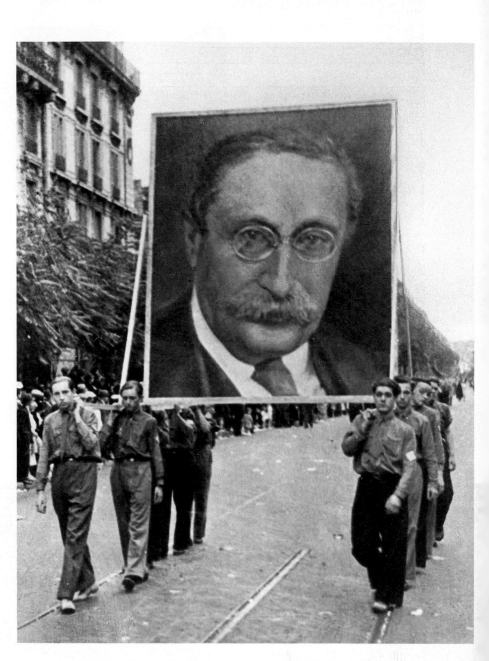

Léon Blum, Prime Minister in 1936, carried in effigy by young socialists.

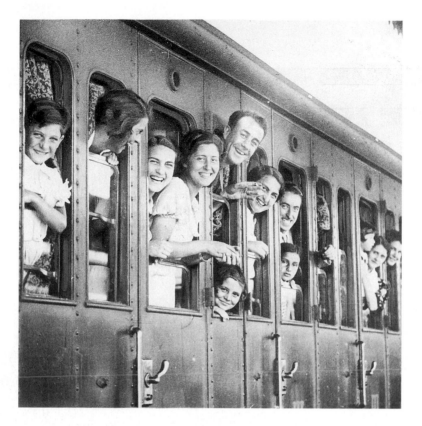

Parisians leaving for their first paid summer holiday in 1936.

Daladier and Bonnet, with contrasted expressions, on their return from signing the Munich agreement in September 1938.

The monkey-house of the Vincennes zoo becomes an air-raid shelter, 1939.

also its near-opposite, the sentimental nature poetry of Francis Jammes. He began to write in sensual terms, strong on scents and smells, about the forces of nature in his boyhood island world, particularly about the wind. He became friendly with Jammes, who thought highly of him and his verses, and through him met Paul Claudel. When his father died and he had to support his family, he followed Claudel's suggestion and entered the Foreign Office.

There Berthelot noticed him. Always eager to take a writer under his wing, he gave Léger advancement and sent him to the China he loved. On one of his leaves the young diplomat visited the Gobi desert and there wrote an esoteric poem in free verse purporting to evoke the nomadic life of a central Asian tribe under the guidance of wise leaders. This work, *Anabase*, signed with a pretentious *nom de plume*, Saint-John Perse, enjoyed a critical success in Paris.

Léger returned from China by way of the United States, where Briand had been attending a disarmament conference. With other members of the delegation Léger went to bid Briand goodbye at New York docks, from where he was taking ship to France. Several delegates pressed Briand to use his time at sea to begin writing his Memoirs. Briand said nothing. In Washington Léger had seen how averse Briand was to putting pen to paper, even for the briefest memo. Aware that his colleagues' exhortations were annoying Briand, Léger said, 'But every book is the death of a tree.' At that time the remark was fresh, and it impressed Briand. There and then he transferred Léger to his personal staff, told him to arrange to sail at once and to have his personal papers brought to the liner; Briand's chief secretary would lend him linen and a razor.

The pilgrim of peace and his gifted young protégé shared a love of the sea and of the countryside. For twelve years they worked closely together, and in 1933, when due for retirement, Berthelot chose as his successor the man whose promise as poet and diplomat he was proud to have been the first to discover.

What sort of man was the new Secretary General? Aged forty-six, of medium height, he had a broad forehead, very intense brown eyes, full cheeks, dark hair and the moustache customary at the period. He had built up a body weakened by boyhood malaria,

through the habit of long walks and controlled breathing. 'Good breathing,' he wrote to a friend, 'is the basis for disciplining the nerves, for balance, for patience, in short for mastery.'

From Peking he had written to his mother about the arrival of a new First Secretary, a man of 'the old school', sure therefore to dislike him. 'But that is unimportant: I can disturb the breathing of a man working in the same room, but no one can disturb mine. You know my guiding principle: never react against anyone, so as not to depend on him, even for the fleeting moment of reaction. It is a question also of hygiene: defence of my oxygen against other men's carbon dioxide.'

In that letter we have a clue to one side of Léger's character. Though he had ceased to write poetry, he was by temperament a poet and possessed to the full a poet's hypersensitive nature. For a public career he had to master that, and outwardly he succeeded. In manner he was friendly and welcoming, but he spoke little, very rarely put his thoughts on paper and was careful not to become closely involved with others. 'My guiding principle: never react against others.' That was one reason why Léger had remained a bachelor, living alone in a modest apartment, furnished, as Berthelot's was, with rare objects from the East, and rarely accepting dinner invitations. His women friends were safely married and of a literary or artistic turn; they included Misia Sert, Anna de Noailles and Marthe de Fels, bluestocking wife of a former deputy and author of a book on Monet.

Another facet of Léger the man was noticed by his secretary, Etienne de Crouy-Chanel. He had a marked distaste for the obvious. Just as in his poetry he chose exotic and rare words, so in everyday conversation. Instead of asking a visitor how he was, he would inquire whether his life was 'harmonious'. The obliqueness that characterizes his verse, the lack of directness, was an essential part of the man.

Léger possessed undeniable qualities for his high office. As often in those born outside metropolitan France, he was an unwavering patriot. He adhered firmly to republican principles and believed in the Third Republic. He had early dedicated himself to the high mission of serving France and he worked tirelessly in that cause.

When he became head of the Foreign Office in 1933 and had to

decide what guidance to give the government of the day, one over-riding dilemma presented itself. France had been largely responsible for creating Czechoslovakia and the new Poland; in doing so she had undertaken to help them economically and to go to the help of either should she be attacked. According to the Deuxième Bureau, France's intelligence arm, Germany had secretly created an army high command, though forbidden to do so by the Treaty of Versailles, and was training her youth with spades of the length and weight of army rifles. If Germany should be preparing to attack Czechoslovakia or Poland, with neither of whom France had a common frontier, France was honour bound to give military help. But her army and air force were equipped and trained only for defence.

An honest observer would then go on to say, 'We find ourselves in a false position. If we cannot or will not go to the aid of our allies, let us immediately disengage from our treaties with them, so that those countries know where they stand and can take action accordingly.

'If, however, we intend to honour those treaties, let us immediately reorganize our military effort so as to be able to provide immediate and effective help. Given our geographical situation, this would almost certainly involve entering Germany by land or infringing her air space.'

Weygand had raised this very dilemma in a letter of January that same year to the Minister of War. Weygand had served in Poland and knew that the Poles, so vulnerably placed between two traditional enemies, looked to France for military help in case of attack. 'We must see [wrote Weygand] how Poland could be helped, as well as the countries of Eastern and Central Europe. The Middle East is specially important because of the Tripoli pipeline, indispensable for our petrol supplies . . . ' Arguing for the creation of large mobile units, the army, Weygand concluded, is not an end in itself: 'It is one of the tools which a nation employs to back its policy. An army can be organized properly only if the policy which it has to implement is clearly defined.'

The Minister, Edouard Daladier, did not even reply to Weygand's letter, and from circumstantial evidence we may guess why. Weygand had raised a good question, the paramount question, but it was not a question for a soldier to raise. In putting it Weygand had

shown himself 'offensive' to his superior, and one newspaper that got wind of the rift even accused Weygand of trying to 'blackmail' the Government. From that moment Weygand was marked down by Daladier and his colleagues for early replacement, while Maurice Gamelin, his future successor, a soldier who early in life had learned to trim his sails to the prevailing political wind, waited quietly for his cue.

De Gaulle was another who had personal experience of Poland and so was able to free himself from Parisian cocoon thinking. He also put the question to himself and though he was careful not to spell it out, his book *The Future Professional Army* in effect provides an answer to it. We must have an army capable of speedy offensive warfare, de Gaulle declared – that is, of aiding our allies – and it must be equipped with the most advanced weaponry.

Unlike Weygand and de Gaulle, Alexis Léger was empowered as a civilian to raise the paramount question, to put it to the Foreign Minister of the day, to provide guidance on the matter in the light of his long experience of international affairs, and finally to demand that the Government answer it and implement the action that must follow logically from their answer. Should the question still be shirked, and the pretence allowed to continue, he would be honour-bound to resign.

Léger did not raise the question, either on coming to office or immediately after. He was not lacking in moral courage, but he knew the mood of the politicians and has told us his guiding principle: 'Never react against anyone, so as not to depend on him, even for the fleeting moment of reaction.' He was to choose instead a more oblique course, and to do so in the light of the French Government's response to Hitler's request for a larger army.

The Foreign Minister of the day, Louis Barthou, was a petit bourgeois from the Pyrenees region who had taken a degree in law, made a rich marriage and entered politics as a moderate with no very pronounced convictions. Highly civilized, he had written on Diderot, Danton and Lamartine, could speak with authority on Bach's fugues and the latest translation of Aeschylus. A jolly 'keep fit' man, at seventy-two he got up at five to take a cold bath and do gymnastics, which made him conceited all morning and lethargic all

afternoon. He had held office just six weeks, and now it had fallen to him to draft a reply to the British Government, which was urging France to accept Hitler's 'request', since when he had been asking colleagues distractedly, 'What, oh what, would Briand have done?'

At nine on the morning of 12 April 1934 Barthou received in his office at the Quai d'Orsay France's ambassador to Berlin. André François-Poncet had spent six months of daily negotiation with von Neurath, his German opposite number, working out, in very vague terms, the *quid pro quo* embodied in Hitler's request. 'Believe me,' he told Barthou, 'an agreement, even if mediocre, is preferable to the absence of agreement. In order to avoid the worst, it is only common sense to resign ourselves to the lesser evil.'

It was a matter of the utmost importance and they discussed it at length. Finally Barthou said, 'You've convinced me. But,' he added, pointing to the floor above, 'it's up there that has to be convinced.' He was referring to the Prime Minister, Gaston Doumergue, who had a temporary office in the building.

Barthou's decision was in line with the 'Trust Germany' policy followed by Briand until his death two years before, and which Berthelot had supported. Léger therefore, the disciple of both, helped Barthou draft the note to be delivered to Britain, while Barthou gave a lunch party, proudly explained his stand to Bérenger, president of the Senate Foreign Affairs committee, and received the senator's congratulations. What followed is of interest because it provides a rare glimpse of Cabinet.

After lunch Barthou was summoned by the prime minister. Seventy years of age, known for his perpetual smile, Doumergue presided over a Ministry of National Unity, which included right-of-centre deputies. Just as Barthou was about to draw from his pocket the text of his note, Doumergue drew a paper from the pocket of his black frock coat. 'No, my friend. Keep yours and read this one. I drafted it myself with two of my Ministers. It's the note we shall shortly ask the Cabinet to approve. Or rather, *you* will ask.'

A flustered Barthou read Doumergue's note as Ministers gathered, among them André Tardieu. A former prime minister, a man of principle, outspoken – sometimes too much so for his own advancement – Tardieu was known as 'the Shark' and had consistently warned about a militarily resurgent Germany.

At the ensuing Cabinet meeting it was Tardieu who led the argument. 'With respect, Foreign Minister, you don't understand the situation. Hitler won't last long, his fate is sealed, an agreement now would only strengthen his position. And if it should come to war, in a week he'll be deposed and replaced by the Crown Prince.'

Since Tardieu was supported by Edouard Herriot, for so long an advocate of rapprochement, Doumergue's position was strong. Barthou therefore reluctantly backed down and asked the Cabinet to approve the note drafted by Doumergue. This pointed out that Germany's increased military expenditure proved that she was already rearming and that this ruined the basis of negotiation. Germany had not shown the least intention of ever returning to the League. France therefore must look to her own defence while continuing to work at Geneva for peace.

After the Cabinet copies of the following communiqué were handed to journalists:

> The Cabinet has unanimously adopted the note which M. Louis Barthou, Foreign Minister, drew up in agreement with the Prime Minister in reply to the latest British note. The Cabinet unanimously agreed on the text as prepared by the Foreign Minister.

Among those who read the communiqué was Geneviève Tabouis. Pale, very thin, Geneviève battled against insomnia and frequent illness to become France's leading woman political correspondent, highly suspicious of Germany. A close friend of Barthou and Léger, Geneviève knew the inside story and commented wryly: 'Thus is history written!'

Next morning, at eight, Léger rang the bell at 35 avenue Marceau and was ushered by a footman into a library of finely bound books. At the far end, in front of the window, a barber was shaving and trimming the short white pointed beard of the Foreign Minister. As he finished his task Barthou rose and sadly confided his feelings to Léger.

'Yesterday I lived the most tragic day of my life. If I'd opposed the Prime Minister I should have had to resign, perhaps brought down the Government. Years ago it was I who increased military service to three years. Could I bring down a government of national unity

because I wished at all costs to agree with Germany? Public opinion would have said I was wrong.'

We note the last words. Right and wrong are decided by public opinion.

Barthou then asked Léger to be so kind as to take him on Sunday to Cocherel, Briand's country home, which Léger had often visited. There by the grave of the pilgrim of peace the Foreign Minister intended to meditate in silence on the implications of the note he had reluctantly signed.

Léger agreed to do so, then returned to his office on the third floor of the Quai d'Orsay. Following Crouy-Chanel's prompting, he had now read *Mein Kampf*. He believed that whatever France and Britain might say, Hitler would triple his army and might well use it aggressively in Eastern Europe. France, he concluded, could no longer continue a policy of drift. Sunday could be a turning-point, for Barthou, who was easily led, would be open to positive advice. For once Léger did not hide his intentions: to Crouy-Chanel he announced dramatically: 'We must play the Russian card.'

Russia was a country Léger had never visited and even in the Quai d'Orsay exact information about conditions there were hard to come by. It is probable therefore that he valued the views of his closest friend among elder statesmen, Edouard Herriot, who had twice visited Russia and after each visit written a book. Given the weight of Herriot's name both as statesman and author, these books were widely read and their views adopted by many moderate Parisians. And, as Barthou had noted, foreign policy must march with public opinion.

On his first visit, in 1922, Herriot said he found no trace of communism. Russia resembled France under the Directory, with a new bourgeoisie emerging. Industry was still in ruins and there were signs of famine, but the worst was over. Money was more plentiful and Herriot, who as a sound Radical held anti-clerical views, ascribed this happy circumstance in part to the fact that the nation no longer had to pay for the upkeep of clergy and churches. He concluded his book by urging the French republic and the Russian republic to be reconciled, and to recommence trading.

In August 1933 Herriot again spent one month in Russia. He went, he announced, as a private citizen to investigate reports of

widespread famine in the Ukraine, but from the moment of his arrival in Odessa the author-statesman was treated as an honoured guest, with the French ambassador in attendance and a train of journalists to impart his utterances to the world.

Herriot began his carefully guided tour. He declared to the journalists that on every side he saw abundance. Shown round a collective farm, he expressed satisfaction that the government allowed every agricultural worker to have his own cow and freely to leave the collective if he wished. On this last point Herriot received an assurance that any attempts to restrict this liberty were severely punished. 'All who use compulsion with the peasants are expelled from the Party,' Herriot reported.

The Frenchman observed a shortage of milk in Ukrainian towns, but was informed by Mikhail Kalinin, titular head of the Soviet State, that milk production had in fact enormously increased but so too had the social services. This had led to a temporary situation where, according to Kalinin, 'milk consumption tends to exceed production, with the result that regulations had to be made with regard to distribution.' On the famine issue Kalinin was categoric. Though the story was 'being brandished around like a scarecrow, it was nothing but the dubious product of Hitlerian propaganda.' Knowing that their guest was a lover of the arts, the Russians put on a ballet for him on the theme of the French Revolution. Again Herriot found matter for praise.

Such were the views set out in Herriot's *Orient*, now selling briskly in the Paris bookshops, at the very moment when thousands of Ukrainians were being starved to death by the Soviet government in a deliberate act of genocide.

There is a curious parallel. In 1768 after a 13-day visit to Tahiti Bougainville told the world of a noble people living in a garden of Eden on the fruits of their soil, bathing in turquoise waters and openly making love, and though closer inspection by other travellers presently revealed infanticide and chronic war, Bougainville's picture of the noble savage prevailed. So now. Paris's Russian colony, closely in touch with their homeland, gaped at Herriot's fatuities and one of them, Dr Ewald Ammende, who headed an interdenominational committee set up by the Archbishop of Vienna to aid the starving, was to publish in 1936 the true account of the tragedy, devoting

a whole chapter to errors in Herriot's *Orient*, but Ammende was not a 'name' and his corrections came too late. Herriot held the stage, with his account of a benevolent government successfully modernizing land neglected under the Tsars, a government that could be trusted.

Such was the French state of mind when Léger took Barthou to Cocherel. There, after Barthou had duly meditated beside Briand's grave, Léger imparted the plan he had described as 'the Russian card'.

He started from the situation he had decided not to contest: the refusal of any French government to build an offensive army such as could honour treaty obligations to her East European allies – allies who were, in Léger's view as in Berthelot's, essential to France's long-term security. From this he went on to propose to Barthou that France should sponsor Russia's entrance to the League of Nations, then sign a military pact with Russia, similar to France's pacts with Czechoslovakia and Poland. Then France would invite Germany to join what would in effect be an eastern Locarno: France would guarantee Russia against Germany and equally Germany against Russia.

Barthou listened to this with closed eyes – he was, said Léger, 'the best listener I have ever known'. It seemed to him to chime in admirably with the atmosphere of Cocherel. Léger's plan was indeed worthy of Briand: collective security extended eastwards. 'Hitler,' said Barthou, 'will find himself encircled or obliged to join in our system.' That system, moreover, as Léger pointed out, might later be extended to all the Balkan states, with a benevolent Russia effectively taking over from France the defence burden in that region.

Barthou approved and saw only one obstacle. The British did not share the French public's view of the Soviet Union and her government, and would oppose her admission to the League. 'First I must convince perfidious Albion!' he said. 'And it won't be easy.'

The two returned to Paris from the political pilgrimage. Léger initiated negotiations in Geneva and with the Soviet ambassador in Paris. With Barthou he went to London and began trying to persuade Britain to waive her objections. Then Barthou, eager to prove he had the energy of someone half his age, set off on a busy round of visits to Central and Eastern Europe, trying with indiffe-

rent success to convince them that France was not handing over to Russia her solemn obligations.

In midsummer Barthou decided to extend southwards France's East European alliances. He envisaged a mutual defence pact between France, Italy and Yugoslavia. This plan was put to King Alexander of Yugoslavia, who received it with scepticism, for he believed Mussolini would demand disputed territory in the Trieste region as the price of a pact. In order to allay his doubts Barthou invited the King to make a state visit.

The King was a steadfast, studious man of forty-five who had managed to quell bickering between Serb and Croat in his unruly new realm. Like Barthou, he was a great reader. Landing at Marseille on 9 October 1934, he drove with the Foreign Minister in an open car down the Canebière, preceded by mounted Gardes Mobiles. Policemen lined the route facing the crowd. In front of the Bourse suddenly a tall, heavily built, poorly clad man succeeded in breaking through the cordon. A colonel, on the left of the car, tried to ride the man off, but the assassin was already past him and on the running-board. He was armed with an automatic rifle, fully loaded.

As the man came across, the colonel slashed down at him with his sabre and the man rolled on the ground, but not before he had fired ten shots into the car. While on the ground he continued firing, wounding two spectators and another policeman. He also tried to kill himself by firing a bullet into his mouth but was prevented by a policeman.

Meanwhile the car drove on to the prefecture. The King had fainted and Barthou was covered with blood. Doctors were hastily summoned. They could do nothing for the King, who had a bullet close to the heart, but they took Barthou to hospital, where they busied themselves with setting a fracture of the arm, overlooking the fact that an artery had been severed. Barthou died soon after.

The assassin was a Croat belonging to the secret terrorist organization Ustasha, which received encouragement from Italy. He succumbed to the sabre wound.

Into this tragic incident much can be read. Men of good will who sought to paste a tidy arrangement of treaties, pacts and other paper solutions over a turbulent area of Europe had been foiled by an upsurge of hatred and violence, while Barthou's fate, in which a

minor wound was attended to while a terminal wound was ignored, poignantly symbolizes muddled priorities in foreign policy.

The assassination of King Alexander effectively ended French attempts at a multiple defensive alliance in the Adriatic, while Barthou's disappearance brought to the Foreign Office Pierre Laval. Laval disliked Léger. Though favouring close relations with Russia, he did not share Léger's hostility to Hitler or his admiration of England. He immediately tried to remove the Secretary General. Léger, however, had in the past two years proved himself an energetic and considerate chief, and above all he had come up with the Russian card. No one save Laval wanted him at this delicate juncture to go.

So Léger retained his post and though he never liked Laval – few did – managed to work with him. He pursued the policy outlined at Cocherel. Britain having waived her objections, Russia was duly admitted to the League, and on 2 May 1935 France and Russia signed a treaty of mutual assistance within the framework of the League. This meant that if either were attacked, military assistance by the other must first be approved by the League.

On 15 May Léger and Laval arrived in Moscow to iron out details relating to the pact and at the welcoming dinner in the Kremlin a curious incident took place. After each of the numerous toasts, Léger noticed that Stalin's glass was refilled from a special decanter, and that Stalin showed no signs of being tipsy. Léger for his part, forewarned by Embassy staff, discreetly tipped his vodka on to the floor. On one such occasion Stalin saw this. After a moment the Russian leader rose. Having already honoured the head of the French delegation, he now proposed to drink to Léger.

In replying, the Secretary General thanked Monsieur Stalin for his gesture and requested him to extend his favour yet further by allowing him to fill his glass with vodka from his private decanter.

Stalin looked annoyed; after a pause he granted the request. 'We raised our glasses and drank,' Léger later recounted. 'It was water. Naturally I said nothing.'

Léger glimpsed another side of Stalin when the Russian put questions about the state of France's arms factories. Laval said production was satisfactory except in the aircraft industry, where

Communist shop stewards prevented overtime. 'Why don't you shoot them?' snapped Stalin. Then, noticing the Frenchmen's shocked expressions, he added, 'But if you quote me on that, I'll issue a categorical denial.' Then, turning to his interpreter, he told him to forget what had been said, otherwise *he* would be shot.

Back in Paris, Léger said to Crouy-Chanel, 'My diagnosis of the Soviet Union is middling, my prognosis favourable,' a remark which seems to reflect Herriot's opinion rather than his own on-the-spot observations.

Léger followed up the Franco-Russian pact by arranging a similar pact between Czechoslovakia and Russia. He believed he had thus effectively shifted French responsibility for the safety of that country to her. The same could not be done with Poland, with her traditional fear of Russia, but in 1934 Poland had signed a non-aggression treaty with Germany, and this appeared to rule out any future call for French aid.

Léger had played his Russian card and to a large section of French opinion seemed to have won the trick. France now had a powerful new friend and had shifted to that friend the main burden of her alliance with Czechoslovakia. Hitler was known to be re-arming but in spring 1935 France could now afford to feel secure.

There were those, however, who saw in the bold new arrangement a flaw as serious as that in the Maginot Line. If Russia were attacked by Hitler, French troops could cross straight into Germany, but if France were attacked, Russia could not send troops into Germany. Poland lay between, and Poland refused to sign any agreement for the passage of foreign troops. For the next four years the French ambassador in Warsaw would hammer away, trying to overcome resistance on this point.

15

FRANCE REFLECTED

While the strength of a country may be measured by collective security pacts and modern defences, it lies even more in national morale. We have seen Parisians at work, producing much that is admirable, and at play, making the most of the present. But when they paused to reflect on the nature of their society, what sort of opinion did they form of it? In answer we may turn to certain writers, novelists in particular, who as so often in France had their fingers on the moral pulse and the ability to express boldly what for others were mere intimations. A distinctive tone is observable from the mid-1920s, gathering strength in the early 1930s.

The first of these writers in point of time, François Mauriac, was born into a well-to-do family of the Landes. He attended the University of Bordeaux, and joined Marc Sangnier's Catholic movement to help and educate the underprivileged. Deciding on a literary career, he went to Paris, where he published elegant, slightly precious poetry. After service in the war as an ambulanceman he married for love a girl of his own milieu and began writing novels. Tall and slim, with a face by El Greco, he attracted his share of would-be Egerias. Finding fidelity within marriage an almost impossible ideal, on this point in 1927 he virtually lost his faith, but was rescued by an intelligent though prickly priest, the abbé Altermann, who took him for retreats to Solesmes and Lourdes. Thereafter he became one of the leading spokesmen of conciliatory Catholic opinion on public affairs.

As a novelist Mauriac chose to reveal the truth behind certain hallowed bourgeois conventions; in *Genitrix* it is the mother-son relationship. Félicité Cazenave lives with her only son, Fernand, at

fifty still a mother's boy. She treats him as none too strong, supervises his diet, sees that he does not get overtired, tucks him into bed last thing at night. If he wants to smoke, he has to do so secretly behind the garden hedge. Once a month he visits a brothel, returning, she is glad to see, tired. He enters local politics, but at his mother's insistence withdraws. He has spurts of anger against her, accuses her of preventing him marrying. But she laughs at the notion that he could ever take a wife.

An insignificant schoolmistress, Mathilde, shows interest in Fernand. Not in love with her, but sensing a possible ally, Fernand marries Mathilde. It is a mistake. The strong mother slowly excludes the less strong wife. Fernand moves back to his bachelor bedroom, next to his mother's.

Mathilde gives birth to a stillborn child and contracts puerperal fever. Félicité, listening at her door, hears the sick woman's teeth chattering but returns to bed without calling the doctor. Mathilde dies.

Looking at his wife's face, peaceful in death, Fernand thinks she might have been peaceful in life if he had behaved better. He starts sleeping in the bed where she died, visits her grave. He accuses his mother of having killed Mathilde by her hostility. She replies that he is as much to blame as she. In a fury he thinks of striking her, then breaks down and sobs 'Maman!'

Félicité dies. Fernand finds that the love he felt for his dead wife has disappeared; it arose only as a way of hurting his mother. Now that she has gone he finds he has nothing more to live for. On the last page, he turns to the aged family cook, letting her stroke his bent brow.

In *Le Nœud de vipères* Mauriac presents an outwardly more normal family. The father is a rich successful lawyer with a capable wife and several grown-up children. Socially, he is beneath her. He discovers that she secretly despises him and has married him only for his money. Moreover, she monopolizes the children's affection and the situation is compounded because they, as Catholics of the bigoted variety, look down on him, a free-thinker. As he grows old, his children, hoping for large legacies, pretend an affection for their father which they do not feel. He retaliates in the only way open to him, by carefully arranging his financial affairs so as to leave them penniless.

In *Le Baiser au lépreux* Mauriac extends his exposure of bourgeois society to the clergy. Jean is physically unprepossessing and sickly, scion of an inbred and degenerate family, but bearing a name esteemed locally. Noémi is the obedient, religious daughter of parents from a lower social stratum who seek to move upward. When Jean shows signs of being attracted to Noémi, they encourage the relationship. Noémi feels pity for the young man but is repelled by his physique. As her mother presses her, she turns for guidance to her parish priest. More from desire to oblige important parishioners than on the merits of the case, he advises her to sacrifice her feelings and marry.

Jean is in love with Noémi but unable to consummate the marriage. Their bed becomes a nightly hell. Noémi experiences the torments of sexual frustration, of resentment, and then of shame at feeling resentment.

Jean's father falls ill and Noémi nurses him back to health. Then Jean contracts an illness to which, neurasthenic and seeing himself as a failure, he presently succumbs. As he buries the young man, the priest wonders for a moment whether he gave Noémi the right advice. But meeting her, he praises her Christian self-sacrifice. She walks off into widowhood and a daughter-in-law's life of service.

Though he set his novels in the provinces, because there 'they still believe in good and evil,' Mauriac's target was equally the Parisian society in which he lived and moved. Cocteau and Ravel, to name only two, were hobbled for life by doting mothers, while very frequent among Mauriac's acquaintances was the breakdown of a marriage arranged for gain or status.

Cocteau considered Mauriac's talent second-rate 'because he has checked his appetites'; the abbé Mugnier, while recognizing genius, deplored Mauriac's view that one is never sure of being saved, that life is a perpetual question-mark: 'I think this absence of serenity in Mauriac's novels is un-Christian.' However that may be, few would deny their concentrated power or their author's sincerity. His portrayal of bourgeois Catholicism as bigoted, narrow and hypocritical shattered some of society's facile smugness.

Another who depicted the society of his day in dark colours was Georges Bernanos. Born in Paris in 1888 to a father who ran a small interior furnishing business and a mother from a peasant family in

the Indre, Bernanos attended the College of the Immaculate Conception, where Charles de Gaulle was in the class ahead, and where religious instruction was given by Jesuits. From his father, a monarchist, he imbibed a lifelong love of olden-days France, its strong faith, chivalry and deeds of daring. He thought of becoming a priest but, finding he lacked a vocation, decided to work, as an active layman in parish life and by his pen, towards a renewal of Catholic values.

Bernanos joined the Camelots du Roi, a monarchist association, and took part in their demonstrations against anti-clerical government decisions, and he wrote for their periodicals. A burly man with a big head, olive complexion and dark eyes, he proved fearless in street scuffles. Then came the war, in which he served all four years as a private in the dragoons, was wounded and mentioned in dispatches. He married a girl from a bourgeois Rouen family with the evocative name of Jehanne Talbert d'Arc, and on demobilization became an inspector for the Nationale insurance company, writing in his spare time.

Bernanos felt sickened by the tepidity and rose-water devotion of France, the so-called 'eldest daughter of the church'. For this war veteran life was a battle between good and evil – critics accused him of being a Manichaean; if we want to win we must fight temptation day and night – especially at night – and be prepared to suffer.

In *La joie* it is Chantal, a girl in her twenties, who suffers. Her widower father, for whom she keeps house, is concerned only with his prestige as a second-rate academic writer and his impending remarriage to a wealthy widow. Without asking for references, he unwisely engages a Russian chauffeur with a shady past. The chauffeur, a 'motiveless malignity', conceives a hatred of Chantal because of the goodness she radiates. He seeks to corrupt her and when he fails spreads lies about her. The novel is a record of how Chantal faces up to her mental suffering, and here Bernanos drew on the diary of Ste Thérèse of Lisieux. The novel ends with the chauffeur's suicide.

La joie was remarkable at this period because it shows evil not just as privation of good but as an active force that can thrive only by seeking to corrupt and destroy goodness. A similar awareness of the power of evil pervades *Journal d'un curé de campagne*. A young

priest of peasant origin comes to a poor country parish, full of zeal but weakened by a painful stomach ulcer. He has to fight tepidity and torpor among his flock; even his sacristan turns out to be an unbeliever. In the nearby château he finds a poisonous atmosphere, for the owner chases local girls while his wife plays the martyr. The curé discovers that it is the wife who is at fault. She has become embittered and closed because she cannot forgive God for the untimely death of her little son. While struggling against his own temptation to despair and the onset of cancer, the young priest slowly brings the châtelaine to face up to her true self, and to accept that her spiritual life is being destroyed by rancour.

Catholic writers were by no means alone in savaging the smugness so prevalent in the 1920s. André Gide as he grew older re-examined his teaching to the youth of France: 'Discover your self and then, whatever society may say, follow its bent.' His plotless novel of 1925, *Les Faux-Monnayeurs – The Coiners* – investigates that question through the interaction of a heterogeneous group of Parisians modelled on Gide himself, Cocteau, Marc Allégret, Madeleine, and his English translator, Dorothy Bussy. Near the beginning one of the young protagonists declares to the woman he loves: 'I should like, all my life, whatever the circumstances, to ring true, pure and authentic. Nearly all the people I've known give out a false note.'

The novel depicts a diversity of 'coiners': fashionable artists who play to the gallery; doctrinaires, people 'all of a piece' who have shut themselves up in a system and stopped growing; the devout, 'for the more a soul steeps itself in devotion the more it loses the sense, the taste, the need, the love of reality.' But are these the only coiners? One by one Gide lets us see that the best among his characters to a certain degree ring false. One wants to be liked, and so shows only his good side. A second emits false opinions in order to elicit and show up others' falsity. Even the elderly, most lucid character, Edouard, a compulsive diarist who represents Gide, finds that introspection erodes an essential element in sincerity, namely spontaneity: 'I think, therefore I cease to be what I might have been.'

In place of his earlier bubbling hedonism Gide declares that he has found himself left with lucidity alone, but a lucidity that conforms to Heisenberg's uncertainty principle, since it falsifies all it touches.

Gide was here rigorously pursuing his chosen path of self-discovery, but for young people who had earlier been promised by him that following one's own bent would ensure an integrated and joyful life, the negative implications of *Les Faux-Monnayeurs* came as a severe jolt.

Another of the post-war hedonists, Paul Morand, also moved towards a less optimistic view of society. In his 1934 novel, *France La Doulce*, – an ironic allusion to gentle old-time France – Jacobi proposes to make a film starring a Spanish Bourbon and a Comédie Française actress. He forms a company with a Romanian, a Greek and a Breton nobleman, M. de Kergael, who is persuaded to put up a million francs by selling some land, the other million to be provided in the form of bonds by equipment-makers, studios and the like. Kergael proposes the subject: the Chanson de Roland, and the title, *France La Doulce*. Jacobi chooses as director a famous German, Max Kron, but Kron cannot be found.

An unemployed man-of-all-film-work, also with the name of Max Kron, arrives in Paris from the United States. Jacobi meets him by chance and, believing him to be the famous Kron, signs him up.

Kron begins filming in the Pyrenees. After five weeks he has shot only fifteen minutes of film, and spent four millions. The company goes into liquidation.

Maître Tardif, a Breton notary, arrives in Paris to retrieve Kergael's money. First he sees a M. Bergmann-France, head of Banque Isaie, and finds himself faced with promissory notes 'covered with as many foreign signatures as a wall of Pompeii with graffiti'. The banker explains that most of those responsible have vanished or changed their names. In the film world 'there is only one honourable status: that of debtor. The ideal is to be 200 millions in debt; then they say your business is of national importance, and you're saved. The State intervenes, the bankers are told to refloat you, the taxpayer pays and everyone is happy.'

Tardif discovers Kron's role in the affair and persuades his friend, the Minister of the Interior, to deport him to the United States. In New York Kron finds powerful backers and proposes to buy back the film on condition that he is repatriated to France. The film, completed by a new director, is the success of the Paris season and makes money for everyone except its original backer.

What a change in Morand's view of Paris! No longer does he see his home city as the fountainhead of art and wit. Its prestigious poetic films about French life are churned out by foreign directors backed by Jewish financiers who change names more often than actors. A Minister of the Interior is a mere weathercock, while the first performance of *France La Doulce* is attended by the Prime Minister, seated next to Kron. Art has been replaced by shady business, backed by shifty politicians.

That we are dealing not with isolated cases of disillusionment but with a more general phenomenon becomes likely when we look at the most gifted of the younger playwrights. Jean Anouilh, the son of a tailor, received his schooling in Bordeaux in the late 1920s, imbibing in his philosophy class the post-victory vogue message that men are moving reasonably and irreversibly towards a more generous, fraternal society. On leaving school Anouilh found himself in a ruthless world of hard-pressed small businesses, fast dealing and trickery. In 1932, when he was twenty-two, he startled Paris with *Le Bal des voleurs*.

The scene is Vichy. Three confidence tricksters, posing as a Spanish grandee and his suite, talk their way into staying in the home of a titled English lady. She knows the grandee in question died some years before, but, bored with her doddering lover, she finds the situation amusing and pretends to be taken in. Meanwhile two shady financiers also frequent the house, bent on marrying the lady's rich nieces. The younger niece, Juliette, is sweet and innocent; she falls in love with the youngest of the thieves, Gustave. Everyone except these two go off to a fancy dress ball. Juliette discovers Gustave stripping the house of its valuables; he ties her up; when she tells him she loves him he frees her and agrees to let her accompany him.

The others return early from the ball. The burglary discovered, they call the police who by mistake arrest the shady financiers. In the last scene Juliette prepares to follow Gustave, accepting that he will continue his life as a confidence trickster.

At surface level it is a first-rate farce, which Feydeau might have enjoyed, but beneath it is an elegy for lost innocence.

All the characters but one in Anouilh's play are rogues or pretenders. We live, the dramatist is saying, in a society of imposture:

everyone is pretending to be someone else, and even the idealistic young have to end by joining in the game.

The most powerful and sweeping portrayal of the defects of French life came from Céline, nom de plume of Louis-Ferdinand Destouches. Born in 1894, he was brought up in a flat in the shopping arcade called Passage de Choiseul, where his mother kept a lace shop, while his father went to work in the Phénix insurance offices. They were typical petits bourgeois, happily married, unadventurous, thrifty, Destouches père like many of his social group blaming the Jews for the failure of small businesses to compete with the large. They made sacrifices so that Louis, their only child, should receive the best schooling, including long stays in England and Germany to learn the languages.

Céline's curriculum vitæ merits attention because its main elements will reappear in his novel, but transformed as though by the brush of Bosch. In the hope of becoming a buyer, he started earning his living in the jewellery trade; then, at eighteen, on a sudden impulse he enlisted for three years in a cavalry regiment. When war came, during the eighth week he got a bullet in the right arm which fractured the bone. After hospitalization he received his discharge. In 1915 he was in the visa department of the consulate in London, where he haunted the docks and Soho. A registry office marriage to a Soho tart lasted only a few weeks. He sailed for Cameroon, where briefly he managed a small cocoa plantation, then fell ill with chronic enteritis and returned to France. The armistice found him lecturing in Brittany under the auspices of the Rockefeller Foundation on the prevention of tuberculosis. He there met Edith, daughter of the head of the medical faculty in Rennes, Athanase Follet.

At this time, aged twenty-four, Céline was a presentable broad-shouldered fellow with thick sensuous lips and most attractive lively eyes of a changeable blue. He was intelligent and an excited conversationalist, carried away by language, but many of those who met him were put off by a tendency to mock and in any situation to seek out the unpleasant side. In a boyhood letter to his parents, for instance, he had described in detail and with gusto how during a rough sea passage a schoolgirl had been sick, and how her thick brown vomit ran down over her polished shoes.

Edith Follet found the young lecturer, with his colourful past, most attractive, and her distinguished father saw promise in him. Céline

responded in a predictable way to this attention from a family socially above him. In 1919 he married Edith, set up home in part of Dr Follet's house, began to study medicine and in 1924, having qualified, opened a surgery in Rennes.

Nineteen twenty-four marks the turning-point in Céline's life. He had an attractive wife who loved him and a sweet little daughter, Colette. With the continuing help and interest of his father-in-law, a bright career opened before him. Instead of taking that road, he set off alone for Geneva, where he found a desk job in the League of Nations' Public Health Department.

In reply to her repeated pleas to be allowed to join him, he wrote to Edith:

> It's impossible for me to live with another person. I don't want you dragging behind me, snivelling and miserable. You bore me, that's the truth. Don't hang on to me . . . I want to be alone, alone, alone, not bossed around, not tied to apron strings, not loved – just free. I detest marriage, I abhor it, I spit on it; it feels like a prison.

Not a word about what Edith might feel, not a word of apology for the pain he was causing her. He never rejoined his wife, and divorce soon followed.

In 1928 Céline settled in Clichy, a poor district of Paris, where he opened a surgery. To his patients he prescribed a healthy diet rather than medicines. This did not go down too well, and they gave him the nickname, '*Pas de café, pas de vin*'. Unable to earn a living in this way, he took a paid job at Clichy Dispensary. Here he quarrelled continually with his boss, a Lithuanian-born Jew with Leftist opinions.

His spare time Céline spent with a truculent Breton alcoholic, Henri Mahé, and his wife Maggy, who lived on a small houseboat. Mahé painted erotic murals for sleazy night clubs and gathered around him a colourful group of vagabonds, prostitutes, down-and-outs, petty criminals, each with some horrific story to tell in colourful slang. They were greatly to Céline's taste.

He formed a liaison with a tall red-haired American dancer, Elizabeth Craig, who was often away on tour or visiting her family and so did not make demands. 'Basically I am a voyeur,' he confided to a friend, 'though from time to time, discreetly, I enjoy indulging

myself.' He now knew that he preferred good-looking women with lesbian tendencies, since they did not tire him with sexual demands. In 1933 Elizabeth, finding him unbearable, ended their relationship.

Céline began to spend his evenings putting on paper scenes from his life in the language, laced with slang, used by his low-life Paris friends. As pages piled up, a long autobiographical novel took shape and became more important to him than his work at the dispensary. It was published in December 1932 under the title *Voyage au bout de la nuit*.

This picaresque book, following roughly the course of Céline's life, is in four main parts. In Part 1 the protagonist, Ferdinand Bardamu, is a reluctant soldier in Flanders, a coward who admits his cowardice to himself, his one aim to sustain a minor wound which will get him into hospital. He feels no hatred for the enemy and cannot comprehend why he is expected to kill them. His officers are depicted as stupid, self-satisfied jingoists and to Bardamu their tenacious efforts to advance the French line by a stone's throw appear one more form of a general madness. An officer in the moment of barking a fatuous command has his head blown off; wounded with their stomachs hanging out wait for stretcher-bearers who fail to arrive.

On leave in Paris Bardamu finds his former boss, a jeweller, paying lip service to the war effort while profiting from the black market. A café star, Musyne, by her patriotic songs makes men believe in heroism; meanwhile she makes a good living by obliging war-profiteering Argentinians.

What the war is to Part 1, the tropical climate of West Africa is to Part 2. Here, in the sweltering heat of a French colony, everyone is ill or about to fall ill. The wives of French officials suffer from irregular menstruation and consequent hysteria; sometimes several months pass between one period and the next. Their husbands are sapped by malaria and dysentery; the natives have festering ulcers or swollen limbs. Bardamu takes work on a plantation but again finds himself a victim, this time of a colonial system that obliges him to pillage the blacks without benefiting the whites. But opposing the system would not help, for the blacks are deeply ingrained with masochism: one African walks through the bush for three days to be flogged. Society under the vaunted tricolour is no more than an extension of the cruel, debilitating, eventually destructive heat.

Part 3, an unconvincing account of Bardamu's misfortunes in industrial Detroit, does not concern us here. Part 4, comprising all the second half of the novel, is set in the Paris suburb of Rancy, populated by murderers, abortionists and wife-beaters. Here Bardamu, who has a medical degree, opens a surgery. But he observes rather than treats the sick. Many are suffering from malnutrition, alcoholism, tuberculosis and advanced VD, and no medicine on his shelves can cure them. In one episode, he is called in to find a young woman who has aborted her child. Blood is oozing from her womb and dripping through the bedclothes on to the floor. Bardamu suggests moving her to hospital, but the girl's mother forbids this, fearing the disapproval of neighbours and legal charges. Bardamu weakly acquiesces and the girl dies.

Bardamu links up with a former comrade, Robinson, who is mentally sub-normal. The couple with whom Robinson lodges wish to evict a grandmother who occupies a shack in their back garden which they wish to repossess. When she refuses to leave, they persuade Robinson to put a bomb near her shack. He bungles the business and badly injures his arm.

Bardamu takes a job in a mental hospital, while continuing to look after Robinson, who has reluctantly agreed to marry Madelon, a predatory young woman from Toulouse with a little money. Robinson proves less than an ardent lover; relations between him and Madelon deteriorate. After a hectic, quarrelsome evening in a fairground they get into a taxi. There Madelon taunts him with lack of virility, and is accused by Robinson of dressing up sexual appetite as love. When he tells her he intends to end the affair, Madelon shoots him dead. After giving evidence at the police station, Bardamu resumes his job in the mental hospital.

A picaresque novel is not impressive in summary, indeed much of the story is a mish-mash from some of Clichy's nastier police medical reports. It is made convincing by Céline's wholly original style. He has written the novel as though talking to the reader, in a clipped, racy idiom, with few abstract nouns, much slang and many hard tactile or visible images. This gives needed unity and makes improbable events appear authentic.

Writers in the past had written with loathing of this or that aspect

of France. Céline is the first to have attacked everything without exception on his horizon with a fury that makes Zola seem rose-water: the war, the peace, all ranks of society including the poor, the French empire, modern technology, the clergy, welfare schemes; and to have depicted his country as a cesspool of senility, physical illness, mental disorders and sexual cruelty as revenge by one party for the failure of the other to fulfil dreams.

But the most original feature of *Voyage* is the protagonist's passivity – a passivity mirrored in the writing, which demotes the subject to the end of a sentence. Bardamu makes no attempt to remedy the misery he meets, and this from metaphysical motives. There is nothing to be done because nothing *can* be done. The flaw is not outside, it is within. The great illusion – the illusion of all -isms – is that men are victims of fate. They are not. They are their own executioners. There is no helping them – or indeed oneself – for the self is deeply flawed and untransformable. In this context hope becomes the ultimate betrayal of truth.

'God is a pig,' says Bardamu in the opening pages, echoing André Breton, and the book implicitly unfolds that charge. Man finds himself moving inexorably towards physical decrepitude, suffering and death, which is the end. There is no redemption, no hereafter. Life is a succession of days of lonely misery, from which the only escape is hatred. In Céline's case, the book in the reader's hands.

Before considering the influence of *Voyage* it is worth asking how Louis-Ferdinand Destouches, who as a boy was loved by caring if intellectually limited parents, who enlisted from choice and rose to be sergeant, who was helped through medical school by an eminent doctor and accepted as one of his family, who in Geneva again received preferential treatment from a kindly superior – why such a man should have turned into Céline, a writer more pessimistic even than Kafka at his most forsaken? The answer perhaps lies in his inability, in Rennes, to assume his responsibilities as husband and father, his choice always of subordinate posts, his voyeurism. Céline surely recognized the weakness, the inadequacy at the heart of his own character, and in default of curing it, chose to transform a defect of spirit into a metaphysic, his private abyss into a general hell.

Céline's *Voyage* received the Renaudot prize, which ensured big sales, and since it is a book that haunts the memory it marked Céline's

contemporaries. A financial success always finds imitators, of whom one was Jean-Paul Sartre. Another pampered only son who became bitter on finding that the world did not particularly like him, he was to publish in 1938 *La Nausée*, with an epigraph from Céline's *Voyage*: the diary of a writer who goes for research to a dim, boring provincial town, ending with a Céline-like conclusion that to present life in the form of a narrative is always to falsify it, since life is composed of discrete actions which lead nowhere and have no order.

Though there is space here only to mention them, it has to be said that the poets added their voices to the new mood. The most gifted, such as Reverdy, Fargue, Char, appeared in the *Nouvelle Revue Française*, then in an anthology from that periodical published in 1936, prefaced by Valéry. Desnos, one of the contributors, reviewed it in these terms: 'Open the book at any page, including mine, and you are sure to find a stock of tears, sobs, melancholy, despair . . . It is not an anthology, it is a firm of undertakers.'

Quite as striking as their common disillusionment with certain aspects of France is the diversity of the authors' presuppositions. Mauriac and Bernanos write as Catholics, Morand and Gide as hedonist-humanists, Céline and Sartre as atheists, seeking to spread an anti-Gospel, the new Bad News. One such author could be dismissed as idiosyncratic, but not all.

Many English writers savaged social conditions in England while having little effect on the population at large, but the French appear to be more deeply stirred by the arts.

The Paris of Chevalier's songs, Clair's films and Guitry's comedies was also a literary city, attaching importance – perhaps undue importance – to new books and according gifted authors the status of guru. The more reflecting Parisians took seriously these new publications, some of which were masterpieces. *La-vie-en-rose* Paris continued in buoyant being – it had its regular customers and its own momentum – but side by side with it now we find a mood of disillusion. Victory had not, after all, changed the nature of man. As Jean de Pange noted in his diary: 'Until 1928 I was an optimist; now, in 1932, I find myself a pessimist.'

The two sides join in one of the most popular songs of the mid-1930s. A butler is telephoning to his absent lady employer. Her favourite grey mare, he tells her, has died. 'How did it happen?' 'The

stables caught fire.' 'How did they catch fire?' 'Because the château burned down.' And so on, until the butler informs his lady employer that Monsieur le Marquis has committed suicide. But after each item of news the butler adds consolingly: '*Mais à part de ça . . . tout va très bien, madame la marquise*' – which is the song's title.

Books such as those we have looked at which emphasize faults promulgate an attitude of fault-finding. From the early 1930s it is remarkable how petty crimes, impostures, robberies and frauds which formerly received scant notice are given banner headlines. Even serious newspapers begin to read like sleazy police magazines.

In 1928 Marthe Hanau, a dumpy woman in her forties with a double chin and a man's haircut, bought for a song a financial rag, *La Gazette du franc*. Posing as a champion of a strong franc, she solicited and obtained letters of encouragement for her paper from Poincaré, Herriot, Briand, Barthou and Cardinal Dubois, archbishop of Paris. Madame Hanau reproached big business with giving too little information to the public. She proposed to remedy this, to guide the small saver, in short to democratize capitalism, a worthy aim.

But to inform the public about shares requires a scrupulous honesty that was lacking in *La Gazette du franc*. Soon, in return for bribes, it was advising readers to buy shares in risky or nebulous companies with seductive names, not quite Greenland Oranges or Nougat Mines of Mozambique, but almost. *La Gazette* also offered small savers a highly attractive 8% interest, paying the first comers with money from the next lot of savers.

With respected if gullible men on her board, Marthe Hanau did well with her schemes until 1934. Then she was found out and many lost their savings. It was a minor affair, though not unique, but Marthe Hanau's arrest, trial and eventual suicide in prison made the front pages, dramatized as in a Mauriac novel, accompanied by editorials bemoaning 'the wave of corruption sweeping our poor country'.

This was part of the rise of the tabloids, and can be paralleled in England and America, but not in Germany, where Goebbels had a stranglehold on the press. Inevitably it had its effect on the nation's morale. Becoming disillusioned with France as depicted by the new gurus and large sections of the press, many thinking people turned to some form of alternative France. Their choices and the division these entailed form the subject of the next chapter.

16

POLES APART

The earliest group to express dissatisfaction with France, the Surrealists, had tried to overthrow bourgeois culture with shock tactics: the surprises of premonitory dreams, of predestined coincidences, of automatic writing, of jangled syntax and so on, to which after a meeting with Sigmund Freud, André Breton added a large dose of Freudian theory. Bourgeois culture proving disappointingly resistant to such attacks, Breton committed himself to Marxism. Though he and the few who followed him into political action did not deal directly with strikes or barricades, they worked tirelessly for the overthrow of French society as it then was, capitalist at home and 'imperialist', to use the Marxist term, in its possession of colonies.

Breton found in the Russia he read about in Marxist pamphlets and articles by fellow-travellers the society he wished to see in France: bourgeois morality and religion swept away, private property abolished and a high status for writers, 'engineers of the soul', according to Stalin. A society open to the future, with all that implied of unexpectedness.

Breton founded a new periodical, *Le Surréalisme au service de la révolution*, published from 1930 to 1933, to purvey these political views. He called for a revolution that would end all constraint upon human beings: 'Open the prisons, disband the army, free mental patients.' Max Ernst contributed an article, '*Danger de pollution*', ridiculing the Church's attitude towards sex, Sadoul's '*Le bon Pasteur*' depicted the soldier-priests fighting in the trenches for France and Church as bloodthirsty monsters. On international affairs Breton held a view, common in England, that Hitler's rise to power was really the fault of France, which by its intransigent politics and

maintenance of the Treaty of Versailles had caused the anguish from which the Führer emerged.

Breton was pressed by Marxist friends to go the whole way and rejoin the Communist Party. But Breton had always been careful to preserve his freedom of action, both as a writer and in his married life. Ever since founding *Littérature* he had put personal liberty, welling up from his imagination, at the top of his list of principles. He refused to rejoin a Party which would tell him what to do and write; nevertheless he continued to work for a new France modelled on Russia.

By adopting Marxism Breton lost some of his followers, notably Max Jacob, who now lived in the precincts of a Benedictine monastery, making periodical visits to Paris wearing the high stiff collar, black tie, long jacket and bowler hat fashionable twenty years earlier. Breton wrote to Jacob in angry terms, denouncing him as a renegade and sneering at his penitential life, while getting his colleagues to ply Jacob with anonymous insulting letters. These caused distress to the ageing poet. 'All the Surrealists are my children,' he complained to Maurice Martin du Gard. 'They rifled my Montmartre manuscripts; they stole all my puns, and now they are hounding me to death.' It is interesting that Breton denied to his former friend the very freedom he demanded for himself.

Another backslider to incur Breton's anger was Salvador Dali. The painter felt no sympathy for Communism – later in life he was to solicit and obtain the title of Count – and in February 1934 he exhibited a painting that shocked even those who were accustomed to the Spaniard's excesses. Under a red herring title, *The Riddle of William Tell*, it depicts Lenin on his knees, with bare buttocks, one monstrously elongated like a baguette extending the whole width of the picture, and supported by a crutch. Breton, furious, issued an order of the day accusing Dali of being counter-revolutionary and proposing to 'exclude him from Surrealism as a Fascist sympathizer and to fight him by every means'.

Eluard and Tzara, then in Nice, intervened in favour of Dali, while urging the painter to moderate his views. On the evening of February 5, convened to Breton's apartment, Dali arrived by car, driven by Gala. He had a heavy cold and wore layers of shawls; from his mouth protruded a thermometer, which he was to consult

intermittently when the argument grew heated. Breton having summarized the charges against him in his heaviest inquisitorial style, Dali defended himself. True, he had made witty remarks in public about the new regime in Germany, but that was because he considered Hitlerism a form of paranoia, and he suggested the Surrealists should issue a text to that effect. Then he explained that as a painter he tried to reproduce his dreams as exactly as possible, without passing moral judgement. He had painted Lenin as he saw him; he would do the same if he dreamed of sodomizing Breton – 'I advise you not to do that,' said the older man in reply.

Removing his shawls one by one, then his shirt, bare to the waist Dali then went down on his knees in front of Breton and begged his pardon. This was Surrealism at its wildest, but Breton did not laugh. Out-manoeuvred, he deferred judgement and sent the painter back to his sick-bed.

Louis Aragon, who had a more adaptable character than Breton, was one of the first Surrealists to join the Communist Party. He went several times to Moscow and, influenced by his new Russian Communist wife, Elsa Triolet, became one of the most listened-to propagandists for Russia and for Communism. In 1931 he published a shrill angry poem, *Front Rouge*:

> Shoot Léon Blum
> Shoot Boncour Froissard Déat
> Shoot the trained bears of social democracy . . .
>
> Glory to dialectical materialism
> and glory to its incarnation
> the Red
> Army.

Indicted on charges of incitement to murder and of provoking insubordination in the army, he narrowly escaped imprisonment, thus adding to his aura with the faithful. He also came out firmly in favour of the Communist line that the only literary form suitable to a Communist is socialist realism. In 1932 Breton broke with Aragon partly on this point, accusing him of betraying the cause of artistic freedom by voluntary servitude to a political ideology.

In 1931, in the Bois de Vincennes, Paris staged a Colonial

Exhibition, complete with replicas of pagodas, a Moroccan kasbah and the temple of Angkor, designed to show the benefits France, Britain, Belgium and other colonial nations had brought to distant parts. Breton published a tract calling for its boycott. He declared that Lenin was the first to understand that the colonial peoples were the natural allies of the proletariat, and that the exhibition was designed to service the purposes of the bourgeoisie:

> The presence of the President of the Republic, the Emperor of Annam, the Cardinal Archbishop of Paris, of several governors and old soldiers, opposite the missionaries' pavilion, and those of Citroën and Renault, clearly expresses the complicity of the entire bourgeoisie in the birth of a new and particularly intolerable concept: 'La Grande France'. It is in order to implant this swindle of an idea that the pavilions of the Vincennes Exhibition were built. It is a question of giving the citizens of metropolitan France the feeling of being properietors which is needed so they can hear the distant sounds of gunfire without flinching.

Colonialism was a simple and easy target. A more complex one arose in 1933 when the French Communist Party organized the Amsterdam-Pleyel Peace Congresses under the leadership of Barbusse and Rolland, in order to create a united front against Fascism. Breton distrusted Barbusse's and Rolland's brand of pacifist humanism and denounced it as counter-revolutionary. Instead, he proposed a new slogan: 'In response to the hypocritical imperialist formula, "If you want peace, prepare for war," we say: "If you want peace, prepare for civil war."'

Breton's intransigent militancy was endorsed by Paul Eluard. In a speech in 1934 to yet another group founded from Moscow, the Association of Revolutionary Writers and Artists, the Surrealist poet warned that in directing itself against Fascism in Germany, the French Left would be likely to find itself the tool of nationalism. It is important to remember, said Eluard, that it was imperialist France that had defeated the Spartacist revolution in Germany and supported White Terror in the Balkans, and – one rubs one's eyes in disbelief – that it was 'French imperialism which is responsible for that exacerbation of German nationalism confronting us today.'

Eluard pointed out that Fascism was not an isolated phenomenon, but that it tainted all Western countries, and he opposed the slightest resurgence of French 'nationalism' – the Communists' word for patriotism – even that implied by an appreciation of the unique qualities of French culture.

The attraction of Communist Russia for young men of sensibility, such an important factor in Paris intellectual life during the early 1930s, is well exemplified in Jacques Prévert. Born in 1900, Prévert grew up in a tiny, run-down Paris flat with two brothers, six cats and a songbird, where he early came to know the miserable side of the city, for his father earned a living visiting the very poor on behalf of a Catholic charity. By 1917 the War was beginning to be loathed by the poor of Paris. In that year Prévert watched troops on leave sympathetic to the mutiny walking through the streets singing the *Internationale*. Having heard the *Marseillaise* 'dished up with every imaginable kind of sauce' to palliate the status quo, he warmed to the *Internationale* and cheered the troops, whereupon he was picked up by the police, who planted a razor in his pocket and told him to sign a confession. When he refused they beat him up.

In the early 1920s Prévert lived in a Montparnasse hotel run by a close friend, Marcel Duchamp. In appearance Prévert resembled Buster Keaton, with brilliantined black hair combed straight back, bulging eyes with heavy lids, a Gauloise usually drooping from the corner of his mouth. His way of letting drop original or ferociously sardonic phrases with a straight face made him a popular figure with the rebels of his day. He held a childlike belief that life would be rosy but for politicians, archbishops, generals and the police. This belief he put into scenarios that no one filmed and into charming little poems, such as *'Quartier Libre'*:

> *J'ai mis mon képi dans la cage*
> *et je suis sorti avec l'oiseau sur la tête*
> *Alors*
> *On ne salue plus*
> *a demandé le commandant*
> *Non*
> *On ne salue plus*
> *a répondu l'oiseau*

237

Ah bon
excusez-moi je croyais qu'on saluait
a dit le commandant
Vous êtes tout excusé tout le monde peut se tromper
a dit l'oiseau.

I put my kepi in the cage
And went outside with the bird on my head.
'So, no more saluting?' asked the major.
'No,
'No more saluting,'
Replied the bird.
'Ah.
'Forgive me. I thought saluting was obligatory,'
Said the major.
'You're completely exonerated. Anyone can make a mistake,'
Said the bird.

In 1928 Prévert wrote the scenarios for *Souvenirs de Paris*, a short film shot by his brother Pierre: a tender declaration of love to the streets, bridges, quais, cafés of a city re-arranged according to his own ideas, where children don't go to school, there are no bosses, only artisans and artists working when they wish, and at every corner pretty smiling girls in cloche hats.

In the early 1930s, as disillusion with France as it was swept over the young, Prévert, with his strong social conscience and a sensitive poet's cringing from militarism, became a Communist. In 1932 he was one of the originators of the Groupe Octobre, a troupe of writers and actors modelled on the German groups Agit Prop and Piscator, who sought to promote revolution in France by performing satirical sketches for working-class audiences.

Prévert wrote two of the Group's most applauded satires. In *Le tableau des merveilles* a troupe of gipsy acrobats, tired of performing for a few coins, decide to put on a marvellous show which, they claim, will be visible only to notable people – well educated, clever men, faithful wives, good Christians. Others – the stupid and dishonest – however much they pay for a seat, will see nothing. The show of course proves a success: everyone claims to see marvels. But a captain arrives late and uninformed: he declares that he sees nothing,

whereupon the Prefect upbraids him: 'You see nothing because you are drunk and because you are certainly a bad Christian, an adulterer, perhaps a Jew . . . You must be, because you see nothing.' Under the direction of Jean-Louis Barrault, it was staged in 1935 in a Left Bank attic, and later performed before sit-in strikers in Paris department stores.

The other satirical sketch, *La bataille de Fontenoy*, starts from the famous scene of 1745 when the French and English commanders in turn offer to let the other side fire first; then introduces contemporary figures, among them arms manufacturers, the Belgian Schneider and the German Krupp, who exclaim: 'Monsieur le Président, we're very sorry, but the ammunition's got mixed up. It will have terrible consequences.' To which Poincaré replies with a smooth smile: 'No, no, it doesn't matter. French shells and German shells belong to the same family. You have only to share them out.'

The October Group had such success with *Fontenoy* they were invited to perform it in Moscow in 1933. Shown round a factory, they asked the guide how much a worker earned. 'Fifteen roubles.' A Russian-speaking girl in the Group quietly put the same question to one of the workers and was told, 'Five roubles.' The same girl spoke to an elderly man. 'Before, we didn't have much,' he told her cheerfully. 'Now, we don't have anything. But it all belongs to us.'

Stalin attended the performance, part of an 'Olympiad of Workers' Theatre', and as the Group prepared to sail home a Party member invited them to sign a document voicing approval of all Stalin's achievements. This they declined to do. But Prévert was to continue an unwavering supporter of international Communism.

In February 1933 literary Paris shook to the news that the unthinkable had happened. André Gide, who had never committed himself to any movement other than the subtle flow and ebb of his own mind, was now an avowed convert to Communism. At the age of sixty-three the most individualist and introspective of writers was hailing the Russia of workers' communes and agricultural cooperatives. So unbelievable was the news that the influential political commentator, Jean Guéhenno, himself a Communist, wrote in *Europe*: 'A man who is ageing and wishes to die young: there you

have Monsieur Gide. When death comes, he wants at all costs to avoid using the language of old age.'

How did the conversion happen and how sincere was it? Gide was living in a fifth-floor apartment in the rue Vaneau, from which, through a communicating door, he could enter the apartment of Maria van Rysselberghe, the Petite Dame, his companion and confidante. He saw Maria's daughter Elisabeth regularly, and his child by her, Catherine, now aged eight. He had a small circle of intelligent friends and as editor of the leading literary review and an adviser to Gallimard's publishing firm, kept in touch with the young. For relaxation he played Chopin and Bach on his piano and double patience with Maria.

Inwardly the picture was less satisfactory. The Protestant Christianity of his early life and which underlay his two masterpieces had crumbled, partly from prolonged hedonism, partly under the influence of Maria van Rysselberghe, for whom the spiritual world was a closed book. He had then pinned his faith on Sincerity, only to discover that even among close friends it proved unrealizable. In the late 1920s, suffering from a spiritual void, Gide projected his personal disillusionment on to his milieu.

In 1931 Gide was asked to write an introduction to *Vol de nuit*, a novel in which Saint-Exupéry described his dangerous life as a pilot for Aéropostale. Gide was deeply impressed by the book and its shy author. He astonished the Petite Dame by speaking wistfully about the desirability of finding fulfilment through a cause outside oneself.

In the same year Gide was lent a book describing in glowing terms the Soviet Five Year Plan. It was not the sort of work he usually read, indeed he had hitherto turned his back on foreign affairs. In 1923 the Petite Dame had noted: 'There is much talk about the occupation of the Ruhr. Gide finds it impossible to form an opinion on this subject, to see clearly, to believe what the newspapers say. He keeps repeating: "I put less and less trust in history."' Nevertheless, Gide read the book on Russia avidly, in two days, and was tremendously impressed. 'I should like to live long enough,' he confided to his Journal, 'to see the success of this enormous effort . . . see what can be achieved by a State without religion, a society without family life. Religion and family are society's two worst enemies.' He felt a strong urge to contribute to the success of these young Russians, 'educated

240

in a new morality', scrambling down a coal pit with no lift 'in their eagerness to help achieve the promised future'.

As Gide read further about Russia and spoke to Communists who had been there, his enthusiasm grew. He began seriously to consider writing a book about Communism. What deterred him was a belief that politics and fiction do not mix, as shown by the novels of Gorky and Romain Rolland's *Jean-Christophe*.

Gide was aware that many of the gifted young, such as Malraux, who had come to Communism via anti-colonialism, were also enamoured of Russia, but there is no need to believe that this was more than a minor factor in Gide's remarkable conversion. Questioned by his closest friend, Roger Martin du Gard, about his *volte-face*, Gide replied that his adhesion to Communism was '*amoureuse, sentimentale, par dégoût d'être du bon côté*'. As so often with Gide, his motives were both positive and negative. His Communism was an affair of the heart, but also a prolongation of his life-long scorn for conventional moral attitudes. In both respects he appears to have been perfectly sincere.

Gide's change of stance did not pass unnoticed. Ilya Ehrenburg, Paris correspondent for the Soviet Press, and his close friend, Paul Vaillant-Couturier, editor of *l'Humanité*, began to ply him with invitations to visit Russia, while a steady trickle of Communist refugees from central Europe made their way to rue Vaneau, where Gide, always generous towards the needy, put them up in a spare room, gave them money and helped them obtain work permits.

Gide now began to play an active part in politics. In 1933 and 1934 he took the chair at meetings of the Communist Association of Revolutionary Writers and Artists; he recorded a broadcast for Russia on the occasion of the anniversary of the Revolution; he inaugurated an Avenue Maxim Gorki in the Paris suburb of Villejuif, standing beside Maurice Thorez, ex-miner and now a Communist député. The usual Press photos of Gide were a familiar sight: high broad brow, intelligent bespectacled eyes, thin sensitive lips, the long head slightly tilted in an attitude of attentive non-commitment. But a photograph taken at the Villejuif ceremony shows a new Gide, chin thrust combatively forward, clenched fist raised in the Communist salute: a man worth more to the cause of French Communism than a dozen other writers.

*

The aim of the Communists was to remake France in the image of Russia, that is, to overthrow parliamentary democracy if necessary by action in the streets, to abolish private property, to outlaw the Church and to dismantle the bulk of the armed forces. In a period of national self-confidence such a threat could have been met by steady nerves, a reassertion of faith in parliamentarianism and the righting of social injustices. But we have seen that France, far from being self-confident, was edging towards self-doubt and self-laceration. The values of family, Church, big business, the army, the short-lived ministries of too-familiar faces that governed the country – these were being called in question. It seemed that there was no longer any firm high ground in present-day France from which non-Communists could defend themselves. And so the non-Communists, like their enemies, constructed an ideal country, this time a France patterned after one of the Frances of the past. They believed that only this ideal France, this better France in the image of the past, could command the loyalty and strength to rally the people against the Communists' ideal country, France remade in the image of Russia.

Whereas the Communists, organized by Moscow with Russian money, were obliged to adopt a more or less unified intellectual position, the Reformers, who came from a variety of backgrounds, within the general category of a revitalized France proclaimed a variety of intellectual views, and are best considered separately.

The first in point of time and numbers was the Union Nationale des Combattants. Founded in 1917 by a municipal councillor of Paris, Lebecq, it chose as its motto: 'United as at the Front'. According to its president, its aim was twofold: 'To help ex-servicemen and to continue to serve France as we did from 1914 to 1918'. Though it specifically avoided political, religious or philosophical ties, the Union favoured the social and political status quo, in the sense that its ideal was the France of 1918, seeing workers' demands backed by strikes as particularly divisive of national unity. The Union had 900,000 paid-up members, 72,000 of whom lived in the Paris region. It paraded on July 14 and on Armistice Day with orderly marches, honouring the tricolour and singing Great War songs.

The second group, also comprising ex-servicemen, was of more recent date. Its founder, François de La Rocque, came of an upper-

middle-class Breton family. Commissioned in the regular army, for nine years he served in Morocco under Lyautey, who taught him, as he taught Pierre Viénot, how to impart a team spirit to men of different backgrounds. La Rocque learned to speak fluent Arabic and was several times wounded and decorated. Retiring with the rank of colonel, in 1930 aged thirty-five he founded les Croix de Feu, an apolitical grouping of former soldiers who had come under enemy fire. La Rocque intended les Croix de Feu not just to parade occasionally but to be actively useful all the year round by helping those in need. Les Croix de Feu built kindergartens and sanatoria, ran soup kitchens in poor neighbourhoods and so on.

In appearance La Rocque was spare, under medium height, handsome, with thinning hair. He led a disciplined life, worked long hours, made himself accessible to all-comers. A poor public speaker, he excelled as an organizer. The France he valued was that of his pre-War boyhood: small farmers, artisans, shopkeepers, thrifty and intensely patriotic, with a tradition of service to France, most often in the Navy.

The 1932 elections ousted the Right and brought in a Left-wing government. It was a time of depression, when farm prices slumped, industrial production fell, exports dropped. With fewer American tourists, Paris's hotels, theatres, restaurants and shops suffered. In the five years from 1929 average income fell by 20%. The new government cut pensions, and this hit ex-servicemen particularly hard.

Against such a background La Rocque's concerns were economic more than political. He asked the government to stop pouring money into State industries, to end dumping of cheap subsidized foreign goods, to curb immigrant labour that made unemployment worse, to protect the value of small savings. He was calling in effect for a Left-wing government to act in favour of the lower middle class. Not surprisingly, the government paid no attention; it was then that La Rocque stepped up protest marches and street demonstrations.

The third group of reformers comprised Catholic patriots nostalgic for pre-Enlightenment France. Their spokesman, Henri Massis, had in his student days been an admiring friend of Charles Péguy, the poet who had moved from ardent and active Socialism to the view that only spiritual renewal, not politics, could improve society.

After a brave war as an infantry officer Massis began his self-imposed task of implementing Péguy's ideal through books, articles in the *Revue Universelle* and friendships. Slim, Spanish-looking, with large brown eyes and sleek black hair, he combined keen intelligence with an open, generous manner. Rejecting Brunschvicg's view that renewal would come of itself, built in to human progress, and Valéry's view that ratiocination and art are the highest manifestations of the spiritual, Massis identified renewal with a return to the Catholic faith, epitomized by the monarchy, the current pretender to which was Jean, duc de Guise, who was obliged by French law to live abroad and hence played no role in public life. For Massis the monarchy had never ceased legally to exist, and the Republic was a usurping structure, destined by its very illegality and its declared anti-clericalism to work against the traditions and true interests of Frenchmen.

Massis's Catholic patriotism took an extreme form. He held the view: 'Outside Christian France no salvation.' In 1927 he published *Defence of the West*, warning that Germany, Russia, the other Slav nations and all the countries of the Far East were dangerous enemies, actual or potential, of the Catholic religion, championed since the days of St Louis by France. *Simpliste* though it was, this form of patriotism exerted a strong attraction on many of the young, disillusioned with the current scene but no lovers of Russia.

A colleague of Massis on the *Revue Universelle*, Jacques Bainville adopted royalism for a different and curious reason. Born in 1879 in Vincennes, he came from a family rooted in the peasantry of Lorraine but for almost a century settled in Paris. The family was strongly republican. As a student Bainville went to Kaiser Wilhelm's Germany in order to research and write a Life of Ludwig II of Bavaria. What struck him in Germany was the order, discipline and respect for the army, and these characteristics Bainville attributed to the monarchy – surprisingly, given his interest in 'the Dream King' of Bavaria. Gradually his inherited Republicanism gave way to a reasoned, but intense, zeal for the cause of monarchy in France as the surest means of establishing an equivalent order, discipline and respect for the army.

By 1920 Bainville was one of France's best informed specialists on Germany. Courteous, with elegant manners and esteemed as a fair

fighter, in that year he published *The Political Consequences of the Peace*, arguing that Germany, still united and almost intact, was a threat to Austria, Czechoslovakia and Poland. He described the Treaty of Versailles as 'too gentle a peace for its hard core'.

Throughout the 1920s and 1930s Bainville drew on his knowledge of the past to illuminate the present. He wrote the best general history of France of his generation, coloured, but not excessively by his royalist views. He was elected to the Académie Française. But in 1934 when he published *History of Three Generations*, arguing that German nationalism had become imperialist and intended to dominate the world at the expense of France and England, no one outside his own immediate circle paid attention.

That France could find regeneration only by returning to the oldest of her structures was a view also held by Jean de Pange, but he came to this belief through a love of Ruskin and thence admiration of English institutions. So strong was this that he sent his sons to be educated at Westminster School. Pange firmly believed that in the ceremony of his anointing before the altar by a bishop a king receives a special grace or sacrament that helps him to rule wisely.

Pange went to Westminster Abbey to attend the coronation of George VI in 1937, a ceremony which moved him deeply, and in the pages of his diary he repeats his belief that monarchy is the best form of government. In the same diary he refers, *en passant*, to the scandalous behaviour of King Carol of Romania, King Ferdinand of Bulgaria and King Alfonso of Spain, but he never makes the connection between his beloved theory and the hard facts of everyday life which would have shown him how weak his theory was – one more example of a cocooned Parisian.

So much for what may be termed the candid Reformers. We turn now to other groups and persons who also urged reform on a past model but whose motives were less pure.

Charles Maurras's Action française described itself as a movement for reform and wished to reshape France as a Catholic monarchy, supported by elected representatives of professional bodies, craftsmen and tradesmen, but Maurras and his aides were motivated by hate and their methods scurrilous. Their *bêtes noires* were Germany, the Third Republic and, because of its international

character, Judaism, though it has to be remembered that in contradistinction to current views, few then thought anti-Semitism particularly dreadful.

In 1926 Action française was condemned by the Pope as an unacceptable harnessing of religion to political ends and its newspaper banned. Maurras described the papal condemnation as a lie and continued as before. Most of the clergy accepted the condemnation, but not so the laity. For a decade Catholics who would have been better employed in working for national unity indulged in bitter but fruitless parochial in-fighting and the adoption of extreme positions.

One of them, Georges Bernanos, wanted a return to medieval France, with a king, pageantry, chivalry, honour and an occasional 'holy war' – enemy unspecified – to keep the faithful spiritually on their toes. Always in favour of the underdog, Bernanos remained loyal to Maurras after the Pope's condemnation, thereby losing a force for balance in his life as well as the friendship of Jacques Maritain and weakening his polemic journalism with absurdities about Jewish conspiracy. Action française, by and large, damaged the Reformers' cause it claimed to serve.

Paul Morand turned against the present not from any love of the Church but from a disillusionment not unlike that which, at a different level, had motivated Gide. Disappointed at his failure in the world of cinema and seeing society drifting away from the Second Empire values he cherished, Morand threw in his lot with those among the Reformers who favoured more authority in government. In an editorial to the first number of *1933*, a new periodical founded by Henri Massis, Morand called for a moratorium on liberalism and more prosecution by the police. 'Everyone is calling for a young State, and a young State is a State that punishes . . . Don't let us allow Hitler to boast of being the only one to undertake regeneration of the West.'

Morand, who in many books had eulogized foreign cities and their pretty women and had married a Romanian, now took refuge in that last resort of the disenchanted, intellectual xenophobia: 'Let us tell Germany not to send us her men dressed as women, her erotic, depressing composers or her doctors specializing in sexual research . . . let her export elsewhere her played-out Expressionists.'

*

246

To round off this picture of the Reformers a word should be said about two leading businessmen who supported the Right partly from conviction, partly for financial reasons. Pierre Taittinger, member of the rich champagne family, war hero, deputy for Paris, believed France needed a stronger executive. In 1924 he founded Jeunesses patriotes, committed to the values of Poincaré's post-war nationalist government. Members wore a uniform, a beret and a badge depicting a sword and winged helmet. In Paris they numbered 7000; some had their own lorries and were trained to move swiftly against Left-wing demos and to erect barricades. Unlike La Rocque, Taittinger was a stirring public speaker and had the qualities of a leader, but as a convinced parliamentarian he rejected that role.

François Coty, perfume millionaire and owner of the *Figaro*, founded in 1933 Solidarité française, to fight Communism and freemasonry and to bring honesty to Parliament. Like Jeunesses patriotes, Solidarité française wore a uniform and were trained for street action. While their trappings were reminiscent of Mussolini's blackshirts, one essential difference stands out: there were too many individualists in the French groups for them to acknowledge or give birth to a political leader.

Despite their diversity of specific aims, these right-wing Reformers united in opposing Communism, which they saw as a Russian import, an insult to those who had fought or died to keep France free, and as the spearhead of an attempt to replace the Catholic Church by atheism; as the Communist anthem, *l'Internationale*, phrased it, '*Il n'est pas de sauveur suprême, ni Dieu, ni César, ni tribun.*' The Communists, for their part, saw the Reformers as their main obstacle to achieving power.

From 1932 Parisian intellectuals effectively gave all their energies to the great ideological war of the day: Communists and fellow-travellers flaunting a banner depicting France of the Future, Reformers a banner depicting France of the Past. Yet both movements nourished themselves on elements in the culture of the day. Solicitude for the underdog – the message of so many films – was applied by Communists to the factory worker, by Reformers to the small shopkeeper and pensioner. A questioning of the basis of authority and rejection of obligations, including the binding nature of marriage vows, was imparted from the stage. The primacy of

private worlds, even of dreams, was to be found in the canvases of leading painters. That each man is the measure of all things was iterated by Paul Valéry – he took it as the subject of his inaugural Collège de France lecture in 1935 – though such a view, according to Plato, leads to intellectual anarchy. And, in the form of background music, café songs with their accent on the rosy side of life induced a belief that differences of opinion could never get out of hand in Paris.

Disillusioned with France of the here-and-now, unable or unwilling to face up to actual problems such as an uncompetitive economy protective of 'the little man', both Communists and Reformers gave all their energy to the ideological war. Every imaginable topic was presented in terms of Left or Right. One of many examples is French history. In 1928 George Lefebvre began publishing a revisionist history of the Revolution from a Marxist viewpoint. Other left-wing scholars such as Albert Mathiez contributed books on the same subject from a similar angle. These were chosen as textbooks by the left-wing Union of Teachers, with the result that a new generation was growing up in the belief that the French and Russian Revolutions were ideologically identical, both moving in the direction of Communism.

The Reformers replied with equally exaggerated versions. Louis Bertrand wrote a *Louis XIV*, overstressing the advantages of monarchy. Jacques Bainville wrote a *Napoléon*, Pierre Gaxotte even found evidence for a rosy *Life of Louis XV*. Both sides, in short, indulged in a favourite French sport: fighting present-day battles on old battlefields.

But the conflict was not just a battle of books. It spilled over to the unlikeliest matters.

Every village and town now had its war memorial. Some depicted a soldier triumphantly holding up his rifle or a laurel wreath, others a prostrate soldier wounded or dying. The latter, asserted the Communists, expressed a rejection of patriotism and, according to their count, outnumbered the former.

Jean Renoir, turned Communist, asserted in all seriousness that Marcel Carné's thriller, *Quai des brumes*, was a 'fascist' film because it showed morally tainted and dishonest characters, making you feel that a dictator was necessary to restore order. Monsieur Emile

Fabre, administrator of the Comédie Française, staged Shakespeare's *Coriolanus*. When Reformers crowded in to applaud its strong criticisms of democracy, Fabre was removed from his job by a left-of-centre government.

The conflict spilled over also to the small details of personal life. In politics the novelist Roland Dorgelès kept pretty well to the centre in so far as such a position was possible at the time. In spring 1932 the socialist President, Paul Doumer, attended the film premiere of *Les Croix de bois* – in which incidentally the officers had been changed into heartless boors – and spoke appreciatively to Dorgelès about it. When, a few days later, Doumer was assassinated, Dorgelès agreed to hold one of the cords of his bier at the funeral, whereupon the Right taunted him with becoming a dirty little socialist. Not long afterwards Dorgelès wrote an article in praise of his car, a Hotchkiss, for the Hotchkiss company magazine. Because that company also made guns, the Left rounded furiously on Dorgelès, calling him a dirty little militarist.

The fury of the ideological conflict, conducted in literally hundreds of periodicals, broadsheets and manifestos, the malicious slurs, name-calling and mud-raking at public meetings against a background of economic hardship and ephemeral Ministries, reached a point in early 1934 where some small provocation would be likely to turn verbal virulence into physical violence.

On 9 January a petty crook named Alexandre Stavisky, who moved in high society and had long been suspected of financial fraud, shot himself or was shot by the police. Soon afterwards it emerged that Stavisky's trial for his crimes had been postponed no less than nineteen times by the Paris procurator, Pressard, who was a brother-in-law of the prime minister, Camille Chautemps, while worthless bonds peddled by Stavisky had been commended to the public by Dalimier, Chautemps' Minister of Colonies. No one, however, offered to resign, and the Government refused an enquiry.

The Union Nationale des Combattants and like-minded groups took to the streets, carrying the Tricolour and calling for clean government. The Prefect of Police, Chiappe, was a stocky, bald, fiery Corsican with the physique of an all-in wrestler, and very popular with his men. He knew that many of the protesters were no more than grown-up boy scouts, that they broke off for dinner between 7.30 and

9.0 and disbanded before midnight, when the Métro stopped, so as not to have to walk home. With his seven years' experience Chiappe permitted them each time almost – but not quite – to reach the Assembly building. Thus there was much ferocious language but little fury.

On the 28th Chautemps and Dalimier resigned, and a new Ministry was formed, with many of the old faces, by Edouard Daladier. A baker's son from Carpentras in the Vaucluse, he had taken a brilliant history degree and become mayor of his home town before serving in the infantry during the whole war, being three times cited for bravery and rising to the rank of captain. Then he had taught history in a Paris lycée before marrying the daughter of a Paris doctor. His wife had recently died and he now lived in a modest apartment with his sister and two sons. His political sympathies were with *le petit peuple*. Solidly built, brusque in manner, shrewd and tenacious, he was called by his supporters 'the bull of Vaucluse'. Whether he was a fighting bull remained to be seen.

As a Freemason and as a colleague of the tarnished Chautemps, the new prime minister was *persona non grata* to the Reformers. They decided to try their luck again, in the hope of obliging Daladier to resign in favour of a government of national unity which would return some power to the Right. In taking this decision they were of course behaving undemocratically and putting themselves in the wrong.

Believing Chiappe to have been too soft in the recent disorder, Daladier dismissed him. He did this, weakly, by telephone, which Chiappe took as an insult, and offered him as a sop a senior post in Morocco, which Chiappe declined. The dismissal infuriated the police force, the Reformers and two of Daladier's moderate Ministers, who resigned in protest.

Daladier was due to be confirmed in office by the Chamber of Deputies on the evening of February 6, and knowing that that date had been chosen for protest action he brought in mounted Gardes Mobiles, though they were unused to working in Paris, and entrusted them to a new Prefect of Police, Bonnefoy-Sibour.

The Reformers so far having made all the running, the Communists decided it was time they called into action their own Association Républicaine des Anciens Combattants, numbering some 3000 in the

Paris region. On the morning of 6 February *l'Humanité* published the following on its front page:

The Association Républicaine des Anciens Combattants announces that it will join in the demonstration planned by the Union Nationale des Combattants, but with different objectives. It intends to protest to the utmost against a regime of profit and scandal and against the government of M. Daladier, who reduced State pensions. It intends to show its anger with this same government which, in order to strengthen its imperialist war policy, intended to give the post of resident general in Morocco to Chiappe, a well known accomplice and protector of Stavisky.

At 5.0 p.m. on the 6th 170 police armed with revolvers and 25 mounted police armed with sabres barricaded the Concorde bridge, sole means of access to the Assembly building from the Place de la Concorde, where demonstrators were expected to gather. They had no tear gas, most effective tool for dealing with rioters, but they had fire hoses. More police were stationed near the Madeleine and in the rue du Faubourg Saint-Honoré.

At 6.0 p.m. crowds began to gather in the Place de la Concorde, shouting 'Down with the thieves! Resign! Long live Chiappe! Police, join with us!' They then stormed the bridge, throwing stones, garden chairs from the Tuileries and chunks of paving. The mounted police then made several charges. The demonstrators replied by throwing fireworks at the horses' legs.

At 6.30 the crowd set a bus on fire.

At 7.30 Solidarité française arrived, a disciplined group numbering 1500. They too stormed the bridge. Failing to drive off the demonstrators with water jets, the police, without orders, fired first in the air, then at the demonstrators. Six were killed, several wounded.

Two thousand Croix de feu marched peacefully up the rue Royale and were directed by the police towards the rue du Faubourg Saint-Honoré. At the corner of that street Colonel de La Rocque saw to his right that only a few mounted guards stood between him and the Elysée Palace. Here was a chance in a thousand to enter the residence of the President of the Republic and present his case

personally. But La Rocque hesitated. Protocol, his army training, respect for superior authority, all held him back. 'I wasn't prepared for this,' he later admitted. 'I had a moment of panic. I turned left... followed by the Croix de feu, and we headed for the Champs-Elysées.'

While the Croix de feu took no further part in events, at 8.45 the National Union of Ex-Servicemen began to march peacefully down the Champs-Elysées, banners proclaiming: 'We want honour and clean government for France' and singing the *Marseillaise*. They were joined by the Communist Republican Association of Ex-Servicemen, banners proclaiming, 'Long live the Soviets' and singing the *Internationale*. They turned into the Boulevards, where their peaceful march was joined by men bent on making trouble, some of them Action française militants, others, like the novelist Drieu La Rochelle, unstable malcontents.

Arriving in the Place de la Concorde, led by the militants, the ex-servicemen, both Reformers and Communists, attacked the bridge. The time was now 10.0 p.m. Twenty times mounted police charged the attackers without halting their volleys of stones and asphalt. Then the Prefect of Police told his men to shoot. Meanwhile, fighting had broken out in the Place de la Concorde, where crowds were attacking the Ministry of Marine with uprooted lamp-posts. Fighting and shooting continued until 2.30 a.m. By then 15 people lay dead and 328 seriously wounded.

Next morning Daladier appealed for calm and held a Cabinet meeting. On the urging of his colleagues he had brought a tank regiment, several battalions of infantry and twenty squadrons of cavalry overnight to the outskirts of Paris. They were ready for the order to march in and cow any further demonstrators. But now the Cabinet had second thoughts. Horrified by the number of casualties and believing unfounded rumours that every gun in the Paris gun shops had been bought by trouble-makers bent on more violence, they urged Daladier not to bring in troops. To their voices the President of the Republic added his. A tender-hearted family man with a tendency to weep publicly on sad occasions – cartoonists depicted him in a puddle of tears – Albert Lebrun telephoned Daladier in alarm and told him he must step down 'in order to avert civil war'.

At midday Daladier took his decision and issued this communiqué:

The government, which has the responsibility for maintaining order and security, refuses to assure it today by resort to exceptional means susceptible of causing a bloody repression and a new effusion of blood. It does not wish to employ soldiers against the demonstrators. I have therefore handed to the President of the Republic the resignation of the cabinet.

'A reed painted to look like iron,' was Blum's comment. But Daladier had not been weak on this occasion; he had shown compassion for his fellow men, which is not quite the same thing.

In the streets of Paris meanwhile the reaction of the majority to the night's bloodshed was horror and consternation tinged with shame. What had come over their city, which since the armistice of 1918 had prided itself on being peace-loving at home and abroad? As Malcolm Cowley had discovered, Parisians were certainly pugnacious talkers but they shrank from punching an opponent on the nose. Many times in the past Paris had chosen to follow up one day's bloodshed with many of the same, but the mood now was quite different. After the night of violence, not least from nervousness, Parisians followed the Government's call for calm. And however much they might criticize it, a majority wanted the Republic to continue.

An innocuous but popular former President of the Republic, Gaston Doumergue, was dusted off from retirement in order to head a Ministry of National Safety, in which Ministers of both Right and Left participated. Pétain gave it weight by agreeing to be Minister of War, and it received a vote of confidence from Parliament, 402 to 125. The Communists and Socialists organized a general strike, with a mass meeting in the Place de la Nation, to protest against the new Government. But this time the protest was purely verbal.

Neither public opinion nor protagonists in the riots on the 6th wanted to use force again. They had been immunized by that night of bloodshed. But the battle had not yet been decided. As a result the two opposing camps, strong as ever, now stepped up their verbal conflict and propaganda. They adopted increasingly extreme positions. Those who sought an ideal France in the future versus those who sought it in the past; the energies of the most gifted were to become even further diverted now from the too real, too painful problems of France in the present.

The first and most notable example of this divisiveness, stepped up now to the point of hysteria, came from the Sorbonne. The Reformers having put themselves in the wrong by trying, however amateurishly, to browbeat an elected government – this provoked a wave of anger among the University elite, already politically to the Left. France's leading physicist, Paul Langevin, had been a Communist sympathizer since 1920, when he had openly defended André Marty, the Black Fleet mutineer who, incidentally, had since become a Communist deputy. In March 1934 Langevin founded the Vigilance Committee of Intellectuals against Fascism and War, with the backing of his friend Jean Perrin, of the influential pacifist essayist Alain, of Langevin's protégés Irène and Fred Joliot-Curie, as well as of Louis Aragon, André Gide, André Malraux and many more. This group declared the Reformers to be Fascists – which, save for a tiny fraction, they were not – and lumped them with the Fascists of Italy and Germany. It followed that anyone wishing to honour France's alliances or to declare himself a patriot to the point of defending his country with modern weapons was *ipso facto* to be branded a Fascist and a warmonger. Langevin's Committee in effect wanted the glory of being anti-Fascist without the sacrifices involved in defending their country against the Fascist danger from abroad. Thus the old conflict took a new turn, one of great potential danger to national survival, and also damaging to France's 'civilizing mission'. Putting this in a European context in April, Paul Valéry said sadly to André Gide, 'Liberalism is now dead.'

17

THE RHINELAND CRISIS

Against the background of divisiveness in public opinion France in March 1936 encountered a crisis serious in itself and even more serious in its consequences. It involved senior politicians, the Army and, most importantly, the head of the Foreign Office.

In the almost two years since his appointment Alexis Léger had acquired a reputation for hard work, efficiency in concluding the Russian pact – and also for secretiveness. He questioned others often but his own views he rarely shared. Few were the occasions when he dipped a pen in his special burgundy-coloured ink to draft a barely legible memorandum or minute a paper.

One reason for this secretiveness was that Léger had conceived a plan which would, he believed, give France security without the need for fighting, and it was a plan he could not share with Foreign Minister Laval, his associate during 1935. The seed-bed in which the plan germinated had been prepared as early as 1912 when, aged twenty-five, Léger had spent six months in England, meeting Gosse, Chesterton, Belloc, Arnold Bennett, W. H. Hudson and, staying at his home in Kent, Joseph Conrad, whose novels of heroism in exotic lands Léger admired. In October the young poet had described his mood in a letter in English to a Parisian friend:

Although I have roamed a little through the country, and at sea (Western waters) on a sailing ship, I must beg your pardon for having 'settled' in London instead of following your advice. You know, I am awfully fond of this town, and between London and Petrea Arabia I don't really think there is any middle place to be tolerated in the world. Moreover, if you knew how very

happy I have been here! Circumstances here have made my life so extraordinarily happy that I wonder whether the future may ever prove the same.

When he became head of the Foreign Office Léger found in his opposite number across the Channel just those qualities in England that he loved. Robert Vansittart, son of a Kentish squire, had been known at Eton as a 'brilliant solitary'. Seven years older than Léger, he was good-looking, with a dark-complexioned, expressive face, and a pleasant deep warm voice. While en poste in Teheran he wrote *The Singing Caravan*, a kind of pseudo-Persian *Canterbury Tales*, and he was later to have a romantic comedy performed at the Malvern Festival. He was also, like Léger, a keen yachtsman. Vansittart was more direct than most Foreign Office men and, flourishing in an era of weak Foreign Secretaries, had been able to urge on Baldwin a resolute policy towards Hitler, though without succeeding in getting that policy adopted. In particular, during 1934–5 Vansittart bravely struggled with the air authorities to get them to take seriously the air force Goering had begun to build on Hitler's orders.

Soon Léger and Vansittart became close friends. On leave in the summer, they sailed together off the Norfolk coast, talking about literature, the East and politics. Léger, less experienced but more imaginative than the older man, came to admire Vansittart's courageous, principled stand, almost unknown in France and rare at the period in England. Perhaps Vansittart played up to this idealized picture. At any rate Léger, who no longer had other close contacts with Englishmen, chose to see his friend as the embodiment of English policy and to build on that view a plan.

Here another aspect of Léger's character calls for notice. In his younger days Léger had been discussing religion with Paul Claudel against the dramatic background of a severe thunderstorm, with Claudel trying to persuade the young friend he admired of the truth of Christianity. At the end Léger replied that he didn't feel any need for an intercessor, explaining, '*Comme les vrais enfants des îles, je suis sauvé de naissance* – Like other children of nature, I was born saved.' We are reminded of Giraudoux's claim to have been born without original sin, and its concomitant: optimistic self-assurance.

256

But in Léger self-assurance went further. The Secretary General liked to recall, and sometimes to confide to intimates, that twice in his life he had been saluted as a god: aged eight, by his Sivaite nurse, and en poste in the Gobi desert by a Mongolian nomad, who had found him asleep in the sand beside the skull of a horse, considered a sign of supernatural import. Like the tribal leader in his poem *Anabase*, Léger believed that he possessed an insight into events denied to ordinary men.

With a character like this it was easy for Léger to move from the belief that Vansittart's views represented the policy of His Majesty's Government to a conviction that Britain could be persuaded to support France in any confrontation with Hitler. Just as commitments to Central Europe had, on paper, been saved by playing the Russian card, so France's stand against Hitler – which Léger saw as sooner or later inevitable – would be stripped of any potential danger by playing the English card.

During 1935 Léger had kept this grand design to himself, knowing that Pierre Laval, Foreign Minister in that year, was anti-English. Mayor of the proletarian Paris suburb of Aubervilliers and senator for the Seine, Laval had useful contacts in all parties but belonged to none, and the joke went that Laval was clever enough even to be born with a palindromic name which spells the same backwards and forwards.

In January 1935 Laval had gone to Rome and concluded a secret deal with Mussolini, for whose rise to power from humble origins like his own the Frenchman felt a sneaking admiration. In return for some worthless sand in Libya and promises regarding Italy's colonial plans, Laval got from Mussolini an agreement to cooperate with France in her commitments to Central Europe. Then, when the Abyssinian war began, Laval, now Prime Minister, found himself torn between his promises to Mussolini – who considered that Laval had given him a free hand in Abyssinia – and the need to keep on good terms with Britain within the League of Nations. When Britain urged France to join in imposing sanctions on Italy, Laval went on, said those who knew, 'trying to save both his faces'.

Geneviève Tabouis published in the press details of Laval's secret deal with Mussolini, and Laval came under attack in the House for conniving with a dictator's aggression. He declined to resign but

when Herriot and others left the Cabinet, on 24 January 1936 he had to step down as Prime Minister. He appeared quite unashamed, telling journalists with a broad smile: 'I have done my duty . . . In foreign policy, believe me, Messieurs, I have worked for the good of France.'

Few would have agreed, certainly not Léger, relieved beyond measure to see Laval's departure. He knew that Laval's secret deal had greatly angered the British but, optimism triumphing once more, he felt sure that now Laval had fallen the incident would be forgotten, especially as he had always gone out of his way in other areas of foreign policy to accede to Britain's wishes. Across the Channel Vansittart, he knew, was hammering away about the grave threat from German rearmament. To colleagues and politicians alike Léger explained that France's position was secure: she had the Maginot Line, she had her alliances with Russia, Poland, Czechoslovakia and Belgium, and could count on Britain's support, with arms if necessary, should Hitler make an aggressive move in the West.

German rearmament meanwhile was proceeding fast. In March 1935 Hitler introduced conscription and accorded Goering almost limitless funds with orders to produce by the end of that year from half a dozen modern factories 990 bombers and fighters superior to French models. Both acts violated the Treaty of Versailles.

In early January 1936 François-Poncet reported from Berlin that Hitler might have designs on the demilitarized zone along the Rhine, about the size of Belgium, from which six years earlier, as a conciliatory gesture, France had completed the withdrawal of occupying troops. The ambassador warned that Hitler might try to recover the demilitarized zone in contravention of the Treaties of Versailles and Locarno, but added reassuringly that he probably would not attempt this for at least a year.

On 24 January 1936 Laval's successor as Prime Minister took office. Albert Sarraut, a Radical socialist aged sixty-three, had agreed to form a government only after five more experienced deputies had declined, believing that Laval's deflationary policies had left the franc so weak it would be necessary to devalue. A former governor of Indo-China and thirteen times a minister, Sarraut had artistic leanings: he collected paintings by the Montparnasse group, was friendly with many of them and attended the party to launch

Kiki's autobiography. He knew well the carefree, peace-loving mood of that part of Paris.

His Foreign Minister, Pierre Flandin, six foot four and solidly built, had been a wartime flying ace. Aged forty-six, in politics he sat right of centre, specializing in finance and aviation. He was known to keep more than one pretty mistress at a time and in public life too had a reputation for promiscuity. For unswerving integrity one had to look to another member of Sarraut's cabinet: Georges Mandel – real name Jéroboam Rothschild, discarded as a handicap in politics – was esteemed as a man of shrewd intelligence and principle, though pitied by friends for a physiognomy so hideous as to prove an insuperable impediment to the premiership.

Sarraut and his ministers knew themselves to be in three ways a weak government: they were in office only till May, when Frenchmen would be electing a new Parliament: they were short of money – the Army budget for 1936 had been set by the outgoing government at a figure lower than in 1935 – and their narrow support in the House could at any moment be overturned. In respect of German intentions, therefore, the Government was more than usually dependent on the advice of Alexis Léger.

Observing a situation of potential weakness in France, Hitler decided to advance his plans for the Rhineland. On 7 March, a Saturday, when the Cabinet would be dispersed, 19 German infantry battalions and 13 artillery units, totalling 22,000 regulars, crossed the border into the demilitarized zone. They were supported by 54 fighter planes. As they marched in, the Rhineland police were incorporated into the army as 21 infantry battalions, making a total of 36,500 men. Anxious not to risk frightening the French people into retaliatory action, Hitler sent only 3,000 to frontier posts immediately adjoining French territory; most he stationed on the eastern side of the Rhine.

When news of this invasion – but not the exact numbers – reached him on Saturday, Léger told his chief legal expert to draft a memo for Flandin, spelling out that Hitler's action flagrantly violated the Treaties of Versailles and Locarno. France therefore had every right to take immediate military action in her own defence, and the British, as co-signatories of Locarno, could be expected to back them all the way.

On the morning of Sunday 8 March Sarraut convened his Cabinet. Flandin having imparted the views of Léger, Sarraut, Flandin and Mandel wished to take immediate retaliatory action.

Other Ministers showed themselves more cautious. First, there were the trained lawyers among them. According to the Treaty of Locarno, the only breach of article 43 which could justify an immediate riposte was one which involved an imminent threat of hostilities. Now Hitler had been careful not to employ offensive weapons such as tanks and bombers. The mere presence of troops was, technically, a non-flagrant violation. According to the legal literalists, France could still act, but only after a decision by the League Council, and that would take up to seven days.

Second, some Ministers pointed with alarm to the deplorable state of public opinion, which had become even more divided than at the time of the 1934 riots by reason of England's recent firmness at Geneva, where she had led the League, including France, to impose economic sanctions on Italy for her conquest of Abyssinia, even though this risked provoking Mussolini to military counter-measures. The self-styled spokesman of 'traditional' France, Jacques Bainville, wrote: 'What Mussolini is claiming for his country is what England already does in India, Egypt, and elsewhere. It is what we do in Tunisia and Morocco. Mussolini wants to exercise a protectorate in Abyssinia . . . Does England want to stop war between Italy and Abyssinia for the love of humanity and defence of the weak, or to protect Lake Tana and the sources of the Blue Nile, that is to say for her own interests in Sudan and Egypt?'

Henri Massis, champion of a 'strong' France friendly to another Catholic nation, issued a manifesto expressing stupefaction that a nation whose Empire comprised a fifth of the globe should oppose a justifiable undertaking by young Italy. In adopting 'the fearsome alibis of a false juridical universalism that puts on an equal footing superiors and inferiors, civilized people and barbarians' Geneva bore the heavy responsibility of unleashing war 'against a nation which for fifteen years had been reawakening, organizing and strengthening some of civilized man's essential virtues.' Massis's manifesto was signed by 850 prominent intellectuals.

On the opposing side, Communists and Communist sympathizers accused the Reformers of being Fascist and raged against the

'bellicose' action of the French government when it grudgingly imposed economic sanctions on Italy in November 1935. Langevin's Vigilance Committee of Intellectuals against Fascism and War gave more of its attention to the second than to the first, while Guéhenno in *Commune* continued to call for 'a France that has disarmed and is modest, but strong in her genius for being reasonable and in her revolutionary tradition'. Anti-militarism in the Latin Quarter reached a point where 90 out of 150 students in the Ecole Normale Supérieure signed a protest against prolongation of military service – the Government's riposte to conscription in Germany – and sent it to the press.

Meanwhile, on 26 November, Giraudoux's *The Trojan War will not take Place* had opened at the Athénée. From this highly placed veteran of the Quai d'Orsay full houses learned that war could never break out provided one said nothing malicious about a neighbouring people. As it happened, in the run-up to the May election maliciousness was fully employed dividing opinion in Paris.

With the public desirous of peace, though for conflicting reasons, and also extremely anti-English, and with his Cabinet divided, Prime Minister Sarraut naturally gave particular attention to the views on the Rhineland crisis of the chief of general staff and commander-in-chief designate of the army. Maurice Gamelin was almost the antithesis of his predecessor Weygand. Short of stature, he had a round womanish face, soft pink cheeks, eyes that looked away from you and a flabby handshake. Taught to draw by an artistic mother, his first ambition had been to become an artist and when in fact he chose a military career he became an outstanding cartographer: the first to use colour to depict relief and to show up key features. He extended a cartographer's care about detail to his administrative duties and proved an excellent co-ordinator. He was not a fighting man; indeed, he prided himself on being more than just a soldier, peppered his conversation with quotations from Bergson and Valéry, and enjoyed turning conversation in the mess to the history of art.

Gamelin owed his advancement to an ability to ingratiate himself with politicians. Early on he had understood that they, the intelligentsia and public opinion generally, did not want to fight, and so he never expressed 'offensive' views such as had cost Weygand his

job and indeed he kept remarkably quiet about his military views. This was not because he had no views, but because they were so singular.

Gamelin had convinced himself that Hitler had no ambitions in the West but intended to expand in eastern Europe. Having first fortified the Rhineland against possible French action, he would then turn on such countries as Austria and Czechoslovakia. Gamelin, like most senior army officers, had no faith in the will or ability of Russia to defend the small states of Europe against Germany. Instead, he pinned his faith on Poland, with whom France had a military alliance, and on Italy, with whom, after Abyssinia had been conquered and the fuss had died down, he wished France to make a military alliance. Given England's moral stand on Abyssinia, it might well be necessary to sacrifice good relations with England to a firm military pact with Italy. In such a collective security scheme France's military role would be pleasingly light. A keen admirer of the French expeditionary force to Salonika in 1915, Gamelin even envisaged some similar undertaking in support of Poland and Italy.

As regards German numbers in the Rhineland, intelligence reports were conflicting. Gamelin chose to believe the most alarming, namely that German forces were ten times larger than they actually were. He therefore informed the Cabinet that he could not act at all on German soil without *couverture* – partial mobilization – which would take eight days and involve the call-up of enough reservists to put 1.2 million men at the ready. He added that when politicians talk of entering enemy country without mobilization 'they forget that we don't have an army suited to such a policy.'

Sarraut also consulted his Minister of War, General Maurin. Now exactly one year before, Maurin had told a Parliamentary commission: 'When we have dedicated so much effort to constructing a fortified barrier, do you think we would be mad enough to move beyond that barrier to *je ne sais quelle aventure?*' So Maurin endorsed the view of his chief of general staff: nothing could be done without partial mobilization.

Sarraut had fought several duels in his youth and in his forties, as a volunteer, had won the military medal at Verdun. He was naturally surprised at the generals' 'lack of combative spirit', to use his own phrase. As for partial mobilization, in the present state of

public opinion, it would cause even more of a disruption than the Stavisky scandal and would cost 30 million francs a day, money the country could ill afford. Sarraut and his Cabinet therefore decided that France could not act alone, they must play Léger's English card.

Sarraut made plans to fly to London. He still intended to respond forcefully, as Poland and Czechoslovakia expected him to do, having promised to honour their treaty obligations to France, and on the 8th made a firm broadcast to the nation – radio had become an essential tool of government – denouncing Germany's treaty violation and declaring that France would not negotiate under the threat of force. On March 9 Flandin proposed mobilizing just two divisions, but Maurin, afraid of unleashing action against France, gave the impression that he knew nothing yet of the army's mobilization plans and Flandin was unable to proceed further.

Sarraut and Flandin arrived in London on the 11th. To their astonishment they found a Government and public opinion that bore very little resemblance to Léger's imaginary view based on adolescent memories of England and Vansittart's hearty anti-Hitlerism. The Prime Minister, Baldwin, was insular to a fault and had over the years neglected defence. A weak Foreign Minister, Samuel Hoare, had been replaced by Anthony Eden, who disregarded Vansittart. And British public opinion was extremely displeased with France over the Soviet pact, over Laval's connivance with Mussolini, and over France's reluctance to impose effective sanctions on Italy, while the influential *Times* continued its favourable attitude to Germany.

Sarraut and Flandin found in London no encouragement for a military riposte. Much, indeed, turned on estimates of Hitler's character. The French considered him to be reasonable and urged that Franco-British firmness would cause him to withdraw, while, curiously in view of later events, it was Neville Chamberlain who replied that the British Government could 'not accept this as a reliable estimate of a mad dictator's reactions'. Baldwin declared that anyway Britain was not in a position to offer military help since in view of the Abyssinian crisis most of her strength had been moved to the eastern Mediterranean. As for the League Council which gathered in London, it took no action, preferring to believe Hitler when he said he was willing to negotiate and to re-enter the League.

Sarraut and Flandin returned to Paris without military help and without a military pact. All they got was a promise of military talks. The visit had been a fiasco. When he heard the news from Flandin's own lips, Léger returned to his office. 'Usually calm and controlled,' said Crouy-Chanel, 'he was shattered. White with anger, he threw his file on the floor, groaning, "Cowards, cowards! . . . They have yielded all along the line."

The outburst tells us much about Léger and his self-righteousness. To it Flandin might reasonably have countered, *'Maudit poète!'* while others might have said he was conforming to his name: *léger* – a lightweight.

How did Parisians react to German troops marching across the Rhine? According to the *Figaro*, 'with dignified calm'. There were no gatherings, no protests, no anger. In the Jockey Club, which purported to be a stronghold of French honour, opinion strongly opposed military action. *'Ils sont chez eux,'* members agreed.

The Left criticized Sarraut's broadcast as 'warmongering'; Socialist deputies unanimously adopted a declaration urging that Fascist and military states should now be confronted with concrete proposals for universal disarmament; the Communists published a manifesto demanding united resistance to those Frenchmen who wanted to conduct war and massacre.

When Flandin returned with news that the incident had been referred to the League, most Paris newspapers expressed relief. The right-wing *Le Jour* accepted Hitler's excuse that he had moved in response to France's treaty with Russia, and concluded 'Here we are caught up in a war between Russia and Germany' and argued that sanctions would only exacerbate a situation which did not really concern France. Only one newspaper, *L'Echo de Paris*, directed by a fearlessly patriotic Breton deputy, Henri de Kérillis, dared to denounce the sacrifice of principle to political opportunism; however, it softened a truth so unpalatable to readers by placing the blame for this squarely on Britain, evidently forgetting that in 1923, despite Britain's disapproval, France had marched troops into the Ruhr. By the end of March Parisians of both Left and Right had convinced themselves that high-principled France had been betrayed by the 'pragmatic' English, some adding that Eden was

delighted to have got his own back for Laval's double-dealing over Abyssinia.

Across the spectrum of the Paris press one detects a failure to imagine what ordinary Germans might be feeling and thinking. Here I believe that Frenchmen's refusal to acknowledge the part their own rancour about Alsace-Lorraine had played in the outbreak of the Great War hindered them from recognizing the huge importance of German rancour over their 1918 defeat and the impetus it could give to revenge.

In Berlin meanwhile, two days after the Rhineland occupation François-Poncet complained to the French chaplain: 'It's quite beyond me. Neurath [Germany's extremely clever Foreign Minister] came to see me a few days ago and said Germany would protest against the Franco-Soviet pact, but I thought he would do so through diplomatic channels. These people do not behave like diplomats.' Dali had shown more perception when he told Breton that Hitlerism was a form of paranoia.

What would have happened had France taken military action alone? Later Hitler was to say more than once that the Reich's military weakness would have obliged him to withdraw, but on each occasion he wished to impress his listeners with the daring of his coup. More trust should be placed in his words to the Austrian premier in February 1938: 'If France had marched then, we would have had to withdraw, perhaps about 60 kilometres; even then we would have held them.'

More important than such might-have-beens were the immediate effects of Hitler's success. The contrast between the angry concern shown by Parisians two years before over a small domestic scandal and the lack of any response now – this disturbed thinking French-men in the provinces, particularly in the eastern regions, where Lyon's newspaper *Le Progrès* judged Hitler's move as a sure sign that he was bent on war. Equally, it disturbed France's allies. Pro-tective big brother had run to London like a little sister. Perceptive observers in Moscow, Warsaw and Prague began to wonder whether France would have the courage to honour the collective security system which the Quai d'Orsay had taken the lead in so laboriously building up.

None of France's small allies was more agitated than Belgium. The Belgians had a military alliance with France dating from 1920, but in the light of the French government's recent irresolute stance, could they expect help from France if attacked?

There was a second consideration. By the Franco-Soviet pact of 1935 France had committed herself to helping Russia in case of attack and now that Germany was about to remilitarize the Rhineland the best land route for help would lie through Belgium. As things now stood, the Franco-Belgian alliance might well suck Belgium into an unwanted war on behalf of Russia.

In the light of these considerations and of other less important causes of friction with France it seemed to the Belgian government no longer advantageous to continue an alliance with France that was earning her Germany's increased displeasure.

On 15 October 1936 Jean de Pange wrote in his diary:

> The newspapers publish a speech made yesterday by the King of the Belgians. He declares that Belgium reverts to a position of neutrality and refuses to come to the help of her neighbours as she had promised to do by the Locarno Pact. This little nation was disposed to have very close ties with us. She had been repulsed by our policy of customs duties. Fear of our pact with the Russian Communists had done the rest.

Pange fails to note, or declines to acknowledge, that the key factor in Belgium's defection was French fudging over the Rhineland.

This important juncture provides a convenient place for reviewing the chain of events that led up to it. In 1919 Berthelot had conceived the grand design of victorious France taking the lead in Europe, protecting the small nations created largely by her. In the late 1920s without openly reneging on the grand design, France had ceased to follow a coordinated policy under the sign of absolute obligations and with certain objects clearly within its sights. The Maginot Line was built, ostensibly to defend France from German invasion. But Pétain, with his own ideas on the matter, saw to it that a gap was left opposite Belgium, so that in the event of a German threat France could enter that country to hold the line of the River Scheldt. With Belgium's defection in 1936, this strategy was, at a stroke, rendered

impossible and France was left with her torso well protected but her throat bare.

Under the influence of public opinion successive governments had rearmed slowly and always defensively, rendering impracticable truly effective help to France's central European allies. More recently, as the German threat increased, instead of striving to help her allies, France had sought help for herself, but again in uncoordinated ways: Léger from Britain, Gamelin and Laval from Italy, the most vociferous Paris intellectuals from Russia.

The Rhineland crisis revealed grave failures of character, judgement and policy in several departments. A healthy society, one adjusted to the world as it is, will recognize such shortcomings and take drastic steps to ensure they do not recur. A sick society, either living in a fool's paradise or preoccupied with comparative trivialities, will fail to recognize the mistakes and let things slide. In the wake of the crisis Europe waited to discover which sort of society France would show herself to be.

18

THE POPULAR FRONT

For the 1936 elections the extreme left-wing Socialist Party joined forces with left-wing Radicals and the Communist Party under the name of the Popular Front, to fight the right-wing Republicans and the Reformers, who called themselves the National Front. In the crucial second round, on 3 May, the Popular Front agreed that all their supporters would vote for the leading Left candidate in every constituency, irrespective of party allegiance. This measure of discipline, rare in French politics, proved effective. Though the swing to the Left in votes was only 3%, the Popular Front won a substantial victory: 376 seats against 220 for the National Front. Most striking was the Communist gain: 72 seats compared to 12 in 1932, many from the Paris suburbs. On 6 June a new Ministry took office, headed by the Socialist Party leader, Léon Blum.

Second of five sons, Léon Blum had been born in the flat above his father's silk ribbon business near the place de l'Opéra. At the Lycée Henri IV he studied philosophy under Bergson and made friends with Gide. He then won a place at the Ecole Normale Supérieure. It was his ambition, while he was there, to be a writer: he wrote poems which Alfred Natanson published in the highly respected *Revue Blanche*, reviewed new plays and became a close friend of Reynaldo Hahn and the witty playwright Tristan Bernard. He tried to write a novel demonstrating that girls should have pre-marital sexual experience, thus allowing them to make a wise choice of husband, but his novel failed to cohere and he published his message as an essay. At the time it caused a stir.

Blum had been brought up in a loose version of the Jewish religion, but at the Ecole Normale, under the influence of the librarian Lucien

Herr, a generous-hearted Hegelian and doctrinaire socialist, Blum adopted an ethico-political belief more ardent than most men's religion. 'Socialism,' wrote Blum, 'claims steadily to reduce the old core of instincts, the obscure evil forces in man that elude the clear light of conscience and the action of his reflective will.'

Literary gifts and political beliefs came together when Blum joined the staff of what was then the leading Socialist newspaper, *l'Humanité*, founded by Jean Jaurès, a navvy's son who had graduated from the Ecole Normale to become the most esteemed deputy on the Left and an anti-war campaigner. During a close seventeen-year friendship Blum learned to love Jaurès and respect his views.

In 1919 Blum entered Parliament and the following year became prominent in the Socialist Party when it separated from the Communist Party. The Socialist Party had strong international links and indeed called itself the Section Française de l'Internationale Ouvrière. Blum and his at first small group gave support to left-wing Ministries but consistently declined Cabinet posts, believing that they would thereby dilute the reforms they hoped one day to impose *en bloc*.

On taking office for the first time Blum was aged sixty-four, tall and strongly built. From behind a pince-nez blue-grey short-sighted eyes looked out calmly above a long thin nose and full lips partly hidden by a fair, silky, drooping moustache. He had flat feet and long white hands, a high, rather girlish voice and, according to the American ambassador Bullitt, 'little fluttery gestures of the hyper-intellectual'. He dressed more fastidiously than any other politician, habitually wearing grey spats over his highly polished shoes, a freshly-ironed handkerchief in his top pocket, a carnation in his buttonhole. He lived in a house on the Ile Saint-Louis, surrounded by choice books and a few recherché objets d'art. His closest friends were intellectuals, creative artists and Sorbonne professors; his brother René was art director of the Monte Carlo ballet, his wife Thérèse a sister-in-law of the composer Paul Dukas.

Blum then was in many respects a typical highly refined Parisian intellectual, more at ease with ideas than with the flux of events, a connoisseur of the arts, including the art of living, an optimistic humanist in the mould of Léon Brunschvicg. What set Blum apart

269

from other intellectuals was a rare determination to achieve power and, with it, the opportunity to spread among the less well-off that happiness he was fortunate enough to enjoy.

Installed in office, Blum lost no time in doing just that. He reduced the legal working week from 48 hours to 40 and made it compulsory for employers to give their staff two weeks' paid holiday, with a 40% reduction on the rail tickets to their holiday destinations. He accorded wage-earners the right to collective bargaining. These changes were much needed, for many bosses paid subsistence wages, the self-made bosses being often the hardest-hearted. Louis Renault would dismiss on the spot any worker he found slacking; Coco Chanel considered that her seamstresses should feel honoured to be working for her, a great artist. One day Madame Fred, the sweet lady in charge of her mannequins, urged Coco to increase their pay, pointing out that they were the best-looking girls in Paris. Coco replied curtly, 'If they're short of money, let them take lovers. They could be kept by the richest and smartest men in Paris.' It was, after all, only what she had done herself.

The franc, for long kept artificially high as a symbol of national pride, Blum was obliged to devalue by almost 30%, but to offset the rise in prices he increased public-sector wages and salaries. He in effect nationalized the Banque de France, transferring management from private financiers to Government appointed officials. Having long declared that it was wrong for big business to make profits out of armaments, he nationalized the arms industry. He also nationalized the aircraft industry, with results to be noticed later.

A staunch believer in women's rights, Blum for the first time gave government posts to women. He made Irène Joliot-Curie under-secretary of state for scientific research, Suzanne Lacore for public health and Cécile Brunschvicg for national education. The latter was already editor of *La Française*, a woman's weekly devoted to social welfare and better international justice; she was to use her new powers to set up 1700 school canteens and to scrap the regulation obliging a woman to get her husband's consent in order to obtain a passport.

August in Paris that year was like no previous August. As factories, businesses and shops shut their doors for two weeks, pale-complexioned workers who had never before had paid holidays

gratefully took the train to the seaside, sat in the sun in deckchairs, breathed in wholesome air and watched their children paddle or build castles on the sand.

Communists and fellow-travelling intellectuals hailed the new legislation not only as a good thing in itself but as a foretaste of even better benefits to come. André Gide at last took the plunge, flew to Moscow for the funeral of Gorky and there declared in a speech that 'the future of culture is linked to the destiny of the Soviet Union. We will defend it.' On his return Gide published a book about his visit, *Retour de l'URSS*: 'Nowhere else can one experience so deeply and strongly a feeling of humanity . . . How many times in that country have tears come to my eyes from an excess of joy, tears of tenderness and love.'

André Malraux, who had started life as an art thief in Indo-China, then turned to anti-colonialism and to Communism, often took a seat at pro-Russian rallies alongside his friend Gide, a complete edition of whose works he was editing for Gallimard. Malraux's praise of Russia tended to be more cryptic than the older man's: 'Communism,' he declared, 'restores to man his fertility'; it also helps him 'to reduce as much as possible the comic side of his existence'. The remarks by Malraux and Gide were made at exactly the most intense period of Stalin's purges.

Jean Renoir, who had used Communist Party funds to make *Le Crime de Monsieur Lange* about a happy workers' cooperative, with scenario by Jacques Prévert, now collected money to make a film cele-brating the French Revolution as a paradigm of the present social revolution. The biggest trade union circulated a prospectus soliciting funds for 'The film of union of the French nation' (in capitals) and below (in small letters) 'against a minority of exploiters.' The result was *La Marseillaise*, a happy film depicting camaraderie between the underprivileged in the first flush of revolutionary ardour.

Across the whole spectrum of left-wing intelligentsia that summer of 1936 was hailed as the beginning of a new millennium, and naturally it rather went to some people's heads. One of the best-liked députés in Parliament, the abbé Desgranges, boarded the train for his Breton constituency to discover that first-class compartments were occupied by working people without first-class tickets, and

when he asked them to make room for him, they said the railways now belonged to them, and he should take a seat in a lower class. This did not, however, affect the abbé's approval of the changes.

In his election campaign Blum had promised not only to give the proletariat better conditions but also to give the world what he termed *la grande paix humaine*. What did he mean, and how did he propose to achieve it?

The answers lie in Blum's convictions and friendships. From his mentor Jaurès he had imbibed a firm belief that international socialism is the perfect expression of human intelligence, and therefore must most effectively preserve peace among nations. It was a belief shared by other *literati* of the Ecole Normale: Romain Rolland, Guéhenno, Alain, Giraudoux, Brunschvicg, and it sounded most convincing when purveyed in general terms among men and women of similar background in a city obsessed with domestic politics and inclined to see foreign affairs as an extension of the one conflict that mattered in Paris: Revolution versus Reform, or, as Blum would put it, Socialism versus Capitalism.

Blum's belief that socialism could lead to international fraternity was further strengthened by his milieu. Close friends included the Collège de France physicist Jean Perrin, the Natanson brothers, Simone Porsche, an actress turned writer, Cécile Brunschvicg, and Horace Finaly, the banker who had helped Louise Weiss to found her School of Peace. All were Jewish. Men like Finaly and the Natansons had family or close Jewish friends all across Europe. Frontiers meant little to them. It became easy in such a group to believe in the brotherhood of men, whatever their flag. Blum, who had travelled little outside France, therefore tended to see Europe not as the messy and immensely complicated cockpit it had become since 1933 but as a French-language crossword which mandarins of broad vision would soon succeed in solving.

On coming to power Blum began by holding out a friendly hand to Hitler, declaring in June that he did not intend 'to doubt the word of Hitler, a former soldier who had for four years experienced the misery of the trenches', the implication being that anyone who had been through one war would not start another. In September Blum declared to a mass rally in Luna Park: 'War becomes possible when

we admit it is possible,' and made it plain that he for one did not admit it. Though circumstances had now significantly changed, he continued the policy of previous peace-loving ministries: doing nothing to provoke his eastern neighbour, thereby prompting Laval to confide maliciously to a friend: 'Whereas Mandel is a Jew who loves war and hates Germany, Blum is a Jew who loves peace and also loves Germany.'

Blum nevertheless took precautions: he showed more energy than his predecessors in trying to put muscle into France's alliances. He allowed Pierre Cot to go to Moscow to try to negotiate a Soviet air accord. He sent Gamelin to Warsaw to try to buy Polish support with a two billion franc loan, while Gamelin, on his own, tried to negotiate some sort of arrangement with Italy, essential in his view for any military action in central Europe. Léger, meanwhile, was beavering away alone for a military alliance with Britain. While all these activities were admirable, their aims were mutually incompatible. Russia blamed France for helping Poland, Poland – with a Foreign Minister, Beck, friendly to Germany – blamed France for negotiating with Russia. Blum, suspicious of Mussolini, would not further Gamelin's plans in Italy, while Britain, hostile to both Moscow and Rome, became even more suspicious than before of France's attempts to be everyone's friend. Thirteen months of the Front Populaire were to bring France no nearer to firm military commitments from her allies.

That first summer of Socialist government nevertheless saw a public optimism about the international scene unknown since the 1920s. Blum's Minister of Education, Jean Zay, declared 9 August a National Day of Peace, describing it on posters as a *Rassemblement Universel*, and some Parisians went off to Saint-Cloud park to hear Blum equate Socialism with world peace. Others preferred to see Sacha Guitry's latest film, *Romance of a Cheat*, preceded by Pathé News showing goose-stepping National Socialists at Nuremberg and, in the same reel (without intentional irony), the nearly nude chorus girls of the latest Lido show swinging high their shapely legs. In the cafés they chatted about Edward VIII's romance with Mrs Simpson and Baldwin's opposition to it; playing on the title of Musset's comedy, one wag remarked, '*On ne baldwine pas avec l'amour.*'

In Spain meanwhile the *Frente popular* had won the elections and a Republican government took office. The murder by left-wing extremists of Calvo Sotelo, the monarchist leader, brought to a head factional hatred and precipitated a civil war between the Republican government and the army headed by General Franco. The essential conflict in Spain was that between a democratically elected government and a military coup from North Africa using colonial troops.

Blum found himself in a dilemma. All his life he had stood for peace but he sympathized with the Republican government which, like his own, depended on Communist support. As the Republicans' situation worsened, he decided he would send them military aid.

At the Quai d'Orsay Léger was pursuing his policy of doing nothing to offend Britain. When he found that Britain objected in the strongest possible terms to Blum's proposed action, he persuaded Yvon Delbos, Blum's Foreign Minister, to oppose any kind of intervention. At a divided Cabinet meeting on 25 July Léger's advice, as propounded by Delbos, carried the day.

Léger then prepared a document calling on the great powers not to intervene in the Spanish war. This document of *non-immixtion*, approved by Blum, was circulated and promptly signed by Britain, Italy, Germany and Russia as well as by France, and no less promptly broken by Italy which sent 70,000 troops to General Franco; by Germany which sent the Condor Squadron to bomb not only military but civilian targets; by Russia; and also by France herself.

For Blum found within his own Cabinet and leading supporters a weight of sympathy for the Spanish Republicans which he could not resist. He therefore sanctioned secret military help. With Blum's approval Pierre Cot, his febrile Air Minister, smuggled at least 70 modern French military aircraft into Spain, including 39 new fighters. They went in crates labelled Mexico and Lithuania, but were in fact unloaded at Santander.

On the extreme Left individual Frenchmen supported the Spanish Republicans, most with words, a few with deeds. Breton explained rather apologetically that he did not volunteer to fight because he had just become the father of a little girl. Of the Surrealists only Joan Miró and the militant poet Benjamin Péret went to fight in Catalonia. There Péret found the real-life situation very different

from what it had seemed in Paris. The Madrid government was scaling down help to the radical Catalan government, and Péret blamed this on the 'bluff, intrigue and cowardice' of Russia, trying to gain control over the leftist parties. He was furious at Eluard, Aragon, Ernst, Tzara and Desnos for signing an open letter of congratulation to Russia for her role in the Spanish conflict.

Among the Communist intellectuals, one who did take part in the fighting was André Malraux. With the connivance of Cot he managed to get into Spain some new or fairly new bombers – twenty Potez 540s and ten Bloch 200s. With some of these, over a period of seven months, Malraux flew missions. He did not know how to navigate a plane or target bombs – which were tipped out by hand – but he won respect from the Spaniards by his drive and courage and was given the rank of colonel. Between missions in Madrid he expounded his Communist views:

> Tense as a spring [wrote the Madrid correspondent of *l'Humanité*], forelock covering one eye, a fag-end in his mouth, full of vocal tics, dressed in a careless elegant way . . . he fascinated the circle of people around him . . . speaking in French of great syntactical complexity and with a vocabulary that was never impoverished by a desire to be easily understood.

To Catholic intellectuals, at the opposite pole, the civil war appeared in a very different light. The Republicans burned or pillaged 2000 churches; they shot in cold blood hundreds of priests and nuns. To Bernanos, who had first-hand experience of Spain, Franco was waging a holy war not unlike that of Ferdinand and Isabella against the Moors. To Massis, self-styled defender of the West, the war was a conflict between European civilization and barbarism, Christian tradition and anarchy.

In Maurras's words, 'a sort of minor philosophic and religious war took place in the French press, each side striving to bring back the worst horrors from the fighting in Spain.' Old labels were envenomed with new overtones. But Bernanos for one soon abandoned his notion of a holy war as he witnessed atrocities by Franco's troops; thereafter he sought to rouse pity in France for the unholy infliction of suffering by both sides on women and children.

Blum's secret aid to the Republicans – 'elastic non-intervention'

as the Government called it – satisfied very few. The Communist leader, Thorez, denounced the Prime Minister for 'this juridical monstrosity that assassinates our Spanish brothers', while his counterpart on the Right, Léon Daudet of Action française, wrote: 'Blum is the noise made by a dozen bullets in the skin of a traitor.'

Senior army officers in particular were shocked that advanced planes, of which France was painfully short, should be sent to help foreigners, not a few of whom had mutinied against their officers and spat on the values cherished at Saint-Cyr. A certain Colonel Gabet was speaking for many when he was heard to remark – and later reprimanded for it – 'Similar events could very well happen here. If they did, I don't know which side I'd be on.' 'Disagreements between Frenchmen were stronger than their hate of the enemy at their gates,' wrote the Portuguese Foreign Minister.

In this disturbed atmosphere the Popular Front welcomed an opportunity for uniting people in a constructive and useful work. Plans for a major Exhibition in Paris had already been laid, but it was Blum's Socialist government that gave the manifestation its distinctive ideology and tone.

Paul Bastid, Minister of Commerce, announced that the Exhibition would express the many aspects of French life and show the latest achievements of art and industry. Forty-two nations would participate, not to vie with one another but to affirm a spirit of concord. Edmond Labbé, given overall charge of planning, was even more specific: 'The International Exhibition of Paris will be a Festival of Peace.'

A late nineteenth-century pseudo-Moorish building on the Trocadéro, a relic of the 1889 Exhibition, was demolished and in its place went up a vast building consisting of two low wings curving on either side of a central terrace, featuring fountains and statues mainly of nude women above a monumental staircase. The façades were sleek and simple, unfluted pillars without capitals supporting an almost flat roof.

In the centre of the terrace stood a Monument to Peace, modelled on Trajan's column, cased in green bronze, covered with olive leaves and bearing in letters of gold the names of the great apostles of peace. At its base in a plain semi-circular building over which flew the flags

of the participating nations an exhibition evoked the horrors of war and the efforts of those groups working for peace.

Fernand Léger, an active Communist, submitted a plan for setting 3000 unemployed to paint the façades of houses in central Paris, one street green, one blue, one yellow, with Notre Dame in blue, white and red, the whole to be illuminated by searchlights from aeroplanes. One wonders what his friend Le Corbusier, who declared, 'All houses should be white by law,' would have thought of the scheme.

The government rejected Léger's plan, preferring to spend money on a Pavilion of Thought, a Pavilion of Intellectual Cooperation, and a Palace of Discovery, where Maurice de Broglie and Leprince-Ringuet built a cloud chamber, current being generated by a reel of copper tubes circling the chamber. Here visitors could observe the passage not only of high-speed particles but also of cosmic rays, now known to be charged particles from outer space.

Paul Valéry, a friend of Blum, was given a prominent role. He served as vice-president to Edouard Herriot in organizing the Pavilion of Intellectual Cooperation, and was 'promoter and coordinator' of the exhibition in the Pavilion of Thought. The theme here was 'the transformation of life into an artistic vision', exemplified in particular by a visual biography of Flaubert: portraits, pictures of his Normandy house, excerpts from his novels.

Paul Valéry also drove home his point about the primacy of art in two inscriptions to be placed high above the Exhibition entrance. They are still there. One invites the visitor to treat the Exhibition as a treasure-house, not a tomb; the other reads: 'Every man creates as he breathes, without knowing it, but the artist is aware that he creates. He puts his whole being into what he does; the pleasurable pain it affords him gives him strength.' For the two inscriptions, totalling 58 words, Valéry received the handsome sum of 8000 francs.

Valéry's role at this period, both within and without the Exhibition, has an interest wider than the merely personal. As a lecturer he acted as successive governments' favourite apostle of peace, travelling regularly to central and eastern Europe to tell audiences dubious about the deep divisions in Paris that France was, and would remain, 'the temple of art and culture'. In these lectures all was Mediterranean light and classical grace.

Yet alarming events to which Valéry turned a blind eye by day had a way of intruding by night. After visiting Munich in November 1936 on his return from lecturing in Poland, he confided to the privacy of his Notebooks the following dream: 'I commanded a detachment of troops who must go to salute Hitler, and be inspected by him. Their uniforms resembled those of former times. I came out of a house to assemble my troops. "Get on parade," I cry. – Hitler is there, in the middle of my men. I wish to make a good impression but don't know the correct orders.' When Valéry tried to make his men form threes or fours, the results proved disappointing. The movement was done rather badly and Valéry left with a sense of embarrassment. But no sign of embarrassment was allowed to darken Valéry's activities at the Exhibition. *Optimisme oblige*.

Between the high ground on which stood the main Exhibition buildings and the Seine rose the Russian pavilion, dominated by a concrete and metal tower faced with Garzan marble, and topped by a gigantic statue of a young worker brandishing a hammer and a peasant girl holding a sickle. Opposite stood the German pavilion, its tower crowned by a swastika and eagle. Inside, a prominent place was given to the production of scientific books.

Both the Russian and German pavilions were completed on schedule. But as the Exhibition opening date, May 1, approached, Parisians became aware with dismay that the French pavilions were far from ready. Indeed on many sites no work was being done. On some the men had gone on strike and amid unopened bags of cement raised the red flag with hammer and sickle; from others the contractors had sent their men home.

What had gone wrong? Louise Weiss, who admired Blum's pacificism, nevertheless criticized him and his party for not having joined left-of-centre governments in the years of prosperity, so that now their huge social welfare schemes had arrived all of a sudden in a year of economic weakness. They were costing a great deal of money. France's deficit in the current year was 21 billion francs, double the previous peacetime high. In February Blum had been obliged to call a 'pause' on new wage increases and social benefits. This caused fury among workers who had been led to expect still more money from 'their' government.

Blum's changes had also hit very hard the cherished small family

firms. Paid holidays and a shorter working week had added twelve per cent to costs and forced many to close. It was anger, on both sides, that had slowed down or halted work, and led to a postponement of the opening to 24 May.

When President Lebrun inaugurated the Exhibition on that day, it was noticed that as the top-hatted cortège passed pavilions still unfinished and not yet open, some of the ambassadors giggled and exchanged knowing smiles. Only in mid-June were the public admitted.

They found in a prominent position a carefully-made replica of a typical French village. The houses were there, the *mairie*, the baker's shop, the butcher's, but where was the church? Every French village had its church but either by design or oversight the church had been left out. This pained and disturbed many visitors.

The public found two works of art deeply impressive for different reasons. One took as its subject a recent event. On 26 April 1937 German planes, acting on orders from General Franco, bombed the small Basque town of Guernica, killing 1,654 women, children and old people. World opinion was horrified. In Paris Jean de Pange was among those who signed a public protest with Maritain and Mauriac, while Picasso, who normally kept aloof from politics, expressed his outrage on canvas. 'In this painting,' he said, 'which I shall call *Guernica*, I clearly express my loathing for the military caste that has plunged Spain into a sea of suffering and death,' and he recalled that his whole artistic life had been an unceasing war against reaction and against the death of art.

Finished in June, *Guernica* took its place in the Spanish pavilion designed by José Maria Sert, husband of Misia. Three and a half metres high, seven and a half long, in black, grey and white Picasso treats his subject in terms of fragmented bodies, outstretched twisted hands, upturned open shrieking mouths. The instruments of this destruction are symbolized by the head of a bull and a stark electric light-bulb within a jagged-edged oval.

Guernica has come to be recognized as one of the most powerful indictments of war ever created and one of the most masterly paintings of Western civilization. At the time and in the context of an exhibition celebrating peace between nations, though its importance was recognized by the perceptive, Picasso's work was meat too

strong for some. Cocteau's friend, Jean Hugo, went to see it with Marie-Laure de Noailles, the rich lady who had commissioned Cocteau's *Sang d'un Poète*. Before this ultimate expression of man's cruelty to the innocent what they talked about was a lamp held high above the scene by an outstretched hand. Was it, they wondered, an oil lamp or an acetylene lamp? Overhearing their discussion, a construction worker said it must be an oil lamp, since acetylene lamps were not allowed into the building. This greatly amused the visitors, for evidently the workman believed the lamp in the painting to be a real lamp. Not a word about the victims depicted by Picasso. The incident, trifling in itself, illustrates yet again the way intellectual Parisians chose to focus on minor detail, partly as a way of avoiding a reality that posed too many grave questions.

The second painting, in Mallet-Stevens's Pavilion of Light, was a commissioned work. Raoul Dufy had been asked to produce the world's largest mural in celebration of *La fée électricité*. The choice of electricity was, to say the least, unadventurous, for a giant statue of the aforesaid *fée* had already dominated the 1900 Exposition. However, Dufy intended to depict the gradual discovery of electricity and its benefits from earliest times to the present by men of many nations. The size of the painting was to be ten metres by sixty, its colours the pinks, pale blues and yellows absent from Picasso's work but specially favoured by Dufy in the scenes of regattas and fashionable race meetings for which he was esteemed.

Dufy worked on separate panels of plywood, 250 in all, which were then assembled on the pavilion wall. At the top are the gods of Olympus, in the centre a fireball of electricity – ironically it dominates the mural as the explosive light-bulb dominates *Guernica*; below a suggestion of dynamos, flanked by figures to left and right, 110 in all, each with its name, from Archimedes to Edison.

The conception of *La fée électricité* is bold, its theme of international cooperation a worthy one. But the huge size demanded was too much for an artist like Dufy, whose gifts lay in delicate, small-scale works. There is a sense of strain, of a brave but unsuccessful attempt beyond the artist's powers. It is the dream of a great work rather than its implementation and in that sense encapsulates both the strength and the weakness of the Popular Front, which had intended this Exhibition to unite the nation behind its belief that war was not possible.

19

PADDLING OVER THE WEIR

In the year 1928 a young Frenchman arrived in Czechoslovakia to take up the post of director of the judicial and economic section of the French Institute. Hubert Beuve-Méry had been born 'in the shadow of Notre Dame', as he liked to recall, the son of a watchmaker. His parents were poor and it was financial help from friends that allowed him to complete his schooling. A famous Dominican preacher, Père Janvier, arranged further help so that Beuve-Méry could take a degree in international law. He began his career as a journalist for a leading Catholic periodical, *Nouvelles Religieuses*, later joining the editorial board. Shortly before moving to Prague at the age of twenty-six, he married a former fellow-student. In appearance he was tall and solidly built, shy, quiet but curious about everything, his favourite leisure pursuit long walks in the mountains. He belonged to the Dominican Third Order for laymen, of which Jacques Maritain, whom Beuve-Méry admired, was also a member.

Czechoslovakia had been conceived at the peace-table of Versailles and brought into being on French initiative. Its population of 13 million comprised Czechs, Slovaks, Sudeten Germans, Austrians, Hungarians and Poles. Some wondered whether such dissimilar molecules could bond, but a number of gifted Czechs, headed by Thomas Masaryk and Eduard Beneš, convinced the Powers that, as in Switzerland, their commitments to democracy would triumph over ethnic cleavages. Berthelot put it more arrogantly: 'People are so stupid that if you draw them a frontier they fill it with patriotism.'

Czechoslovakia made an encouragingly stable start as an independent state and attracted foreign capital. French industrialists

bought into the highly efficient Skoda heavy machinery and armaments complex, while the Czechs for their part were appreciative readers of Gide and Morand, well informed about Braque and Ravel. The best restaurants offered French cuisine, the smart shops Paris fashions.

Beuve-Méry warmed to Prague, quickly made friends and took on additional duties. He became technical adviser to the French Minister, a professor at the Czech Business School and a correspondent for several Paris newspapers. More important, by his intellectual integrity and keen grasp of political issues he won the confidence of senior members of the Czech government. When the President, Beneš, who was a Czech, clashed with the prime minister, who was a Slovak, more than once Beuve-Méry used his influence, legal expertise and tact to work out a solution acceptable to both.

By 1935 Czechoslovakia was the only country in southern and eastern Europe to retain a democratic form of government. But the continued existence of so small a country depended on her alliance with France. In that year France renewed her 1924 military pact with Czechoslovakia, extending it so that Russia too promised help should Czechoslovakia be attacked.

While this provided a certain degree of reassurance to Prague, Beuve-Méry noticed that his compatriots showed little interest in the country they had brought into being. Though beautiful Prague lay nearer to France than Nice to Paris, fewer than 8000 Frenchmen visited it in any one year. The French Government and French importers showed little desire to help a struggling young economy: as Beuve-Méry wrote in one of his articles: 'Why doesn't France buy from Czechoslovakia the hops, beer, woods, oils, graphite, paper, chemical goods which she now imports from Germany? Czechoslovakia offers the same quality and equivalent prices.'

As early as 1933 Beuve-Méry read *Mein Kampf* and studied the methods of the early Nazis. He concluded that the old danger of German expansion had become a mystique, was unamenable to reason, and must therefore be met by strength based on principles. He and Beneš agreed that Hitler meant what he said in his book, that he had aggressive designs on Austria, then on Czechoslovakia.

At noon on 24 July 1934, acting on Hitler's orders, ten Austrian Nazis, dressed in Austrian army uniforms, burst into Chancellor

Dollfuss's office, shot him and left him on a sofa, ignoring his pleas for a priest. At once Beuve-Méry travelled to Vienna in time to hear the poignant wireless broadcast in which Dollfuss, bleeding from the throat, announced his resignation, shortly before succumbing to his wound.

Two years later came the Rhineland crisis, during which among France's friends and allies only Czechoslovakia voiced emphatic and repeated determination to support France in every contingency.

Convinced that Germany would soon annexe Austria, thus placing industrialized western Czechoslovakia like a tasty morsel between German teeth, in 1937 Beuve-Méry travelled to Paris to sound the alarm. There he saw senior ministers, senior officials in the Quai d'Orsay and officers in touch with the General Staff.

As the consequence of his heavy spending Blum had fallen and been replaced by a Radical 'trimmer', suave Camille Chautemps. When Beuve-Méry asked Chautemps what he would do in the event of Hitler threatening Czechoslovakia, the Prime Minister seemed 'to fall from the moon and showed no more understanding of France's obligations than a junior official in the provinces'. Other ministers blamed Beuve-Méry for raising the question at all and thus sowing doubt in Prague.

At the Quai d'Orsay René Massigli of the political directorate, who was close to Alexis Léger, told Beuve-Méry that the Secretary General was doing everything in his power to get the politicians to make a firm stand, but much would depend on the attitude of Britain's prime minister Chamberlain. He advised Beuve-Méry confidentially not to put too much faith in the government's declarations of solidarity.

Daladier, Chautemps's Minister of Defence, told Beuve-Méry that he had made all necessary arrangements with the General Staff and would stand by them. But he declined to give any details, and from Army friends Beuve-Méry learned that plans to take joint action with Russia had stalled because Poland still firmly refused the passage of Russian troops.

Back in Prague Beuve-Méry thought it his duty to tell President Beneš, now a close friend, of this sounding and, should his doubts about France's attitude prove valid, to urge him to maintain a certain freedom of movement. As he listened Beneš grew pale and

then very angry. 'How dare you, a Frenchman, speak like that about your country? I know the history of France. She has never broken her word, and won't begin now. So what sort of game have you been playing?' From that day on Beneš refused to see Beuve-Méry, who nevertheless continued to visit Paris, acting like a gadfly in high places.

Early in 1938 Hitler increased his pressure on Austria, threatening invasion. Chautemps's government hesitantly warned Hitler against any change in the status quo, but was finding itself in grave financial difficulties occasioned by Blum's reforms, including a run on gold reserves. In order to get a majority in the Chamber Chautemps asked the Socialists to join him. They refused and on 9 March Chautemps resigned. On the 11th, a day when France was without a government, Hitler's troops crossed the frontier and took possession of the Führer's homeland. A new short-lived government, again led by Blum, addressed a note of protest to Germany, as did Britain, only to have them scornfully rejected as interference in Germany's 'internal affairs'.

The Popular Front being now a spent force, on 10 April a new government took office; Radical in name but effectively covering a wide political spectrum, it included such resolute patriots as Georges Mandel and Paul Reynaud. Those like Beuve-Méry who saw that France's security was now intimately linked to the survival of Czechoslovakia, expected from this new government, supported as it was by deputies of both Left and Right, a firm reassertion of France's treaty obligations.

It came as a shock therefore when on the very next day *Le Temps*, unofficial mouthpiece of the Quai d'Orsay, published on its front page a letter from an esteemed constitutional lawyer who taught at the Sorbonne, Professor Joseph-Barthélemy, a friend of Brunschvicg and others who still preached international arbitration of disputes, and a frequent writer of editorials in *Le Temps*. Entitled 'Troubled Conscience', the letter began with a number of honeyed compliments to Czechoslovakia, then continued:

Twenty years have passed and the country is still not unified. The problem is complicated by an ethnic tangle. A macedoine of peoples creates a macedoine of questions. Today we can put the

problem like this: In order to preserve the Czechoslovak state in its present form, a political mix of several nationalities, is it worth setting fire to the world? In order to maintain three million Sudeten Germans under Prague's Czech authority, must three million Frenchmen die: my sons, your sons, all the youth in our universities and schools, in our countryside, our shops, our workshops? Sadly but firmly I answer: No!

Joseph-Barthélemy then argued that the demise of the Locarno agreement had rendered legally obsolete France's treaty with Czechoslovakia, and concluded with a literary allusion:

For a cause lost in advance we should be honour-bound to smash our heads against a wall. France would be obliged to commit suicide. She has given her word. She has put her signature at the bottom of certain papers, like the character in Shakespeare. But instead of giving a pound of flesh, for no reason other than her honour, in a hopeless cause, France would have to shed hundreds of litres of blood . . . No cause in the world justifies France committing suicide.

Joseph-Barthélemy's letter had immense importance at the time in its effect on Parisian opinion, and because it was immediately translated on Goebbels's orders, to be widely circulated not only in Czechoslovakia but throughout the Balkans. Beuve-Méry for his part was horrified, all the more so since he acted as Prague correspondent for *Le Temps*. After three days' reflection he wrote a reply, as a rare declaration by an honourable Frenchman at a critical moment of history.

Cher Maître,
 I cannot refrain from telling you my feelings of shock and revolt at your latest article in *Le Temps*. Please permit me to do so in as much as we contribute to the newspaper, in Prague I am fighting in the front line and as a student I considered you an esteemed teacher and friend.
 You start by promising 'hard words'. Why then do you launch into a lyrical eulogy of Czechoslovakia, which you are abandoning to its sad fate? People here find that offensive. They have taken note of your regretful 'No', but beg you to spare them your

tender solicitude and the glass of rum offered to a condemned prisoner. When recently invited to a public meeting to scatter petals of eloquence and poetry on Austria's coffin, Mauriac in my opinion did the right thing when he replied that he preferred to bow his head and keep silent.

Beuve-Méry then took the professor to task for exaggerating German strength and French powerlessness. The French were in fact materially strong, but what good was a strong army once a nation has become 'cowardly and disoriented'? The true nature of France's powerlessness lay in the absence of national feeling, eroded on the one hand by bourgeois insouciance and on the other by Communism. Though there were no visible signs of it yet, Beuve-Méry believed that party hatreds could produce armed conflict such as he had seen in Austria and continued thus:

> In the event of war I will be called up and as the father of three sons I am glad to think that you want to save your children's lives and mine. But I fear in such a stance the false prudence and false realism which, abandoning one position after another, could lead to civil war, as a prelude to foreign war . . .
>
> For the moment, if your conscience is really troubled and if, as you say, you are not certain of always being right, for God's sake hold your tongue. It is not impossible that Czechoslovakia will end by being lost, like Austria. Lost without a war, through our fault . . . But do not shout to the Germans that the way to Czechoslovakia lies clear, that they can go straight there and that you are already feeling at the back of your eyes the discreet tear you will shed for Prague on the day it submits.

To this letter Beuve-Méry awaited a reply. Weeks passed, but none came. Worse, as Hitler's demands for 'his' Sudetens became shriller, the editor of *Le Temps*, Jacques Chastenet, came out openly in favour of Joseph-Barthélemy's betrayal. Furthermore, he refused to print any dispatch by Beuve-Méry unfavourable to the Germans.

Resignation on a point of principle was not a noticeable feature of French life in the 1930s but six months later Beuve-Méry went to see Chastenet and asked for as much freedom as *The Times* gave its Berlin correspondent. When Chastenet refused, he handed in his

notice. It was a painful moment but one from which, characteristically, Beuve-Méry drew strength. Solemnly, secretly, he pledged himself one day to start a newspaper that would respect and print the views of its journalists on the spot. Six years later the first issue of *Le Monde* would appear.

It was not Alexis Léger who promoted Joseph-Barthélemy's letter: Léger wanted France to take a strong enough line over Czechoslovakia to regain Britain's confidence and win that longed-for alliance. In order to understand how the letter came to appear we must look more closely at the government of the day.

In April 1938, after Blum's second ministry had fallen, deputies decided they wanted a prime minister who would face up to a weak economy and a worsening international situation. They chose Edouard Daladier, aged fifty-three, and he was probably the best available man for the job. With his furrowed brow, sad eyes and perpetually worried expression, badly turned out in crumpled jacket and trousers too long for him, he did not look like a leader, but then deputies had never wanted a leader in the usual sense. Daladier had other qualities: he was honest, intelligent, hard-working, a patriot, trusted by the man in the street. And he seemed to be strong in so far as a man could be strong within the limitations of French Cabinet government and his own past.

Describing his ministry as a 'Government in the service of peace and *la patrie*', Daladier sought in the first instance to foster national unity by healing the rifts left by Blum's instant Socialism. But he knew he was distrusted by the Right for his handling of the February 1934 riots and for having joined Blum in forming the Popular Front. Although he had a big majority in the Chamber, he could not govern without the support of bankers and industrialists. This was much in his mind when he came to fill the post of Foreign Minister.

The likeliest candidate was Joseph Paul-Boncour, who had urged a military riposte to Hitler's occupation of the Rhineland and had experience in the job; another was Georges Bonnet, who had never been Foreign Minister but had proved an able Finance Minister in Chautemps's government, taking the unpopular measure of raising income tax by 20%. Four months previously Bonnet had had friendly talks with von Papen, German ambassador to Austria, about a possible change in France's central European policy, and was

suspected of being an 'appeaser' – the term was now in use. But Bonnet, who came from the higher bourgeoisie, had excellent relations with leading bankers and industrialists, and this was what finally weighed with Daladier.

In appearance the new Foreign Minister was a gift to cartoonists, with an enormous nose, thin jutting chin and almost bald pate over which he carefully brushed his remnants of hair. He had married a pretty wife, Odette, with powerful family connections; ambitious that her husband should become prime minister, she was known as *soutien-Georges*, a pun on *soutien-gorge* (bra).

Despite his abilities, Bonnet was not popular, the reason according to a Cabinet colleague being that 'he suffered from an almost physical inability to tell the whole truth. There are always things held back and not made clear, so that finally no one knows how much truth there is in what he says and how much bluff.' The last word is noteworthy, and was to become a *leitmotif*.

It was Georges Bonnet who gave the nod for publication of Joseph-Barthélemy's letter, which so shocked Beneš and all Czechoslovakia's friends, and it was Bonnet who began to favour those at the Quai d'Orsay who wished to extend to central Europe the formula of non-intervention applied in Spain. In the corridors of power people began to ask whether these were the new Foreign Minister's first or last acts of appeasement.

Daladier took office on 10 April against the background of Hitler's increasingly strident demands for the German-speaking parts of Czechoslovakia. On the 27th he flew to London with Bonnet and Léger to test Léger's claim that England would back France in military action to defend her ally – a re-run, in effect, of France's 'little sister' role after the Rhineland occupation.

The British Government saw the new crisis differently from their French counterparts. England had no treaty with Czechoslovakia, and behind the safety of the Channel would not be imperilled by a German move on Czechoslovakia as France would be. Moreover, the previous summer Foreign Secretary Halifax had had friendly talks with Hitler, describing him as 'a Gandhi in Prussian boots', that is, stubborn but essentially a man of peace, and Halifax had told the Führer then that Britain was not opposed to gradual changes in central Europe. Chamberlain saw no reason why English troops

should involve themselves in what was essentially a French responsibility. He told Daladier that Britain would not join in military action to preserve Czechoslovakia.

Back in Paris, Daladier called in his Chief of General Staff. He asked Gamelin to 'specify the military action France could take against Germany and in support of Czechoslovakia, on the basis that mobilization is only the first step'.

Gamelin still clung to his view that Germany would expand eastwards and would not attack in the West, provided France made no move against the Rhineland. He expected Poland to come to the defence of Czechoslovakia, whereupon France could send an expeditionary force through the Balkans in support, but this would depend on agreement by Italy. To shore up his opinion he convinced himself – in the face of contrary evidence from intelligence sources – that German fortifications in the Rhineland – the Siegfried Line – were now so far advanced as to preclude any French offensive against them.

True to form, Gamelin did not give a direct answer to Daladier's question. 'The power of our offensive,' he told the Prime Minister, 'will depend on whether or not the attitude of Italy requires us to leave forces in the Alps and North Africa. The effectiveness of aid to Czechoslovakia also depends on the aid which could eventually be furnished by ... Romania and Yugoslavia, the Soviet Union, Poland and the British Empire.' These, he said, were questions for the diplomats to decide. Finally, in a monumental piece of responsibility-shifting, he declared that the important factor in the present situation was the air force, and that was in the hands of General Vuillemin.

Since the decision in 1933 to build hedgehog planes, France's air policy had followed a zigzag course. In 1934, when it became clear that Germany was beginning to build a powerful air force, France put in hand a programme of 1500 fighters and bombers. But the old impediments of the prototype system, almost no mass production and an inspectorate concerned with minutiæ hampered delivery. From 1933 to 1937 only 68% of military planes ordered were actually delivered.

The 340 bomber, for example, was ordered from Amiot in 1934. Six different versions were built, with four different motors, and still

the Inspectors were not satisfied. In 1937 a version was finally approved, but more than twelve months were then spent discussing whether it should be built by the Amiot company or the Nord company. Even by spring 1938 the first 340 bombers had not been delivered.

The Air Ministry, as we saw, had responsibility for building civil as well as military aircraft. Up until 1936, in line with government disarmament policy, one third of production went on civil aircraft. In 1936 Pierre Cot adopted a plan for a fleet of prestige transatlantic seaplanes: no less than eight prototypes were commissioned from five firms, and this at a time when the air force was complaining about non-delivery of urgently needed bombers and fighters.

In 1936 Blum nationalized the aircraft industry, which was expected to prove a panacea by providing much-needed funds. What it amounted to in fact was that the State bought the aircraft factories, but management remained the same, slowed down now by platoons of civil servants. Production methods also remained the same. As a result, for France's air force the year 1937 was to prove virtually an *annus non*. While in that year England produced the Gloster Gladiator and Hawker Hurricane I, and Germany the Messerschmitt Bf 109B, France produced no new fighter, and her only new production bomber was the Farman 222, of which 36 were built: with a maximum speed of 199 m.p.h. the Farman compared unfavourably with the Heinkel He 111B (230 m.p.h.), launched a year earlier, of which some 300 were already delivered.

Only a man of outstanding gifts could have overridden so many obstacles. General Vuillemin, commanding the air force, was not such a man. He had had a brave war but he lacked executive ability and, like Gamelin, had a passive character. Nor was he over-astute. In August 1938 he was invited to Germany to watch Luftwaffe manœuvres. In a modern version of Potemkin's villages, the best German planes were switched from one base to the next to appear several times with different registration numbers. Vuillemin was taken in.

When Daladier questioned Vuillemin about the role his air force could play in the event of a confrontation with Germany, Vuillemin replied that his planes could not protect Paris, could not protect mobilization, and could not provide reconnaissance for the army. He

added that in the event of war all his planes would be destroyed in a fortnight.

This was indeed a gloomy picture. France could best compensate for inferior numbers by forging superior weapons, with, as Colonel de Gaulle had urged, the emphasis on speed and mobility; and billions had been spent in the hope of providing superiority in the air. It says much therefore for Daladier's courage that he decided to honour France's alliance within the limits of the possible. Poland was still refusing the passage of Russian troops, so France would mobilize along the Rhine in order to hold enough German troops there to deter them from attacking Czechoslovakia, and if Germany did attack her small neighbour French troops would make sorties into the Saar.

In an important speech on 12 July Daladier declared that 'our solemn guarantees to Czechoslovakia are inevitable and sacred,' and that 'he possessed the will never to go back on our word.'

The mood in Paris ranged from anxiety to alarm, Daladier's stand winning guarded praise or criticism, according to party allegiance, the Communists, on Moscow's orders, supporting a strong stand. In this connection it is noteworthy that 'constant messages' from the German General Staff encouraging France to resist Hitler's claims against Czechoslovakia and declaring that the Nazi regime would collapse in case of war were suppressed by the French ambassador, François-Poncet, who did not report them to the Quai d'Orsay because he believed 'that their origins made them suspect and that they might unduly strengthen the hands of the warmongers in France'.

Warmongers were certainly not evident in Paris, where people were becoming alarmed about attack from the air, though doing little about it. At meetings of the municipal council the Left opposed any air raid precautions as a pretext for 'militarizing' the working class and bringing war nearer, while the Right insisted that speedy evacuation of civilians could be safely achieved only by constructing a vast system of underground motorways. Earlier, Jean de Pange noted in his Journal: 'A police sergeant calls and asks if I would like to resume my rank as an officer and take part in ARP exercises.' Pange was a good patriot but he replied: 'Time enough should war come.'

That was far from being Daladier's attitude. He had kept for himself the Ministry of National Defence and War, which he had already held from 1932 to 1934, and he chose to work from the Ministry building, formerly the house of Napoleon's mother, in the rue Saint-Dominique. Now quite knowledgeable about military matters, he spent long hours with senior officers cutting through red tape and speeding the supply of needed equipment. Because of his poor showing during the Rhineland crisis and more recently in May, General Gamelin had detractors in the High Command and they urged Daladier to remove him, but this he declined to do on the grounds that there was no suitable replacement. The truth is that he shrank from sacking people, his experience with Chiappe being still a painful memory.

'*Auguste* – imposing' – so friends described their hard-working prime minister, but *Auguste* was also a colloquial name for Coco the clown, so Daladier's enemies were able to make the compliment backfire. For the former history teacher, now that he had become eminent, decided to take up riding, and on Sundays could be seen astride Blanco, trotting heavily beside a lady friend, the petite and plump Marquise de Crussol. Heiress to a tinned sardine fortune, married to an impoverished nobleman, the marquise saw herself in a political role. 'The sardine who thinks she's a sole,' tittered Parisians, on account of her lack of discretion and her noisy quarrels with Hélène de Portes, the ambitious mistress of Paul Reynaud, Daladier's rival. The marquise played only a small part in Daladier's life but she did not help the image he wished to project, of a strong man working outside the factions to restore national unity.

On Bastille Day Daladier organized a bigger than usual military parade centred on the Arc de Triomphe. Then, in that anxious summer, came a short agreeable interlude, a state visit by George VI, described in an Italian newspaper as 'the new king of the crown colony, France'. Madame Bonnet busied herself retrieving Napoleon's vermeil dinner service from Malmaison and installing a marble bathroom for the royal couple. Dinner at the Quai d'Orsay was followed by a visit to the garden, illuminated, said André Maurois in *Le Figaro*, by 'the magic wand of Titania'. The party went well, Paul Morand writing to Madame Bonnet: 'Thank you both for one of the most beautiful evenings ever seen in Paris.' At

another entertainment Yvonne Printemps and Maurice Chevalier contributed cheerful songs, but the *entente cordiale* of Edward VII's day was notably missing, for the good reason that, Léger excepted, almost no one highly placed on either side of the Channel had worked to revive it.

Léger meanwhile was giving Daladier full support. He repeatedly assured the Czech minister in Paris, Osusky, that France would honour her engagements. But behind his back the appeasers were at work. Both Osusky and Léger's private secretary, Crouy-Chanel, happened to like the French *fauve* Friesz. One day they went to an exhibition of Friesz's paintings. Osusky appeared troubled and said that Bonnet had told him France would not be able to honour her promises. Had the Foreign Office changed its policy? 'Certainly not,' said Crouy-Chanel and did his best to reassure the minister, while Léger, informed and very angry, took precautions that Bonnet should not communicate independently with Prague. Bonnet, meanwhile, tried – though unsuccessfully – to get Beuve-Méry sacked from his job in Prague, where he had become the driving force in strengthening Franco-Czech solidarity.

On 13 September, a day when a staged uprising of Sudetens caused seven deaths, obliging the Czech government to proclaim a state of siege, Bonnet was found by the British ambassador to be in a state of 'sudden and extraordinary collapse'. He had just had a visit from Colonel Lindbergh who, arriving from Germany, told him that Hitler possessed 8000 warplanes, was building 1800 a month, and could pulverize British and French cities. Lindbergh's figures were exaggerated – Germany had 3,200 front-line planes and was producing 700 a month – but Bonnet found in them further justification for a policy chosen long before.

On the 23rd Czechoslovakia mobilized her army and on the following day Daladier called up 100,000 reservists. Among those who took the train for the frontier was the writer Henri Massis, a reserve lieutenant. 'Officers and men drank their ration of wine together, vowing to smash the dictators,' but he noted that the men sang the *Internationale* and *A bas les cent familles!* Pange, meanwhile, wrote in his Journal: 'Will we go to war for the Czechs when we did not lift a finger over the Rhineland?'

Britain meanwhile was looking for a peaceful solution and found

in Bonnet a willing associate. An Anglo-French plan was drawn up calling for concessions to Hitler and submitted to Hodža, the Czech premier. For three days Hodža and his ministers agonized whether to accept it. Finally Hodža rejected the plan, but told the French minister, Lacroix, that if France should decide not to take military action alone, that is, without England, he would reconsider the plan.

Daladier learned this in the early evening. He wished to hold a Cabinet immediately but his ministers were at home or elsewhere – Georges Mandel the warmonger and German-hater in a suite at the Ritz with his latest actress friend, Berthe Bovy – so he called the Cabinet for eleven next morning.

As Pange had foreseen, one act of appeasement facilitates a second. Bonnet feared that a majority in the Cabinet might back Daladier or that Hodža might change his mind, so he telephoned that night by a public line to Lacroix, ordering him to go at once to Hodža and inform him that France would not fulfil her engagements without England. Lacroix did this, whereupon Hodža accepted the Anglo-French plan. But the telephone line, which ran through Germany, was being tapped. From that moment Hitler knew that the French were bluffing.

Daladier discovered Bonnet's duplicity and was furious. He considered dismissing him but since to do so in mid-crisis would further weaken the French position, he let him stay. When he flew to Munich a few days later, however, he left Bonnet in Paris and took Léger with him.

At a dinner during the Munich conference one of the embassy secretaries listened to a sad-eyed Daladier voice his dilemma: 'Is it better to give up our influence in central Europe or to sacrifice three million Frenchmen?'

The terms into which Daladier put his choice are noteworthy. He does not speak about preserving Czechoslovakia, or France's solemn promise to stand by her ally, which he himself had endorsed in July. He sees the choice solely in terms of France's interests – but in a curiously myopic way. He cites France's influence in central Europe, but by 1936 that had fallen to zero, while in specifying casualty figures he repeats Joseph-Barthélemy's figure of three million, which was entirely guesswork.

In the event Daladier, with Chamberlain, agreed to Hitler's demand

for the Sudeten region. He then flew home, fearing a rough reception from a crowd who, he believed, would feel as ashamed as he did. To his astonishment the thousands of Parisians gathered at Le Bourget gave him a tumultuous welcome. He drove from the airport in an open car to Paris with Bonnet beside him, Daladier's face like a mask of tragedy, Bonnet's all smiles.

Those faces represented the two faces of France that autumn, as Czechoslovakia was dismantled, the Poles, whom Gamelin had dreamed would lead resistance to Germany, seizing the coal-rich Teschen region. Most apparent was the smiling face, smiling on several counts. For the little man, hero of so many films, would not after all be marched away; young lovers, celebrated in so many songs, would not have to part; the café saxophone and accordion would not be drowned by bugle and drum. *Paris Soir* hailed Chamberlain as 'the angel of peace' and opened a subscription to buy him a house in the trout-fishing Basque region. Jean Cocteau voiced a more selfish view: 'Long live the shameful peace!' – one more sign that life was amusing paradox. To an American correspondent, William L. Shirer, Paris that October seemed 'a frightful place, completely surrendered to defeatism with no inkling of what has happened to *France* . . . Even the waiters, taxi-drivers, who used to be sound, are gushing about how wonderful it is that war has been avoided, that it would have been a crime, that they fought in one war and that was enough. That would be okay if the Germans, who also fought in one war, felt the same way, but they don't.'

As winter closed in, the graver face became more evident. The airman-novelist Saint-Exupéry beat his breast in *Paris Soir*: 'When peace was threatened, we discovered the shame of war. When war seemed averted, we discovered the shame of peace.' And what had led a nation that believed itself great to behave shamefully? People began to look back on the past two decades and to ask, 'What went wrong? Who is to blame? Or is no one to blame?' Their questions and answers call for a new chapter.

20

GROPING FOR UNITY

On a cold Sunday in January 1938, seated before a log fire in the Parliament building, one of the most respected deputies in the small centre party, Desgranges, discussed with the president of the House education committee the large grant being made for school films which, they agreed, were not strictly educational, and from there went on to the national radio.

> Our French radio [wrote Desgranges in his diary, reporting the conversation] practises a praiseworthy eclecticism. It gives us the socialist ideal in Jaurès, Communist mystique in Gorky's *La Mère*, Protestant puritanism in Pierre Loti's tragedies, the attractive figure of Christ in *Dieu vivant*. For small groups of French people, young and old, gathered round two million sets, the result is a jolly sort of scepticism. Programmes go round all the cults without adopting any. In the absence of conviction, nothing is left but the attraction of self-interest. That is how a people allows itself to be corrupted and lost.

A more radical explanation was offered by Marshal Pétain when as guest of honour at a banquet in December 1934 he addressed an audience of leading intellectuals including Brunschvicg, Joseph-Barthélemy, Mauriac and a dozen Academicians. Speaking, he stressed, as a civilian, he claimed that France's educational system had slipped away from its original purpose as defined in 1870. Its present goal was the development of the individual considered as an end in himself. Certain teachers aimed openly at destroying the State and society. 'Such men bring up our sons to ignore or to scorn the *patrie*.'

Pétain had in mind not only declared pacifist teachers such as Alain and Guéhenno, but André Gide, who encouraged an attitude of *disponibilité* – opting out of social duties – and the Surrealists who, by different methods, tried to ridicule patriotism.

Pétain went on to compare the situation at home with that in Germany, Italy and Russia. While rejecting the solutions there applied, he said that he had to point out that modern war involved the whole nation and therefore demanded thorough preparation at the moral level. Links should therefore be strengthened between schools and the army. There should be more physical education and character-building. He concluded by stressing an urgent need 'to convince teachers of their responsibilities to the State, to establish a charter of patriotic teaching in schools, to monitor such teaching throughout the nation, in short, to spell out everyone's duties.'

Another soldier made a different analysis. In June 1937, the day after Blum's government fell, de Gaulle said to a lawyer friend:

> In our social conflicts it has always seemed to me that the motive was much less 'greed' than 'jealousy' . . . In the 'little man' this jealousy becomes envy; in people higher up it takes the form of pride: *'Noli me tangere!'* The question of more money (salary, profits, holidays, etc.) would be quickly solved if something could bring both sides together morally. That something one has to admit has been found by Fascism, by Hitlerism too; nevertheless, how could we accept a social balance paid for by the death of freedom? What is the solution? Christianity admittedly provided one. But who will discover a solution valid for today?

Where de Gaulle senses a lack of general cohesion, Beuve-Méry identifies a particular moral failing. By the early 1930s, he was shocked to discover, many Parisian journalists were selling their pens. In Bucharest he watched King Carol preside over a gathering of foreign correspondents, at which his chamberlain handed each a gift-wrapped box: 'Embroidered lingerie for your wives, gentlemen!' at which the correspondent of *L'Intransigeant* raised his hand and with a roguish smile asked for two boxes: 'One for my wife, one for my little friend.' In Bulgaria the government director of information handed Beuve-Méry an envelope crammed with bank notes. When the Frenchman declined it coldly, the other gave a pinched smile

and, opening a drawer of his desk, showed him a list of French journalists who regularly accepted his government's money.

Back in Prague Beuve-Méry gave dinner to the brothers Jean and Jérôme Tharaud, famous roving correspondents who had been covering the Abyssinian war. They described to Beuve-Méry the atrocities they had seen, the sufferings of women and children.

'Is it true,' asked Beuve-Méry, 'that Italian troops have been using mustard gas?'

'Certainly.'

'We never read anything about it in your articles,' interposed Madame Beuve-Méry.

'Ah, Madame, our articles are written in return for travel facilities. What counts are our books.'

A fifth explanation of France's plight came in a book that certainly counted, for it caused a furore. This was *Bagatelles pour un massacre* (1937) by Céline, in which the novelist claimed first to identify a physical cause:

> The massacre of the whole French race by alcohol is one of the main causes of a general flabbiness ... of this great anæmia, sterility, banality, boredom, of this total lack of inspiration, this effeminateness, repetitiveness, malicious gossip, the pettily vindictive compound of most unfortunate defects, which for almost a century have marked France's intellectual output. The Frenchman is the only living being under the sky, animal or man, who never drinks pure water ... He is so perverted in his tastes that water now seems to him harmful. He turns away from it as from a poison.

On this mass of servile creatures, weakened by centuries of alcohol, by petty squabbling and by hatred there descend the Jews:

> To hack at this French mud, to rummage in it, to extract all the juice, all the gold, the profit, the power, is for the Jew a princely game ... The slave approaches him, stumbling, worn down by his fetters. It's enough to tread him underfoot. The white man, the Frenchman especially, comes to loathe everything that reminds him of his race. He won't have it at any price ...

298

Everything that lacks the Jewish hallmark, that doesn't stink of Jew, is today dismissed by the Aryan as lacking in taste, reality, flavour. He insists on Jewish bluff, Jewish greasiness, Jewish flashiness, Jewish crookedness, Jewish imposture, Jewish level-ling, everywhere so-called Jewish progress . . . Everything simple and straightforward in his own Western nature arouses instinctive suspicion and hatred of such ways, but he rises against these tormenting phantom feelings, ceaselessly twists and turns until he routs them. Truth and simplicity now appear to him repulsive . . . A total inversion of æsthetic instincts . . . Propaganda and advertising have made him deny his true rhythm . . . What he looks for in the cinema, in books, in music, in painting is grimace, artificiality, convolution, Afro-Asian contortion.

Such a people, Céline concludes, will one day suffer defeat and be served up in their own wine sauce.

This denunciation – and it fills two hundred pages – needs to be quoted, since it shows how an intelligent man, afflicted by the plight of his country but feeling himself incapable of doing anything to put it right, betrays his own better self, not like the Frenchman in his tirade by swallowing Jewish values, but by swallowing Goebbels's anti-Semitism and even calling for pogroms in France. It illustrates also, in pathological form, a common attitude of the situation in 1938: putting the blame on others.

Of these examples by clever men trying to find causes for France's failure to preserve peace in Europe, the first is fairly oblique; de Gaulle's is a question rather than an attempt at an answer; Pétain's is cogent but does not go far, while Céline's indictment of alcohol, while interesting, cannot be taken seriously. None goes very deeply or generally into France's failings, and it has to be said that in this they are typical. Clever French men and women were not generally reflective about such matters, perhaps because, at a time of alarm, it can be very painful to lay bare failings and admit to being in the wrong.

During the inter-war period two presuppositions in particular I believe underlay much of the thinking and decision-making. In

trying to identify the first it will be helpful to recall that trio of Parisian philosophers, Brunschvicg, Bergson and Valéry, who taught that mankind has a built-in drive – intellectual, biological or both – to agreement, fraternity and eventual unity, while remaining silent about impulses to dominate and evil generally.

According to their line of thought the natural condition of man is peace. Peace is not something that has to be strained for, week in week out, with many sacrifices; it is present already. It is a right, as vital as the right to bread, Briand told Louise Weiss in 1924. All wish to preserve it and by the exercise of intelligence can preserve it. This view was reinforced by film, theatre and song.

In preserving peace intelligence must go hand in hand with optimism. In a rare interview in 1935 about France's foreign policy Léger declared:

> [Optimism] is a basic instinct for organic well-being. Pessimism is not only a fault against nature, it is an error of judgement as much as a form of desertion. It is the sin against the Spirit, the only one that is unforgivable. No reason to make it a French sin.

By using *esprit* ambiguously to mean both mind and the Holy Spirit Léger takes the Christian condemnation of the man who knowingly rejects truth and uses it against pessimists. Any who would doubt Léger's assertion that France would remain safely at peace within its network of alliances was committing a sin against intelligence.

Léger's is admittedly an extreme position but it illustrates how humanism could blur or displace moral considerations and discount evil. It influenced even those who believed in values superior to the merely human. In March 1937, preoccupied by the deteriorating international scene, Jean de Pange re-read his Journal of ten years earlier and drew this conclusion:

> I tell myself that where I have failed from the intellectual point of view is that I have not meditated on the problem of Evil or arrived at the conviction that it really exists. My easy life has led me to consider it as a deficiency rather than as the supreme reality.

The dangerous effects of optimistic humanism at the national level

300

become most evident from the mid-1930s. When your neighbour talks threateningly, even dæmonically, you conclude that he cannot be in earnest. When Daladier threatens to go to war for Czechoslovakia, knowing that your fellow-countrymen are peace-loving, you conclude that Daladier is bluffing. When in fact no war results, you will be fortified in later believing that Hitler's demands on Poland may also be bluff.

Towards the end of the 1920s, when the euphoria of victory wore off and hard economic times set in, the shortcomings of French society came under scrutiny. Many found the prevailing humanism unequal to the scale of the problems. Out of self-laceration and sometimes near-despair they fell back on a second presupposition, utopianism. We have seen the utopianism of a Communist society, the utopianism of the Monarchists. These turned men's minds away from trying to resolve very real difficulties; in one sense they were acts of betrayal towards real-world France. Furthermore, being mutually exclusive, they set one group of Frenchmen fiercely against another.

Then there was the military's belief in the Maginot Line and pacts that need not be strictly honoured by France – these were equally, though in a different way, utopian. So too were the Air Ministry's repeated assurances to the government, backed up by long columns of statistics, that France, one year or at most two years hence, would possess thousands of modern bombers and fighters: planes which not only were not built but which, given cottage industry methods, could never have been built. This kind of utopianism is not far from Breton's trust in fated coincidences and Dali's portrayal of his dreams as reality.

I believe a third important factor in France's failure to ensure peace in Europe is less a presupposition than a limitation. It was pinpointed in a conversation between Henri Bergson and Jean de Pange in February 1937, when the Nobel laureate characterized Frenchmen of his day as 'so full of their own ideas they cannot understand foreigners'.

The Europe devised at Versailles was only one of many possible Europes. To flourish, indeed to survive, it would require to be constantly invigorated by and from Paris. But in Paris the intense individualism of the philosophers and artists manifested itself

collectively: Parisians occupied themselves fully with their own concerns, notably the production of beauty, art, wit and entertainment. The energy that might have been directed abroad was turned inwards. Paris, in short, chose to be self-centred. And this apparently succeeded, for why else would so many of the discerning from all over Europe come to live and work in the city of light?

So absorbed were they by their own dazzling achievements that Parisians rarely travelled abroad. According to a shrewd Belgian observer, Charles d'Ydewalle, 'they treat all Europe other than Germany as part of France': an attitude that becomes less puzzling when we recall that in many countries the intelligentsia spoke French.

'We must learn how to escape from ourselves,' Pierre Viénot had pleaded in 1931, 'understand things that are different from us.' His plea fell on deaf ears. Everything was referred to France, even at the expense of the facts: the Joliot-Curies were given sole credit for having unveiled the atom's secret, no mention being made of the great pioneer Rutherford, while in a very different field Josephine Baker of St Louis had been accorded a new birthplace, the French West Indies, and French parents. Even those shaping foreign policy, such as Herriot, Léger and Blum, clung to a static, French-centred concept of this or that foreign country, instead of revising their attitudes in face of a dynamic, fast-changing reality that took less and less account of France. Maurice Gamelin, too, falls under Bergson's stricture: to take only one example, at a time when Mussolini was moving closer to Hitler, he maintained that in any future conflict the Italians would choose the course most agreeable to France: remain neutral and thus make possible a French riposte in eastern Europe.

In so complex an issue as France's shirking of international responsibilities many factors combined. I have proposed three that seem to be particularly important, but it is a matter about which readers will wish to make up their own minds.

In the winter of 1938–39, after their immediate post-Munich euphoria, Parisians began to bump down to reality. A very strong and ruthless power had expanded territorially at the expense of small nations and appeared set to continue that course. France,

morally and perhaps also militarily unprepared to fight, had twice shirked confrontation and now, it seemed, must take a decision: had the risk to her national survival become so great that she must indeed fight an unwanted war, or should she continue to try to buy peace with concessions?

Jean de Pange, in the aftermath of Munich, blamed Berthelot for creating Czechoslovakia in the first place; Berthelot, he wrote in his journal, should have opted for a Danubian federation as he, Pange, had proposed. He then went on to blame Beneš for having treated minorities less than fairly: 'no one can regret Beneš's disappearance.' Pange in short saw France's foreign policy since 1919 as a huge mistake, and so the question presented itself to him, and to moderates like him, in these terms: how far do you go in defending a mistake? Is honour worth dying for when it is others, not the politicians, who will do the dying? This takes us straight into Shakespeare's *Henry IV, Part I,* and the points of view expressed by Hotspur and Falstaff. For the moment Pange could not see his way to choosing between them.

The Catholic hierarchy likewise found itself unable to answer the question, and individual Catholics felt free to answer according to their interpretations of Christ's teaching. Beuve-Méry, ready to lay down his life for a friend, urged military resistance if necessary to any future demand by Hitler.

The abbé Mugnier gave a different answer. Esteemed by numerous friends for his honesty and unselfishness, Mugnier spoke for many peace-lovers when he said that the thought of going to war for another country made him sick. '"We have promised," people tell me. Well, let us break our promise. This business of honour is a hangover from a stupid, narrow classical education. It smacks of Plutarch's *Lives.*'

While respecting the abbé's opinion, we may question his analysis of classical education. When he was at secondary school in 1869, it did indeed centre on Plutarch; in succeeding generations, however, it narrowed to mythology and æsthetics. Valéry the poet chose to write about Narcissus, Cocteau about Orpheus, while Giraudoux brought to the stage pacifist Greek generals. Valéry the European lauded Euclid and the Parthenon, others Praxiteles, but amid the panegyrics no one thought fit to notice that if the arts and literature

flourished in Periclean Athens it was only because her citizens decided to fight for their freedom against the massed armies of Persia and later against Sparta, the archetypal figure being Socrates on active service standing sentry in bitter frost at Potidæa.

Even at this late stage very few sought to discover the true nature of Nazism. Whereas in the early 1920s a large section of the press had treated prostrate Germany as incurably militaristic, in the late 1930s paradoxically the vast majority of Paris newspapers avoided printing stories that might show Germans as other than peace-loving.

One of those who sought to discover the facts for himself was Roland Dorgelès. After demobilization Dorgelès had returned to a literary career. He wrote plays, stories in the mood of René Clair's film *Paris qui dort* and travel journalism. In his spare time he boxed and ran a charity that helped *grands mutilés* from his old regiment. At a performance of *Madame Butterfly* he fell in love with the lead singer, Hania Routchine, daughter of a Russian immigrant cabinet-maker, a warm-hearted lady eager to see the good in others: as Dorgelès put it, 'Hania pays compliments to a pickled herring.' He married her in 1923. They were both thirty-eight and had no children but the marriage proved a success.

Dorgelès was a Catholic who did not practise and a patriot who did not vote, not like Cocteau from irresponsibility but because he saw politicians as promoters of a Left-Right divide. He himself took a centre position. While denouncing particular injustices he had witnessed on a visit to Indo-China he unequivocally rejected the fashionable solution of Communism. As the most popular member of the Académie Goncourt he used his influence to get the Goncourt prize for *La Condition humaine*, though its author, Malraux, was a militant Communist.

The point of difference between Dorgelès and most Parisians who through their writing influenced opinion is that Dorgelès travelled abroad. He regularly got away from the intellectual hot-house, thick with stock phrases and prejudices. And so he saw France and France's neighbours from outside. In 1933, at a public meeting presided over by Albert Einstein, he spoke from the floor on behalf of the persecuted Jews of Germany, the first French writer to do so. That was the year when Ernest Hemingway, another Parisian – by

adoption – who also travelled abroad, wrote to his wife: 'I hate Hitler because he is working for one thing: war. He says one thing with his mouth and does another with his hands.'

In the summer of 1936, at the height of polarization, Dorgelès decided to go and see for himself the so-called utopias his contemporaries preferred to their own country. Accompanied by Hania, who had fluent Russian, he travelled off the beaten track in the Soviet Union, then to Berlin, Munich, Austria, Hungary and Italy, where he met Mussolini. Dorgelès asked the Duce why Italy didn't conclude an alliance with France, to which the other replied with a hint of sarcasm, 'Which France?', later claiming that the French were in tow to England. 'France has the world's strongest army,' said Dorgelès stoutly, but this, he noticed, seemed to make no impression.

The most overwhelming experience of Dorgelès' journey occurred when he re-entered France. There, after four months in an atmosphere of spiritual oppression and lies, he was at last able to breathe the pure air of freedom. He felt a sense of release and also surprise that for so long he had taken it for granted.

Gathering his notes, Dorgelès arranged them around the theme of liberty stifled, half the book going to Russia, half to the other four countries. Though methods might vary from one to another, the end-result was the same in all: truth stifled by an all-powerful State, men reduced to servility. The point about France, therefore, the paramount point, was that he and everyone else were free to express their views. So Dorgelès gave to his book the title *Vive la Liberté!*

But this privileged possession carried with it responsibilities. 'In the countries where I travelled,' he wrote, 'enslaved peoples turn their eyes towards us, envious eyes full of anguish, eyes full of hope.' Dorgelès' message was all the stronger for being implicit: We must be ready to defend that precious possession, not only in our own interests but also in those of our less fortunate neighbours.

Dorgelès knew that in putting such experiences and conclusions before the public he would be swimming against the tide. It was quite in order to laud Russia or to laud strong government as practised in the dictatorships; it was quite in order to castigate Stalin or to castigate Hitler and Mussolini; what was inadmissible was to castigate Russia, Germany and Italy all at once, and what was naïve beyond the bounds of belief was to claim that France all the while had

been holding in her hand, and was still holding, the torch that lights the world.

Vive la Liberté appeared in 1937: in effect an alarm bell, but one which the Paris press, with a few exceptions, chose not to hear. The book satisfied neither Left nor Right, and its message that liberty might have to be defended in battle displeased a still pacifist public opinion. 'Monsieur Roland Dorgelès,' one reviewer declared, 'is advocating another Franco-German butchery. That will allow him to write another masterpiece.'

But if his book was ignored or scorned by the factious, it did find readers, as every truthful book will do, and many of those readers wrote to the author, no less than eight hundred in all. They wrote to tell him that he had dared to put into words a central and vital truth, long obscured by the petty bickering of partisan politicians and intellectuals and by the fantasies of discontented utopianists: that tyranny will not rest until it has crushed all freedom, and that France's dilemma now was no longer whether she would risk war to save peace, but whether she would fight before it was too late in order to save freedom.

Another who found his way through fantasy to the real world was Robert Desnos. As a producer and writer for French radio the former Surrealist received letters from a cross-section of listeners across France, and it was these that helped to open his eyes to what was precious in a country so fiercely derided as unlovely. In 1936 he asked, 'What do we find in the poets who call themselves the flower of intelligentsia? We find that they have been weeping. Now, one doesn't go weeping to battle if one wants to win. One goes singing, and song is absent from French poetry today.'

Desnos provided several good poems to fill the gap; one of them, '*Chant pour la belle saison*', expresses a plain patriotism in simple language. It begins:

> This evening I am singing not about what we should fight
> But about what we should defend.
> The pleasures of life.
> The wine we drink with friends.
> Love.
> A fire in winter.
> A cool river in summer . . .

And closes with these lines:

> The freedom to go where we choose
> The feeling of dignity and many more things
> Forbidden to other men.

> *Je chante ce soir non ce que nous devons combattre*
> *Mais ce que nous devons défendre.*
> *Les plaisirs de la vie.*
> *Le vin qu'on boit avec les camarades.*
> *L'amour.*
> *Le feu en hiver.*
> *La rivière fraîche en été . . .*
> *La liberté de changer de ciel.*
> *Le sentiment de la dignité et beaucoup d'autres choses*
> *Dont on refuse la possession aux hommes.*

Many in other walks of life, under the shock of Munich, also felt impelled to work for national unity in defence of freedom, though not always with success. Léger's personal secretary, Crouy-Chanel, obtained leave of absence in order to try to start a weekly with a journalist friend, intended, as he put it, 'to shout out to Frenchmen: "Breakneck idiots! Wake up! Danger is at hand."' He prepared a dummy, costed production over a trial period at 500,000 francs[1] and solicited help from rich business friends. At the end of a fortnight with pledges in hand for a mere 20,000, Crouy, saddened, resumed his duties at the Quai.

In the wake of Munich, it might have been expected that one or more of Daladier's Cabinet would resign. But no, why should they? As Barthou had said to Léger in 1934, the criterion for measuring good and evil was no longer personal principles but public opinion. And public opinion expressed itself in the Chamber. Other than the Communists, who acted as Moscow told them, only two deputies voted against the Anglo-French agreement with Hitler, one being the Breton patriot Henri de Kérillis, whose voice in *L'Echo de Paris* had continually opposed appeasement since the Rhineland crisis.

[1]£2940 or $14,285, at 1938 values.

307

In December 1938 Bonnet brought Ribbentrop to Paris to sign a cosmetic pact guaranteeing France's frontier with Germany. But by now opinion was beginning to stiffen and it was decided that Madame Bonnet should not publicly present Frau von Ribbentrop with a bouquet of flowers.

Hope tempered by doubts continued until the spring of 1939. At the end of March Hitler demanded from Poland the return of Danzig and the 'corridor' dividing East Prussia from the rest of Germany – territory transferred to Poland at the Versailles Peace Conference. This drew from Chamberlain a solemn assurance that if Poland were attacked Britain would lend her all possible support.

If she had had to choose alone, France might well have defaulted on her 1921 treaty with Poland, but now in Britain she had, if not yet a formal ally, a friend prepared to be resolute. In one of the earliest opinion polls, 70% of Frenchmen replied Yes to the question, 'Do you think France and Britain should resist any new demand by Hitler?' Only 17% said No.

It was one thing to admit the need for resistance, another to achieve it. Daladier, combining the premiership with National Defence, worked tirelessly within the limits of his character and the possibilities open to him, but on 29 March a shrewd Swiss observer of the French scene wrote in his diary:

> The effort Daladier is making today to restore to France the prestige she once possessed appears to me to be too heavy for a man who has long been part of the discredited political pack. He cannot impose his will on them. They don't believe in him. They snigger.

One of Daladier's hidden enemies now was that Parisian optimism we have noted. Even from official sources Frenchmen received the impression that should war come they wouldn't have to make any real effort in order to reap the fruits of victory. These would just fall into their laps. A man who had served as a Minister in Blum's government talked publicly about the German mechanized divisions: 'When they went into Austria and Czechoslovakia all the tanks and armoured cars broke down on the roads.' An article in *Revue des Deux Mondes* entitled 'Peace-War' stated that the great powers shared a profound aversion to the horrors of total war, therefore

they would undoubtedly limit hostilities, as in the eighteenth century, to symbolic actions. France would send planes and guns to Poland, and fighting would be confined to that area alone.

Daladier nevertheless pressed doggedly forward with military preparations. He reversed Pierre Cot's policy of building strategic bombers, concentrating instead on fighters. Jean Monnet in Washington persuaded President Roosevelt to supply France with 1700 planes at a cost of 95 million dollars. French bank accounts in the United States held a thousand million dollars, transferred there illegally by French people who feared a war; it was suggested that these dollars should be seized and used. Daladier's Finance Minister, Paul Reynaud, whose watchword was '*Défendre le franc, c'est défendre la France*,' declined to seize the escape-hole money and said gold reserves did not permit such expenditure, while the generals said French models were superior to American; the main trade union said it would be wrong to take orders from French workmen, and Paul Louis Weiller, head of the large Gnome-Rhône aero-engine company, objected to losing valuable business. It says much for Daladier's drive that he over-ruled them all and in December sent Monnet to Washington to buy 1000 planes. But in that same month Daladier was informed by General Vuillemin that training of aircrews had lagged badly, there were not enough pilots to fly the planes on order in France, and he actually recommended a cut-back in aircraft production.

At an international level Daladier concentrated on military staff talks with Britain and on trying to get some firm military agreement with Russia, though as early as 1936 visiting generals were reporting that the question being asked in Moscow was no longer, How would Russia help France? but, Whom would she help? One other event in the diplomatic field is noteworthy: in March 1939, with the ending of the Spanish civil war, Daladier appointed as ambassador to Franco's Spain Marshal Pétain, who thus made his entry into international politics.

If a majority of Frenchmen now believed that self-preservation demanded a firm stand over Poland, in Paris opinion was still dangerously divided. Paul Morand and Jean Cocteau, like many artists, believed that fighting would be the end of civilization, not a precondition for preserving it; they supported Bonnet's increasingly

frantic attempts to save the peace at almost any price. In the world of cinema Abel Gance made an even more pacifist sound version of his 1917 film, *J'accuse*, in which the dead of the Great War rise from their graves to make an impassioned plea for peace. Jean Giraudoux continued to eulogize the Germans: 'You don't know the young Nazis, you don't know how handsome they are, how heroic, how self-sacrificing.' 'Giraudoux this side, Goebbels that,' remarked one observer, 'the flute and the trumpet.' In 1939 Giraudoux was to be appointed head of France's Propaganda.

Louise Weiss still placed her hopes of peace in getting the vote for women, but this was a measure shelved by the Senate in face of more urgent concerns. Langevin's Committee against Fascism opposed the by now intense rearmament by France and Britain. Breton and the Surrealists, still at odds with the Communist party, opposed war preparations as a shirking of the real task: letting imagination reshape the world.

André Gide in 1937 made a characteristic volte-face, publishing a second book about Russia, as full of criticisms as the first had been of praise; in particular he who as a young man had written, '*Familles, je vous hais*,' now blamed the absence in the Soviet Union of family life, of real homes. In January 1939 he foresaw the collapse of civilization, putting the blame, like Céline, on everyone but himself, and trundled off to Egypt, confiding to his diary: 'A country pleases me only if it provides many occasions for fornication.'

The Catholic Reformers divided into those, like Massis, who saw Communism as the ultimate barbarism and still hoped in some unspecified way to do a deal with Germany, and those in the orbit of Maritain who were working for unity in France as a condition of winning the approaching war and directed their efforts to healing the shameful gap between bourgeois and proletarian Catholics.

Henri Bergson, like Paul Valéry, pursued his thinking to its logical conclusion, but in a different direction. As he sadly observed the collapse of humanist efforts to preserve peace, he came to trust the mystics' conclusions that he had described in his *Two Sources of Morality*, 'unanimous in their experience that God needs man, as we need God. And why would He need us if not to love us?' Painful arthritis prevented him making public his views in lectures but in 1937 he drafted his will, which includes the following paragraph:

My thinking has led me ever closer to Catholicism, in which I see the complete fulfilment of Judaism. I would have converted had I not seen these past years the first signs of the fearful wave of anti-Semitism which is going to sweep the world. I have chosen to remain among those who very soon will be persecuted.

Bergson's move to Catholicism is all the more remarkable since just before the Great War the Church had placed his early books on the Index because they denied the possibility of objective truth.

Poulenc, when depressed, found comfort in walking the streets of Paris, and many others did so now too, as the city's mood shifted uneasily between hope and alarm. Postcards of Chamberlain were now on offer at cut prices, no longer an angel but *'Monsieur j'aime Berlin'*. Two intelligent new plays were being talked about: Cocteau's *Les Parents terribles* and Giraudoux's *Ondine*. At the pavement cafés, still bright and cheerful, one song struck a different note and became very popular: tiny Edith Piaf's bravely tender rendering of *'Mon Légionnaire'*, a girl's love for a Foreign Legion soldier who falls in action on the sands of North Africa.

In March Parisians began to receive gas masks and plans were put in hand for evacuating all children, for Pouderoux, head of the fire brigade, had declared that fifty incendiary bombs would set the whole city ablaze. At the request of the army, car headlamps had been changed from white to amber, the idea being that any enemy car would be instantly recognized by its white headlamps. But the emphasis was on passive defence, as Maurice de Broglie's colleague, Leprince-Ringuet, discovered when he undertook a survey of scientific research: 'I was stupefied to find that there was no centre for studying or producing poison gas, though it had been widely used in the Great War, that the study of metals by X-rays was practically non-existent, that for the whole field of chemical warfare France possessed one Gunpowder Engineer with no specialist experience.'

Leprince-Ringuet sought an urgent interview with Daladier. Hardly had he begun to speak when Daladier's private secretary interrupted sharply: 'How had he obtained information about poison gas and chemical warfare? That was top secret and he had laid himself open to criminal prosecution.' Daladier, however, overruled his secretary, listened, and in summer 1939 set in motion a training

programme to produce fifty or so scientists – 'within four to six years'.

But events outside Paris moved at a speedier rate. On 23 August news of the utmost gravity arrived from Moscow. In that city, four years earlier, Léger had played his Russian card, the card that was supposed to win France the rubber. At Versailles the Powers had unilaterally taken territory from Russia in order to re-create Poland – an act that a powerful country could be expected one day to try to reverse; moreover, the Leader and Teacher of All Times and All Peoples so dear to Herriot and others in Paris had shown his true colours by proposing to Léger and Laval that French shop stewards preventing overtime in aircraft factories should be shot. Yet Léger had thought fit to declare then that his prognosis of the Soviet Union was 'favourable' and to act on that assumption: the most damaging of his many failures to understand foreigners.

Now, in August 1939, Russia and Germany signed a non-aggression pact. Two could play at breaking promises. Paris learned the news with stupefaction. Some of the wise owls of French Communism changed overnight into flustered starlings; a few, notably Aragon and Malraux, braved the shock and declined to place any blame whatsoever on their Russian friends.

The defection of Russia placed not only Poland but France in a very dangerous military position. Gamelin, while repeating to the Poles that he would launch a full-scale attack on the Siegfried Line if their country was invaded, decided that any French action in that sector must be limited to token sorties.

If Poland should fall, Gamelin planned that Belgium should become the battlefield. This was the War Council's 1932 strategy for avoiding a second devastation of the land of France. But now the basic assumption of that strategy had altered: Belgium was neutral and would not allow French troops to take up defensive positions on her rivers.

At first Gamelin met the difficulty as so often with a hope, this time that his friend, Van den Bergen, Belgian Chief of Staff, would persuade his government to drop their neutrality, a hope as illusory as Léger's, in 1936, that Vansittart would persuade the British government to fight for the Rhineland.

With Belgium showing no sign of abandoning neutrality, Gamelin nevertheless clung to his plan. He would meet an expected attack

through the Low Countries by rushing France's strategic reserve into Belgium and up as far as Breda in Holland, even though this would leave the weakest section of the Maginot Line, along the Ardennes, vulnerable to a massive assault by German armour.

The French public naturally knew nothing of Gamelin's proposed strategy. They centred their hopes on the Maginot Line. The huge system of bunkers with all their complex technology was placed on full alert: a physically formidable piece of engineering but morally insidious, for it had engendered in all ranks 'the Maginot Line mentality', evident behind the joking in its graffiti: 'Before executing an order, always await the counter order.' 'Do nothing – but do it early.'

Behind the Line, according to the best estimate, were 700 fighters and some 200 bombers; also 2,815 tanks, some dating from the Great War, others modern. The tanks were to work in team with the infantry, so the Hotchkiss H35 had been rejected because too fast (17 m.p.h.) in favour of the slower R35 (11 m.p.h.). Purposely they had no radio, for that would have allowed them to assume independent missions. Nor did Gamelin, in his headquarters on the outskirts of Paris, have radio communication with his field commanders: it took him 48 hours to get an order through to all commands.

But already Gamelin had finalized and imparted his plan for meeting the main German attack which, he assumed, would come through the Low Countries as in 1914. He would move troops quickly through Belgium but, attaching small importance to airplanes, left air cover out of account. This plan he had coordinated and perfected with his field commanders, bringing to it his well-known attention to detail. All had been rehearsed repeatedly – on paper and on maps. It was a perfectionist attitude as seen in Etienne de Beaumont's prearranged masquerade balls and in the 72 rehearsals for Poulenc's ballet *Les Biches*. It was very reassuring but it did rule out initiative.

On the first day of September German troops invaded Poland. As the lesser of two evils the French government had decided to honour their treaty with Poland, knowing that Britain would do so too. Bonnet, however, tried to delay action by Whitehall, saying 'evacuation of women and children from our cities is not complete.'

On September 2 Edouard Daladier went to the Chamber. Mounting the rostrum immediately beneath the seat where a now valetudinarian Herriot presided, he asked deputies for exceptional credits of

69 billion francs 'in order to confront the international situation'. Everyone knew why the credits were suddenly needed; they were duly voted and Daladier left the Chamber, but during the whole proceeding no one pronounced the word 'war'.

That same day France ordered general mobilization. In the evening Bonnet sent an urgent message to Rome for Mussolini that 'a symbolic withdrawal of German troops would make it possible to hold a four-power conference in San Remo' – 'a suggestion,' says Ciano in his diary, 'that I threw in the wastepaper basket without even consulting the Duce'.

On September 3 at eleven o'clock Britain declared war on Germany. At noon the French ambassador in Berlin informed the German government that 'as from 5.0 p.m. today, 3rd September, the French government finds itself obliged to fulfil the engagements which France has contracted towards Poland and which are known to the German government.'

The news was received in Paris in shocked silence and with some murmuring: 'Die for Danzig? No.' Numbed groups clustered round big pasted-up notices, reading verbose details of evacuation and mobilization; at the railway stations reservists kissed wives and mothers goodbye before boarding their train to join their regiment, but without the sense of pride and the assurance that had marked 1914. There were almost no conscientious objectors, but neither were there flowers in the rifles. Most were puzzled. Hadn't Briand declared to the League of Nations that men have 'a right to security, as they have a right to bread'? since when successive governments had promised peace as a right. Now it had been snatched from them.

The trains left; parents and family drifted home. Many could remember Armistice Night, jubilant crowds in front of the Madeleine and in the place de l'Opéra dancing and singing, the laughter, the exultation, tens of thousands of voices united in the *Marseillaise*. As though in one of Antonin Artaud's cruel productions, the crowds had been struck silent, the carnival ball's pretty disguises changed into gas masks, while jazz trumpets played reveillé.

In one sense an epoch had ended; in another it contained the immediate future. The events of the next three years, the *drôle de guerre*, defeat, capitulation and the subsequent political division of France were to be a logical unfolding of inter-war choices.

SOURCES AND NOTES

A cross-disciplinary book such as this draws for part of its background on standard works in several different fields. These will be familiar to students and it would be superfluous to list them all here or indeed the many newspapers, periodicals and little magazines that debated issues of the day. The notes that follow identify the works, notably biographies based on primary sources, that I have found most useful in exploring my main themes and understanding leading protagonists, and they give references for new or hitherto neglected information. Unless otherwise stated, the place of publication of books in French is Paris, of books in English, London.

PREFACE (pp. xiii–xvii)
'the journey cannot be guaranteed . . .' *The Times*, 26 August 1919.
 Sailings from the United States: Billy Klüver and Julie Martin, *Kiki's Paris* (1989), p. 168 and note.
 'Our epoch pleases me . . .' Ravel to Nino Frank, in Arbie Orenstein, editor, *A Ravel Reader* (New York 1990), p. 497.

CHAPTER 1: FROM WAR TO PEACE (pp. 1–14)
Dorgelès at war: Micheline Dupray, *Roland Dorgelès: un siècle de vie littéraire française* (1986), pp. 121–92.
 'a vast cosmopolitan caravanserai . . .' E. J. Dillon, *The Peace Conference* (1919), pp. 3–4.
 'A cable arrived . . .' Lord Riddell, *Intimate Diary of the Peace Conference and after, 1918–1923* (1933), 8 March 1919.
 Pressures for a speedy peace: Harold Nicolson, *Peacemaking 1919* (1933), p. 190.
 'Here on the eleventh of November . . .' The words are by Binet Valmer. Hitler was to remove the pavement in 1940; after World War II the French reassembled it.
 Berthelot's character: Paul Claudel, *Œuvres en prose* (1965), pp. 1274–92; Jean-Luc Barré, *Le Seigneur-Chat: Philippe Berthelot 1866–1934* (1988), pp. 47–83.
 'the right for lice to eat lions': Barré, *op. cit.*, p. 297.
 'Philippe is convinced . . .' Edmond Jaloux in the privately printed *Un souvenir de Philippe Berthelot* (n.d.).
 Berthelot's plans for a new Europe had been formulated as early as December 1916; they were incorporated in the Allies' official note to President Wilson on 10 January 1917. Barré, *op. cit.*, pp. 312–13.
 'Clemenceau finds Berthelot's hotchpotch absurd': Paul Cambon to his son, December 1918, cited *idem*, p. 331.

Berthelot recites Hugo to Clemenceau: *idem*, p. 341.

Berthelot became Secretary General of the Foreign Office in September 1920. In 1921 he overstepped his authority by supporting, unsuccessfully, his brother André's hard-hit Banque industrielle de Chine. After three years under a cloud he returned to his post which he held until 1933.

CHAPTER 2: A NEW HEDONISM (pp. 15–33)
Cocteau's appearance, dress, manner: Jean Touzot, *Jean Cocteau* (1989), pp. 17–25.

'Life is the obverse . . .' *idem*, p. 266.

Spiritualism in end-of-war Paris: Claude Mignot-Ogliastri, *Anna de Noailles* (1987), p. 306.

'A big table . . .' Abbé Mugnier, *Journal* (1985), 18 February 1925.

Cocteau's encounter with Heurtebise: Francis Steegmuller, *Cocteau, a biography* (1970), p. 350.

L'Ange Heurtebise: in Jean Cocteau, *Poèmes 1916–1955* (1956), pp. 63–73.

Cocteau's reconciliation with the Church and meeting with Père Charles Henrion: Touzot, *op. cit.*, pp. 99–103.

'and I began to cry . . .' *idem*, pp. 226–7.

The scandal of *J'adore*: Maurice Martin du Gard, *Les Mémorables*, II (1960), pp. 283–6.

Morand's service in the Literary Section of the Quai d'Orsay: Ginette Guitard-Auviste, *Paul Morand* (1981), pp. 83–4.

Morand at *Le Bœuf sur le toit*: Ginette Guitard-Auviste, *op. cit.*, pp. 88–91.

The Proust ball: Jean-Louis de Faucigny-Lucinge, *Un gentilhomme cosmopolite* (1990), p. 110.

Minister in Siam: Ginette Guitard-Auviste, *op. cit.*, pp. 113–14.

'"This journey . . ." Mugnier noted . . .' Abbé Mugnier, *Journal* (1985), 30 January 1926.

'He rushes up to Hélène . . .' Ginette Guitard-Auviste, *op. cit.*, p. 126.

'I have the fastest car in France . .' *idem*, p. 148.

For Gide's life at this period the main sources are his *Journal*, his correspondence, notably with Roger Martin du Gard (1968) and *Cahiers de la Petite Dame*.

Gide's liaison with Marc Allégret: Eric Deschodt, *Gide: le contemporain capital* (1991), pp. 178–80.

Gide's proposal to Elisabeth: *Cahiers de la Petite Dame*, I, 30 August 1922.

'I have never been able to renounce . . .' *idem*, 31 September 1926.

CHAPTER 3: MEN OF REASON (pp. 34–44)
Léon Brunschvicg's beliefs and career: Marcel Deschoux, *La philosophie de Léon Brunschvicg* (1949), with a biographical appendix by Madame Brunschvicg.

'"Einstein," he told . . .' Jean Guitton, *Un siècle, une vie* (1988), p. 128.

'He looks like a senior civil servant . . .' Maria van Rysselberghe, *Cahiers de la Petite Dame*, I (1973), 31 August 1926.

'You've studied Pascal . . .' Guitton, *op. cit.*, pp. 127–9.

Henri Bergson's character and work: Jacques Chevalier, *Entretiens avec Bergson* (1959); Guitton, *op. cit.*, pp. 138–40.

'The mystics are unanimous . . .' *Les deux sources de la morale et de la religion* (1932), p. 270.

Paul Valéry's character and beliefs emerge most candidly from his *Cahiers* (Pléiade edition 1973–4) and from André Gide-Paul Valéry, *Correspondance 1890–1942* (1955).

'Instinctive horror . . .' Paul Valéry, *Œuvres* II (1958) Cahier B 1910, p. 572.

'In literature there is always something sly . . .' *idem*, p. 581.

'Valéry is not a Christian . . .' Abbé Mugnier, *Journal* (1985), 25 May 1922.

'I was shown into a well-kept home . . .' Maurice Sachs, *Le Sabbat* (1946), pp. 146 and 158.

Maritain's most important book is *Humanisme intégral* (1936); his criticism of anthropocentric humanism is on pp. 32–6.

CHAPTER 4: THE FEMININE TOUCH (pp.45–57)

Furniture: Alastair Duncan, *Art Deco* (1988); lacquer screens: Philippe Garner, editor, *Phaidon Encyclopædia of Decorative Arts 1890–1940* (1978), pp. 64–8; decorative sculpture: *idem*, pp. 100–3.

Paris salons: Jean-Louis de Faucigny-Lucinge, *Un gentilhomme cosmopolite* (1990), pp. 90–7.

Misia Sert's apartment: Maurice Sachs, *La Décade de l'illusion* (1950), p. 58.

Anna de Noailles and Paul Painlevé: Claude Mignot-Ogliastri, *Anna de Noailles* (1987), p. 357.

'So this is the balm . . .': *idem*, p. 370.

'They say nice things . . .' Abbé Mugnier, *Journal* (1985), 20 February 1936.

Portraits of Anna de Noailles: Claude Mignot-Ogliastri, *op. cit.*, pp. 284–6.

Suzanne Lenglen: Alan Little, *Suzanne Lenglen: Tennis Idol of the Twenties* (1988).

Character and career of Coco Chanel: Frances Kennett, *Coco: The Life and Loves of Gabrielle Chanel* (1989).

'She was small and very slim . . .' Maurice Sachs, cited in Pierre Galante, *Les Années Chanel* (1972), p. 65.

'woman is in tow to man . . .' Abbé Mugnier, *Journal* (1985), 22 April 1923.

CHAPTER 5: ENEMIES OF REASON (pp.58–74)

Early Surrealist writing appeared mainly in the periodicals *Littérature* and *La révolution surréaliste*. Breton's inter-war writings, including *Champs magnétiques*, the Manifestos and the autobiographical *Nadja* are available in *Œuvres complètes*, I (1988).

'The window sunk . . .' *Œuvres complètes*, I (1988), p. 57.

'SURREALISM. Pure psychic automatism . . .' *idem*, p. 328.

Louis Aragon's character and career: Pierre Daix, *Aragon, une vie à changer* (1975); contributions to Breton's periodicals, speeches as reported in *l'Humanité*, editorials in *Ce Soir*.

317

Automatic writing and trances: Marie-Claire Dumas, *Robert Desnos ou l'exploration des limites* (1980), pp. 45–51.

Aragon and Nancy Cunard: Anne Chisholm, *Nancy Cunard* (1979), pp. 102–7.

Desnos's love for Yvonne George: Marie-Claire Dumas, *op. cit.*, pp. 75–8, and for Youki, pp. 84–103.

'L'étoile du Nord . . .' *idem*, pp. 390–1.

The quotations from *Rrose Sélavy: idem*, pp. 303–4.

CHAPTER 6: THE SEARCH FOR MAN'S CENTRE (pp. 75–94)

The Montparnasse painters and Kiki: Billy Klüver and Julie Martin, *Kiki's Paris* (1989), *passim*.

Miró's character and career: Joan Miró, *Ceci est la couleur de mes rêves* (1977).

Kahnweiler's circle: Pierre Assouline, *L'homme de l'art: D. H. Kahnweiler 1884–1979* (1988), chapter 6.

Surrealists: Max Ernst, *Au delà de la peinture* (1937); Suzi Gablik, *Magritte* (1985); René Magritte, *Ecrits complets* (1979).

Eluard's purchase of *Le temps menaçant*: Jean-Charles Gateau, *Paul Eluard et la Peinture Surréaliste* (Geneva 1982), p. 360.

The Secret Life of Salvador Dali (1968); Fleur Cowles, *The Case of Salvador Dali* (1959); Tim McGirk, *Wicked Lady* (1989).

The syndicate to help Dali: Jean-Louis de Faucigny-Lucinge: *Un gentil-homme cosmopolite* (1990), p. 130.

Léger's artistic creed: Fernand Léger, *Functions of Painting*, edited Edward F. Fry (1978).

'Let's go into the factories . . .' *idem*, pp. 46–7.

Brancusi's character and works: Pontus Hulten *et al.*, *Brancusi* (1986), pp. 134–213.

'Peering Head': Charles Juliet, *Giacometti* (1986), p. 21.

Picasso in the inter-war years: Fernande Olivier, *Picasso et ses amis* (1933); Paul Eluard's correspondence and articles; Roland Penrose, *Picasso: his life and work* (1973).

CHAPTER 7: FILM (pp. 95–110)

Man Ray's career: Man Ray, *Self Portrait* (1963).

'He photographs people . . .' Billy Klüver and Julie Martin, *Kiki's Paris* (1989), p. 108.

Cocteau's *Le Sang d'un poète*: Francis Steegmuller, *Cocteau, a biography* (1970), pp. 409–11.

René Clair's films: Georges Charensol and Robert Régent, *50 ans de cinéma avec René Clair* (1979).

'This violent experience . . .' *idem*, p. 18.

'*Baisez, monsieur, baisez encore!*' *idem*, p. 22.

Clair, Picabia and *Relâche*: Klüver and Martin, *op. cit.*, pp. 136–7, 232.

Vigo and *L'Atalante*: Pierre Lherminier, *Jean Vigo*, (1984) pp. 53–6, 173–6.

Gance's *Napoléon*: Kevin Brownlow, *'Napoléon': Abel Gance's Silent Classic* (1983).

Other films concerned with war: Robin Buss, *The French through their Films* (1988), pp. 104–5.

CHAPTER 8: THE STAGE (pp. 111–20)

Pagnol's arrival in Paris: Raymond Castans, *Marcel Pagnol* (1987), pp. 67–85.

'I have a very distinct impression . . .' *idem*, p. 67.

'At least I am punctually unpunctual . . .' *idem*, p. 88.

Pagnol's triumph compared to Lindbergh's: *idem*, p. 125.

'Unpaid? Then how do you live?' *idem*, p. 126.

Tardieu's liaison with Mary Marquet is described in the latter's memoirs: *Ce que j'ose dire* (1974), pp. 187–229.

Guitry's plays and career: Dominique Desanti, *Sacha Guitry: cinquante ans de spectacle* (1982).

Artaud formulated the principles of theatre of cruelty in *Le Théâtre et son double* (1938).

Pacifist currents: Philip Fischer, *The French Theater and French Attitudes toward War, 1919–1939*, unpublished University of Connecticut thesis, 1971, chapter iv: Playwrights against War.

Giraudoux's career and plays: Donald Inskip, *Jean Giraudoux: The Making of a Dramatist* (1958).

'That perhaps was the beginning of my success . . .' Pages de Journal, *La Nef*, February 1949, p. 5.

CHAPTER 9: SONG AND DANCE (pp. 121–38)

Maurice Chevalier and Mistinguett: James Harding, *Maurice Chevalier* (1982), pp. 33–66.

Lyrics of favourite songs: Pierre Saka, *La chanson française à travers ses succès* (1988).

La revue nègre: Josephine Baker, *Une vie de toutes les couleurs* (1936).

Satie's character and career: Georges Auric, *Quand j'étais là* (1979), pp. 21–33.

Satie and Brancusi: Pontus Hulten *et al.*, *Brancusi* (1986), pp. 148–57.

'You never need money . . .' Darius Milhaud, *Notes without music* (1952), p. 149.

'My despair increases daily . . .' Ravel to Ida Godebska, in Arbie Orenstein, editor, *A Ravel Reader* (New York 1990), p. 195.

'He is a child and an old man . . .' Emile Vuillermoz, cited Roger Nichols, editor, *Ravel Remembered* (1987), p. 25.

Ravel's intentions in the *Bolero*: René Chalupt, *idem*, p. 49.

Ravel on the *chansons de Paris*: *idem*, p. 155.

'I've written only one masterpiece . . .' Arthur Honegger, *Incantation aux fossiles* (Lausanne 1948), pp. 91–2.

'There was something of the spoilt child . . .' Pierre Bernac, *Francis Poulenc, The man and his songs* (1977), p. 30.

'I am well aware . . .' Francis Poulenc, *Selected Correspondence 1915–1963* (1991), p. 98.

Poulenc's conversion: Pierre Bernac, *op. cit.*, pp. 28–9.

Messiaen's character and works: Claude Samuel, *Conversations with Olivier Messiaen* (1976); obituary by Jennifer Bate, *The Independent*, 29 April 1992.

CHAPTER 10: THE ENGLISH-SPEAKING ENCLAVE (pp. 139–54)
Dos Passos and Cendrars: George Wickes, *Americans in Paris* (New York 1969), pp. 98–9.

'I participated in an actual marriage . . .' *idem*, p. 71.

'Loafing around in little old bars . . .' *idem*, p. 93.

Cowley punches a café-proprietor: Malcolm Cowley, *Exile's Return* (1934), pp. 169–70.

Hemingway in Paris: Ernest Hemingway, *Selected Letters 1917–1961* (1981); *A Moveable Feast* (1964).

'You're an expatriate . . .' From *The Sun Also Rises*, quoted Wickes, *op. cit.*, p. 149.

Little magazines and printing presses: Wickes, *op. cit.*, pp. 171–87.

'I cannot see any special talent . . .' Richard Ellmann, *James Joyce* (1959), p. 502.

The review of Joyce's *Ulysses*: Louis Gillet, in *Revue des Deux Mondes*, 1 August 1925.

Gershwin in Paris: Edward Jablonski, *Gershwin* (1988), pp. 153–72.

Gertrude Stein: *How to Write* (Paris 1931); analysis of 'Arthur A Grammar': Shari Benstock, *Women of the Left Bank: Paris 1900–1940* (1987), pp. 185–6.

Djuna Barnes: *idem*, pp. 230–56.

Henry Miller: Alfred Perlès, *My Friend Henry Miller* (1955).

'Get old manifestos . . .' Wickes, *op. cit.*, p. 264.

CHAPTER 11: TWO CHEVRONS, A SHIP AND THE ATOM (pp. 155–71)
'One professor for each subject . . .' Louis Leprince-Ringuet, *Noces de diamant avec l'atome* (1991), p. 19.

Citroën's character and career: Silvain Reiner, *La Tragédie d'André Citroën* (1954).

The building of the *Normandie*: Jean-Pierre Mogin, *Le Normandie, seigneur de l'Atlantique* (1985); its decor and furnishings: Alastair Duncan, *Art Deco* (1988), p. 42.

Maurice and Victor de Broglie: Jean La Varende, *Les Broglies* (1950), pp. 290–336, and Leprince-Ringuet, *op. cit.*, pp. 35–44.

Irène and Frédéric Joliot-Curie: Spencer Weart, *La grande aventure des atomistes français* (1980), pp. 69–98.

Ernest Mercier and Redressement: Richard F. Kuisel, *Ernest Mercier, French technocrat* (Berkeley, 1967).

Out-of-date French steelworks: Jean Monnet, *Mémoires* (1976), p. 277.

CHAPTER 12: TOILERS FOR PEACE (pp. 172–85)
Louise Weiss's upbringing and career: *Mémoires d'une Européenne*, I (1968) and II (1969); Weiss papers, Bibliothèque nationale.

Edouard Herriot's character: Robert Rothschild, *Les Chemins de Munich*, pp. 24–7 and John Gunther, *Inside Europe*, revised edition (1936), pp. 155–6.

The League of Nations in 1924: Louise Weiss, *op. cit.*, II, pp. 202–223.

Briand's character and foreign policy: Bernard Oudin, *Aristide Briand* (1987).

Viénot's views on Germany: Pierre Viénot, *Incertitudes allemandes* (1931). 'Many Germans . . .' *idem*, pp. 151–2.

Jean de Pange's peace-making efforts: *Journal*, four volumes (1964–75), *passim*.

Painlevé 'leaping in the air . . .' An observation by Gilbert Murray, who worked with him in Geneva: Duncan Wilson, *Gilbert Murray O.M.* (1987), p. 363.

The School of Peace: Louise Weiss, *op. cit.*, pp. 282–6.

The Peace Congress of 1931: *idem*, pp. 318–23.

CHAPTER 13: DEFEND AND AGAIN DEFEND (pp. 186–201)
Pétain and the Hervieu Dining Club: Jacques Isorni, *Philippe Pétain*, I (1972), pp. 298–9.

Maginot and the building of the Line: Vivian Rowe, *The Great Wall of France* (1959).

Higher War Council's decision not to extend the Maginot Line: French Army Archives, Carton 1 N 21 vol. 16, May–June 1932. Gamelin voted in favour of extending fortifications but soon fell into line behind Pétain.

'If one told Berthelot . . .' Charles d'Ydewalle, *Vingt ans d'Europe 1919–1939* (1939), p. 22.

Weygand's battle to increase length of service: Philip Bankwitz, *Maxime Weygand and civil-military relations in modern France* (Cambridge, Mass. 1967).

De Gaulle and *Vers l'armée de métier*: Jean Lacouture, *De Gaulle, Le Rebelle* (1984), pp. 224–59.

'Ten thousand citizens . . .' Ladislas Mysyrowicz, *Autopsie d'une défaite: origines de l'effondrement militaire français de 1940* (1973), p. 176.

Air force orders and the prototype system: Emanuel Chadeau, *De Blériot à Dassault: L'industrie aéronautique en France 1900–1950* (1987), pp. 166–94.

Production impeded by the civil service: Etienne de Crouy-Chanel, *Alexis Léger ou l'autre visage de Saint-John Perse* (1989), p. 199.

CHAPTER 14: THE RUSSIAN CARD (pp. 202–18)
'I suppose you have read *Mein Kampf* . . .' *Jean Guéhenno et Romain Rolland 1919–1944* (Cahiers Romain Rolland 23; 1975), p. 297.

Press copies of *Mein Kampf*: Etienne de Crouy-Chanel, *Alexis Léger ou l'autre visage de Saint-John Perse* (1989), p. 187.

Léger's character, career and political aims: *idem*; Fondation Saint-John Perse, *Les Années de Formation, 1887–1925* (1985).

'"Good breathing . ." he wrote to a friend . . .' Saint-John Perse, *Œuvres complètes* (1972), p. 729.

'But that is unimportant . . .' *idem*, p. 859.

'We must see how Poland could be helped . . .' Bertrand Destremau, *Weygand* (1989), p. 248.

Louis Barthou bows to Cabinet opinion: Geneviève Tabouis, *Vingt ans de 'suspense' diplomatique* (1958), p. 171.

'Yesterday I lived the most tragic day of my life . . .' *idem*, pp. 169–70.

Léger and Barthou visit Briand's grave: *idem*, p. 171.

Herriot's visits to Russia: Robert H. Johnston, *New Mecca, New Babylon* (Montreal 1988), pp. 130–33.

Laval, Léger and Stalin: Crouy-Chanel, *op. cit.*, pp. 162–6.

CHAPTER 15: FRANCE REFLECTED (pp. 219–32)

Bernanos's background and religious development: Georges Bernanos, *Correspondance*, I (1971), pp. 32–60.

Céline's upbringing and career: François Gibault, *Céline*, I (1977) and II (1985).

'It's impossible for me to live . . .' *idem*, I, p. 270.

'Open the book . . .' *La Flèche*, 21 March 1936, cited Marie-Claire Dumas, *Robert Desnos ou l'exploration des limites* (1980), p. 251.

Gide, sensitive as usual to a change of mood, started a series in 1930 called *'Ne jugez pas'*, which recounted unsavoury crimes by those with warped minds, and contributed the first volume, *L'affaire Redureau*, about a model boy of fifteen who without apparent motive killed seven people.

CHAPTER 16: POLES APART (pp. 233–54)

Breton and the Surrealists in the 1930s: articles in *Le Surréalisme au service de la révolution*; Helena Lewis, *The Politics of the French Surrealists 1919–1945*. Unpublished New York University thesis, 1971.

Max Jacob harassed by the Surrealists: Maurice Martin du Gard, *Les Mémorables*, I (1957), p. 281.

Dali and *The Riddle of William Tell*: Henri Béhar, *André Breton, Le grand indésirable* (1990), p. 269.

'Shoot Léon Blum . . .' André Breton, *Misère de la poésie: "L'affaire Aragon" devant l'opinion publique* (1932), pp. 25–7.

'The presence of the President of the Republic . . .' André Breton *et al.*, *Ne Visitez pas l'Exposition Coloniale* (n.d.), p. 1.

Prévert's political activities: René Gilson, *Jacques Prévert: des mots et merveilles* (1990), pp. 55–75.

Gide's conversion to Communism: Eric Deschodt, *Gide: le contemporain capital* (1991), pp. 243–56.

Massis's career and writings: Michel Toda, *Henri Massis, un témoin de la droite intellectuelle* (1987).

Daladier's dismissal of Chiappe: Serge Bernstein, *Le 6 février 1934* (1975), pp. 132–4.

The riots in Paris: Maurice Martin du Gard, *Les Mémorables*, II (1960), pp. 124–8; Serge Bernstein, *op. cit.*

La Rocque's moment of panic: Etienne de Crouy-Chanel, *Alexis Léger ou l'autre visage de Saint-John Perse* (1989), p. 204.

By now desire for a strong leader with full powers is to be found across the whole political spectrum. In February 1936 a group of CGT trade unionists wrote to Daladier: 'Become our Dictator . . . Be our Saviour. Our country is confident that you alone can effect a general cleansing. So assume full powers, and in this way we shall stop floundering.' Archives Daladier, cited Bernstein, *op. cit.*, p. 224.

Alain's influence with the Vigilance Committee of Intellectuals: André Sernin, *Alain, un sage dans la cité* (1985), pp. 360–70.

'Liberalism is dead': Eric Deschodt, *op. cit.*, p. 248.

CHAPTER 17: THE RHINELAND CRISIS (pp. 255–67)

'Although I have roamed . . .' Saint-John Perse, *Œuvres complètes* (1972), p. 797.

'Like other children of nature . . .' Fondation Saint-John Perse, *Les Années de Formation, 1887–1925* (Aix en Province, 1985), p. 52.

Léger twice saluted as a god: Jean Bernard, *Mon beau navire* (1980), pp. 168–9.

Laval's devious character: John Gunther, *Inside Europe*, revised edition (1936), pp. 148–52.

'I have done my duty . . .' Laval in Geneviève Tabouis, *Vingt ans de 'suspense' diplomatique* (1958), p. 254.

Events of March 1936: James T. Emmerson, *The Rhineland Crisis* (1977).

German troop numbers: *idem*, p. 111.

Massis's manifesto: Michel Toda, *Henri Massis, un témoin de la droite intellectuelle* (1987), p. 301.

'a France that is disarmed . . .' *idem*, p. 300.

Gamelin's character and career: Pertinax, *Les Fossoyeurs* (1946), pp. 49–52.

Gamelin's strategy based on Poland and Italy: Nicole Jordan, 'The Cut-Price War on the Peripheries' in Robert Boyce and Esmonde M. Robertson, editors, *Paths to War* (1989) and Nicole Jordan, *The Popular Front and Central Europe* (Cambridge 1992), pp. 81–5.

'When we have dedicated . . .' Paul Reynaud, *Le problème militaire français* (1937), p. 27.

'Cowards, cowards!' Etienne de Crouy-Chanel, *Alexis Léger ou l'autre visage de Saint-John Perse* (1989), p. 190.

'It's quite beyond me . . .' Jean de Pange, *Journal*, IV (1975), 16 March 1938.

CHAPTER 18: THE POPULAR FRONT (pp. 268–80)

Blum's character and career: Jean Lacouture, *Léon Blum* (1977).

'"Socialism", wrote Blum . . .' *idem*, p. 78.

'If they're short of money . . .' Pierre Galante, *Les Années Chanel* (1972), p. 94.

Gide's visit to Russia: Eric Deschodt, *Gide: le contemporain capital* (1991), pp. 254–6.

Workers in first-class compartments: Abbé Jean Desgranges, *Journal d'un prêtre député 1936–1940* (1960), 1 August 1936.

'Whereas Mandel is a Jew . . .' Maurice Martin du Gard, *Les Mémorables* II (1960), p. 169.

Blum's foreign policy: Nicole Jordan, *The Popular Front and Central Europe* (Cambridge 1992); Jean Sagnes et Sylvia Caucanas, éditeurs, *Les Français et la Guerre d'Espagne* (Perpignan 1990).

The 1937 Paris Exhibition: *Exposition Internationale Paris 1937*. The Official Guide, English edition (Paris 1937).

Fernand Léger's plan to paint Paris red, white and blue: Pierre Assouline, *L'homme d'art: D. H. Kahnweiler 1884–1979* (1988), p. 465.

'I commanded a detachment of troops . . .' Paul Valéry, *Cahiers*, II (1974), p. 175.

Weiss's criticism of Socialist political strategy: *Mémoires d'une Européenne*, II (1969), p. 269.

Reactions to *Guernica*: Jean Hugo, *Le Regard de la Mémoire* (1983), p. 457.

CHAPTER 19: PADDLING OVER THE WEIR (pp. 281–95)
Beuve-Méry's character and career: Laurent Greilsamer, *Hubert Beuve-Méry* (1990).

'People are so stupid . . .' Etienne de Crouy-Chanel, *Alexis Léger ou l'autre visage de Saint-John Perse* (1989), p. 273.

'Why doesn't France buy . . .' Laurent Greilsamer, *op. cit.*, p. 97.

'How dare you, a Frenchman . . .' *idem*, p. 116.

Barthélemy's letter and Beuve-Méry's reply: *idem*, pp. 110–14.

'[Bonnet] suffered . . .' de Monzie, in Juliusz Lukasiewicz, *Diplomat in Paris 1936–1939* (New York 1970), p. 289.

Gamelin's attitude at Munich: Nicole Jordan, 'The Cut-Price War on the Peripheries' in Robert Boyce and Esmonde M. Robertson, editors, *Paths to War* (1989), pp. 128–66, citing Papiers Daladier, 2 DAI Dr3, 'Munich', pp. 70, 95–7, and drawing on General Schweisguth's memoranda in the French Army Archives.

'The power of our offensive . . .' Maurice Gamelin, *Servir*, II (1947), pp. 318–19.

Deficiencies of air force policy: Ladislas Mysyrowicz, *Autopsie d'une défaite: origines de l'effrondrement militaire française de 1940* (1973), pp. 191–5.

Vuillemin duped at Luftwaffe manœuvres: Robert Rothschild, *Les Chemins de Munich* (1988), p. 348; his defeatist attitude during the Munich crisis: Jean Cuny et Raymond Danel, *L'aviation de chasse française 1918–1940* (1975), p. 143.

François-Poncet suppresses messages: Nicole Jordan, *The Popular Front and Central Europe* (Cambridge 1992), p. 288.

Daladier and the marquise de Crussol: Robert Rothschild, *op. cit.*, p. 308.

The Quai d'Orsay reception and Morand's thank-you note: Georges Bonnet, *Dans la tourmente 1938–1948* (1970), p. 29.

Osusky, Bonnet and Crouy-Chanel: Crouy-Chanel, *op. cit.*, pp. 221–2.

'Officers and men . . .' Michel Toda, *Henri Massis: un témoin de la droite intellectuelle* (1987), p. 319.

Bonnet telephones Prague: Crouy-Chanel, *op. cit.*, p. 224.

In a balanced assessment of the Munich settlement (*The Price of Peace* [1979], pp. 978–1004), Telford Taylor concludes: 'The contribution of hindsight is not so great as to give one much pause about concluding that the British and French governments *should have* realized, as a number of their members did, that they could confront Germany more advantageously *with* Czechoslovakia in 1938 than without her during the next several years.'

'[Paris] . . . a frightful place . . .' William L. Shirer, *Berlin Diary* (1941), p. 125.

CHAPTER 20: GROPING FOR UNITY (pp. 296–314)

'Our French radio . . .' Abbé Jean Desgranges, *Journal d'un prêtre député 1936–1940* (1960), p. 179.

Pétain's criticism of the educational system: Jacques Isorni, *Philippe Pétain*, I (1972), pp. 345–7.

'In our social conflicts . . .' Charles de Gaulle, *Lettres, notes et carnets 1919–juin 1940* (1980), p. 457.

French journalists accept bribes: Laurent Greilsamer, *Hubert Beuve-Méry* (1990), pp. 84–5; Jean-Baptiste Duroselle, *La Décadence* (1979), pp. 203–9.

'The massacre of the whole French race . . .' L. F. Céline, *Bagatelles pour un massacre* (1937), pp. 149 and 68.

'[Optimism] is a basic instinct . . .' Saint-John Perse, *Œuvres complètes* (1972), p. 597.

'I tell myself . . .' Jean de Pange, *Journal 1937–1939* (1975), 4 March 1937.

'so full of their own ideas . . .' *idem*, 1 February 1937.

'they treat all Europe . . .' Charles d'Ydewalle, *Vingt ans d'Europe 1919–1939* (1939), p. 73.

'"We have promised", people tell me . . .' Abbé Mugnier, *Journal* (1985), 28 June 1939.

'I hate Hitler . . .' Ernest Hemingway, *Selected Letters 1917–1961* (1981), p. 396.

Dorgelès's tour of Eastern Europe: Micheline Dupray, *Roland Dorgelès: un siècle de vie littéraire française* (1986), pp. 301–8.

'This evening I am singing . . .' Marie-Claire Dumas, *Robert Desnos ou l'exploration des limites* (1980), pp. 256–7.

Crouy-Chanel's attempt to found a periodical: Etienne de Crouy-Chanel, *Alexis Léger ou l'autre visage de Saint-John Perse* (1989), p. 238.

'The effort Daladier is making . . .' Guy de Portalès, *Journal*, II (1991), 29 March 1939.

'When they went into Austria . . .' René de Chambrun, *I Saw France Fall* (New York 1940), p. 76.

Daladier and the order for American planes: John Haight, *American aid to France 1938–1940* (New York 1970), p. 107, note 7.

'You don't know the young Nazis . . .' Laurent Greilsamer, *Hubert Beuve-Méry* (1990), p. 137.

André Gide's volte-face on Russia: *Retouches à mon 'Retour de l'U.R.S.S.'* (1937); 'A country pleases me . . .' André Gide, *Journal* (1941), 3 February 1939.

Pouderoux on incendiary bombs: Ladislas Mysyrowicz, *Autopsie d'une défaite: origines de l'effondrement militaire français de 1940* (1973), p. 185.

'I was stupefied . . .' Louis Leprince-Ringuet, *Noces de diamant avec l'atome* (1991), pp. 94–6.

Maginot Line graffiti: René de Chambrun, *op. cit.*, p. 56.

Gamelin's defence strategy: Nicole Jordan, 'The Cut-Price War on the Peripheries' in Robert Boyce and Esmonde M. Robertson, editors, *Paths to War* (1989), pp. 156–8; Nicole Jordan, *The Popular Front and Central Europe* (Cambridge 1992), pp. 290–305; Astier de La Vigerie, *Le ciel n'était pas vide* (1952), p. 23. In a recent reappraisal, *The Republic in Danger* (Cambridge 1992), Martin S. Alexander argues that Gamelin organized ably 'a programme of unprecedented peacetime defensive preparation' but concludes that he fell prey to 'overweening confidence in his own ability as a broker, a fixer and a mediator'.

INDEX

Tabouis, Geneviève 212
Tailleferre, Germaine 133
Taittinger, Pierre 247
Tanguy, Yves 80
Tardieu, André 114, 180, 211–12
Taylor, Frederick Winslow 155
Teilhard de Chardin, Père Pierre 38
Temps, Le 284–6
Tharaud, Jean 298
Tharaud, Jérôme 298
Thomson, Virgil 146–7, 148, 149
Thorez, Maurice 241, 275
Toklas, Alice B. 149–50
Tombeau de Couperin, Le 129
Topaze 113–14
Train Bleu, Le 19, 133
Transatlantic 144
Trefusis, Violet 51
Triolet, Elsa 70, 235
Trojan war will not take place, The 119–20, 261
Two Sources of Morality and Religion, The 38
Tzara, Tristan 61, 234, 275

Ulysses 144–6
Union Nationale des Combattants 242, 249, 252
United States
and Treaty of Versailles 7–9
loans to Germany 9, 181
and League of Nations 12, 176
as seen by expatriates 148
offers France military planes 309

Vaillant-Couturier, Paul 241
Valéry, Paul 39, 48, 50, 138, 172, 254, 278, 300
attitude to poetry 39
on Christianity 40
view of Europe 40–1

supports women's rights 56
encourages Breton 62
opposes industrialization 170
friendship with Pétain 188, 192
inscriptions for 1937 Exposition 277
Vallée, Yvonne 123
Van Rysselberghe, Elisabeth 30–1, 240
Van Rysselberghe, Maria 30–1, 36, 240
Van Rysselberghe, Théo 30, 31
Vansittart, Sir Robert 256–7, 258, 263
Verdun, battle of 186–8
Versailles, Treaty of 8–9
Viénot, Pierre 181–2, 302
Vigilance Committee of Intellectuals against Fascism and War 254, 261, 310
Vigo, Jean 104–6
Vigo, Lydu 104–6
Villard, Pierre 42
Viñes, Ricardo 131, 134, 138
Vitrac, Roger 116
Vive la Liberté! 305–6
Voyage au bout de la nuit 228–30
Vuillemin, General Joseph 290–1, 309

Walter, Marie-Thérèse 92–3
Weiller, Paul-Louis 309
Weiss, Louise 173–81, 278, 310
Westminster, Duke of 55
Weygand, General Maxime 193–6, 209–10
Wilson, Woodrow 7–9, 11, 12, 37
Wilquin 165
women's rights 56–7
Wooden Crosses, The 2–6, 13
Wood, Thelma 152
World War I 1–10, 186

Ydewalle, Charles d' 302
Youki (Lucie Badoul) 72, 76–8
Yugoslavia 11, 180

Zay, Jean 273